Praise for *Diane von Furstenberg*

"Fascinating."

—*New York Times Sunday Book Review*

"Un-put-downable."

—*Wall Street Journal*

"Thoroughly reported. . . . Rich with delicious details. . . . A timely tale of a woman who knows what other women want: Everything."

—*USA Today*

"Absorbing. . . . Adds to the 'DVF' canon by wrapping the history of von Furstenberg's spectacular career and often scandalous personal life in a cultural and feminist context."

—*Chicago Tribune*

"A compelling portrait."

—*Atlanta Journal-Constitution*

"Fascinating. . . . Examines the designer's rise to stardom from her postwar, European childhood to the personal scandals of her adulthood through a feminist lens."

—*Bustle*

"Explores the pulse and impulses of the designer."

—*Daily Mail* (UK)

"In a thorough and balanced look at von Furstenberg's life, Diliberto not only probes the pain caused by her roller-coaster professional and personal mishaps but tallies the triumphs that came through sheer perseverance and an unwavering belief in her abilities and vision. . . . Diliberto's biography of a determined yet often self-destructive woman adds to the legacy this force for fashion and female autonomy has bequeathed to the world."

—*Booklist*

"Fast and engrossing. . . . A fun and insightful read about both the woman and the larger fashion universe."

—*Chicago Business Journal*

"Unwrap and enjoy."

—*Library Journal*

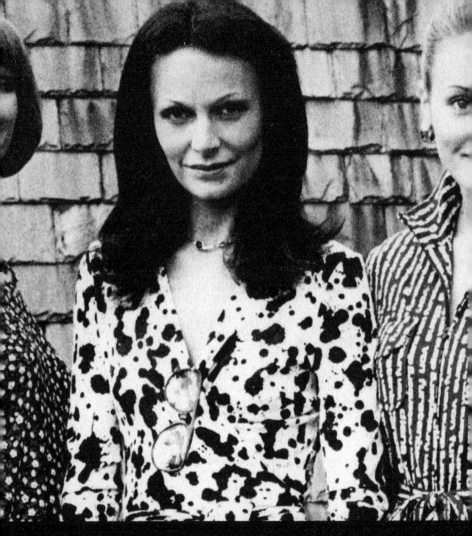

Diane Von Furstenberg

A LIFE UNWRAPPED

Gioia Diliberto

DEY ST.

AN IMPRINT OF WILLIAM MORROW PUBLISHERS

DEY ST.

DIANE VON FURSTENBERG. Copyright © 2015 by Gioia Diliberto. All rights reserved. Printed in the United States of America. No part of this book may be used or reproduced in any manner whatsoever without written permission except in the case of brief quotations embodied in critical articles and reviews. For information address HarperCollins Publishers, 195 Broadway, New York, NY 10007.

HarperCollins books may be purchased for educational, business, or sales promotional use. For information please e-mail the Special Markets Department at SPsales@harpercollins.com.

A hardcover edition of this book was published in 2015 by Dey Street Books, an imprint of William Morrow Publishers.

FIRST DEY STREET BOOKS PAPERBACK EDITION PUBLISHED 2016.

Designed by Shannon Plunkett
Title page photograph © Clifford Ling/Evening News/Rex USA

Library of Congress Cataloging-in-Publication Data has been applied for.

ISBN 978-0-06-204124-1

16 17 18 19 20 OV/RRD 10 9 8 7 6 5 4 3 2 1

for Dick
and for Joe

Contents

Prologue

*T*he first time I saw Diane von Furstenberg, in the mid-1980s, she was alone, walking up the rue de Seine in Paris dressed like a Left Bank intellectual in a black sweater, black pants, and flat shoes. For a woman who was known for wearing sexy dresses, Cleopatra makeup, stilettoes, and luxuriant falls of fake hair, she looked startlingly unadorned—more Susan Sontag than DVF—with her face scrubbed clean and a frizz of natural curls foaming around her head. Her curvy body, though, had a sinuous grace hinting at lost glamour, and the moment she pushed in the tall doors at number 12 and disappeared into the courtyard beyond, I realized who she was.

When I saw her again, five years later, this time on Madison Avenue in Manhattan, she'd been returned to full glamour mode—heels, fishnets, slinky dress, and fur coat. It was at the height of antifur chic in New York, when the only people who dared wear fur on the street were pimps and pushers. Diane, though, didn't seem concerned that someone might throw a can of paint on her. She looked invincible. But her businesswoman-on-top-of-her-game appearance was just an act, like her

bluestocking pose in Paris. The relationship with the European writer for whom she'd forsaken Fashion had ended. She was struggling to restart her business and regain her confidence.

These glimpses of Diane in Paris and New York pointed to the roller coaster quality of her life and her talent for reinventing herself with every rise and fall of fortune. They also offered clues to her enduring success in Fashion, a world defined by ephemerality. Diane knows from her own experience how seductive it can be to don a more intriguing identity, to live your dreams by becoming someone else.

In 1973, at the dawn of the disco era when she was just twenty-seven, she created the wrap dress and became rich and famous. Within three years, more than a million wraps were sold. During a time of deep feminist stirring, the dress thrived as a cult object, symbolizing a woman's right to be liberated *and* alluring. Diane had come up with the idea following the breakup of her marriage to the hard-partying Austrian prince Egon von Furstenberg. He'd left her with two children and a princess title, conferring on her a whiff of otherworldly romance that fueled her fame.

Countless newspaper and magazine articles portrayed her as the epitome of a new kind of woman, the alpha female who made her own millions, dressed flamboyantly, and took lovers whenever she wanted. Diane didn't follow the seventies paradigm of what a woman needed to do to get ahead. She didn't tamp down her allure in order to be taken seriously. Nor was she superior, as it was thought a woman had to be, to the men who dominated her métier. She befriended such male stars of American fashion as Halston and Oscar de la Renta, but she never tried to compete with their finely crafted clothes. Instead, she forged her own path in step with the cultural zeitgeist. From the seventies through the nineties—decades when women would travel further toward financial independence, sexual freedom, and professional success than they ever had before—Diane dressed them for the rocky journey.

Over the years, I'd seen pictures of Diane, panther-eyed and sleekly coiffed, looking out from glossy photos, including the cover of *Newsweek*

in 1976, and in advertisements urging women to "feel like a woman, wear a dress." I'd heard her on the radio preaching a gospel of independence, advising women how to lead a man's life and still be a woman, how to find love and happiness and professional success, and look hot while doing it. I'd read about her late nights at Studio 54 and her many affairs, including one with actor Richard Gere and another with a South American artist she met on the beach in Bali. And I'd been wearing her clothes for years. Few fashion-conscious young women in the seventies were indifferent to the charms of the wrap dress, and I owned my share. Only after I began work on this book, however, did I learn from Diane the proper way to wear one.

We were standing in the fifth-floor kitchen of the downtown building where she lives and works, clearing the dishes from a light supper of salads her cook had prepared. Diane looked intently at my dress, at its black top and flared skirt in a black and white abstract print, and though the meal had been excellent, her face took on the expression of someone who'd just eaten something unpleasant. "You've got it all wrong," she said, furrowing her brow.

She untied the narrow sash of my dress and pulled the silk jersey top as tight as she could across my waist, then retied it, looping the sash just once. "If you do it right, it stays," she said.

Diane had performed this ritual on scores of women through the years—tying and untying wrap dresses for customers of all ages, sizes, and ethnicities. She loves to hear from women how they fell in love or asked for a promotion in a DVF dress, how her clothes gave them confidence and pleasure, lifted their spirits, and, for a few moments, let them forget their troubles. What is fashion, after all, if not a release from reality, a way to fool yourself for a while that the world is a better place than it is?

THIS IS A BOOK ABOUT the remarkable life of a unique personality who built a fashion empire around a vision that has as much to do with

womanhood and its complexities as it does with clothes. Diane created a style that was bold without being hard-edged, sexy without being vulgar, and cheerful without being unsophisticated. Its appeal derived from the insight it reflected into what women *really* wanted. Diane understood the tensions in women's lives—between work and family, love and independence, femininity and ambition—because she'd struggled with them herself. Her ultimate triumph came after a series of humiliating failures. She tested the principles on which she built her life and her business but in the end returned to them with more purpose than ever. "I have clarity again. But I went through some horrible times," says the multilingual Diane, adding in one of her quirky misuses of an English word, "I lost security [that is, confidence] in my own company."

As a CEO, Diane broke every rule about how a businesswoman should behave, vamping into meetings in fishnets and clingy jersey and sidling up to male colleagues while purring, "What is your sign?"

Her life brims with such contradictions. A fierce feminist, Diane has nonetheless repeatedly upended her life for lovers, moving households, neglecting her business, and even once selling an apartment to be with a man. She's made a great deal of money, and spent a great deal, too. She seems to have spent much of her career in financial denial, and unable to keep track of her fortune, she's almost gone bankrupt twice.

In a fashion world defined by exclusion and cruel hierarchies, she is known for her generosity and kindness. There is nothing she wouldn't do for her family and friends—extravagant presents, infusions of cash when needed, sympathy and encouragement. She's become a kind of Queen Mother of Fashion, beloved by her fellow designers, her employees, and the rank and file of the industry—seamstresses, stylists, salespeople, photographers, and publicists.

Her second act has been aided by the ascendance of fashion in the new millennium as a potent pop-culture force. Diane works hard to keep her name in the daily conversation by blogging, tweeting, Instagramming, and talking endlessly to the press, often about her favorite causes for

"empowering" women—"my mission in life," she says. In 2010 she created the DVF Awards, which each year honor several women activists. She's also become deeply involved with Vital Voices Global Partnership, a nonprofit foundation that promotes women's economic progress, and she's spoken out against some of the most controversial issues in fashion: the prevalence of anorectic and underage models and the underrepresentation on the catwalk of minority women.

Diane wants her company to last long after she's gone, but paradoxically, some of the qualities that have made DVF the woman an icon—including her openness, curiosity, and eagerness to try just about anything—have hurt her brand. "She's a terrible, terrible manager," says her son, Alex von Furstenberg, who runs a private investment office for the von Furstenberg family and sits on the board of his mother's company. "My mom says yes to this person and yes to that person. She has a good meeting with someone and says, 'Okay, I'll do it,' be it a children's line or housewares."

From time to time she still gets involved in "crap" licensing deals, as Alex puts it, such as a fragrance she did in 2011 "that went nowhere and we had to buy it back for more than we put up" to get it off the market.

Dee-ahn, as her intimates call her, using the French pronunciation of her name, would never brood on such mistakes. She is militantly upbeat. "I never get in fights, and I have no memory of pain," she wrote in her first autobiography. She doesn't hold grudges; she's not interested in staying angry. She has an uncynical belief in the inherent goodness of people and has remained friends with almost all of her old beaus. When she's upset, she doesn't scream. But those who know her well—and some of her staff have been with her for forty years—know when she's displeased. "The vibrations are so intense, the walls are shaking," says Olivier Gelbsman, her lifelong friend and director of DVF Home Design.

In 2001 Diane married for the second time, to media mogul Barry Diller, with whom she had been close for decades. Their marriage is different from yours and mine. They have more money. Also, they don't live

together. In New York, Diane stays in the loftlike apartment high above the DVF boutique in the Meatpacking District that is also the site of her company's headquarters. On entering the building, visitors see one full set of the silkscreen portraits Andy Warhol made of Diane in 1982, and half of the set the artist made in 1974. (The other half hangs in Diane's Paris apartment.) She sleeps alone under a bamboo pavilion draped in beige linen that looks like it could be the home of a Bedouin fashionista in the Moroccan desert. While in Manhattan, Diller stays at the Carlyle Hotel. The couple travel together, however, including excursions on *Eos,* Diller's immense yacht, and they spend time together at Cloudwalk, Diane's estate in Connecticut, and at Diller's house in Los Angeles.

In honor of the fortieth anniversary of the wrap, Diane collected wrap-dress stories from women around the world—women could post their stories through a link on her website, dvf.com, in Chinese, Flemish, French, Portuguese, Russian, or Thai. Like thousands of others, I, too, have a wrap-dress tale: One night in 1977 while wearing a green and white geometric-print wrap to an interview for a job as a newspaper reporter, I noticed a good-looking young man with sandy hair and kind blue eyes sitting at the rewrite desk. He noticed me, too. After I got the job, we began dating, and we were married a couple of years later. It was the start of a new life for me, and though I had no way of knowing it at the time, almost the end for Diane. That year, her business nearly went bankrupt.

Once you've left your seat in the front row of Fashion, it's almost impossible to reclaim it. Fashion is a world that worships the new and reviles the old, where one moment you're in and the next you're out. That is its glory and its curse. Diane is the rare designer who has defied the odds, and today she is once again on top. Her comeback turned out to be a bigger success than she dreamed, with her clothes, accessories, and home-design products in stores across the nation and DVF boutiques in seventeen nations beyond the United States (forty-seven stores in Asia alone), as well as Hong Kong and Macau. Museum exhibits have hon-

ored her life and work, and since 2006 she has reigned as president of the Council of Fashion Designers of America, the influential nonprofit association that promotes American fashion through awards to designers and collaborative programs with retailers.

Her sixty-eight-year-old face appears unaltered by plastic surgery. Her reddish brown hair, several shades lighter than it was in her youth, tumbles in curls to her shoulders. She often wears one of her colorful, above-the-knee sheaths, high heels, and an oversized gold-link bracelet, each link engraved with one of her meditation sutras.

In her traveling for store appearances and chatting up customers, Diane's life today is similar to when she first started out, hurrying through airports, a garment bag slung over her shoulder, on her way to catch an early flight to Cleveland or Dallas or Miami. Now, however, she has access to a private plane, and there's no problem staying late. She doesn't leave until she's signed autographs and posed for pictures with every last fan who wants one. No one knows better than Diane how completely women identify her clothes with images of the flesh-and-blood woman herself.

Since the start of Diane's career almost a half century ago, American fashion has changed immensely. Marketing, something for which she has a natural gift, has become increasingly important as the focus of the industry has shifted away from the intricacies of craft, of construction and fit. In this sense, fashion has moved closer to Diane's idea of affordable, wearable clothes that delight as much for the intangible qualities they evoke as for their components of style. She overrode her own insecurities with tough determination. "What I think I'm really selling is confidence," she often says. For Diane, an all-enabling belief in oneself is a woman's best asset, more alluring even than the perfect little dress.

SEVERAL YEARS AGO, WHEN I first approached Diane about writing this book, her reaction was "Let's wait until I'm dead." She worried that a biography published during her lifetime would literally kill

her—a superstitious fear, certainly, but one based on personal experience. The European writer she'd lived with in Paris had written a biography of the Italian novelist Alberto Moravia, and soon after it was published, Moravia dropped dead. (He was eighty-two.)

Nevertheless, Diane and I continued to correspond, and gradually she warmed to the idea of my writing about her. Finally, she decided not to stand in my way. She introduced me to her family and friends and encouraged them to talk to me. Though Diane has had no control over this book and did not read it in advance, no subject was off-limits. "I have no secrets," she says.

Not even *beauty* secrets. One recent morning, as soon as she sat down to talk to me in her office following a photo shoot to promote her new E! reality show, *House of DVF*, she removed the hairpiece she'd worn for the pictures and flung it onto the table.

It's hard to imagine the earnest bohemian I saw on the rue de Seine in the mid-eighties, or the intimidatingly glamorous businesswoman I ran into on Madison Avenue five years later, having the insouciance to be so open. But Diane has come a long way in twenty-five years. Like only a handful of fashion figures, she has succeeded in imposing her vision on the culture—a view of women that joins feminist ideals of independence and achievement to old-world notions about sex and femininity. She told Kathy Landau, her onetime vice president of design, that she knew she wanted to be famous at age twelve—from then on, everything she did funneled toward that end. Her career represents an iconic success for a modern woman and a case study in how to catch your dreams—even while sleeping around and smoking a lot of pot. Diane had no unique talent, no formal training, and no college degree. She rose to the top of American life on sheer will and hard work—okay, also with a little help from two wealthy husbands and some well-connected friends.

Indeed, Diane has an astonishing array of influential and powerful friends from the worlds of politics, business, publishing, theater, Hollywood, fashion, and philanthropy. It would be easy to attribute her culti-

vation of life's top achievers to opportunism. On the other hand, it's hard to find anyone who says an unkind word about her.

"Feline," the adjective most used by reporters to describe Diane, implies cunning as well as sleekness. Speaking in a vaguely foreign accent, her voice has a sensual purr, yet her manner in person is candid and humorous. "I always seem to be at a turning point," she said to me while perusing entries from her old diaries. "And I'm always getting my period."

Diane is unselfconscious and does not embarrass easily. Few people would choose the journalist who held them up to ridicule in a major magazine to cowrite their memoirs, as Diane did with Linda Bird Francke. Nor would many people send to acquaintances photos of themselves with a swollen and black-and-blue face, as Diane did several years ago following a skiing accident.

Walking through the woods at Cloudwalk, her Connecticut property, recently, Diane was dressed in black leggings shot with holes and a pair of black Uggs, while a gaggle of little white dogs yapped around her. Her phone buzzed every few minutes, but she ignored it to focus on our conversation. Diane's talk ranged from the origin of Cloudwalk's name—possibly a reference to the ethereal clouds over a volcano in Bali, a favorite destination of the estate's original owner—to the book she's reading (a new biography of Coco Chanel), to her children and grandchildren, to a long-ago love affair that ended badly.

Among the five houses at Cloudwalk, Diane installs her guests in the original dwelling, a four-bedroom home with a big, Martha Stewart kitchen, a cozy living room with a fireplace, bookshelves, and comfy furniture that Diane says hasn't been re-covered in forty years. In good weather, meals prepared by Lourdes, the cook, are served on the terrace by the pool.

Diane herself sleeps in what was once the tobacco barn and is now a dramatic studio/boudoir with vaulted ceilings, treasures from her travels, and an immense table that looks like it was carved from a giant tree.

"Like Tolstoy, I love huge desks," says Diane, whose New York office also holds an exceptionally long table.

The basement of the building houses Diane's vast archive, a half century of fashion and personal history—racks of dresses, stacks of plastic bins holding fabric swatches, diaries, and letters—all meticulously organized by Diane's longtime archivist, an Italian linguist, who, as a student in the 70s, worked as Diane's au pair.

Diane von Furstenberg: A Life Unwrapped traces her life in detail to 2001, the year Diane married Diller. As the title attests, I've been most interested in exploring the forces and people that shaped Diane. I cover the last fourteen years—which have been well documented by the fashion press—more glancingly in the epilogue.

This is the story of how Diane became DVF. It begins in Brussels with a young woman who survived against all odds to become Diane's mother.

Lily

Fifteen days after being freed from the Neustadt concentration camp at the end of World War II, Lily Nahmias arrived home in Brussels, stumbling off a train in scuffed soldier's boots, her emaciated body hidden under the olive-drab uniform a GI had given her to cover her rags. When her fiancé, Leon Halfin, saw Lily, then twenty-two, he couldn't believe she was the same woman he'd fallen in love with two years before. She sensed Leon's revulsion at her ravaged appearance—though he never said anything—and offered to release him from his promise to marry her. But Leon, an electronics salesman ten years Lily's senior, was a man of honor, and the marriage went ahead as planned. When Lily gave birth to a perfect little girl on New Year's Eve, 1946, she felt reborn herself. And for Leon, who'd lost most of his family in the war, the birth "turned life into gold. It started all my good luck," he later said. The new parents named their daughter Diane Simone Michelle. She was their miracle baby, their revenge on the sorrow and horror of the past.

With Diane's birth, the beautiful life Lily had envisioned once again

seemed within reach. She'd been born in Salonika, Greece, in 1922 and had emigrated with her parents and two older sisters to Brussels when she was seven. Her father, Moise, worked for Maison Dorée, the most luxurious textile shop in the city—a relative of Lily's mother, Diamante, owned the shop. The family lived in bourgeois comfort at 45 rue de la Madeleine in a posh part of town. Lily was completing high school at the Lycée Dachsbeck in May 1940 when the Germans occupied the city.

Lily, her mother's sister, Line, and Line's husband, Simon Haim, owner of the Maison Dorée, joined the exodus of Belgian Jews to Toulouse in the unoccupied part of France. One day, Simon Haim brought Lily to a meeting with an exuberant, dark-haired Russian émigré, Leon Halfin, who was acting as a broker to exchange money for the refugees. Leon had arrived in Brussels in 1929 at seventeen. He had planned to become a textile engineer, but when his father's textile business in Kishinev went bankrupt, he gave up his dream of attending university. He went to work, eventually finding a job with Tungsram, the Hungarian manufacturer of vacuum tubing and lightbulbs.

Leon was living in a hotel in Toulouse, hustling work while waiting out the occupation. He and Lily struck up a friendship. Then word came from Brussels that it was safe to return—the Germans weren't mistreating anyone—and so everyone packed their bags and went home.

Soon after, the Germans ordered all the Jews in Brussels to register at Gestapo headquarters on avenue Louise. On December 19, 1940, Mosche Nahmias dutifully recorded the birth dates and other biographical information about himself, his wife, and his eighteen-year-old daughter, Lily, in the Gestapo register. By this time, Lily's eldest sister, Juliette, was married and living with her husband, Darius Levi, and their small son above the lingerie shop they owned at 15 rue Haute. Another sister, Mathilde, lived in Paris with her Spanish husband.

The stories of German tolerance that had drawn the Nahmiases back to Brussels quickly proved unfounded. German soldiers patrolled the streets, checking identity papers, sometimes pulling on the yellow Stars

of David Jews were required to buy for five francs and wear at all times. If the cloth stars had been loosely basted instead of sewn on and came off easily, the soldiers would issue fines to the offenders and sometimes arrest them. Jews disappeared in the middle of the night, never to be seen again. Jewish musicians, doctors, teachers, judges, and salesmen lost their jobs.

Because of the German race laws, Lily was not allowed to attend university, as she had hoped. Instead, she enrolled at a trade school in Brussels and trained to become a modiste, a ladies hat maker. By now Leon Halfin had left Tungsram and fled to Switzerland. "My father was not the sort of person who could hide in someone's house and wait for the war to be over. So he took the risk of fleeing," says Philippe Halfin, Diane's brother.

Leon packed a few clothes and stashed a trove of gold coins in his socks. Diane still has them, and when she feels anxious—before a fashion opening, say—she tapes one into each of her shoes. Leon traveled with a Christian girlfriend named Renée. At the Swiss border, police confiscated his money (it was returned to him when he left the country after the war) and kept him under surveillance as a Jewish refugee. Within no time Renée eloped with a Swiss policeman, and Leon began to think of the pretty girl he'd met in Toulouse. He wrote Lily a letter, which reached her by chance.

Before the war, she had been the adored baby in the family, so sheltered that her parents would not let her leave the house to go shopping without a chaperone. But when the family returned from Toulouse, her parents sent Lily to live with a Christian couple in Auderghem, outside Brussels. They probably did not know that the husband and wife were resistance workers for whom Lily acted as a courier, delivering false identity papers to Jews trying to escape Brussels. One day, when she was making her rounds on her bicycle, Lily decided to visit her family home on rue de la Madeleine. As soon as she entered the building, she had a feeling of lightness, as if the roof had been removed. Her parents

were gone and the apartment was empty, all of the furniture and valu-
ables stolen.

The Nazis had driven the Nahmiases out. One night a few weeks
earlier, a pounding on the door of their apartment came so loudly that
Lily's parents could feel it in their stomachs. A swarm of Nazis rushed in,
knocking over lamps and tables, rummaging through drawers and cup-
boards, and stashing silverware in their pockets. The couple was forced to
move in with their daughter Juliette on rue Haute, adjacent to the com-
mercial district, which had been designated the Jewish zone. Cold with
panic, Lily fled the building, glancing in the mailbox on her way out. It
held a single letter—Leon's.

Within no time, hundreds of pages flew back and forth between the
young lovers. For Lily, life in Brussels had become a shimmer of fear,
with the only moments of calm provided by Leon's letters. He poured out
his heart to her: *This will be over soon; we will get through it and be together.*
In one letter, Leon proposed marriage; in her response, Lily accepted.
Diane still has the letters, marked with a thick blue vertical line in the
margin, indicating that they had been cleared by the censors.

Since they'd been born in Salonika under Turkish rule, and since Tur-
key was neutral in the war, Diamante and Moshe Nahmias held a mea-
sure of protection—the Germans weren't arresting Jews with Turkish
passports. But Lily had been born while Salonika was under the rule
of Greece, which was now at war with Germany. Late on the night of
May 5, 1944, during a routine roundup, Brussels police wearing swastika
armbands nabbed Lily in the apartment where she'd been living. In sub-
sequent days she managed to write a couple of notes to her parents, which
somehow reached them. "I think a lot about you. That's what makes me
courageous," she had scrawled on a piece of cardboard. "I love you so
much. Excuse me if I've ever given you any trouble."

The same day of Lily's arrest, Diamante and Moshe Nahmias were sent
to an internment camp in a former old-age home in Scheut, a suburb of
Brussels, where they were imprisoned with other Jews whose Turkish pass-

ports, wealth, high status, or friendship with the Belgian queen Elisabeth dissuaded the Nazis from deporting them to concentration camps. They remained there until November 1944, after the liberation of Belgium.

Meanwhile, Juliette and her husband had gone into hiding at the home of Christian friends. They notified Leon in Switzerland of Lily's arrest, writing in code: Lily has been hospitalized, and we are praying for her.

The bare facts of Lily's arrest and imprisonment were recorded by the Nazis in meticulous ledgers that have been preserved at the Musée Juif de Belgique in Brussels. She remained in prison in the town of Malines for ten days, leaving on May 17, 1944, on Convoy 25, the second-to-last to transport Jews out of Belgium to German concentration camps. It carried 507 men, women, and children; Lily was prisoner number 407. Her postage-stamp-sized picture, pasted in the Nazi record book with pictures of 25,000 other deported Belgians, shows a lovely young woman with light, wavy hair dressed in a fitted coat and scarf. Throughout her life, the first thing people noticed about Lily was her smile, dazzlingly warm and bright. In almost every picture that survives of her she is smiling. Not in this one.

On the journey to Auschwitz, Lily attached herself to a motherly older woman. She clutched the woman's hand as the cattle car lumbered to a halt on May 19, and the prisoners scrambled to the ground. When the Nazi in charge directed the older woman to join a group on the left, Lily followed, and the guard allowed it. But a higher-ranking Nazi standing by in a white coat, whom Lily came to believe was Josef Mengele, ordered her into the group on the right. He saved her life—the 108 Jews in the group on the left were immediately gassed.

In the barracks, Lily overheard anguished voices. "Do you smell the crematorium? We're all going to die!" She covered her ears, refusing to descend to the pit of despair. She thought of her parents and Leon and felt the power of their love and prayers.

At Auschwitz she worked in a bullet factory and recalled later that she

made the bullets badly so they'd malfunction. Lily had been at the camp eight months when, on January 17, 1945, as the Allied armies closed in, the SS command in Berlin sent orders to Auschwitz to execute all prisoners. In the chaos of the German retreat, however, the order was not honored, and the Nazis began moving prisoners out. At the end of a long, frigid march in the snow, Lily ended up at Ravensbrück, a woman's camp fifty-six miles north of Berlin. From there, she was sent to one of its satellites, Neustadt-Glewe which was described by one prisoner as "the worst of the worst of the worst," with unimaginably sordid barracks, so crowded there was no room to lie down at night, and walls black with lice. In the two and a half months that Lily was there, from February 18 to May 8 an average of seventy prisoners a week died from starvation or illness; others were sent back to Ravensbrück to be gassed. One survivor described the piled bodies as "a huge mountain of corpses two meters tall."

Lily awoke from a fitful sleep on May 5 to find the German guards gone, while a group of men—who, from their rags and ravaged physiques, appeared to be former prisoners—worked with tools on the electrified fence surrounding the camp. Suddenly, the gates opened, and Lily and her fellow prisoners were free. Wandering the countryside, she was picked up by a group of US soldiers patrolling the area. She was hospitalized for a week at an American base. When she was well enough to travel, the Americans sent her home.

Thanks to her mother's ministrations, which included feeding her bits of food every few minutes, Lily quickly gained back some of the flesh she'd lost as a prisoner. In a picture taken on her wedding day in November 1945, a month after being reunited with Leon, she looks thin but mostly restored to the stylish, brown-eyed beauty she'd been before the war. The wedding was like a dream, the town hall filled with friends and flowers, the bride and groom standing in front of the justice of the peace. At that moment, all they desired was to be together. Like many couples who married in the wake of the Holocaust, Lily and Leon were united by their powerful sense of renewed life. As it turned out, though, this

would not be enough to sustain them, and eventually they'd be wrenched apart by the stronger force of the horror they'd endured. They would stay married for sixteen years, but it would be a troubled union, scarred by wounds that wouldn't heal.

THE LIFE THAT LILY AND Leon embarked on with baby Diane was both a denial of and a rebuke to the war. Leon started his own business dealing in electronic tubing, which at that time was a vital component of most electronic devices from radios and TVs to radar systems. He didn't diversify; he focused on one product and became Europe's major supplier. With the birth of Diane's brother, Philippe, in 1952, the family was complete. The Halfins moved into a penthouse apartment at 80 avenue Armand Huysmans in Ixelles, a middle-class Brussels neighborhood of large, comfortable apartment buildings across from a vast park, the Bois de la Cambre. The area must have been a force field of style. Audrey Hepburn, born in 1929, spent the first years of her life a few blocks away on rue Keyenveld.

Diane's mother "wasn't a fashion person; she didn't talk about fashion," says Diane. Lily always dressed beautifully, however. She patronized a couturier in Brussels who copied clothes by Paris designers and wore cashmere and jersey garments from the shop owned by her sister Mathilde off the rue du Faubourg Saint-Honoré in Paris. Lily also owned a sable coat, which she'd bought with her reparations check from the German government. For Lily, beautiful clothes were a way of beating back sadness and celebrating life. Clothes mattered *because* they were frivolous. To be alive and free to buy a fur coat was a gift.

Lily's elegance was accompanied by a powerful intuition and curiosity about people. "Lily was extremely sensitive," says Diane's girlhood friend Mireille Dutry. "She could tell if something wasn't right in your life just by looking at your face." Adds Diane's brother, Philippe, "My mother always gave very good advice. She had impeccable judgment."

When Lily first caught the teenage Diane smoking, instead of lectur-

ing her about how bad cigarettes were for her health, she said, "'Wouldn't it be more interesting to be the only one who didn't smoke?'" Diane recalled. "I was so anxious to be individual that I just quit."

But for all Lily's spirit, she suffered from serious depression. "Lily had post-traumatic stress disorder really badly," says her granddaughter, Diane's daughter, Tatiana.

Many studies over the years have documented the high incidence of PTSD among survivors of the Holocaust. Few of these survivors received psychiatric help, and their problems only intensified over time. Lily's psychological and emotional difficulties were compounded by physical ones, also results of her wartime trauma, particularly malnutrition. "She had a lot of pain in her body, and her eyes were awful," says Tatiana.

Hardly a day went by that Diane didn't see her mother cry. "It must have been so hard to not ask anything of your mother because you didn't want to put any pressure on her because she's so frail and broken," says Tatiana.

The doctor who examined Lily before her wedding warned her that childbirth in her frail state might kill her. When Lily discovered she was pregnant, she and Leon tried to induce a miscarriage by taking long, jarring rides on Leon's motorcycle over the cobblestone streets of Brussels. It had no effect, and Lily was secretly relieved. Later, when Leon brought home some pills that were supposed to induce a miscarriage, Lily threw them out the window. She had begun to feel a deep yearning for her unborn child, a belief that the baby would be her lifeline. "If I hadn't been born, my mother might have killed herself," Diane wrote in *The Woman I Wanted to Be*.

Leon, Diane's father, "was another traumatized person, another broken heart," says Tatiana. He never got over losing his family in the war, and he compensated by becoming a workaholic. "He never stopped working," adds Philippe.

Though Diane has never consulted a psychotherapist, some experts might connect the insecurity that has plagued her throughout her life

to her mother's experiences during the war. Perhaps Diane internalized Lily's fear and sorrow. Perhaps Lily's fragility gave Diane a sense of instability, a feeling that the ground could shift beneath her at any moment.

At the same time, however, Diane showed traits of exceptional resilience that researchers have also noted in the children of Holocaust survivors, including adaptability, tenacity, initiative, and street smarts. These were qualities that Diane shared with Leon.

Indeed, in temperament, she is much more like her father than her mother. Leon "never saw limits. Diane is the same way," says Philippe. "She got her strength from him. It's like you have a certain model of car, and then years later a new version comes out, which is an improvement. This is how I think of [Diane and Leon]. No one has energy like those two. It's the kind of energy that can move mountains."

"There was very little darkness in my father," adds Diane. "He liked to work, eat, and make love." He was awesomely successful at his job, and he adored Diane and Philippe. Of course, he loved Lily, too, but he often seemed indifferent to her suffering. "He didn't want to acknowledge her wounds, so he ignored them," wrote Diane. She has no doubt that Leon slept with other women when he traveled, but "that was not the problem between my parents," she wrote. The problem was "his insensitivity toward" Lily.

Affectionate and boisterous, Leon drove a big blue convertible Chevy at a time when American cars were a rarity on the streets of Brussels. He embarrassed his children at parties and weddings by singing loudly, sometimes in his exuberance picking up glasses off the table and smashing them on the floor. "He loved Diane intensely," says Philippe, "more than any other man ever would."

Years later, when Diane returned to Brussels a celebrity, Leon would meet her at the airport with a huge bouquet of red roses. Once, without warning Diane, Leon called *Le Soir*, Brussels' most important newspaper, to invite a photographer to his house to take a picture of him with his famous daughter.

As a child, Diane felt like a mini adult, caught in the prison of childhood, smothered by Leon's adoration. She longed to escape. Driving around Brussels on errands with her father, she'd sit on her knees so she'd look bigger. Diane never fooled anyone that she wasn't a child, but some people mistook her for a boy. Dark and gap-toothed with frizzy hair that coiled close to her head, she looked impish and clever. She loved to read, yet, at the Lycée Dachsbeck, from which Lily had graduated and which Diane attended from kindergarten to age thirteen, she was an indifferent student.

At school, Diane found herself in a sea of delicate blondes, little girls who would grow into sleek, silk-limbed beauties with straight golden hair. She felt like an outsider, establishing the pattern of insecurity in her life. That insecurity, however, has been one of the ignitions of the confidence she has fought to achieve and that she strives to impart to other women through her clothes and the example of her life.

Diane believed she could never rely on her looks. "I really thought I was a dog when I was a young girl," she says. She developed other assets. She strove to be charming and sophisticated, even in kindergarten, where she experienced her first male conquest. Five-year-old Didier Van Bruyssel, now a Brussels businessman, fell under her spell. "We met at school and I immediately liked her. We became friends. Then, I remember dancing with her at some fancy children's party with my parents watching and feeling overcome," says Bruyssel.

Diane was aware of her effect on the boy and enjoyed every moment of it. Even then, "I always wanted to be a femme fatale," she told the writer David Colman.

Growing up, Diane and her brother, Philippe, had only a vague sense of being Jewish. Their parents didn't practice their religion or even talk about it. In fact, Philippe didn't know he was Jewish until he was nine, when the headmaster at his school asked him if he knew what the six-pointed star meant. When Philippe answered no, the headmaster was

stunned. "But you're Jewish," he said. "How could you not know it's the Star of David?"

"I just didn't know," recalls Philippe. "It wasn't that our Jewishness was hidden. It didn't mean that we didn't want to be Jewish. We were secular. We celebrated [the Christian festival] Saint Nicola, which in Belgium is on December sixth. At the time, there was maybe one synagogue in Brussels. The Jewish community would hire a theater or a cinema for a day to use for services."

As her children grew older, Lily talked to them about the war, but usually it was only to tell them something uplifting, to inspire them to be stronger or to convey the impression that she had not been profoundly damaged by her experiences. "She never talked about anything really bad," says Philippe. "She pretended always that things were all right."

She talked "about little things" at the concentration camps, Diane wrote in *Diane: A Signature Life*—about the pleasure of sitting outside in the sun in spring and "how much she had longed for a plate of spaghetti or how she had exchanged a piece of bread for a comb or how she had cut off the bottom of her dress to make a belt. They were almost boarding school kinds of stories, not death camp kinds of stories."

Lily's outward optimism grew from her desire to protect her children. She couldn't bear for them to know what she'd suffered or what she'd had to do to survive. On her deathbed at her son's home in Brussels in 2000, she confessed something horrific to her nurse, Lorna MacDonald, but made her swear that she wouldn't tell anyone, especially Diane and Philippe. Lily told the rabbi who came to see her at the end that she'd revealed a dark secret of the Holocaust to Lorna, but she refused to tell him specifics. After Lily died, the rabbi demanded that Lorna reveal what it was. "He said it was part of the Jewish cause, that I had to tell him," recalls Lorna. "But I couldn't betray Lily's wishes. I just couldn't."

"Lily didn't seem to be [ruined], she seemed the most unscathed of any survivor I've ever encountered, at least outwardly," says the writer

Fran Lebowitz, a close friend of Diane's since the seventies. "Lily told a lot of very specific stories which would end with, 'And so, I told Diane.' She believed that she'd learned things in the concentration camp that could be applied to real life. To me that's a heroic way of looking at it. The Holocaust is so morally grotesque that it doesn't have an application to anything else, to the kinds of disappointments a person in regular circumstances could have."

Lily often recounted the story of arriving at Auschwitz and her terror at being separated from the older woman to whom she'd clung, then realizing that the Nazi who'd separated them had saved her life. The lesson: what first appears to be a catastrophe may be a blessing in disguise, and the person who appears to be your deadliest enemy may be your redeemer.

Lily had two sets of tattooed numbers, which she had removed from her arm about ten years after the war, mostly because people stared at them, and that made her uncomfortable. A trace of black ink remained, but "no numbers," says Philippe.

Like that black smudge, the horrors of the war stayed with her and with those who loved her. "She was so depleted, but also her family treated her like a baby," says Tatiana. "They had a lot of guilt because she was the only one of them arrested, and she was the youngest. They were nurturing a side of her that she needed; she needed to be reparented." But the coddling prevented her from becoming fully independent. She had nightmares. She could never be alone, and she always slept with the light on.

Her dreams became focused on Diane. *Don't be just a wife; you can do more,* Lily insisted. She was strict, far stricter than Leon, who traveled constantly for business and wasn't around to discipline the children. Indeed, her child-rearing methods could be harsh. "She was a tiger mom," says Diane. To cure Diane of her fear of the dark, for example, Lily once locked her in a closet. Diane was terrified, but it worked: she never feared the dark again.

Lily pushed Diane toward independence, and the little girl loved "the illusion" of having her own separate life. "When I was eight years old my mother put me on a train by myself to go to Paris, where I was met by my aunt Mathilde," Diane wrote. "I loved the adventure."

Girls who grow up to be famous rarely begin life in sweet docility. Diane didn't want to please. She wanted to rule. "I still feel sorry for children. . . . I have the absolute opposite of Peter Pan syndrome," she told Fern Mallis in a 2012 interview at Manhattan's 92nd Street Y. She was frustrated being so small and powerless, so fully dependent on adults who were deeply flawed. She knew she was stronger than her mother, which contributed to her feeling of preternatural maturity.

She couldn't wait to start her *real* life, and she spent a lot of time fantasizing about what she would do when she was free and what kind of woman she would be—she would re-create herself as beautiful, independent, and confident, what she would later call the DVF woman.

Every day Diane took tram number four to the center of Brussels with her best friend, Mireille Dutry, one of the delicate blondes in her class. Their favorite game was "pretending we were princesses," says Mireille. "We called each other Princess. Princess Diane, Princess Mireille. At the same time, of course, we were shooting water pistols at each other on the way to school."

Ever since Disney released the animated *Snow White and the Seven Dwarfs* in 1937, the company has been trading on little girls' fantasies of growing up to marry a prince. For European girls who'd been raised in societies that actually had monarchies, that fantasy was even more powerful. "It would be something you could really aspire to," says Myriam Wittamer, another childhood friend of Diane's.

As one of the best-known women entrepreneurs in Brussels, Tinou Dutry, Mireille's mother, ran a successful exporting business with her husband. She led the kind of purposeful life that Lily wanted for Diane and that Diane wanted for herself. Auburn-haired, beautiful, and impeccably dressed in fitted suits, Madame Dutry clicked briskly through her

apartment on the highest heels, impressing Diane with her glamour and confidence. Diane was "totally sure" that she wanted to be exactly like her when she grew up.

The Dutrys often traveled for their business, and Mireille and her sister were raised by maids, a situation that opened up opportunities for the children and their friends to get into mischief. Diane and Mireille "were two devils," says Mireille.

From her bedroom in the family's penthouse apartment on avenue de l'Orée, Mireille could see across the rooftops into Diane's bedroom on avenue Armand Huysmans, and they developed a system for signaling with lights when someone approached on the streets below. A boyfriend meant three flashes; two flashes meant "Beware, your parents are nearby, and if there's a boy in your house, you better get rid of him," says Mireille.

As Diane moved closer to adolescence, the strains in her parents' marriage became more pronounced. Leon never really understood the full psychological and emotional consequences of Lily's wartime experience. For her part, Lily came to believe that men were weaker than women, less astute and shrewd. *Les pauvres* (poor things), she called them, with a mixture of contempt and pity. Diane absorbed this attitude, and it fueled her sense of self as strong and powerful, the equal or better of any man.

When the Halfins traveled, they flew on separate planes, so as not to orphan their children in the event of a crash. On one trip to New York, Lily found herself seated next to a handsome Swiss businessman, Hans Muller, and they struck up a conversation. He was ten years younger than Lily, divorced and the father of a young son, Martin. He became her lover.

"I'm sure it was a more playful relationship [than she had with Leon] because it didn't come right after the war," says Tatiana. "Maybe Hans gave her the chance not to be seen as a victim, to have fun, to travel. He was younger, hotter." Still, Lily was never wholly committed to the relationship, Tatiana says. "She always had one foot out, you know. Hans never became integrated into the family as a stepfather or a stepgrandparent."

Martin Muller disputes this version of his father's relationship with Lily. Though it might have cooled a bit by the time Lily's grandchildren came along, it was "during the years they lived together a very passionate, de facto marriage," he says.

Hans Muller had grown up in Alsace. His Christian father had died when he was a baby, and he'd been raised by his Jewish mother. Before World War II they'd crossed the border into neutral Switzerland, where they remained. Hans married a Swiss woman, who gave birth to Martin in 1953. At age three, the little boy was horribly injured in a car accident and hospitalized for several months. During that time, his mother met and fell in love with an American man and moved with him to the United States. "I never saw my mother again," says Martin, who is now a gallery owner and book publisher in San Francisco.

Hans traveled even more than Leon Halfin. His work bartering commodities took him around the world. "By his early thirties my father had been to just about every country on the globe," says Martin.

At the height of the Cold War, Hans grew rich structuring extraordinarily complex deals in Eastern bloc countries that were closed to most Westerners. He would sell Colombian coffee and Israeli bananas, say, to the Czechoslovakian government, which would pay him in typewriters and bicycles. Then he'd sell the typewriters to Sears & Roebuck in the United States and the bicycles to China.

When Diane was thirteen, Lily arranged to send her to boarding school in Lausanne, Switzerland, which was near Geneva, where Hans lived. By now, Lily was spending a great deal of time in the large apartment Hans shared with Martin and the child's nanny, Gilberte, in Champel, a posh section of Geneva noted for its parks and expensive homes. Leon didn't want Diane to go to boarding school, but she was thrilled to be getting out of Brussels, which she found excruciatingly boring. She hoped something exciting would happen to her once she left home.

Lily delivered Diane to her new school, the Pensionnat Cuche, on a sunny September day. After dropping off Diane's luggage in her room,

they went into town for tea. "You will become a woman soon," Lily said, looking intently at her daughter.

Diane blushed to her ears. "Don't worry, I know everything," she stammered.

Lily smiled. "Remember, we all do the same things. We work, we eat, we cry, we make love. What makes you different is how you do it."

It was typical of Lily not to deliver the clichéd parental lecture about how boys only had one thing on their minds and don't respect girls who are "easy." "I loved her for saying that to me, for trusting me, for telling me that all that mattered was that I take responsibility for myself, and if I could do that, my life would be about more than the things I did; it would be about how I did them," Diane recalled.

The Pensionnat Cuche was the start of Diane's transformation, of her becoming the confident, independent woman she'd dreamed of becoming as a child. Just being on her own, away from her family, gave her a feeling of strength and freedom that imparted a mature, assured cast to her face and manner. When she returned to Brussels for the Christmas holiday, her brother went to the airport with Lily to pick her up. "I didn't recognize Diane, she was so profoundly changed," Philippe recalls. "She may have cut her hair. But it was more than that. She looked completely different. She was not the same person in my eyes."

After Diane had been at boarding school for two years, Leon insisted she return to Brussels. "My mother wanted me to be exposed to [the wider world], but my father didn't understand why I wanted to go to boarding school," says Diane. Their marriage was dissolving, and they fought constantly. Tensions between Leon and Lily that had been there from the start, including Leon's workaholism and Lily's depression, came to a head over her affair with Hans Muller. There was much to keep the couple together: their children, of course, and their shared experience of the Holocaust. But "my grandparents were trying to run from their pain instead of connecting through it," says Tatiana. "I was never there when they were together, but it didn't seem like they were a good match. I

think Leon had the emotional depth, but I don't think he had the intellectual or poetic depth" to satisfy Lily.

Diane sided with her mother and didn't speak to her father for long periods. Lily wanted her freedom and independence, and Diane felt she deserved it. But Philippe, then nine, was devastated. "The divorce was war. It was really tough, and it broke the family apart," he says.

At fifteen in 1962 and eager to improve her English, Diane enrolled in Stroud Court, a girls' boarding school in Oxfordshire, England. Though essentially a finishing school, Stroud Court offered its students a solid, general education. Diane read the canon of English writers from Chaucer and Shakespeare to Oscar Wilde and John Keats, and the great Russian writers, including Tolstoy and Dostoyevsky. "Growing up I was interested in literature more than anything," Diane once told a reporter. "But when I asked somebody, 'What can you do if you like books?', they said you could be a librarian. The librarian in my school had big thick glasses and bad breath, and I didn't think I wanted to be a librarian."

In her spare time, Diane explored the English countryside with its lyrical, rolling hills and romantic, twisting rivers. Her interest in nature, which had begun in Brussels during her long walks with Mireille in the Bois de la Cambre, grew into a passion. It was the start of an aesthetic awakening, the beginning of her understanding of art and design, of texture, light, and pattern. She lovingly recorded her experiences in journals and photographs, a habit she has kept to this day.

At the time, Diane had no idea that she would become a designer, but many of her early prints were inspired by the animals, trees, and flowers she saw as a schoolgirl in England. Her signature style of vividly colored bold prints derived from hints of nature—the bark of a tree, the shape of a leaf, the stones of an old garden wall, water rippling through a river.

Her forays in nature opened her heart to beauty, and her reading of Keats's "Ode on a Grecian Urn" led her to think about its larger meaning. In papers for English class, she explored beauty as a defense against death and the passage of time. To love beauty, whether in the form of an

antique urn or an exquisite dress, is to be connected to a long, rich history of beautiful things and the people who cherished them.

She also discovered physical love. Her first year at Stroud, she lost her virginity with a Persian boy named Sohrab who was studying architecture at Oxford. After she'd slept with Sobrab, she wrote to a boy she'd dated in Brussels but refused to sleep with because "at fifteen I was too young," telling him that she'd finally had sex.

Diane also had an affair with a lesbian friend named Deanna. "She was very shy and masculine, and she intrigued me," says Diane. "I was in love with her."

During Diane's time at Stroud Court, London was undergoing a transformation. On periodic trips to the city, Diane and her friends shopped on King's Road, the nerve center of swinging London, where electric-guitar sounds pounded from the boutiques and the salesgirls aspired to look like Jean Shrimpton, a willowy, doe-eyed cover model with long, straight hair, white lipstick, and black, feathery lashes. Mod fashion was part of the excitement of the age, along with the pill and rock music, and it gave the boarding school girls entrée to a new world of sex, glamour, and celebrity. Just by wearing vinyl go-go boots and microminis they felt like they were almost dating Paul McCartney.

It also gave Diane a vivid glimpse of the symbolic power of fashion, of how clothes are always more than clothes—how they offer clues to personality and character, to cultural and social currents. Most of all, clothes reflect the wearer's sense of self. It was an insight Diane would later exploit to great effect.

Historically, women's fashion had been a story of shackles and pain: hoops; bustles; voluminous, filth-gathering skirts; enormous, feather-bedecked hats; and corsets that distorted and squeezed the body to near suffocation. Fashion depended on the wealth of fathers and husbands and the aid of armies of servants. It symbolized the helplessness of women and the constriction of their lives. Who could think clearly under a hat that looked like a catering tray and weighed as much as a baby? A woman

in billowing skirts couldn't even get into a carriage by herself, let alone enjoy relatively spontaneous sex. As Jean Cocteau once noted, with so many layers of complicated clothing, getting undressed for a tryst had to be planned like moving house.

At the turn of the century, Paul Poiret designed clothes that didn't require disfiguring corsets. Then, after World War I, Coco Chanel created a style of casual elegance epitomized by easy-to-wear jersey suits and "little nothing" dresses that still define how women want to look. With one brief throwback to the Belle Epoque—Dior's 1947 "New Look" that returned women to full skirts and structured bodices—fashion since 1920 has been a celebration of modern women, of their freedom, sexuality, power, and beauty.

The clothes of the 1960s, when Diane came of age, signaled the triumph of youth—from Mary Quant's minis, Ossie Clark's hippie-chic frocks, and Zandra Rhodes's flamboyant colors, to the hard-edged, space-age shapes of Courrèges and Paco Rabanne. For Diane and her friends these clothes were a rebellion against the correct formality of their mothers, who still wore gloves and hats, stiff suits, girdles, and pointy bras.

AFTER GRADUATING FROM STROUD COURT in 1965 with the equivalent of a high school degree, Diane and her friend Deanna enrolled in a program in Spanish studies at the University of Madrid. They shared a small, dingy room in a convent-like girls' pension. The city teemed with rioters protesting the repressions of the Franco regime. Diane and Deanna ducked into churches to avoid the street fighting but occasionally got caught in it. Once, a policeman confiscated Diane's camera and ripped up her film.

Strikes by students frequently shut down the university. Classes were held so infrequently that Diane ended up spending many afternoons at the movies, where she picked up the Spanish she'd intended to learn in school.

In spite of the excitement of the protests and her close relationship with Deanna, Diane was lonely in Spain. The friends "had no social life whatsoever," Diane recalled. But her life was about to change.

Over a Christmas ski holiday in Gstaad with her mother, Diane ran into her Venezuelan friend, Isabel, from the Pensionnat Cuche. Isabel brought Diane into a lively circle of rich, young sybarites. This was the fringe of the jet set—the term was coined by Igor Cassini, brother of Jackie Kennedy's couturier Oleg Cassini (themselves descendants of Russian aristocrats) to refer to that collection of film stars, socialites, and European aristocrats "who all seemed to know one another and to be effortlessly beautiful and rich," as Diane wrote. The pack followed the social seasons from Antibes to Athens to Mykonos to New York and Paris, ending up at Gstaad for the three months of winter. Most of the jet-setters lived on trust funds; few had jobs. Diane saw in this group the perfect antidote to her dull, bourgeois background.

Gstaad was "a gaudy dream of freedom and fun," wrote Taki Theodoracopulos, one of the chief chroniclers of this world. The fun included moonlit parties at the Eagle Nightclub on the resort's highest peak; trips on the chairlift up the mountain after dinner and ski runs down by torchlight before dawn; and romantic trysts, some fleeting, some that lasted for a few weeks at best. Diane had an affair with the Venezuelan owner of a shoe business, a man named Vlady Blatnik (not to be confused with the Spanish shoe designer Manolo Blahnik). He gave her a bright green silk Emilio Pucci shirt with black silk pants and black silk boots, her first designer outfit.

This was what it meant to be someone's mistress—to receive lavish gifts and be treated to dinners at expensive restaurants and nights in five-star hotels. At first it was exciting, but Diane soon realized the role of mistress was a kind of captivity—demeaning and boring—and she would soon tire of it.

Still, the role allowed her to satisfy some of her curiosity about men. Lily had taught her not to be afraid or ashamed of sex, a lesson Diane

took to heart enthusiastically. From the moment of her first affair, with Sohrab at boarding school, sex had a central importance in her life. Over the years, Diane would sleep with many men—"one thing I don't regret," she says—and fall in love with a few of them. At times she would find solace in sex and at times be motivated by it. The power of her style would derive from the heat of sex flowing through it. But—with one nearly devastating exception—Diane would never lose herself entirely in a relationship with a man.

Egon

After a few months in Madrid, Diane moved in with her mother and Hans Muller in Geneva. She enrolled in courses at a local secretarial school and at the University of Geneva, but as usual she remained an indifferent student. Once, when her mother and Hans were traveling in South America, she faked an appendicitis attack to avoid exams and convinced a doctor to remove her appendix. Afterward, Diane checked herself into a clinic to recuperate, and she spent most of her time sunning herself in the garden. By the time her mother returned and found out about her operation, "I looked tan and felt great," Diane wrote in 1998.

She took a part-time job as a receptionist at Investors Overseas Services, the finance company run by Bernie Cornfeld, the Brooklyn-reared, nebbishy hustler who'd built a mutual fund empire that bedeviled market regulators across the globe. Cornfeld had started in the 1950s selling mutual funds to Americans living abroad. He employed ten thousand salesmen in one hundred countries—many of whom had been lured by his trademark pitch: "Do you sincerely want to be rich?"

In 1965, around the time Diane went to work for Cornfeld, the American Securities and Exchange Commission accused him of violating US securities laws, and Cornfeld agreed to get out of the US market and stop selling to Americans, who, in any case, made up a small percentage of his business.

With Cornfeld, Diane saw what it meant to be astoundingly rich. Short, bald, and nasal-voiced, Cornfeld had an unassuming presence that belied his over-the-top lifestyle of sports cars, horses, yachts, houses, parties, and women. He divided his time among a French castle, a mansion in the Belgravia section of London, and a villa in Geneva that had been built by Napoléon. Everywhere he went—even to gray meetings with gray-suited bankers—he was accompanied by a colorful posse of miniskirted young beauties. "Every pretty girl in Geneva worked for Bernie," Diane said years later.

IOS would go bankrupt in the seventies and Cornfeld would be accused of defrauding his employees by coercing them to buy stock as the company sank. He would spend almost a year in jail, though eventually he would be exonerated of all charges, dying in London in 1995 at sixty-seven. When Diane worked for him, though, Cornfeld was still riding high.

During this time, Diane began hanging out with an international group of young people who were privileged, attractive, and hard-partying. They went to nightclubs several times a week and on the weekends danced all night. Diane's style in those days tended toward bohemian looks, which fit the louche persona she cultivated: cowboy hats, fingerless gloves with silver bells, peasant blouses, and bell-bottoms. Nona Gordon, a friend who was studying to be a UN interpreter, remembers Diane as "chubbier than she is now, and she wore this awful white lipstick."

Diane was also "naughty," says Gordon. She recalls one night at Griffin, a favorite nightclub of the students, when Diane disappeared into the bathroom with Gordon's beau. When Diane emerged a while later, Gordon slapped her hard across the face. "Diane told me I was completely

crazy, that she hadn't done anything with my boyfriend," Gordon recalls. "But I didn't quite believe her, and to this day we argue about it."

On another night, at the eighteenth birthday party of a friend at a private home in Lausanne, Diane met a handsome young man with blond curls, mischievous eyes, and a dimpled smile revealing gapped front teeth. He was Egon von Furstenberg, a bona fide prince. His complete name was Eduard Egon Peter Paul Giovanni Prinz zu Furstenberg, and he'd been born on June 29, 1946. His father, Tassilo von Furstenberg, was a direct descendant of Charlemagne, and the family's castle sat in the German Swiss border town of Donaueschingen, the source of the Danube River. His mother, Clara Agnelli, was the sister of Gianni Agnelli, the chairman of Fiat, and she was herself an heiress to the Fiat fortune founded by her grandfather. She also had some American blood—her grandmother, the American adventuress Jane Campbell, had married a wealthy Italian aristocrat.

Egon had been baptized by the future Pope John XXIII and raised in immense luxury in a Venetian palace. As an infant he'd had a wet nurse; as a child he'd had his own nanny and tutor. At age ten he was sent to Le Rosey, an exclusive boarding school in Geneva from which King Farouk and the shah of Iran also graduated. "I was out of touch with reality," Egon admitted to a reporter in 1981.

"Egon was beautiful, one of the most ravishing children I've ever seen," recalls the film producer and photographer Countess Marina Cicogna, a friend of the Agnelli family and a granddaughter of politician and businessman Giuseppe Volpi, one of Italy's wealthiest men. "He had great natural charm as a child and was curious about people, even people who were much older."

Egon's looks—a slim, straight body, handsome face, and head of abundant gold curls—derived from his father. From his mother he inherited a love of fashion. Even as a child he was obsessed with clothes. When he was twelve, he told his mother that his chief birthday desire was "to go to Paris to see the Dior collection." He got his wish.

Egon and his older sister, Ira, "were very spoiled," says Cicogna, much more so than their younger brother, Sebastian, who was born in 1950 and grew up to be a successful businessman, the founder of the Italian bank IFIS. "I think their mother, Clara, enjoyed having these very beautiful, well-dressed children." Clothes remained important to Egon and Ira, who as a young woman rarely wore anything but haute couture, even to ski.

The other Agnellis—a family who are to Europe what the Rockefellers are to America—"didn't spoil their children like that," adds Cicogna. They insisted their offspring work hard and get good educations. Clara let Egon and Ira "do what they wanted."

After all, the children's father, Tassilo, did what *he* wanted. "My grandfather just wanted to drink and hunt and hang out with his friends," says Diane and Egon's son, Alexandre von Furstenberg.

At fifteen, Ira married a man twice her age—the thirty-one-year-old playboy Alfonso of Hohenlohe-Langenburg. The huge, extravagant 1955 wedding included sixteen days of parties attended by four hundred guests and was covered by the press—the first time journalists were allowed to photograph an Agnelli wedding.

Egon had what the writer Stanley Elkin called "oyster-in-an-r-month" instincts, the unerring sense of the über-privileged about such protocols as when in the season to retire your black dinner jacket and start wearing your white one. What's more, Egon had a sunny temperament that drew people to him. "He was adorable," says Nona Gordon. "Guileless. He had a heart of gold and was very generous. But he was the most amoral thing I've ever come across. He'd fuck anything—boy, girl, whatever."

At the time Egon and Diane met, he was living in Lausanne and taking an occasional course at the University of Geneva. His main preoccupation, though, was to hang out with his boarding school friends Marc Landeau and Cedric Lopez-Huici, who would eventually graduate with degrees in economics. "Egon wasn't studying like we were," recalls Landeau. "That wasn't his thing."

DIANE AND EGON BECAME FRIENDS, but they did not fall immediately in love. To her, he seemed "childish." To him, she seemed "like a rich girl from upper Scarsdale," the Westchester County suburb, he later told a reporter for *People*. "My family had money, but not MONEY," as his did, Diane said.

"At the time, I don't think he knew what Scarsdale was," says Diane. In any case, "he went after me," she continued. "One reason was because he thought I was well connected" with Geneva's coolest students.

One afternoon when Egon and Diane took a ski trip together to Megève, an hour and a half outside Geneva, Egon's car became stuck in the snow, and he trudged off for help. While he was gone, Diane sneaked a peek at his passport. "I wanted to see whether it was written that he was a prince because I had never really met a prince before," she recalled in 1998. (Egon's passport held no mention of his title.) Getting the car unstuck turned out to be easy, but Diane had been charmed by Egon's "helplessness." Soon afterward, they became lovers on the roll-out bed in Lily and Hans's apartment. They were nineteen.

Despite Egon's money and title, his pedigree and connections, Diane was the *real* force in the relationship. She knew it when she fell in love with him; it was *why* she fell in love with him

Still, marrying a prince was hitting the jackpot for a European girl. Diane's best friend, Mireille Dutry, with whom she'd played princess as a child, had already married one, Christian von Hanover. Mireille was just sixteen, the never-before-married prince, forty-three. "He was twenty-seven years older than me, and he had no money," she recalls. But her bourgeois parents were enthralled by his title and pushed her into the marriage, "*exactement* like Marie-Antoinette," Mireille says.

Mireille kept her head, but it was hardly a fairy-tale match. Immediately after her 1963 wedding, she moved with her husband to a dank, gloomy wreck of a castle in Austria, where she was cut off from friends her own age. She gave birth to two daughters but sank into despair and became addicted to pills. In 1976 she and Hanover were divorced.

Mireille didn't meet Egon until after he married Diane, "but I knew his father very well," she says. "I used to see him at balls in Austria. I remember dancing the waltz with him at a hunting dinner, and he could barely stand up, he was so pissed. He was wearing what we call in Germany a hunting tuxedo, a dark green or black typically Bavarian-looking tux for fox-hunting balls. I remember he reeked of alcohol and mothballs. Probably some housekeeper had just taken the tux out of storage where it had been sitting forever."

IN DECEMBER, EGON TOOK DIANE to Villa Bella, his mother's chalet at Cortina d'Ampezzo, where he'd spent every Christmas holiday since childhood, and where, since adolescence, he'd shown up every season with a new girl. "We were all waiting to see the catch of the year," recalls Mimmo Ferretti, a close friend of Egon's brother, Sebastian, and the son of the Tuscan factory owner who would later produce Diane's dresses.

Ferretti and Egon's other friends were aghast at Egon's choice. They were used to seeing him with aristocratic blondes. Diane was dark, Jewish, sultry, and exotic. "She was so different from every other person we ever saw him with," says Ferretti. "She wore theatrical makeup. It wasn't normal makeup. Purple eye shadow. Dark nail polish." More shocking, though, Diane returned the next year. "Egon rarely brought the same girl twice," says Ferretti.

By this time, Diane and Egon were deeply in love, though neither of them felt ready to settle down. Diane moved to Paris and got a job as assistant to the photographer's agent Albert Koski, a dashing, black-haired Polish native who wore Mao-style tailored suits by Farouche. Koski represented the most celebrated photographers of the day, including David Bailey, Art Kane, and Bill Silano. "At the time photographers would get paid just once, they'd get so much per job, and that was it. My thing was to get them rights every time their work appeared in different magazines or a poster or book. And they all became very rich," he says.

At first Diane rented a small, furnished studio on avenue Georges Mandel in the Sixteenth Arrondissement. Soon, however, she moved in with her mother in an apartment on rue Pergolese. Martin Muller says his father bought the apartment for Lily so she could spend part of each year with her sister Mathilde, who lived in Paris with her husband.

Diane knew that Lily needed company. "My mother was very unhappy by herself," says Philippe. When Lily was alone—even with loved ones close by—the memories of all she had suffered in the war came flooding back to torment her.

Diane's days were spent at Koski's four-story townhouse on rue Dufrenoy, also in the Sixteenth Arrondissement, a redoubt that served as his home, office, and photo studio. "It was a crazy house," says Koski, who divided his time between Paris and London, where he also had a house and studio. "People were coming in and out all the time; photographers would come from all over the world; they would sleep there, take their shoots there, designers would show their collections there."

"I was like an assistant," Diane recalls. "Most of the time, I was answering the phone to tell either the girls Albert slept with or the photographers he had to pay that he wasn't there."

Jealousy raged among the photographers, and "Diane was very good at making sure that none of it got out of hand," says Koski.

For Diane, Koski became the center of what was happening in fashion, media, and celebrity. "I had to put together the books of photographers and send it to agencies," Koski recalls. Diane helped him and in the process absorbed a great deal about fashion photography, knowledge she put to good use when she had her own business. "She was very quick. She picked things up very fast. I liked that about her," says Koski.

Diane had arrived in Paris in the late sixties, as the long, black shadows of World War II were finally starting to fade. The postwar lives of Parisians had been marred by the pall of war and occupation. "There was a lid over Europe," recalls Koski's wife, the filmmaker Danièle Thompson, who was raised in Paris. "Until 1950 you had tickets to buy food.

When you went to school, you wore dark uniforms, and the city was dark. People were dressed in a very sad way."

Suddenly Paris sprang to life as the old order crumbled, sparked by young people demanding change. May 1968 in France was the most serious expression at the time of a far-reaching youth revolt across the Western world—from the anti-Vietnam protests in the United States to the terrorist activities of the Baader-Meinhof Gang in Germany. The French protests, though, came closest to a real political revolution—they led to a strike involving ten million workers and the unseating of a president, Charles de Gaulle.

Profound social change was under way. It would reach deep into life, politics, and culture, and it would be symbolized by the new freedoms claimed by the young. "It is strictly forbidden to forbid," read a notice tacked to a door at the Sorbonne. It became a rallying cry, one of the signature slogans of the era, along with "Live without limits and enjoy without restraint."

Sex was a key element of the new freedoms. Before 1968, says Cedric Lopez-Huici, Egon's friend, "when you had a girlfriend, there was no sexual intercourse. You were going out with her, kissing her, doing everything *but*."

Now everyone was doing *everything*, joyously and without restraint. Diane was an enthusiastic participant. "Diane was wild. She slept with all sorts of people," says Nona Gordon. "A lot of them she's forgotten."

Every evening and weekend, every trip provided an opportunity for sex. Visiting Gordon at a film festival in Deauville, where the young woman was working as Omar Sharif's personal assistant, Diane had a dalliance with the *Doctor Zhivago* star. "He was the worst lay I ever had," she says.

Diane sympathized with the rebel students and workers, but only "in the most superficial way," she admitted. She was too busy having fun. Sometimes, though, Diane and her friends collided with the student radicals. One night a group of protesting students had pushed through the

barricades to confront police near the club New Jimmy's on boulevard Montparnasse. The writer Taki Theodoracopulos, who also was present that evening, recalled opening the door to see what was going on outside. A Molotov cocktail hurled by a rioter exploded in the foyer. Diane and her friends, who a moment before had been dancing to the jerky form of French pop known as yé-yé, poured out into the street, mingling with the rioters.

At the hot nightclubs—Castel's, Le Privé, New Jimmy's, Le Sept, Le Pré Catalan—and the jet set watering holes from Gstaad to Saint-Tropez, the demimonde mingled with the jeunesse dorée and the children of the bourgeoisie. The currency was youth and style, qualities Diane had in abundance.

Still, she lacked the pedigree to gain entrée to the "best" parties, *les grandes fêtes* hosted by such aristocrats as Jacqueline de Ribes and Marie-Hélène de Rothschild. She did not have a "de" in her name; she was not rich; she was not beautiful in that delicate porcelain way of a faubourg aristocrat. "Diane was a plump, Jewish Belgian girl who was very funny," says Taki. "She did imitations of how foreigners spoke French. She wasn't at all glamorous. I never saw her at those very exclusive parties that used to take place in those days. She was a girl people knew, a middle-class girl."

But she was popular, and she developed warm friendships, particularly with women. "She liked women. She had genuine women friends," says Taki. She harbored a powerful instinct to nurture and protect, and she was drawn alike to the neediness of men *and* damsels in distress.

One night at a Saint-Tropez party in in one of those posh villas that had overtaken the curving shoreline like eucalyptus, Diane was strolling through the fragrant gardens overlooking the sea when she came upon a beautiful young woman sitting alone on a stone bench sobbing. Her name was Florence Grinda.

Between sobs, Florence explained that her husband had left the party with another woman. Diane suggested they go for a drive in Grinda's car (Diane hadn't yet learned to drive and didn't have a license). Although

Diane says the two young women had met previously in Geneva, Grinda recalls that she "didn't know [Diane] at all." Still, she and Diane "went for a drive for about an hour until I stopped crying, and ever since we've been friends. I thought that was a very rare thing to do."

As it turned out, Florence was no ordinary girl married to an ordinary cad. She'd grown up on avenue Foch, the daughter of Gisèle and Jean Michard-Pellissier, a business lawyer who counted among his best friends Aristotle Onassis. Florence's husband was Jean-Noël Grinda, a tennis star and fixture of the fast-living Parisian set that revolved around playboy photographer Gunther Sachs and his wife, Brigitte Bardot.

Diane's talent for making friends reflected her warmth and interest in others, but she also had a knack for getting close to people who had entrée to the worlds of power, money, and celebrity. "Once we went to a concert in Paris, or maybe it was a dinner, where Liza Minnelli was singing," recalls Grinda. "Diane jumped in front of Liza and actually got down on her knees to tell Liza how much she loved her and how wonderful she was."

Chief among Diane's glamorous new friends was Marisa Berenson. Just as a decade later Diane would stand as a vivid representation of the seventies in New York, Marisa embodied the Parisian beau monde of the sixties. Already a famous model when Diane met her in 1968, Marisa was an ethereal gazelle of a girl with long chestnut hair and huge, glittering green eyes. Marisa had been born modeling—she first appeared in *Vogue* in 1947, when the magazine ran a picture of her baptism. "My whole life has been lived at Condé Nast," she jokes.

Also at Hearst. At age five, Marisa and her younger sister, Berry, landed on the cover of *Elle* in matching red dresses with sashes in shocking pink—a color made famous by their famous grandmother, the couturiere Elsa Schiaparelli. Like dazzling Nicole Diver in F. Scott Fitzgerald's *Tender Is the Night*, Marisa represented "the exact furthermost evolution of a class," so that most women seemed plain and dull beside her.

On her mother's side, Marisa was descended from a famous Neapoli-

tan astronomer; on her father's side, she was related to art historian Bernard Berenson. Her father, Robert Lawrence Berenson, was an American diplomat of Lithuanian Jewish descent. Her mother was Countess Maria Luisa Yvonne Radha de Wendt de Kerlor, known as Gogo, the daughter of Schiaparelli.

Sent off to boarding school at age five, Marisa had led a childhood of both loneliness and lavishness, of motherless bedtimes and holiday tea parties where little girls were served by footmen in white gloves. She had emerged from this overstuffed yet undernourished background to become a star of the Parisian youthquake.

Neither Diane nor Marisa remembers how they met, perhaps at a party in Paris. Though they'd been raised in remarkably different circumstances, there was much to draw them together. Both had fierce wills and a determination to be independent. Marisa also had a vulnerability that appealed to Diane. For her part, Marisa found Diane a refreshing change from the snooty French girls she met modeling. "We became instant close friends," she says.

Marisa and Diane dressed to be noticed, piling on the makeup and costume jewelry, bangles, Tibetan chains, and thick belts covered with huge stones. Their look was eccentric and eclectic. "We'd go from being hippie chicks to very glamorous to very dressed, to very undressed," says Marisa. "There wasn't just one look. It was an explosion of self-expression."

One favorite look of theirs combined teeny hot pants with platform shoes and Yves Saint Laurent jackets. They would dress up, iron their hair—they were both tormented by unruly tresses that frizzed at the least excuse—and head out to the restaurants, cafés, and clubs.

At the time, Marisa was living in her grandmother's grand *hôtel particulier* at 22 rue de Berri, a residence that had once been home to Princess Mathilde, Napoléon's niece. The interior was a jumble of treasures that the couturiere had collected over the years. Many were works by the famous artists she'd befriended in the twenties, including a Salvador

Dali compact that looked like a telephone dial. She also owned tapestries by François Boucher. Feathers and jewels instead of flowers sprouted from Schiaparelli's vases.

On her way out for the day or evening, Marisa tried to avoid "Schiap," as the designer was known by her intimates. Schiaparelli disapproved of what she considered her granddaughter's eccentric outfits and makeup. "My grandmother didn't think I was elegant at all," says Marisa. "She'd look at me leaving the house, and she'd say, 'You're not going out in *that*!' I'd have on a miniskirt or mini-shorts, and she just thought it was so vulgar."

Diane knew that Marisa had a very famous grandmother "who was a tyrant," but she never met Schiaparelli. The couturiere was always upstairs, and Diane was always downstairs, she recalls.

The friends loved movies and would sometimes see two or three in one day. After spending an afternoon in a darkened theater, the two young women, dressed to the nineteenths in microminis and bangles or gossamer tops and low-slung bell-bottoms, would saunter into La Coupole in Montparnasse for oysters, and everyone would stare—exactly as they'd hoped.

Their style was startlingly new. The sixties were a turning point for fashion, marked by the ascendance of individuality and the decline of couture. In just one year, from 1966 to 1967, the number of couture houses in Paris plunged from thirty-nine to seventeen. The next year, Balenciaga retired, bemoaning that there was no one left to dress. His clients were dead or dying, and so was their way of life, with its rival salons and grand balls, ladies' maids and drivers in livery. With the student and worker protests soon to be followed by the resignation of Charles de Gaulle, who had dominated French politics since the end of the occupation, a spirit of openness and change infused all levels of Parisian society.

And yet. Marie-Laure Noailles, a descendent of the marquis de Sade, patron of the surrealists, and star hostess of Old Paris, lived on in her *hôtel particulier* on the Isle St. Louis, a remnant of the world of French sophistication and privilege that was closed to Diane. Marisa had been

born to this world, and through her, Diane would glimpse it. "I knew everyone there was to know," Marisa says.

In addition to the old guard, Marisa introduced Diane to the new international elite—a mixture of pop singers, fashion designers, photographers, movie directors, and Hollywood stars—many of them from working-class backgrounds. This group intersected and mingled with the jet set crowd of socialites and aristocrats.

Some of the people Diane encountered with Marisa she'd already met while studying in Geneva. Egon had introduced her to others. "We were all Eurotrash," says Mimmo Ferretti. "We were not like the children of rich Europeans now who are sent to America to study. We were all taking drugs and carousing, but we were the most fun, and we are all still together, still friends—those of us who are still alive.

"It was the best time since the belle époque," he continues. "We had a choice—live in the moment or settle down and go to work. I lived in the moment. If you were to meet someone who was in Paris in the belle époque, you'd say, 'Oh, you met Toulouse-lautrec!' And if the answer was 'Oh, no, I was too busy working and getting married and having three kids,' you'd look at the guy like he's crazy. He missed it all!"

DESPITE THE "HEDONISTIC PLEASURE" OF being young in Paris, as Diane wrote in 1998, on some deep level she remained an outsider. She would never be a true *Parisienne*. She would never be part of *le gratin* (the upper crust). She could sometimes tag along with Marisa to the homes of aristocrats, but the world of the Faubourg St. Germain with its inscrutable rules and Proustian intrigues would remain closed to her.

Of course, Fashion was all about exclusion, and no one understood this better than the French, going back to the days of Louis XIV. When the Sun King began wearing a special coat with slashed sleeves, he passed a law that prevented anyone but his courtiers from donning copies of it. Only he and a handful of others could wear red-heeled shoes, a symbol of their power to crush their enemies under their feet.

Later, Marie-Antoinette, perhaps history's most famous clotheshorse, decreed that only she and her closest friends could wear *le grand corps*, a jewel-bedecked corset that was tighter and meaner than anything worn by ordinary women. *Le grand corps* was so constraining that one princess passed out every time someone at court told a joke. She could never get enough oxygen to laugh.

If Diane had stayed in Paris, it's unlikely she would have become a famous designer. As a Belgian, the French fashion establishment would never take her seriously. With the exception of the father of haute couture himself, Charles Frederick Worth, only one non-French designer at that point had ever succeeded in Paris couture—that was the Chicago-born Mainbocher, who happened to have French ancestors and a very French name, Main Bocher, which he collapsed into one word.

The models, photographers, and fashion journalists Diane met through Koski and Marisa were living the kind of über-glamorous life she coveted. She grew restless working as Koski's assistant, and in the summer of 1968 she abruptly quit her job. "I didn't wait for my month's salary. I took Albert's radio, charged a plane ticket to him, and left," Diane recalled.

"I guess she knew I wouldn't mind," says Koski. "I was very rich, and her salary wasn't so extraordinary. It was a very relaxed company, and a very relaxed time."

Now Diane was free to travel with Marisa. At the Mare Moda fashion weekend in Capri, the friends "stayed in a pretty hotel and dressed up and went to wonderful parties," Diane recalls. "I met Valentino and [his partner] Giancarlo Giammetti, and Italian playboys. Both Marisa and I ended up having a romance with Italian playboys."

At Mare Moda, Diane also ran into Angelo Ferretti, the flamboyant owner of thriving textile factories in Italy, whose son Mimmo was a friend of Egon's brother. Ferretti invited Diane to apprentice with him, to learn everything she could about clothes manufacturing. It would turn out to be the most important relationship of her early career. "I

was looking for my door to be independent, and Ferretti opened it for me," Diane says.

ANGELO FERRETTI'S FACTORIES SAT IN a nest of textile companies in Parè, near Como, Italy, thirty miles north of Milan on the shores of Lake Como. The area swarmed with billionaires, duchesses, and movie stars who lived in extravagant villas high in the hills, and with artists who peddled their work to the textile manufacturers. In his mid-forties, Ferretti played the role of big-shot businessman—bossy, volatile, and flamboyant. A tall, bulky man, he wore bespoke suits and owned a yellow Maserati that he drove suicidally fast through the Italian hills. He also had a black Rolls-Royce that he drove to work and parked smack in front of the factory's main entrance, blocking the door. Though reckless in most of his habits, he was almost comically fastidious about his clothes. If he noticed a wrinkle in his trousers when he arrived at work, he'd give the pants to a seamstress to press, then wander around the premises in his underwear, greatly enjoying the reaction of his workers. "He was like a king," recalls Sue Feinberg, the designer who would later oversee production of Diane's clothes at Ferretti's factory outside Florence.

"Today he'd be in jail for the way he treated his employees," adds Diane, noting that he screamed "Imbecile!" at them whenever he was dissatisfied with their work, which was a great deal of the time. No doubt he'd also be in trouble in this environment-conscious age for what Diane says was another Ferretti practice: dumping his toxic, leftover dye in Lake Como.

People whispered that Ferretti had won his Como factories in a poker game. Actually, he'd bought them after World War II with loans from relatives, including his father, an officer in the Italian army. A combination of business acumen, luck, a stellar product, and a cadre of diligent, talented workers enabled him to keep his family and his mistresses in style, in villas and swank apartments, jewelry and fast cars, despite a gambling habit that should have ruined him.

Most of his weekends were spent at the roulette tables in Monte Carlo, where he lived rent-free in a three-room apartment, courtesy of the Hotel de Paris Monte-Carlo. In Paris, he stayed at the Plaza Athénée on the tab of the city's premier gambling club, Le Grand Cercle. A diabetic, he traveled everywhere with a cooler of insulin.

Diane immediately felt at home in Como. Her grandfathers and grandmothers, her uncles and aunts, had owned and worked in textile firms and clothing shops. In Italy, as in Diane's family, textiles were more than cloth. They came from the blood and soil of the people. Many of the workers in Ferretti's factories had learned the crafts of weaving, dyeing, printing, pattern making, and sewing from *their* parents, in a long line stretching back generations.

Angelo Ferretti's success was built largely on a new cotton-jersey fabric he developed. "It was article six-oh-three-oh; I still remember the number," says his son Mimmo. "We were the first to do it. We put together two different kinds of yarn, and, wow, it worked. Instead of shrinking ten percent, it shrank only five percent, and it held all its color." It would become the fabric of the wrap dress and play a huge role in Diane's success.

Ferretti had some designer accounts—he made shirts for Ferragamo and Louis Féraud, for example. Mostly, though, he used his gorgeous cotton jersey for "horrible stuff, really schlocky things like you'd find at Monoprix or UPIM [the European equivalents to Target]," says Feinberg. Among them were tens of thousands of T-shirts. Until Diane came along, she adds, "I don't think Ferretti realized what he had."

Still, Diane learned a great deal from Ferretti: how to spot designs that would translate into good prints for fabric, how certain colors worked together harmoniously, and the various techniques for dyeing. "Ferretti had thousands of prints," says Diane, who spent hours going through them, and quickly she developed her "own point of view." Designs that "had some movement to them," particularly ones that evoked nature—

animal skins, tree bark, leaves—sparked her imagination the most and would become signatures of DVF style.

DIANE SPENT THE FALL OF 1968 traveling back and forth between Ferretti's factories in Italy and her mother's apartment in Paris. At the time, Egon was living in New York, where he had enrolled in a training program at Chase Manhattan Bank. He and Diane had broken up, though they remained friends, and when he brought his new love, an Italian girl, to Paris for a visit, he asked Diane to arrange a dinner party for her. Diane complied. Through Florence Grinda's connections she "borrowed a dress from Lanvin" for the dinner, Diane recalls. "It was at Maxim's, and we were maybe twelve people. I remember Marc [Landeau, Egon's close friend] taking me home afterward, and I was really down."

It saddened Diane that Egon would be taking his new girlfriend, not her, to his mother's house in Cortina for the Christmas holiday. So convinced was she "that [she'd] lost the love of [her] life" that she consulted a fortune-teller. The seer's prophecy: Diane would be married and pregnant within six months, though by whom, the fortune-teller didn't say.

At the end of December, Diane went to Saint-Moritz with Marisa. "I was making a lot of money as a model, and I wanted Diane to come with me, but she didn't have the money, so I pulled this wad of cash from my bag and gave it to her," recalls Marisa.

In Saint-Moritz they shared a room at the five-star Badrutt's Palace Hotel, where management gave deeply discounted rates to beautiful young people, whose presence they felt enhanced the atmosphere. "We'd go down to have massages to stay in shape, then we'd come up to the room and order room service and eat everything on the menu. Then, we'd go out to ski, and at night we'd party," recalls Marisa.

Egon's uncle, the married Fiat chairman Gianni Agnelli, was staying at the hotel with a gorgeous Italian actress who was his mistress. "He

used Marisa and me as decoys," to draw attention away from his affair with the actress, says Diane. "If you're with three girls, it looks [more innocent] than if you're with one."

On New Year's Day, Egon showed up and took an inexpensive room under the eaves at the hotel. His Italian girlfriend was nowhere in sight, and he confessed to Diane that he still loved her. "We spent the night together, and Egon invited me to New York," Diane recalls.

She knew Egon was bisexual, and she accepted it. In the pre-AIDS world of the jeunesse d'oré, sexuality was fluid, in an almost pre-Freudian, nineteenth-century way. "We didn't think in terms of gay or straight," says Marisa. "We were just free. I was in love with Helmut Berger. It didn't bother me that he was bisexual. We adored each other. My grandmother was horrified. But to me it all seemed very natural."

There was a certain glamour attached to dating a bisexual man, and a sense of conquest in sparking heterosexual desire. Many of the gay men in Diane's circle were handsome, sensitive, romantic, caring, and well dressed. They could dance well, and they were enthusiastic lovers. "When they were with you, they were really with you," says Gigi Williams, a makeup artist who worked for Diane in the seventies and slept with her share of bisexual men. "They weren't testosterone-driven, misogynistic, or womanizing, like so many straight men," adds Williams. "They were very empathetic. Anyway, everybody was everything in those days."

Excess and flamboyance were celebrated. What damned you was excessive caution and dullness and adherence to bourgeois ideas about proper behavior and sexual categories. This did not mean that people didn't fall madly, exclusively in love, and that hearts weren't broken. It meant only that tolerance—or at least its appearance—prevailed.

Whatever their sexual inclinations, men of Egon's background were expected to marry and produce an heir. Egon began introducing Diane as his fiancée even before they discussed marriage. And she worked hard to play the part of consort to a prince. "She was not terribly at ease socially, not very self-assured," recalls the photographer Marina Cicogna, who

produced movies in the sixties and seventies. "She was a girl from a good family in Belgium, but she hadn't been exposed to the world of wealth and glamour that Egon had grown up with."

Cicogna first met Diane when Egon brought her to a party Cicogna hosted in Venice during the September 1967 Venice Film Festival. A rich cast of movie stars showed up, including Jane Fonda, Marcello Mastroianni, Elizabeth Taylor, Catherine Deneuve, and Claudia Cardinale. "It was supposed to be a fun, yé-yé sort of party. We'd asked everyone to dress in white and gold," Cicogna says.

Most of the women wore the kinds of clothes they'd wear to go dancing at a nightclub—short party dresses or sexy pants outfits. Diane arrived on Egon's arm dressed like her mother in a black and white Chanel suit with a white blouse and foulard, clutching the chain of a shoulder bag. In a photograph Cicogna took of her that evening, she looks pale and scared.

DIANE HAD HEARD STORIES ABOUT Manhattan, about its swank eateries and smart hotels, its neon glamour and Wall Street zest. When she told her mother about Egon's invitation, Lily gave her a plane ticket as a twenty-second birthday present. Lily knew Diane would be staying with Egon and his roommate, Baron Stanislaus Lejeune, at their apartment at York and Eighty-First Street. Diane told her father, however, that she would be living with a girl named Suzanne Lejeune. She knew he'd disapprove of her bunking with a man "and this way he could still write to me [in care of] S. Lejeune," Diane recalls.

She left Paris on a cold night in January 1969. As the jumbo jet lifted higher and higher, Diane looked out the window. The tall, twinkling city had flattened out to resemble a swath of black silk spattered with crystals and paillettes. The journey that would change her life had begun.

New York

iane fell in love with New York the moment she stepped from the taxi onto the pavement in front of Egon's building and got her first whiff of Manhattan air—that heady mix of glamour, power, danger, grittiness, and wealth. *This* was where she belonged.

At Egon's side she entered the recherché world where society and celebrity meet. The old guard in New York admired Gianni Agnelli, the rich and influential head of Fiat, and embraced his charming, handsome nephew. It didn't hurt that Egon himself was a prince, a title that gave him a magical glow, invoking romance, fairy-tale endings, and an exotic history of palace riches and court intrigues. Since moving to New York, Egon had been invited everywhere—to Park Avenue dinners and grand charity balls, to gallery openings and polo games in Southampton. Now he took Diane with him. She met everyone from Diana Vreeland and Andy Warhol to Brooke Astor, Nan Kempner, and Truman Capote. Painfully aware that she was included on guest lists because she was

Egon's girlfriend, "Diane tried desperately to fit in," says the writer Bob Colacello, who met her soon after he arrived in New York.

"Egon introduced me to all these [society] girls who'd take me to lunch at 21 and La Grenouille, and they'd explain to me how 'if you sit on *that* side, it's Siberia,'" and social suicide, "and it all felt so strange," says Diane.

The sixties had been a time of freaks and hippies, of political activism and radical chic. Soon the revolutionary spirit, faux and otherwise, would be overtaken by the dawn of the disco decade with its hedonistic brew of style, irresponsibility, indulgence, and glitz. At the fringes was the drug- and sex-soaked demimonde that thrived in the downtown clubs and gay bars. Egon moved effortlessly through the night worlds of New York. "He was in perpetual party mode," says Colacello.

Though Egon participated in the training program at Chase Manhattan, his banking career stalled. "He never really made any money," says his son, Alex. Still, his family money enabled him to live comfortably, and Diane, as his live-in girlfriend, did not have to work.

The idea of being a kept woman, though, horrified her. It contradicted everything about the life of freedom she craved. It also was an impediment to her most deeply held ambition—to be *somebody*. Since financial independence, Diane believed, was the first step to this end, she toyed with becoming a model. Francesco Scavullo, a fashion photographer best known for his portraits of celebrities such as Brooke Shields and Burt Reynolds, took pictures of her. But when Diane showed her portfolio to Wilhelmina Cooper, the head of Wilhelmina Models, the prestigious agency that represented Lauren Hutton, Janice Dickinson, and Beverly Johnson, Cooper turned her down flat. At a lissome five feet, seven inches tall (she'd shed the chubbiness of her late-teen years), Diane's figure was in the modeling ballpark. She also had high, chiseled cheekbones and large, wide-set eyes, which made her extremely photogenic. Her face, though, was too strong and mature-looking for American magazines, which at the time favored softer, less exotically pretty women.

Still, Diane's ambitions focused increasingly on fashion. In Europe it was easy to find affordable, well-designed clothes in comfortable knit fabrics. Diane herself looked good in these clothes, and she sensed that American women would like them, too. The problem was, they weren't available in the United States. Diane noticed on her many shopping excursions with Egon that American department store fare tended to be either expensive copies of French designers, hippie bell-bottoms and peasant dresses, or schlocky polyester wear. She greatly admired the colorful, fluid designs of Halston, Giorgio di Sant'Angelo and Stephen Burrows. As "a boy-about-town," Diane says, Egon knew these designers and gained access for himself and Diane to their studio backrooms. Here Diane saw firsthand how New York fashion was made. Designs by the likes of Halston, Sant'Angelo, and Burrows, however, were expensive and out of reach for most women. Diane sensed an opportunity.

She knew nothing about designing. "What I did know . . . was that the world of fashion was fun, glamorous, very cool and I loved it," she wrote. She would discover that it was also hard work.

In the spring she returned to Italy. Ferretti had bought another factory, this one a sprawling cement building on the outskirts of Montevarchi, an ancient market town nestled in the Tuscan hills. During the Renaissance rule of the Medicis, Montevarchi flourished as a center of the wool and silk industries. After the unification of Italy in 1870, it became a hub of sartorial manufacturing—first of felt hats, then of shoes and women's and children's wear.

Diane struggled to absorb as much as she could about the manufacture of clothes. At night, after the workers had gone home, she stayed behind with the pattern maker and, using whatever remnants of fabric were around, made her first samples. The first garment she designed was a green jersey dress with a seven-meter-long green and red sash.

In May, when his training program at Chase had ended, Egon joined his friend Marc Landeau, who'd just graduated from Columbia Business School, on a two-month tour of Asia. On the way, he stopped in Italy to

visit Diane. They spent a romantic weekend in Rome, and soon afterward
Diane discovered she was pregnant. She considered having an abortion,
which was illegal in Europe at the time, as in the United States. She'd
known girls in Geneva who'd had abortions, though, and she had the
name of a doctor who performed the procedure. Lily convinced Diane
that she had an obligation to tell Egon of her condition, so Diane sent
him a telegram in Hong Kong:

> i am sorry to disturb your journey, but it is
> impossible to decide alone. result of the analysis
> was positive. i am thinking of the dr. s. solution.
> i await your decision. love you more than ever.
> diane.

Landeau recalls the exact moment Egon received the news. "We were
in this little hotel early one morning, when a porter came up to the room
with the telegram. Egon hesitated only a moment, then rushed out to
send a telegram back to Diane." She's kept it all her life:

> marriage will occur the 15th of July. organize it
> as rapidly as possible. i rejoice. thinking of you.
> love and kisses, eduard egon.

"Egon wasn't the most monogamous of persons," says Landeau. "But
Diane was his girlfriend, and Diane turned him on, and Diane was his
family. If he was going to have children with anyone, it was going to be
with Diane."

Afterward, Egon and Landeau went to a French restaurant to cele-
brate. "There was a very pretty woman sitting next to us with her hus-
band, and Egon said, 'You know, I'm so excited. I'm getting married, and
I'm going to be a father.' And the woman said, 'That's so nice, and look
at me; I'm pregnant, too!' Egon goes over to her and puts his hand on
her belly so he can feel her baby's heartbeat." Her husband didn't object.
"Egon oozed charm. He could get away with anything," says Landeau.

His future wife may have been pregnant, but that didn't interrupt Egon's trip. As the friends traveled to Bali, Laos, Cambodia, and Japan, Egon worked on the guest list, and whenever they found themselves on an Air France flight, he'd ask a flight attendant to mail the list to Diane when the plane returned to Paris.

Despite Egon's enthusiasm about the wedding, Diane was embarrassed to be a pregnant bride. She didn't want anyone to think Egon *had* to marry her. Of course, that's exactly what people in Egon's social world believed. "They felt that Diane was on the make and had taken advantage of Egon," says John Richardson, the art historian and Picasso biographer, who met the couple when they first moved to New York.

With Lily in tow, Diane traveled to Venice, where she ordered a trousseau of tablecloths and sheets with the von Furstenberg monogram from Jesurum, Italy's most famous manufacturer of handmade lace. She and Lily also visited Diane's soon-to-be mother-in-law at Morocco d'Venezia, the eighteenth-century villa outside Venice where Clara lived with her second husband, Count Giovanni Nuvoletti, to discuss plans for the wedding, now just six weeks away. The villa was more enchanting than Diane had expected. The stuccoed house had cornflower-blue shutters, a red-tiled roof, and pink roses cascading from window boxes. More roses meandered over the property, perfuming the air.

Clara was in a unique position to be wary of *and* sympathetic to Diane. Her own grandmother, the plain but clever Jane Allen Campbell, had been an American adventuress straight out of a novel by Edith Wharton. Born in 1865 in New Jersey, Jane had tried to find a rich husband in New York. When that failed, she traveled to Rome, where her wealthy aunt lived, and she landed an Italian prince, Carlo Bourbon del Monte, Clara's maternal grandfather.

Anti-Semitism was not uncommon in the von Furstenbergs' social set, and to understand the visceral prejudice of many European aristocrats it helps to read Proust. In *Remembrance of Things Past*, the protagonist Swann describes a French prince who was so anti-Semitic that he let

a wing of his chateau burn down rather than borrow fire-fighting equipment from the Jewish Rothschilds next door. The same prince also chose to suffer an agonizing toothache, rather than consult the only available dentist, a Jew.

Clara's own in-laws from her first marriage, the von Furstenbergs, had been disappointed when Tassilo married *her*, a girl without a title, despite her grandmother's marriage. Her commoner status compromised the position of their children in the *Almanach de Gotha*, the directory of Europe's royalty and higher nobility, and ruined their sons' chances of being received into the Knights of Malta, the oldest surviving order of chivalry. As Alex von Furstenberg points out, however, Tassilo was the younger son, and "in those aristocratic families in Europe, the oldest son gets everything, and the younger sons marry rich people. That's how it worked."

Diane insists she never felt the sting of anti-Semitism from Clara. (Diane's friend Howard Rosenman recounted a purported anti-Semitic incident involving Clara in a *Los Angeles Times* piece five years ago. Diane denies that it ever happened, and Rosenman now backs away from the account.)

Tassilo, though, on several occasions made remarks that could be interpreted as anti-Semitic. At dinner the night before his son's wedding, he drank too much and kept repeating to the young woman who was seated next to him, "Egon is a prince. He's so handsome. Why is he marrying this dark, plain little Jewish girl?"

Several years after Diane and Egon married, Tassilo told journalist Linda Bird Francke that "Jews are clever and shrewd," qualities that his half Jewish grandchildren would "need."

ON THAT PRE-WEDDING VISIT TO Venice, while Lily and Clara went over the guest lists, Diane went out to the gardens. Lily adored Egon and didn't seem concerned that Diane was marrying an Austrian. Clara, too, seemed excited about the wedding. But Diane was unsure if

Clara's "enthusiasm was genuine," she recalled. The sun was very hot, the air windless. Strolling through the beds of roses and hydrangeas, past the long avenues of poplars and linden trees that stretched out from the house, Diane felt her heart swell with conviction. She vowed to prove to Egon's parents that their son had chosen well, that she was a person of value. "I got ambitious when I got pregnant because I wanted to show myself and the world that marrying a prince with Agnelli money was not my goal. My goal was to be independent," she says.

Diane dreamed of transformation, of success, of perhaps even turning herself into a celebrity. Such things were possible in America. Maybe she would be a famous fashion designer like Halston or Yves Saint Laurent. By sheer will and hard work, by calling forth the drive that had always been in her, she would succeed.

She went back to Ferretti's factory and told him she was pregnant, getting married, and moving to New York for good.

Diane and Egon were married in a civil ceremony at the town hall of Montfort-l'Amaury, just outside Paris, on July 16, 1969. The bride wore a flower-bedecked picture hat and a long-sleeved white dress designed for her by Dior's Marc Bohan, with cutouts that revealed layers of pastel petticoats. Since she was pregnant, Diane said, she "felt it wasn't really appropriate to wear completely all white."

Because of the von Furstenberg name, the wedding was covered by all the usual publications that paid attention to society nuptials. No one mentioned Diane's pregnancy, and there were many rapturous descriptions of her appearance. *Vogue* said she looked "Romany romantic," adding that the nuptials had "a gypsy brilliance."

Following the ceremony, there was a reception for five hundred guests at the Auberge de la Moutière, "a charming provincial inn considered the countryside version of Maxim's," as Diane wrote. "The movie *Tom Jones* had recently come out, and I wanted to replicate the mood and visuals of the country-side feast. My father hired all the singers and musicians from Rasputin, a Russian nightclub in Paris, to perform at the reception.

My father sang and broke a lot of glasses. But there was a shadow over the wedding."

Tassilo showed up for the ceremony but declined to attend the reception, out of deference to his cousin, the reigning von Furstenberg patriarch. The cousin-patriarch disapproved of the marriage because Diane was Jewish. As Tassilo later told Linda Bird Francke, "Eddie [his nickname for Egon] understood. He sent a girl to my room." The snub hurt and humiliated Diane and made her even more determined to prove to herself and her in-laws that she was a worthy bride for their son.

After a short honeymoon sailing the fjords of Norway, Diane and Egon went to a little house that Clara had bought them as a wedding present on Sardinia's Costa Smeralda. The area, which had been developed by the Aga Khan, was a popular anchoring spot for the yachts of jet-setters, including Princess Margaret and her husband, the earl of Snowdon; the king of Greece; and Elizabeth Taylor and Richard Burton. The newlyweds' house on the sea was round "like a woman," Diane said, with doors in every room opening onto a terrace. They were joined by a group of friends, including Marisa Berenson and Nona Gordon. The women wore tiny bikinis and diaphanous caftans; the men were tanned and barechested. There was a lot of swimming, sunning, drinking, pot smoking, and dabbling in group sex, instigated by Egon, according to Nona Gordon. "I have a vision of them all on the roof of that little house: Talitha and Paul Getty and Arndt von Bohlen and a whole group of people, and they were all fiddling with each other's *things*," Gordon recalls.

Though she became a serious cocaine addict, when it came to sex, Gordon was conventional, and she refused to join in. "I was so upset, I rushed off to my room. I was crying, and they were all laughing at me," she says.

Diane denies that group-sex parties took place at the von Furstenbergs' house in Sardinia. Still, Gordon says, "orgies were completely normal for Egon."

He "was like Pan, like Dionysius," says Bob Colacello. "But he had

so much charm, it never seemed sleazy with him. And it was also the time. All through the seventies into the eighties before AIDS became an issue, people were very carefree and footloose, and things happened rather spontaneously and indiscriminately."

At the end of the summer, Egon flew to New York, while Diane went to Montevarchi to pick up her dress samples from Ferretti's factory. In October, six months pregnant, she sailed for Manhattan aboard the Italian liner *Raffaello*. Diane's New York married life began in a blur of parties, dinners, and shopping excursions. Egon loved buying clothes for his wife, not only as a treat for her but also for practical reasons. He wanted to help Diane learn as much as she could about fashion—he had thoughts of making fashion his career, too. He started a job at the New York investment bank Lazard Frères but would soon give up on a career in banking. "I was never a good analyst," he said. "I had too much joy of living to be down there [on Wall Street]."

Egon told a reporter that his uncle Gianni Agnelli had given the couple ten couture dresses as a wedding present. According to Egon, Agnelli told him, "Go to Paris, go to Saint Laurent, go to Courrèges." The idea was that the von Furstenbergs would be inspired by the exquisite clothes.

Unfortunately, the story was untrue. "That's the kind of thing Egon could have made up," says Diane. Gianni Agnelli's wedding present to the newlyweds was a painting by Josef Albers.

As they explored the offerings in New York stores, Egon urged Diane to look closely at the design, fabric, colors, and structure of clothes. In this way, he helped develop her eye and a sense of the American market. For a time, as part of a Lazard program in the business of retail, Egon joined the buying staff of E. J. Korvette, the struggling discount department store. His preferred style, however, remained decidedly old school high-end. "I hated his taste," says Diane. "Egon liked complicated clothes in luxe fabrics, such as satin duchesse. He didn't understand why I wanted to do simple little jersey dresses."

With no formal training in the fashion arts, Diane did not sketch, drape, cut patterns, or sew. When she first apprenticed herself to Ferretti, she did not understand the basic construction of clothes. "I started out an amateur," she says. She relied on Ferretti's pattern makers, print designers, and seamstresses to help her realize her vision of a few easy dresses and separates. She would describe what she wanted, and the Ferretti workers would translate her words into clothes. Diane was a quick and avid learner, though, and eventually, as time went by—and she watched the workers drape, pin, snip, and sew—she'd come to know everything there was to know about making fashion.

Her chief talent, though, had little to do with the nitty-gritty of designing, of mastering technique and conjuring innovative shapes. "My strengths have always been in the marketing of an idea," Diane said. "I'm involved with an attitude. I think of what women want to wear."

Lugging her Vuitton suitcase full of samples, Diane made the rounds of New York retailers. She had three styles—a T-shirt dress, a shirtdress, and a long, tented dress. These were "classic dress bodies that had been around for a long time, but no one had really played them," says Richard Conrad, who became Diane's partner in 1972. "They fit almost everyone, and when you put them in a fabric [like Ferretti's] that no else could make, you had winners."

Still, the clothes took a while to catch on. Some store executives refused to even meet Diane. Others looked at her samples without buying anything. One exception was Ron Ruskin, the executive vice president of Best and Co. Diane "just showed up" at his office one day, Ruskin recalls. "No appointment. My secretary buzzed me and said, 'There's a woman here who's hugely pregnant, and she has some samples she wants to show you.' They were unique. Different from what we had. More European, dressy. I was impressed, so I sent for our buyer. She was impressed, too, and we placed an order."

Diane's son, Alexandre, was born by cesarean section on January 25, 1970, after Diane had been in labor sixteen hours. The night before,

Diane and Egon had gone dancing at one of the popular new discos. The jewelry designer Kenneth Jay Lane remembers that she was wearing a dress covered in glittering paillettes, and that he "was dancing madly with her. Maybe that's what brought on her labor."

With a nanny to care for her son, Diane occupied herself with launching her business and getting back in shape so she'd look the part of a glamorous princess. She later admitted that she wasn't very maternal when her children were born. Instead of enjoying them, she was obsessed with losing her pregnancy weight so she'd fit into her jeans.

In the minds of many of the von Furstenbergs' Park Avenue acquaintances, Diane's little dress operation was a hobby, not a real business. *Isn't it nice that Egon's wife has something to do during the day? Aren't her little dresses sweet?* But Diane clung to her work as a lifeline. "I was racked with insecurity," she wrote. "I had no identity of my own. No one really knew who I was, not even me. The person who went to parties was Princess von Furstenberg, a character who'd stepped out of a fairy tale. It was just as much a fairy tale to me."

Soon after Alexandre's birth, Diane's first shipment from Ferretti's factory arrived at Kennedy Airport. At the customs warehouse she discovered that the fabric content listed on each garment had been written in Italian. So Diane sat on the floor of the icy warehouse for hours, crossing out the Italian on the labels and rewriting the fabric content in English.

With a few small accounts to keep her going, Diane traveled on her youth fare card to Italy to oversee production of her next batch of fashion. Ferretti was supplying her with the materials and labor on long-term credit. She paid him back as the clothes sold, but her orders during those first seasons were small, and she was never sure Ferretti would actually fill them. His factories were busy churning out mountains of T-shirts and other items, and Diane had to beg and use every wile in her arsenal to persuade Ferretti to stop his machines to make her clothes.

In New York, Diane hauled her samples from store to store in search of more accounts. Her dining room served as her office, with a big black

phone and order books from Woolworth's on the table and clothes hung over the backs of chairs.

In March, Diane got an appointment with Diana Vreeland, the influential *Vogue* editor. She had been to Mrs. Vreeland's office once before, when she'd first come to New York to stay with Egon and thought she might like to be a model. The Empress of Fashion had made it clear that Diane wasn't modeling material. Since then, Diane had seen Mrs. Vreeland at parties in Manhattan, and now she stood nervously in her red lacquered office, the scent of Rigaud candles filling the air. A group of editors surrounded a model who was trying on a series of outfits. To one side stood Vreeland herself, a tall, beaked crane of a woman with rouged ears, Vaselined eyebrows, and a severe black bob so rock hard with hair spray that it was said to "clink" whenever a waiter bumped it with a tin tray. Vreeland's voice was as magnetic as her person, a gravelly bourbon-and-cigarette mix that shocked and delighted with its Delphic pronouncements: "Pink is the navy blue of India." "Blue jeans are the most beautiful thing since the gondola." "The bikini is the most important thing since the atom bomb."

It was hard to know if Vreeland was ridiculous or a genius; perhaps she was a little of both. She exemplified what was fun and exhilarating about Fashion and also what was silly. She was affected and imperious to the point of freakishness. Many people were terrified of her. Not Diane.

She arrived with a beat-up suitcase holding wrinkled dresses. "We had the model try on Diane's clothes," recalls Grace Mirabella, an assistant to Vreeland who would soon succeed her in *Vogue*'s top job. "It was the first time I'd seen them, and they were just nifty," a favorite *Vogue* adjective. "They were so simple and right for the moment."

"Terrific, terrific, terrific," pronounced Vreeland before disappearing out the door.

Vreeland loved "body-celebrating fashion . . . that worked with the dynamic, active [figure], and she continued to venerate it throughout her time at the magazine," wrote biographer Amanda Mackenzie Stu-

art. Diane's fashion fit this aesthetic. But not all of *Vogue*'s editors were impressed. Several of them thought Diane's clothes were unexceptional, not particularly well made or inventive. Still, as Diane was packing up to leave that day, one editor, Kezia Keeble, took pity on her and advised her to show during New York Fashion Week, the biannual event that allowed designers to display their wares for buyers and the media. Fearing that the sharks on Seventh Avenue "would eat me up," the scared newcomer avoided the Garment District, where most designers showed their work (Fashion Week had not yet been organized at one central location). Instead, as Keeble advised, Diane took a small showroom in the more comfortable territory of Midtown, at the Gotham Hotel on Fifth Avenue at Forty-Sixth Street.

She hired a model, Jane Forth—a pale, skinny teenager who was part of Andy Warhol's Factory crowd and would soon be on the cover of *Life* as "the new now face"—and got on the phone to buyers. She wasn't shy about using her title. "This is Princess von Furstenberg," she'd say. "I've designed a collection of dresses in Italy I'd like to show you." She also organized a small fashion show in the Gotham Hotel's banquet room with students from a modeling school she found through the Yellow Pages. Someone had given her a bouquet of tulips, so she gave each girl a tulip to carry.

Some of the buyers came to Diane's showroom because they'd read about her in the society columns and they were curious. Many of them left without buying anything. Diane's first sale that week was to Sara Fredericks, a dress shop in New Jersey. Soon after, Fred and Gayle Hayman, pioneers of Rodeo Drive in Los Angeles and owners of the swank boutique Giorgio Beverly Hills, bought sixty dresses. They sold them to actresses such as Ali MacGraw and Candice Bergen, who were photographed wearing them to Hollywood parties, which generated a flurry of important early publicity for the young designer.

Diane's clothes had the soft, sensual feel of silk slips yet looked polished enough for a date or a job interview. Diane had seen something new

on the streets of New York, in the way women wore their miniskirts and flirty boots, their tight, skimpy shorts and long, swinging hair. She had captured the sexy exuberance in the air and reflected it back to the world in printed jersey.

The collection Diane showed at the Gotham Hotel set the tone for all that was to come: easy, flattering clothes at affordable prices. There were three basic looks: pants with tunics, floor-length dresses, and shirtdresses that tied at the waist. Most were prints, either blurry flowers on dark backgrounds or paisleys. Many of the tunics had hoods, a precursor to the hoodie, which would become an iconic garment of hip-hop culture. Everything was priced between $24 and $100, $570 in today's dollars.

The clothes sold well, and the reorder rate was high. Though Diane's business was not yet making money, she was on track to turn a profit. What's more, she had the support of Diana Vreeland, "who was really crazy about Diane's clothes and had the authority to put her on the map," says Gloria Schiff.

"I think your clothes are absolutely smashing," Vreeland wrote Diane on April 9, 1970. "I think the fabrics, the prints, the cut are all great. We hope to do something very nice for you."

To appear in *Vogue*, which at that time published two issues a month, meant instant exposure to America's most fashion-conscious women and all the nation's important retailers. In 1970 the editors suggested a date to run a picture of a Diane outfit, but she pushed for an alternative date that would better suit the schedule of deliveries from Ferretti's factory.

Grace Mirabella was stunned. "'Don't put me in *Vogue*' wasn't something we were used to hearing very often," she recalls. "In the end, Diane had to go along with what we wanted to do, but she was stern about it for a long time."

One of Diane's outfits—a long, hooded cape with a matching tunic and pants—appeared in *Vogue* on July 1, 1970, in an article titled "You're Going to Love the Way You Look in the New Fashion." Four months later, on November 1, the magazine featured one of Diane's outfits that

sold for one hundred dollars—a pale violet flowered cotton tunic with elasticized waist and cuffs over matching pants—in an article titled "More Dash Than Cash." Two weeks later Diane was in *Vogue* again. In a feature on accessories, a model wore one of her panne velvet dresses.

Around the same time, *Women's Wear Daily* anointed Diane "New York's newest designer," a key affirmation from the feisty tabloid that covered the fashion industry and from its powerful publisher, John Fairchild.

Tall, blond, and blue-eyed, Fairchild had the virile elegance of a matinee idol and, in fact, had posed for recruitment posters during a stint in the army. His polished, to-the-manner-born looks, however, belied his toughness and aggressive, scoop-obsessed journalistic style. His father, Louis, had inherited the paper from *his* father, but until John came along, *WWD* was a staid, black-and-white broadsheet that covered everything from the Paris collections to the zipper business in an earnest, colorless style.

John Fairchild changed all that. With a talent for cattiness that comes so naturally to those in Fashion, he began gleefully panning collections, breaking release dates on sketches of clothes, and reporting whatever scurrilous gossip about designers he heard. He stopped at nothing to get a story. Sometimes he disguised reporters as messengers. Other times he had them stand in the windows of buildings opposite couture houses in Paris to get the dirt on the designers' inner sanctums.

Thanks to these tactics and his cultivation of sources, often disgruntled underlings at the top houses, he had his share of fashion scoops. While *WWD*'s European bureau chief in 1957, he got ahold of Givenchy's tradition-smashing sack dress weeks before it was shown to buyers and splashed it on the publication's front page.

Fairchild reveled in his power to make or break designers and to set trends. He could be capricious and vindictive and occasionally reckless, sometimes publishing unfounded rumors as fact. But *WWD* also wrote about fashion incisively, often with literary flair and acerbic wit. Fairchild himself wrote a column posing as the fictitious Hungarian countess Lou-

ise J. Esterhazy, a name he borrowed from Comte d'Esterhazy, one of Marie-Antoinette's best friends. He made fashion provocative and new. He wrote about the intersection of fashion, the arts, politics, and society at a time when the mainstream newspapers and the business press did not cover fashion seriously and when the fashion magazines devoted themselves to puffery and fantasy.

Fairchild was largely responsible for creating the cult of the celebrity designer. He covered designers like movie stars, running pictures of them at glamorous parties and writing about their homes and love lives. But he doesn't think he or *WWD* had much impact on Diane's career, because the newspaper didn't give major play to mid-priced clothes. "We were sort of stuck in the rut of very, very, very, very High Fashion," he says today.

Still, Diane and all designers—high and low—were helped by Fairchild's elevation of fashion in the culture at large. What's more, Fairchild liked and admired Diane. "She has a lot of guts. Diane's tough but not ruthless. She's daring and naughty, and her clothes, too, had that naughty European look," he says. That didn't stop *WWD* from poking fun at her or dissing her collections from time to time. Yet, overall, the newspaper and its sister publication, the oversized monthly magazine *W,* launched in 1972, gave her positive coverage.

DIANE'S ASSORTMENT OF KNEE-LENGTH shirtdresses, pants with tunics, and floor-length dresses was one of the few fashion success stories of the 1970 season, which had virtually been ruined by John Fairchild's militant promotion of the midi—or longuette, as he dubbed it—mid-calf-length skirts, dresses, and coats.

Miniskirts were still the cornerstone of many of America's most popular dress and sportswear collections, but Fairchild was sick to death of them. Skirts had been steadily rising since the mid-sixties and by 1970 had gone about as far up the thigh as they could go. Instead of promoting practical knee-lengths, however, Fairchild decided to push the midi,

a dowdy look hitherto associated with Amish women and turn-of-the-twentieth-century suffragettes. Starting in January, in stories, gossip columns, and pictures, *WWD* had relentlessly plugged the longuette. At the time, the nation was suffering a recession. Many clothing manufacturers had gone out of business, and retailers were skittish about taking gambles on clothes that might not sell. They relied on *WWD* to tell them what women wanted, and so they stacked their racks with midis. That season Diane, too, produced a midi—in brown, blue, and red velvet— and *WWD* quoted her saying, "Longuette is the length of today."

But women adamantly rejected the length and campaigned to bring back shorter skirts. Buttons emblazoned with STOP THE MIDI began showing up on the blouses of miniskirted girls across the country. Protests erupted in several cities. In Dallas, 335 customers of the Sanger-Harris store signed a petition that read, "We object strongly to being suppressed into buying the midi exclusively. We like looking feminine and intend staying that way, even if it means shopping elsewhere."

The midi debacle illustrated an important new trend. Women were dressing to please themselves; the old arbiters of taste had lost their clout.

ALEXANDRE WAS BARELY SIX MONTHS old when Diane found herself pregnant again. She didn't let her condition slow her down. Mimmo Ferretti remembers Diane showing up at the factories in Como and Montevarchi hugely pregnant. "Diane totally charmed the workers, who called her 'La Furstenberg,'" he says. "They'd do anything for her— rush orders, last-minute orders. Obviously, it was in Diane's interest to charm them, but that's the way she was."

Diane's baby was due in February 1971. Her gynecologist had advised her to have another cesarean "because I had hardly healed from the last," she wrote. "He gave me a two-week window, and I chose February 16." One and six added up to seven, which she considered her lucky number. February also happened to fit nicely into Diane's shipping schedule. On that day she delivered a perfect little girl, whom she named Tatiana. Her

friends in Fashion thought the names of her children honored Alexander Liberman, the powerful Condé Nast editorial director, and his stylish wife, Tatiana du Plessix, whom Diane regarded "like parents." But Diane says that's not true. "I just liked the names, though I used to joke that if I had a third child, I'd call it Liberman."

At the same time she launched her business and gave birth to her children, Diane also oversaw the renovation of an apartment at 1050 Park Avenue, an elegant 1923 building. Diane combined two units on the third floor to create one large home and hired Parisian decorator Pierre Scapula to design a stylish setting for happiness. Until the renovation was complete, Egon and Diane lived on the twelfth floor, while Tatiana and Alexandre lived with their nanny in the smaller, third-floor unit, which sparked some disapproving comments in the press that the von Furstenbergs were indifferent parents.

Entering the apartment felt like stepping into the foyer of Scheherazade's lair, with the walls and ceiling curtained into a pleat-roofed tent in a dizzyingly patterned red Javanese print. (It was also reminiscent of Diana Vreeland's famous "garden-in-hell" red salon several blocks away at 550 Park Avenue.)

The décor rejected the "tous les Louis" interiors Diane had seen in Europe's best homes—there wasn't one Marie-Antoinette clock or regency commode. The living room had red lacquered walls and cushy banquettes covered in deep-pile velvet. Paintings by Josef Albers, Hans Hofmann, and Larry Rivers adorned the walls. Atop tables sat Fabergé boxes made from quartz, coral, rubies, and enamels. Navy blue straw blanketed the walls in the bedroom, and nine tone-on-tone paintings by Richard Anuszkiewicz, a founder of op art, zigzagged on a wall over the bed. A vicuña throw covered the bed itself, where every morning at eight the couple ate breakfast from trays brought in by an Italian maid, the papers spread out in front of them. Off the bedroom, a mirrored alcove held a writing table, a silkscreen print of Marilyn Monroe, and a huge white leather beanbag chair.

Like Diane, the apartment had the veneer of high sophistication. It was designed to seduce, and Diane used it, as she used her beauty, her exotic accent, her title, and her clothes, to bewitch and bedazzle. The social world that Diane entered as Egon's fiancée opened wide to her as his wife. Prince and Princess von Furstenberg had at least four invitations every night, and their own parties drew the top people from New York society, media, culture, and fashion.

Though only twenty-three in 1970, Diane seemed older and intimidated many of her peers. Bob Colacello, the editor of Andy Warhol's *Interview,* recalls "being kind of frightened of Diane for a long time. She seemed overwhelming to me, and so seductive. She was like a golden asp or something. She seemed sophisticated to the point of being jaded, and a lot of that was Egon. I think she felt she had to make herself very sophisticated to fit into Egon's world."

In her quest to know everyone who was anyone, Diane had little time for little people. "As *Interview* started to become a more viable publication, and as she started to think that maybe I had something, we became friendly," recalls Colacello. "And I started to see that side of her that's more earth mother than Weimar Republic cabaret singer."

"I got the feeling that she'd singled me out," says Jann Wenner, the founder and pubisher of *Rolling Stone.* "She thought, 'Oh, he's an interesting guy, and he's doing something really important and valuable.' Diane loves that—important people, powerful people doing big things. She gave me a book called *The 100 Most Important People,* or some such thing, inscribed with a message to the effect that I should aspire to this group, that this was my destiny. Of course, I was flattered."

The von Furstenbergs' parties were legendary for the relaxed atmosphere, the abundant food, and the exciting mix of people. "They invited whoever was happening, whoever was intellectually stimulating," says Howard Rosenman. Guests ranged from Diana Ross and Halston to Susan Sontag, Henry Kissinger, Mick Jagger, and Christina Onassis. It was as "up there," in Warhol's phrase, as it got. Many guests were high in

another sense—alcohol flowed, and drugs were consumed freely in the apartment's back rooms.

"We were smoking pot, taking a little coke, or not so little," recalls Colacello. "We drew the line at heroin. Coke was not seen as self-destructive. It let you drink more and stay up later."

Thousands of miles away, the Vietnam War raged and the death toll soared. No one at the von Furstenbergs' parties was destined to die in combat in Southeast Asia, though some would eventually lose their horrific battles with drugs and AIDS.

The fashion crowd in general opposed the war and the presidency of Richard Nixon, who took office in January 1969, "but it was a group that cared more about style and beauty and fun and pleasure than it did about politics," says Colacello.

When Fashion did intersect with politics, it tended to be in frivolous ways. In the late sixties, at the height of the Age of Radical Chic, Diane's friend Valentino did a floor-length trapeze dress in jade silk printed with ferocious, rhinestone-eyed black panthers—the hipster designer's sly salute to the Black Panther Party. "It was an amazing dress," says one wearer, Chicagoan Helen Harvey Mills, who got hers at Marshall Field's 28 Shop. "But I never would have worn it if I thought I was making a political statement."

THROUGHOUT THE VON FURSTENBERGS' MARRIAGE, Egon led a separate life in the city's gay bathhouses and backroom bars of the far West Village. Diane knew about his gay activities and tried to accept it. "Egon was never really gay," she says. "He was bisexual. He was promiscuous, and not just with men." In the world he'd grown up in, sexual fidelity was for the dull and ordinary, the bourgeois. "Only maids are in love," Egon's uncle Gianni Agnelli told his sister Susanna, when she was pining for her absent boyfriend. Love was something for "cheap magazines."

One Sunday morning Mart Crowley, whose hit play, *The Boys in the*

Band, was enjoying a long off-Broadway run, took Howard Rosenman to meet the von Furstenbergs at a brunch at their apartment. Rosenman was astounded to see that one of the hosts was the handsome blond man he'd partied with the night before at the Continental Baths, where men socialized wearing nothing but little white towels. Egon and Rosenman "looked at each other and burst out laughing," Rosenman recalls.

Egon introduced himself to Rosenman, then turned to Diane and said, "This is the guy I was telling you about."

Diane's need to be independent was deeper and stronger than her need for fidelity; it was almost a physical requirement, like breathing. The open marriage she shared with Egon allowed her to maintain her cherished independence. It also fed her sense of self as a naughty siren. She had affairs, too.

John Richardson puts a more calculating spin on Diane's acceptance of Egon's gay affairs. "Egon had an aristocratic circle and a New York social circle, and he also had a big gay circle. That's where Diane was very clever in taking advantage. It probably helped her [career] enormously; the gay community is rather involved in the fashion world. And Egon was so popular. Everyone who met him liked him. He was an incredibly nice man with beautiful manners," Richardson says.

Diane, on the other hand, in the minds of the New York social elite, "was slightly taken as a joke at first," says Richardson. "She wasn't exactly princess material." In part that was because she was Jewish; in part it was because of her bourgeois Brussels background; and in part it reflected her raging ambition, which was seen as unseemly to those who'd been to the manor born. She was a climber, "passionately interested in her own glory," Richardson continues.

Nevertheless, the society connections were a great boost to Diane's fledgling business, as they have been for designers throughout history. Coco Chanel used her aristocratic lovers and famous friends, including Jean Cocteau, the arts patron Misia Sert, and Sergey Diaghilev of the Ballets Russes, to build her business. The turn-of-the-twentieth-century

couturier Paul Poiret, who is generally credited with ridding women of disfiguring S-shaped corsets, threw over-the-top parties attended by the gratin of Paris, and won reverent coverage in the press. Going further back, to eighteenth-century France and the birth of couture, dressmaker Rose Bertin grew rich thanks to the patronage of her most famous client, Marie-Antoinette.

Equally important to Diane's ambitions were a group of designers she met during her first years in New York: Giorgio di Sant'Angelo, Stephen Burrows, Bill Blass, Oscar de la Renta, and Halston. Not only were they at the forefront of a fashion revolution resulting in a distinctly American style of dressing, they were also becoming celebrities themselves. In New York in the seventies, they were the pilot fish of sex and glamour and a new kind of fame that was available to all, even if it lasted for only fifteen minutes.

New York served as ground zero for the action, though the cash-strapped city was scarred by graffiti and filth and wounded by poverty and crime. At the same time, a glitter of fresh ideas swirled up. Downtown, the new genre of performance art, blending theater, dance, music, and visual art, allowed artists to create in real time before an audience. Uptown, *Saturday Night Live,* produced by Lorne Michaels at NBC Studios in Rockefeller Center, forged a new kind of ensemble-based television. Abstract expressionists, pop artists, rock musicians, independent filmmakers, and New Journalists, writing in a novelistic style, thrived in New York's hothouse of innovation. In Fashion, much of the creativity blazed from gay culture, which only recently had come into its own following a long suppression. Most of the celebrated male designers were gay, as were large numbers of the support staff of the fashion industry.

LIKE HIGH SCHOOL, NEW YORK fashion nurtured a top clique—a group of insiders who ruled as the arbiters and stars of cool. This is what Bob Colacello called the New Seventies Society. It included

designers—Halston, Diane, Giorgio di Sant'Angelo, Oscar de la Renta, Fernando Sanchez, Calvin Klein, Stephen Burrows; pretty young women, including Bianca Jagger, Anjelica Huston, Elsa Peretti, Marisa Berenson, and her sister, Berry Berenson; and celebrities from music, film, and publishing—Mick Jagger, Diana Ross, Jack Nicholson, and Truman Capote.

Diana Vreeland, who'd become a consultant at the Metropolitan Museum of Art's Costume Institute after being ousted from the editorship of *Vogue* in 1971, was queen and Halston was king.

Born Roy Halston Frowick to a middle-class family in Des Moines, Iowa, in 1932, Halston grew up to be a strapping six-footer, slender and handsome with chiseled cheekbones, a full head of sandy hair, limpid green eyes, and a soft, girlish mouth. He got his start, like Coco Chanel and Rose Bertin, making hats, and in the mid-sixties he turned to fashion, designing small collections for Bergdorf Goodman. In 1968 he opened his own atelier at 33 East Sixty-Eighth Street, overlooking Madison Avenue, and for his first collection he showed twenty-five simple outfits in jersey, wool, and Ultrasuede. The next morning at nine thirty, Babe Paley, the brightest jewel of the Beautiful People—BPs in *WWD* parlance—was waiting at his front door to order an argyle pantsuit. Halston was launched.

In the seventies he blossomed into a pop culture superstar. During the day, dressed in a black turtleneck and narrowly cut trousers, a cigarette held vertically aloft in his long fingers, Halston worked at his red lacquered desk, surrounded by pots of orchids. At night he went out to clubs and parties with the Halstonettes, his entourage of models in identical Halston outfits. He attended opening nights with Liz Taylor and binged on scotch with Liza Minnelli at the Pines on Fire Island. He was a bold-faced name in the nation's gossip columns, the subject of *New Yorker* cartoons and Top Ten songs.

The public did not see the dark side that Diane knew close up—the

cocaine addiction and the endless parade of male prostitutes he ordered up to his room at night. His behavior distressed Diane, who greatly admired Halston's talent.

Diane and Egon were regulars at Halston's parties in his coldly stark modern house on East Sixty-Third Street. The cathedral ceilings, floating staircases, and gray flannel seating platforms provided the background for evenings of free-flowing drugs. Fashion insiders, pretty girls, celebrities, and hustlers mingled with grand dames, including Martha Graham, who enjoyed Halston's patronage, and Betty Ford.

The von Furstenbergs often ended up at Halston's house after an evening that started, say, by socializing with the old guard at an uptown charity event, then moved to partying downtown with the hipsters at a club like Max's Kansas City, a favorite of rocker Patti Smith, who'd arrived in New York around the same time as Diane.

The von Furstenbergs had the looks, money, style, and decadence to rise to the top. Soon they were the most talked-about couple in New York. Diane dressed to be noticed and photographed—during the day in Saint Laurent skirts and blazers, hippie-chic dresses from Ossie Clark, and romantic crushed-velvet pants and ruffled shirts by Jean Bouquin, the French designer who epitomized Saint-Tropez cool. At night, she dazzled wearing dresses in diaphanous fabrics with plunging necklines and armholes that showed a good deal of her breasts. She liked to reveal them, posing topless occasionally, once for Francesco Scavullo for the cover of *Town & Country*, though the picture, with a clothed Egon, was cropped to show only her sculpted shoulders and chunky David Webb necklace.

Nudity was "an important part of the seventies. From 1969 to 1980, everything—art, music, literature, politics and (as we know now from lawsuits against the Catholic Church) religion—involved people taking their clothes off," wrote humorist P. J. O'Rourke in his foreword to *New York in the 70s*, a collection of photographs assembled by Allan Tannenbaum, photo editor of the now defunct *SoHo Weekly News*.

As Tannenbaum's photos attest, public nudity was glorified, an expression of the unbridled sexuality that pulsed through pop culture. It could be found at private parties and downtown clubs, at political demonstrations and performance-art installations. The New York cable show *Ugly George* provided one of its strangest expressions. Tricked out with zany video gear, a man calling himself Ugly George prowled the city streets, accosting young women and asking them to expose their breasts for his camera. A surprising number of women agreed to follow Ugly George to secluded spots in alleys and doorways, and sometimes even returned with him to his apartment.

THE VON FURSTENBERGS TRAVELED OFTEN, following the seasons with other migratory jet-setters, from New York to Saint-Moritz to Cortina to Sardinia to São Paulo and back. The press alternately ridiculed and fawned over Diane as a "princess," but mostly fawned. At the time, the title had a certain cachet. These were the glory days of "international white trash," a phrase coined by writer Anthony Haden-Guest to describe the hordes of hard-partying, hard-spending Europeans, many with dubious aristocratic titles, who washed up on the shores of Manhattan. They were fleeing the stuffiness of old European society, unstable economies, high taxes, and kidnappings. "I didn't have to carry a gun in New York like I did in Italy," says Mimmo Ferretti, who worried that his family money made him a target for kidnappers.

In New York, the up-all-night, no-job-to-go-to Europeans—good-looking, sophisticated, and gorgeously dressed—found freedom, excitement, and acceptance. They were sought-after guests at fashionable dinners, parties, restaurants, and clubs. The Europeans gave New Yorkers an excuse to admire old world glamour and status and, as the revolutionary spirit of the sixties waned, made it "all right to be stylish and irresponsible again," as Bob Colacello wrote.

Most of the reporters who covered Diane's first fashion opening, in April 1970, focused on her link to European royalty. A *New York*

Times piece in which Bernadine Morris, the paper's chief fashion writer, referred to Diane as "the Princess" was typical. Other journalists emphasized her status as a society star. In her *New York Post* column, Eugenia Sheppard, for example, described the parties Diane and Egon had recently attended and didn't even mention Diane's collection until the third paragraph.

The stories reflected a fundamental fact: *Diane* was the product. Her most "brilliant invention was herself," says John Richardson. "That's what she's all about." Diane re-created herself as a beautiful, on-top-of-the-world princess, and this, combined with her natural "style and charm and charisma," as Macy's chief, Terry J. Lundgren, put it, was what drew people to her and her brand.

"I did make it all up," Diane says. "But I'm not an imposter!" The invention comported with her deepest sense of self, of the strength, discipline, confidence, courage, and sophistication she strove to achieve.

"I remember when we first started, when Bloomingdale's first bought Diane's dresses," recalls Francine Boyar, Diane's house model in the seventies. The store "took out a full-page ad in the *New York Times* and told Diane she had to be in the picture in one of her dresses and she had to come to Bloomingdale's because the customers wanted to meet the princess."

The myriad images of Diane in the media reinforced the idea of her as sexy, beautiful, glamorous, and successful. By association, these qualities attached to her clothes. Though the designer herself still suffered bouts of gnawing insecurity, she imparted a veneer of glowing confidence to the public. Diane gave women permission to wear color, prints, and clingy fabrics, which they otherwise might not have had the courage to don.

"It's all about archetypes," says Stefani Greenfield, creative brand director of DVF Studio. Wearing Diane's clothes made women feel more like their image of Diane, "more powerful and confident," Greenfield says.

From the start, Diane was selling much more than clothes. She was selling an idea of womanhood that joined feminist ideals of independence and achievement to old world notions about sex and femininity.

In an era when college girls who wore lipstick were stigmatized on some campuses for colluding with male oppressors and professional women were urged to tamp down their sexuality by wearing masculine suits, Diane broke the rules about how a liberated woman should behave. She vamped into meetings in teetering high heels, fishnets, sexy dresses, and full makeup, speaking in a vaguely French accent with a whiff of Euro decadence that gave her the allure of a foreign femme fatale.

She enjoyed whipping off her shirt for photographers. (*WWD* ran the full topless picture from Diane's *Town & Country* cover shoot, noting that the magazine perhaps "disappointed" readers by printing a cropped version.) To a ball in Dallas around the same time, Diane wore a floor-length Capucci dress with two suspender-like straps that barely covered her breasts. She so entranced the Texas oilman sitting next to her at dinner that his furious wife demanded to talk to Diane in the ladies' room. "I think she was going to beat me up or something," Diane told *Newsweek*. (Today she has no memory of the incident or how she managed to avoid the confrontation.)

Her disco diva exhibitionism often cast Diane in a frivolous light. Yet her entrepreneurial verve was grounded in a serious feminist conviction: Women should find fulfilling work that enabled them to support themselves.

That principle has been a cornerstone of feminist thought since Charlotte Perkins Gilman published her groundbreaking study *Women and Economics* in 1898. "Nothing makes a woman feel more insecure than being trapped, doing something because she has no alternative," Diane wrote in her 1977 *Book of Beauty*. "I believe that to be happy with a man you have to know that you could leave him and take care of yourself. To stay with him because he pays the bills and supports you financially and because you don't feel that you could take care of yourself is a form of slow death."

Diane understood that most women wanted it all—career, love, marriage, children—and despite any feminist anger they might have toward

the patriarchal forces that held them back, they yearned to look pretty and attractive to the opposite sex. This was the chief tension in Diane's life—achieving the independence and power of a man while remaining a feminine woman.

DIANE HAD BEEN IN BUSINESS for barely a year when she realized she'd been operating in an amateurish manner on luck, connections, and Ferretti's credit. Her business had started to build, but with only twenty accounts, her volume was still too tiny for the big Seventh Avenue firms. What's more, her shipments from Ferretti were reliably late. No one took her seriously. "They thought I was another one of those social girls who pretends she wants to work," she recalled.

She began to think the best thing would be to join a firm as a house designer and leave the business details to others. After being turned down by two manufacturers—Jonathan Logan and David Crystal—whom she'd approached about joining their firms as a division, she talked to Johnny Pomerantz, CEO and son of the founder of Leslie Fay, a major apparel conglomerate.

Pomerantz, who met with Diane early in 1971, advised her to stay in business for herself but to get a partner who knew the inner workings of Seventh Avenue and could help her develop the infrastructure of a real fashion house. "I liked Diane's clothes, but mostly I liked her," says Pomerantz, who met Diane at her makeshift showroom at the Gotham Hotel. "I thought she was a special person. She was exciting. Ambitious." He also sensed they had much in common. "I saw a book on her shelf about being Jewish, and I'm Jewish."

It was almost a professional qualification. Most of the manufacturers who ruled Seventh Avenue were Jewish, the children and grandchildren of immigrants who'd arrived in New York at the end of the nineteenth century. In those days, the nation's power elites were dominated by New England, Wall Street, and Chicago WASPs. But on Seventh Avenue

there were no quotas, no social, religious, or educational barriers to impede smart entrepreneurs.

Jews were naturals for the rag trade. Because their land had been confiscated over the centuries by the rulers of Europe and Russia, Jews had been pushed into becoming bankers, peddlers, and tailors. Their survival depended on discerning the needs and appetites of the larger culture. An instinct for what would sell accelerated their success on Seventh Avenue, as it would in Hollywood, where Jews also became the captains of the town industry.

By the turn of the twentieth century, 60 percent of all Jews employed in New York worked in the garment industry. Clothes were a way not only to put food on the table but also to reinvent yourself. Levi Strauss's blue jeans of 1873 were the first Jewish success story in American fashion, followed by the post–World War II moguls who became spectacularly rich and, a generation later, by the design stars Calvin, Donna, Ralph, and DVF.

Pomerantz recognized in Diane the kind of coarse strength essential for Seventh Avenue success epitomized by his father, Fred. When Johnny started out as a salesman for Leslie Fay, he handled fifteen styles, and his father forbade him from taking an order unless the buyer bought every style he offered. One day, Pomerantz recalls, "the buyer for Bloomingdale's came to the showroom and gave me an order for fourteen styles, a bigger order than I'd ever seen in my life. But I told her I couldn't take it until I checked with my father."

"Tell her to go fuck herself," Fred Pomerantz told his son.

"You're not going to like this," Johnny told the buyer before repeating his father's words. She ended up taking the fifteenth style—Pomerantz still remembers it was number 2118. "And after that she became my best customer," he says.

Diane decided to take Pomerantz's advice, and to help her set up a new company, Pomerantz introduced her to Richard Conrad, manag-

ing director of Laurence Gross Ltd., which made clothes in the "young designer" category. At thirty-nine, the tall, bespectacled Conrad "seemed so old," Diane recalls, but he knew his way around Seventh Avenue, and she needed his expertise and connections. A graduate of Rutgers University, Conrad had worked his way up in the rag trade, starting as an order picker, and he learned the business from one of its masters, Henry Rosenfeld, who'd made his first million before age thirty-five and was head of an eponymous business on Seventh Avenue.

On a thoroughfare of slick operators, Rosenfeld was one of the slickest. He'd grown rich by offering copies of expensive dresses—"class" in Seventh Avenue parlance—at "mass" prices. This simple formula earned him a chauffeur-driven Cadillac, a summer house in Atlantic Beach, an airplane, a boat, twenty-five pairs of solid-gold cuff links, and, despite his balding, undistinguished appearance and lack of education—he hadn't read a book since dropping out of high school—an affair with the world's most desirable woman, Marilyn Monroe.

Rosenfeld, who had a wife and two daughters, met Monroe through his racetrack buddy Milton Greene, a *Look* magazine photographer who became the star's manager.

Rosenfeld paid Monroe's bills at the Waldorf Astoria, where she stayed in New York in the early fifties before her marriage to Arthur Miller.

The dazzling star often came to Rosenfeld's showroom, which was decorated like the nightclub El Morocco with zebra-striped upholstery, electric-blue walls, and palm trees with cellophane leaves. While he was working for Rosenfeld, one of Conrad's jobs was to serve Monroe. "Henry would say, 'Dick, do me a favor, take Miss Monroe into the stockroom and let her try on anything she wants. But don't touch her!'"

Rosenfeld's most popular model during Conrad's tenure was a collared Arnel-and-cotton shirtdress with a sash belt that sold wholesale for $8.95. "We had it in four colors. Henry ordered a million yards of fabric, and he told his salesmen on the road to offer the stores just that one item.

That important lesson fit very neatly into the Diane situation, when the opportunity arose to have one sensational dress," says Conrad.

He had been following Diane's progress in *WWD*. He was curious about her and her clothes, and he agreed to meet her at her suite in the Gotham Hotel. During their meeting, Diane pulled off her shirt and, braless, tried on a couple of sweaters for Conrad's reaction. Then she gave him two shirts she'd had made for him in Ferretti's fabric, so he could experience how wonderful it felt against the skin. "I wore them on the weekends, and I felt a little funny because they weren't exactly manly prints. But I got her message about the importance of the relationship between fabric and body," Conrad says.

Before Diane would sign a contract with Conrad, she insisted he meet Egon. Throughout her career, she kept the practice up—having family members vet key employees. "He took me to a fondue restaurant on Fifty-Sixth Street to check me out," says Conrad. "He was very good-looking, very pleasant."

Having passed the Egon test, Conrad signed a contract with Diane at the end of December 1971. Soon afterward, Diane went to Italy to oversee production of her next collection. "I'm making beautiful things and rushing around, doing 1,000 things at once," she wrote her new partner. "So happy we are going to be the best team on Seventh Avenue."

Diane could pay Conrad only a modest salary—according to her, $300 a week, but she offered him a 25 percent stake in her company. "We put together an operating plan of what the first line was going to be. We were going to make or break it on the first line because we didn't have the capital to get to the second line," Conrad recalls.

Diane's father had given her eighty thousand dollars as a wedding present, but she'd spent it. She had only Ferretti's credit and ten thousand dollars from a diamond ring she had pawned. (The ring had been a present from her father and Egon to celebrate Tatiana's birth, and she later bought it back, paying a huge interest.) The new partners started work on

April 1, 1972. "The first thing we did," Conrad says, "was get the hell out of Fifty-Sixth Street and onto Seventh Avenue."

Since the early 1800s, Manhattan's Lower East Side had been the center of clothing manufacturing, providing garments for workers on farms in the North and slaves on southern plantations and, later, uniforms for soldiers of both sides fighting the Civil War.

As the demand for ready-to-wear apparel surged with industrialization, the Garment District was pushed toward Midtown, settling into a neighborhood bordered by Forty-Second Street on the north, Thirty-Fourth Street on the south, Fifth Avenue on the east, and Ninth Avenue on the west. Seventh Avenue ran through the center of the district, "a place of Dreiserian amounts of soot and lint, crammed with hamburger dives, cigar shops, dress rack operators, models, and fabric salesmen, and controlled by manufacturers who'd arrive in their chauffeured Packards and Cadillacs," Bill Blass wrote.

The luxury showrooms of these rich manufacturers symbolized the power of fashion in New York's economy. Still, the inspiration, the lifeblood of Seventh Avenue remained Paris. In France, designers were Leonardo da Vincis of cloth and thread, whose reputations were built on vision and tradition. At the Burgundian court of Philippe Le Bel, the king of France from 1285 to his death in 1314, for the first time in history women began changing their clothes to showcase their status, taste, and wealth, not because the weather changed or their garments wore out. In the seventeenth century, Louis XIV created a standard of luxury dressing that demanded rules and endless reinvention. In response, a fashion industry bloomed in Paris to satisfy the lust for the latest finery worn at Louis's court. The craving soon spread throughout Europe and beyond.

In the nineteenth century, during France's Second Empire, Charles Frederick Worth set up shop on the rue de la Paix and ushered in haute couture with its rigid hierarchies and elite cabals. In the twentieth century, Paris designers became world-famous celebrities, the names Chanel,

Lanvin, Balenciaga, Patou, and Dior heralded from the pages of *Vogue* and *Harper's Bazaar* and the women's pages of US newspapers.

In contrast to France, American fashion had always been aligned more with commerce than with art. With a few exceptions, labels on even the highest-end fashion contained only the names of the manufacturers. For years, the *New York Times* had a strictly enforced policy of not publishing the names of designers, instead only mentioning those of the companies for which they worked. In the American fashion magazines *Vogue* and *Harper's Bazaar*, neither the editorial features nor the ads provided the names of American designers. These local fashion leaders labored in obscurity in the back rooms of Seventh Avenue, keeping their heads down, "grateful" to be given a chance to knock off seventy-nine-dollar copies of Dior dresses, as Bill Blass noted.

Twice a year, with almost religious devotion, American buyers, manufacturers, designers, and journalists made the pilgrimage to Paris to witness the city's couture openings. What they saw determined the silhouette, colors, skirt lengths, and accessories for the next season. American women, too, were hooked on French clothes, either the real things or knockoffs.

That began to change during World War II and the Nazi occupation of Paris, when suddenly America was totally cut off from France. New York's garment unions, clothing manufacturers, and department store executives feared that the US business would collapse. To stave off disaster, they formed the New York Dress Institute and made a historic agreement to launch a national promotional campaign. They set up a contract stipulating that one half of 1 percent of the cost of every union dress would go into a fund that would be used for advertising American clothes. They also hired the public relations maven Eleanor Lambert, the daughter of an advance man for Barnum & Bailey's circus, who thought New York designers could be promoted like French couturiers.

Lambert told New York's manufacturing and store executives to figure out who were their most creative designers. The business execu-

tives chose eleven, including Norman Norell, Hattie Carnegie, Bonnie Cashin, Claire McCardell, and Mainbocher, the Chicago-born French couturier who'd recently fled Paris for New York. Lambert called them the Couture Group, and to publicize them she came up with three ideas that became fashion traditions: the Best Dressed List, which endures today under the auspices of *Vanity Fair*; Press Week, the forerunner of today's biannual Fashion Weeks; and the Coty Awards, the precursor of awards now handed out by the Council of Fashion Designers of America.

Paris couture never fully recovered its status and luster after World War II. The old French way of structuring clothes had definitely ended. Fashion now depended on the gracefulness and fitness of the body moving beneath the fabric, rather than couture's way of correcting, buttressing, and harnessing the female form. Fashion also was becoming more democratic. Modern life chipped away at the idea of "perfect" dressing, of one standard, one ideal, and Paris was losing its grip as the be-all of style. Fashion no longer was seen as a rare luxury conferred by a few stars like Coco Chanel. In 1970, the eighty-seven-year-old designer was still going to work in her Paris atelier. But Chanel was dying and so was the couture she represented—though even if Tim Gunn of *Project Runway* fame put a stake through its heart, couture wouldn't disappear entirely.

Meanwhile, New York designers were perfecting a style of dressing that would soon define how the world wanted to look: casual, comfortable, and easily stylish. The milestone marking the American ascendance came at a legendary fashion show at Versailles on November 28, 1973. Cooked up by Eleanor Lambert, the show was held as a fundraiser for the palace of Versailles, but Lambert's intent was more mercenary—to bring attention to American designers. The organizers staged the event in the extravagantly gilded Opéra, where in 1770 the future King Louis XVI had married Marie-Antoinette, history's enduring symbol of the calamity that can befall a fashionista who spends too lavishly on her wardrobe.

The event was staged as a fashion show preceded by entertainments,

with Liza Minnelli performing for the Americans and Josephine Baker performing for the French. The fashion segments pitted five Parisian couturiers—Marc Bohan of Christian Dior, Hubert Givenchy, Pierre Cardin, Yves Saint Laurent, and Emanuel Ungaro—against five stars of New York ready-to-wear—Bill Blass, Stephen Burrows, Anne Klein, Halston, and Oscar de la Renta. Until then, the idea of American designers showing in Paris "had been completely unheard-of because the French scoffed at anything we did. They thought all we were good for was copying *them*," says Burrows.

The show also broke ground by showcasing Burrows, an African American designer, and by featuring eleven gorgeous African American models, the first time black models had been paraded so prominently on a Paris runway.

Though there was no official scoring, by all accounts the New Yorkers won. The American clothes dazzled with freshness and vitality: Halston's cashmere sweater dresses, Burrows's brightly colored lettuce-hemmed skirts, Blass's sophisticated flannel pants, Klein's easy, go-to-work separates, de la Renta's flowing chiffon gowns. Such clothes proved that great style didn't have to be couture. This was the essence of American fashion—simple, informal separates that could be mixed according to the wearer's own style and not the dictates of some imperious designer. In contrast, the elaborate gowns, fitted suits, and structured day dresses shown by the French looked stiff and old. The poker-faced French models, walking carefully and erectly across the stage in the manner of a traditional defilé, as classical music played, looked rigid and dull, compared with the American girls, who, smiling broadly, vogued to tunes by pop artists such as Barry White.

At the end of the Americans' presentation, the French citizens in the audience jumped to their feet, cheering and throwing their programs into the air. "We killed," says Burrows.

The Versailles show has been hailed as a turning point in fashion, the first time in three hundred years that the world stopped looking to

France for inspiration. Actually, the shift had been going on since World War II, though Versailles marked a moment of acceleration. The next years would see a different direction in fashion, when New York ready-to-wear would set style standards across the globe. Manhattan became a sequined dreamscape of creativity and ambition, as journalists, hairdressers, photographers, models, makeup artists, designers, and their hangers-on swarmed to the city.

The stage was set for the rise of DVF.

No Zip, No Buttons

*T*he offices of Diane von Furstenberg sat on the fifth floor of 530 Seventh Avenue, a thirty-two-story art deco tower ornamented in brass as rich as the buttons on a Chanel suit. In a block filled with towers of fashion, 530 was the biggest, tallest, and most prestigious, a beacon of commercial optimism for the better dress trade on a street prone to busts. Since its blue-ribbon-and-champagne opening soon after the stock market crash in 1929, there had never been a time when every square foot of the building wasn't leased.

It was a lucky building, and luck was what Diane needed most. Of the seven thousand or so firms crowded into the aging buildings of the Garment District, one fifth disappeared each year, casualties of the ruthless competition that has always characterized fashion. Some would be reborn under new names with new partners; others would be gone forever.

In 1972, Seventh Avenue was still designing more than 90 percent of clothes bought by Americans, and the Garment Center was still New York's largest employer. It also provided the city's most promising dream factory, a place where smart, ambitious entrepreneurs could literally go

from rags to riches. Get a run of luck and you can make fabulous money, one manufacturer told *New Yorker* writer Lillian Ross. "All you need in this business is one good dress."

But by the early seventies, Garment Center jobs had declined by nearly half, to 160,000 from a peak in 1947 of 350,000. Some of the jobs had been lost to Newark and southern Westchester County, where they were filled by low-wage black and Hispanic workers. Others had moved south, though International Ladies' Garment Workers' Union (ILGWU) agreements limited Seventh Avenue firms from relocating to southern states.

The job decline threatened a complex ecosystem that was a vital cultural force, a breeding ground for innovation and talent. As Diane later told Guy Trebay of the *New York Times,* the city's fashion primacy relied on "beehives" of small-scale manufacturing on Seventh Avenue.

A centralized, compact garment district, as Trebay wrote, made it possible for aspiring unknowns "to design and sew a garment at home, and then, with luck and an initial order from, say, Bergdorf Goodman, to take that sample to [a garment district] building and have a pattern made, graded for size, the fabric rolled in from a nearby wholesaler, the pieces cut and assembled and the finished product shipped without leaving a single block in the center of Midtown."

Though Diane's clothes were made in Italy, she believed her creativity was fed by the hothouse of ideas and energy on Seventh Avenue. Every morning before ten she took a taxi to her office, often dressed in jeans, since she frequently spent part of her day helping out in the shipping room. She loved being in her office in the morning, sharing a grapefruit with Dick Conrad and drinking coffee while the harsh cries of the workers and the clattering of clothes racks rose up from the street. Over the brown walls she'd hung colorful Andy Warhol flower posters, and she'd filled the offices with inexpensive desks and tables from the Door Store. This was where she belonged; everything about it felt right, like coming home to her parents. While Conrad entertained and cajoled buyers in the

firm's little showroom—with Diane sometimes serving coffee incognito and eavesdropping on the conversations—Diane worked the phones in her office, calling socialite friends such as Marion Javits, Nan Kempner, and Mrs. Richard Berlin, wife of the owner of *Town & Country,* "to create some buzz" for her clothes, Conrad says. Later, she'd drop off dresses at their homes, hoping they'd wear them to prominent social events and be photographed in them.

Diane and Conrad started with just two employees—a Haitian receptionist and a Trinidadian woman named Olive who sent out orders from the stockroom. Olive would sometimes work with Conrad until 1 A.M. to get all the orders out to the stores. The labels on the clothes read "Diane Von Furstenberg, Made in Italy." (She didn't lowercase the *V* in her name until 1999.) The initialism "DVF" would not appear on anything designed by Diane until 1975 when she first stamped it on sunglasses marketed under her name. (She'd used it earlier on her personal stationery.) "DVF" became her trademark, though it would not be widely employed in Diane's publicity, either by her or those writing about her, until her comeback in the late nineties. The launch of her website, dvf.com, in 1999 accelerated the media's adoption of "DVF" when referring to Diane and her fashion business.

However, the *idea* of DVF and, specifically, the DVF Woman—strong, independent, on-the-go, and sexy—had existed in Diane's mind since she'd first dreamed of a career. "That woman stayed with her through all her design years, and continued to grow up with Diane," says Kathy Van Ness, a fashion and luxury executive who worked for Diane in the eighties. The DVF Woman was Diane's self-image *and* her customer profile. "She was someone who would look great and be confident all the time, anywhere," continues Van Ness. "As time went on," and the place of women in American culture became more assured, "Diane's customers became more sophisticated and more powerful and the DVF Woman evolved."

Diane's first shipment of clothes under her partnership with Conrad arrived from Ferretti's factory in June 1972. A fifteen-thousand-dollar

duty tax was owed, "but we didn't have the money to pay it," Conrad recalls. He took the Pan Am freight agent out to lunch and asked him if he'd release the dresses on credit, something that had never been done before. "I promised to pay him in forty-five days when the stores paid *us,* and he went for it," says Conrad. "But that's how close we were to being on the edge."

To the immense relief of the new partners, the clothes sold well. Soon they were able to hire a secretary, three saleswomen, and a house model. Diane also hired a young designer, Sue Feinberg, to oversee production at Ferretti's Montevarchi factory. A graduate of the Rhode Island School of Design, Feinberg had studied couture technique at the L'Ecole de la Chambre Syndicale in Paris. During college summers she'd interned for Bill Blass, and while working for the Italian couturierè Simonetta and her husband, Fabiani, Feinberg had become fluent in French and Italian. Back in New York (she'd grown up in the town of Rye) in 1972, she'd heard about Diane and went to see her. Diane looked at Feinberg's port- folio, then asked her astrological sign. "Libra," answered Feinberg.

"Oh, that's good. I have a close friend who's a Libra," said Diane.

Her faith in astrology and her New Age flirtation with parapsychol- ogy often exposed Diane to ridicule. In the early seventies it reinforced perceptions of her as a flaky dilettante. Diane's attitude, though, echoed beliefs held by many designers—a professional group whose success depended on a seer-like talent for divining the desires of women. Paul Poiret hired a clairvoyant to advise him on lucky and unlucky colors. Christian Dior filled his pockets with lucky charms, frequently consulted fortune-tellers, and until his death regularly employed an astrologer who charted his horoscope. Coco Chanel considered 5 her lucky number. She always scheduled her fashion openings on the fifth day of February and August, and in 1921 she named her signature perfume Chanel No. 5.

Diane's mother also was in the habit of consulting psychics and fortune-tellers. Long before the war and her own marriage, a psychic told Lily that someday "she'd have a famous daughter," says Diane.

The designer once told an interviewer that in an earlier life she'd been a slave girl in Brazil and in another, the son of a powerful army general. She also believed she had powers of extrasensory perception (ESP). Certain days were good for her. She liked to sign contracts on Fridays, for example.

Asked today about the reports of her belief in psychic phenomena, Diane shrugs. "When you're young, you want to know what's going to happen in the future," she says.

What Diane was talking about when she talked about ESP was her intuition, her talent for sensing what would play in the marketplace. This is a gift, like perfect pitch—you were either born with it or not. She also had style, an innate flair, which is also a gift.

Historically, designers have been reticent in discussing who contributed to the creation of their clothes. They're reluctant to alter the public perception that a single individual designs a fashion collection, the way a single artist creates the images on a painted canvas. Fashion, though, is a highly collaborative process. The head designer is like the conductor of an orchestra with myriad sections. Each employee of the design house plays a specific role—scouting fabrics, sketching prints, designing collars or sleeves, making patterns, sewing samples—all contributing to the collection's symphony of style.

As Diane became increasingly occupied with promotion and marketing in the United States, she relied on Feinberg to translate her ideas into three dimensions. Feinberg moved to Italy soon after Diane hired her, and in recognition of the young woman's contribution to Diane Von Furstenberg Limited, Diane gave her a percentage interest in the company and twenty-five cents for every item of clothing produced. Diane traveled to Italy for a brief stay once a month. In her absence, Feinberg oversaw all matters of production: pattern making, cutting, assembly, and fitting of the clothes. "I had a lot of things made and sent to New York, and Diane and Dick would edit them based on what they thought would sell," says Feinberg.

"Diane's greatest talent was her eye for selecting," says DeBare Saunders, who designed jewelry for Diane's company in the seventies. "She was a brilliant editor. She'd look at ten things and pick out the most fabulous, the most saleable."

From the start, Diane's whimsical, colorful prints were key elements of her style. Her design process often started with prints, and ideas for prints could come from anywhere. "Diane would arrive in the morning with a picture of anything that looked interesting—a photo, a cigar band, a box top. Somehow, she found the damn things, they became her inspiration," says Conrad.

The idea for Diane's popular twig print, for example, came from the packaging of the French perfume Cabochard, which Feinberg spotted in a store in Europe. She sent the package to Ferretti's factory with instructions to make the print larger. Feinberg then worked with the print makers to get the colors and proportions right. The original twig print was in green and white, but eventually Diane would offer it in fifteen colors. Feinberg also designed prints herself—including an inkblot print that she created by throwing ink on paper laid out on her terrace. Sometimes Feinberg purchased designs from print artists in Paris. She also collected objects, lingerie, and bits of fabric in colors she liked and organized them in boxes according to hue: reds, greens, blues. In the case of the twig pattern taken from the Cabochard box, she showed items to the colorist in Como, and they worked together to arrive at the right shades. Next, the print was transferred to fabric using a silkscreen process. Ferretti's jersey had an elasticity to it "that took the color very well," Feinberg says. "It felt like cashmere," adds Dick Conrad.

After a roll of cotton jersey produced in Como arrived at the Montevarchi factory, it would be unfurled across the worktables, and the pattern maker, a woman named Bruna, would get to work creating the template for a garment conceived by Diane. Next, a seamstress would make a prototype of the item, and Feinberg, acting as the fit model, would try it on. She was a perfect size ten. (She used two other women to fit sizes eight

and six.) In couture, prototypes are made in muslin and adjusted before being cut in fine fabric. But Ferretti's fabric was inexpensive, and Feinberg didn't think twice about using it for samples.

By the time Diane arrived in Italy in July 1972 for her monthly trip, her next collection had gone into production. Looking at the soft mounds of garments piled up, she grew concerned. "I'm very worried because of the quantity of merchandise, but I hope we will sell it all!!!" she wrote Conrad.

One day while working in the factory, Diane saw a fetching wrap top that Ferretti had done for Louis Féraud. "It had dolman sleeves, but also a collar and cuffs, and it gave me an idea," she recalls. She refined the garment into a top that resembled the type of cover-up ballerinas wore over their leotards. Then she created pants and A-line skirts, some with pleats, to be worn with it.

The wrap top was part of a collection that included around ten styles—flowing caftans, a pantsuit, a flannel tent dress, tops, skirts, pants, and jersey shirtdresses "with no zip, no buttons," as Egon described them.

In the New York stockroom the clothes piled up floor to ceiling, the garments organized by color and style and folded neatly in plastic bags. Buyers loaded their choices into grocery shopping carts. There were only two "dogs," fashion parlance for flops, says Conrad. A group of angora dresses failed "because they itched," and the pantsuit was cut so small no one could get into it, "not even Diane."

Everything else flew out of the building, and the reorder books filled up. The wrap top and skirt was a huge hit, as were the caftans and shirtdresses. These were clothes whose time had come. Diane had opened her business at the height of an American sportswear revolution that had begun in the fifties. Halston, Stephen Burrows, Calvin Klein, and other young designers, aided by new fabrics and technologies, were refining the idea of fashion for the active life of a modern woman, creating light, easy clothes that were true to the contours and movement of the body.

Upheavals in fashion typically coincide with seismic cultural and

political shifts. During the French Revolution, Marie-Antoinette lost her influence on style along with her head, and afterward *les citoyennes* rejected the queen's corsets, wide pannier skirts, and towering pouf hairdos for a style of undress—fluid, lingerie-like frocks and loose curls—that embodied the spirit of liberation.

In the burst of modernism following the horrors of World War I, hemlines went up, waistlines and bosoms disappeared, and black, previously the color of mourning, morphed into the standard of chic. Three decades later, in 1947, Christian Dior set the clock back fifty years when he introduced his New Look—full skirts, cinched waists, and boned bodices. Actually, the look was anything but new. It was a regression to the belle époque and a time when women had no status, when the ornate femininity of their clothes signaled their subservience and dependence. In the United States the end of World War II coincided with a yearning to return women to domesticity. Dior's New Look comported perfectly with the 1950s American glorification of the Wife.

The next dramatic change came in the 1970s. The woman's movement, the pill, jet travel, and an explosion of youth—by 1970, one half of the American population was under thirty—fed a new ideal of individual autonomy in all things, including clothes. There were no rules anymore, except to do your own thing. In fashion that meant a crazy mishmash of styles—from flowered maxis, floppy hats, and bell-bottoms to fringed leather jackets, pantsuits, space age jumpsuits, and vinyl boots. The dresses offered in department stores and boutiques tended to be either fussy, Frenchified confections or extremely expensive high-end fashion from the likes of Halston, Bill Blass, and Oscar de la Renta. No one was doing a simple, affordable little dress.

As a designer, Diane has always been more interested in the feelings inspired by clothes than in the technicalities of cut and fit. She knows that the true subject of fashion is romance—women in alluring outfits and the emotions they evoke. Sex was a big part of Diane's life, and the force of her style came from the heat of sex flowing through it. "Feel

like a woman, wear a dress," the slogan she wrote on a photo Roger Prigent took of her in his studio for a 1972 *WWD* ad, would be frequently invoked by Diane and the media as an expression of her enduring fashion philosophy.

The slogan happened by accident. Prigent, a Frenchman and a friend of Diane's, had posed her on a big white cube, "but when I saw the photo the cube took too much real estate and looked like a huge white spot," says Diane. "So I took my dark navy fountain pen and wrote the phrase offhandedly" to fill up the white space. She never dreamed it would stick.

Helping women feel good about themselves, urging them to enjoy being women, became her mission as she traveled around America to department stores and boutiques. It didn't matter if you were chubby or skinny, old or young, pretty or plain. It was how you carried yourself, how you used what you had, that mattered.

At the time, feminists were fighting against being judged on their appearance, a problem men didn't have, noted Gloria Steinem, "since men's bodies are valued more as instruments of power than of attraction."

Feminists such as Steinem abhorred society's emphasis on a woman's physical allure. They objected to the fashion industry encouraging girls and women to focus on beauty as their highest calling, and they argued that the industry set impossible—even unhealthy—standards.

Diane, though, believed that beauty was empowering in itself, an idea that should not have been lost on Steinem, whose flowing tresses, slim, miniskirted figure, and sexy legs made her the media's favorite feminist spokesperson. Once Steinem hit the activist scene in the late sixties, she completely overshadowed Betty Friedan, the dowdy, middle-aged author of *The Feminine Mystique*, the 1963 book that is widely credited with igniting second-wave feminism.

Diane came from a European culture that valued female beauty as a goal every women could accomplish through dressing well and enhancing her assets (or compensating for her defects) with diet, grooming, and makeup. In contrast, America's strong Puritan tradition regarded fash-

ion and face paint as false masks. There's always been an anti-fashion prejudice in America. Even people who never miss an episode of *Project Runway* or an issue of *Vogue* are likely to complain that fashion is shallow and irrelevant.

The European concept of beauty, though, was rooted not in popular culture but in classical ideals of harmony and grace. This was not the beauty of face and figure in the fashion magazines and cosmetics ads but rather the inner beauty accessible to every woman, regardless of her age, size, or ethnicity. Harmony and grace were elements of female identity, and they could coexist comfortably in the same woman with such traditionally male ideas of identity as professional success, intellectual achievement, and political and financial power.

This was Diane's message as she traveled around the country, hurrying through airports toting a garment bag on her way to catch a plane. The glamorous presence of Diane in stilettoes, fishnet stockings, and a slinky dress was the clinch to many a large sale in Cleveland and Dallas and Miami. She had an uncanny gift for connecting with her customers. They felt—and still feel—that her clothes fulfill the subliminal promise of fashion, to soothe them in their deepest, most private places, where they yearn for freedom and love.

And yet many of the fashion insiders Diane hoped to impress the most continued to regard her as a dilettante. *WWD*, the bible of the fashion industry, didn't take her seriously, dismissing her first Seventh Avenue show in November 1972 as lacking "excitement." The paper sniped, "Maybe it was all the noise" from the Garment Center rally for Democratic presidential candidate George McGovern that kept people away, so that "only two of Diane's friends, Nan Kempner and Kenny Lane, showed up." The brief article, which featured pictures of a tank dress, a shirtdress, a long-sleeved V-neck dress, an evening pants outfit, and a caftan, noted that "Diane is thinking dollars. Those simple little print cotton acetate jersey dresses which form the basis of her collection are meant to sell—not make fashion news."

Of course, the customer didn't care about fashion news. The customer cared, as retail executives knew, that Diane made pretty, easy-to-wear clothes that women could afford. One of the most popular styles in that first Seventh Avenue show was "a silk jersey tent dress with a little jeweled neck and a little yoke above the bust line with a lot of fabric," Conrad recalls. It looked good on a variety of ages and body types. "We sold it for $89.75, which was half of what anyone else could have sold it for because of the way we worked with Ferretti," Conrad adds.

Everything in Ferretti's factory was sewn on a merrowing machine, which made seams by wrapping thread around fabric edges, a cheaper system because it cut out the last steps of finishing and ironing. Merrowing was used mostly on low-cost garments, "not for Liz Claiborne" or other department store-quality clothes, says Feinberg.

In its review *WWD* conceded that some of Diane's prints were pretty, especially a figurative one of pandas, but complained that she "could have done without those Pucci-like prints." Actually, it was a *Gucci*-like print that got her in trouble in the summer of 1972. On a trip to Ferretti's factory, Dick Conrad had given Ferretti three Gucci ties in four colors he'd picked up in Rome. "I told Ferretti to make them into dresses. I said, 'prints *like* this.' I didn't mean for him to copy them line for line," says Conrad.

But that's exactly what Ferretti did. Diane sold hundreds of dresses in the copied Gucci prints, including the firm's iconic horse-bit design, sparking an angry letter from a son of the Gucci founder.

The blunder passed without a lawsuit or any other serious repercussions (as did the borrowing of the Cabochard packaging). Orders continued to pour in, and by the end of 1972, Diane's business had made $1.2 million, about $8 million in 2014 dollars.

"EGON ENCOURAGED ME TO WORK, then he was jealous," says Diane. Her husband attributed much of Diane's success to her use of *his* name, not to mention the doors that had been opened to her as

his wife. He thought it only fair and proper for them to own the von Furstenberg dress business together, an idea that was anathema to Diane, who craved the independence that came with having something that was hers alone.

She urged Egon to create his own, separate success. "You always push others. Why don't you push yourself?" Diane told him. But Egon lacked Diane's drive and ambition. She "was so much smarter than Egon, but she tried to keep him from seeing who was wearing the pants," said her friend Berry Berenson.

In November 1972, after flirting briefly with the idea of opening a restaurant, Egon started a menswear business based in an office in the Empire State Building. He offered a few sports jackets made in Italy and caftans for men, copying Diane, whose caftans for women had sold well.

Diane tried to help Egon's fledgling operation by presenting a joint his-and-her collection in May 1973 that *WWD* reported "made a strong simple statement." Egon showed sweaters and shirts, some in the same geometric, matchstick, and broken-circle prints as Diane's dresses; she showed a variety of shirtdresses and an evening tank dress with a shirt jacket. "I cannot imagine a dress that isn't a shirtdress," she told *WWD* a month before the wrap dress bloomed in her mind.

When she wasn't in her office, Diane was traveling to stores around the country, once visiting fourteen cities in thirteen days. She also traveled with Egon for social events. In the midst of her business start-up in 1971, for example, she and Egon went to Egypt, where Diane bought a diaphanous silver antique caftan, and afterward flew to France for that year's most important social event—the Bal Proust that Marie-Hélène de Rothschild threw at the Rothschild family château of Ferrières to celebrate the centenary of the writer's birth. It was one of the last grand balls in the old tradition of the European aristocracy. Diane looked the picture of a princess in a billowing black taffeta gown by Oscar de la Renta.

Her life was extraordinarily hectic. She struggled to balance the demands of her business, her children, her employees, her social life, and

Egon. "I was just trying to catch the train. It was crazy. But I never lost my mind. I never lost control. I took some drugs, but I never lost control there either," says Diane.

Nevertheless, the stress took its toll. Her hair, which she had blown out and styled twice a week, started to fall out. Luckily, she had masses of it, so the loss was noticeable only to her. It was a depressing sign, though, that all was not right in her life.

Chief among the things that were wrong was her marriage. "Egon had a lot of lovers," Diane says with deadpanned understatement. She retaliated by having a few herself. As long as Egon was not emotionally involved with the men he slept with, Diane reasoned, they were no threat to her marriage. Then Egon fell in love, or at least into serious infatuation, according to Francine Boyar, Diane's house model at the time. The young man was a handsome architect, and Boyar says Diane enlisted her to seduce him away. "Diane came to me one day and said, 'Oh, I'm so worried because Egon's really in love with this guy," recalls Boyar. (Diane, however, has no memory of this and says that among Egon's lovers, this particular young man " wasn't special.")

Diane invited Boyar to a party at her house so she could meet the man, who, like Egon, was bisexual, says Boyar. He "was gorgeous in a Jewish math-teacher kind of way, with curly hair and glasses," adds Boyar, who was smitten. The young man was just as attracted to the tall, shapely model, and they quickly became involved.

"We ended up having this unbelievable relationship," says Boyar. The young man, who has since died, "loved me, and I almost married him. Egon was furious because I'd stolen his boyfriend. He wanted Diane to fire me. But Diane couldn't have been more thrilled."

IN FEBRUARY 1973, NEW YORK magazine profiled Diane and Egon in a now famous cover story headlined "The Couple That Has Everything. Is Everything Enough?" It was an embarrassing portrait, featuring details about their sex life and provocative pictures, including

one of Egon in nothing but a towel and one of Diane with her naked back to the camera in a Manhattan boutique where she was trying on shirts. Reporter Linda Bird Francke did little more than record the couple's remarks, and Diane and Egon revealed themselves as decadents whose marriage was a sham. "You just live once, and I am getting the most out of it," said Egon. "After a while, passion—you know—cools. So a little here, a little there at three in the afternoon. What harm?"

"We don't take anything very seriously," Diane added. "The only way for a relationship to survive, I think, is to have no sex at all. After all, you marry for friendship, for companionship—and passion after a while . . . pfffft. I mean, does it excite you when your left hand touches your right?"

Egon admitted that the couple had engaged in a threesome with a woman in Paris. "But you know what?" he told Francke. "It was just twice as much work for me." He hinted at his own bisexuality, "that were he to meet an attractive man, he would not be loath to experiment." Diane said she wasn't homosexual, though she, too, obliquely admitted to experimentation. "What is the point of being a woman if you have to drop yourself two stages to act like a man? Butch dykes upset me. A pretty, attractive woman? That's different."

(Diane says today, "Our sex life wasn't unusual. It was the seventies!")

Soon after the article appeared, Egon called Francke to complain. "You destroyed my marriage," he said. He protested that the magazine had taken the couple's comments out of context. It annoyed him that Francke had repaid their generous availability by poking fun at them. They'd invited her into their home, talked to her, and let her observe them over the course of a week. Egon's father, Tassilo, who was in town, also talked to Francke. As if to confirm that Egon had inherited his louche manner, Tassilo tried to grope Francke as they rode together in a taxi. "He treated me like I was just some disposable piece of American meat," says Francke. The journalist, who later worked with Diane on both of her memoirs, was appalled by Tassilo's "sense of entitlement as

this European prince." He also thought it necessary to bring up Diane's religion, noting, as Francke wrote in her article, that her children represented "the first time in nine centuries that we have Jewish blood."

Many of the von Furstenbergs' friends were horrified by the story—the result, they thought, of allowing your private life to become too public. "Egon was more upset about it than I was," says Diane. In fact, for her the article was a revelation. "I read it and thought, 'That's not me. I don't want to be part of *that* couple. I'd rather be on my own.'" Diane knew that Franke, with her shrewd reporter's eye, had seen deeply into the truth of the von Furstenbergs' marriage, a reality that until that moment Diane had been unwilling or unable to see. On some deep level she didn't want to be a couple with *anyone*. She didn't want to make the compromises and adjustments required to be part of a marriage. She couldn't stand to give up any of herself. (Later, when she found herself doing exactly that with another man, she would be profoundly unhappy.)

Diane didn't smoke, but one morning soon after the *New York* article appeared, she arrived at her office and immediately asked Conrad for a cigarette. "She said, 'Egon's leaving, and I'm not sure what I'm going to do,'" Conrad recalls. "It was one of the very few times I ever saw Diane ruffled. The separation was a change at a time when she was moving very far, very fast, and in those circumstances you don't want any impediments. And her kids were young. Egon was their father. She was thinking as she was talking, which was her style. She wasn't sure what her next move should be."

Blowing a sibilant jet of smoke toward the ceiling, Diane asked Conrad how he thought the breakup would affect business. "I don't know about your personal life," he told her, "but it's *good* for business."

Conrad felt that Egon was a drag on Diane's rise. He was around, and he was an annoyance. Once when Diane was away, Egon was hanging out in her showroom as Conrad was trying to close a deal with the buyer Charlotte Kramer from Saks, who Conrad says "had the biggest pencil in the business," retail parlance for buying clout. "Egon says to Charlotte,

'I'd love to sit with you and tell you what you should buy.' He's saying this while I'm working with her, and he's messing up my act."

At first Egon didn't understand why he and Diane couldn't continue as they had before the *New York* article. He held the typical European aristocrat's attitude toward marriage—it was for preserving bloodlines and fortunes; wives held a secondary status to their husbands. In a way, Egon believed, Diane's success belonged to him. "Either you give me your business, or we separate," he told her.

"Okay, we separate," she said.

Once the decision to break up was made, Diane and Egon tried not to listen to outside parties and kept discussions about the dissolution of their union between themselves. "We shared a lawyer and had one meeting with him when we formulated our separation. There was no alimony," says Diane.

Egon moved out and got his own apartment at Eighty-Second Street and Park. Diane remained at 1050 Park. Soon the two were friends again. "He still came over every day at six. We still spent holidays together and remained very close," Diane says.

To the end of Egon's life, Diane continued to rely on his emotional support during her frequent bouts of insecurity and often called him late at night for reassurance. "Do you love me?" she'd ask.

"Of course, I do," Egon would say. "Now go to sleep."

The Wrap

ne evening in 1973, soon after Egon moved out and at the height of the Watergate scandal, Diane turned on the TV in the bedroom of her Park Avenue apartment and saw an image that changed her life. Julie Nixon Eisenhower, President Nixon's daughter, was wearing one of the designer's popular wrap tops and A-line skirts while being questioned at a news conference. As Julie defended her embattled father against charges that he'd covered up the break-in at Democratic National Committee headquarters in the Watergate complex, Diane noted the flattering contours of her top, how the snug fit and V neck enhanced Julie's curves without being too provocative. Diane had little sympathy for Nixon, but his younger daughter impressed her. Julie looked confident and forceful, so different from the guileless girl in pictures at Nixon's inauguration. It was as if Julie had absorbed the spirit of her clothes to become a new woman, a woman more like Diane—bold, independent, alluring.

Diane had seen this happen before—on her trips around the country when she watched women of all shapes and ages try on her clothes—she

had seen how they'd go into the dressing rooms as frumps and come out, well, not exactly sirens, but feeling better about their bodies and themselves because Diane's brightly colored clothes in printed jersey with no zippers or other clunky hardware were so easy and hopeful. Like all good fashion, Diane's designs caught the spirit of the moment, of what was at the heart of women's lives: their need for love and romance as well as equality at work.

The clothes were like living things to her—like her two small children sleeping nearby with their nanny. When she held the soft, graceful garments in her hands, she felt she was holding her own sunny future.

That evening Diane flung the vicuña comforter aside and leapt out of bed. Standing in front of the black and white screen, she stared at Julie Nixon Eisenhower and suddenly realized: If a simple little top could do so much for a woman, what if she extended it to the knee and turned it into a dress?

RICHARD CONRAD AND SUE FEINBERG tell a different wrap-dress creation story. They say *Conrad* came up with the idea after seeing Diane's wrap top and skirt ensemble. "I knew we could cut our costs in half if we sewed the wrap top to the skirt," because a one-piece garment is cheaper to manufacture than a two-piece outfit, says Conrad. "I suggested that to Diane, and the first one-piece wrap dress" was born.

Feinberg says she happened to be in New York that day and heard Dick Conrad say, 'Let's make it into a dress.'"

Among others who've taken credit for the wrap dress over the years is Clovis Ruffin, a designer who was known for creating clingy T-shirt dresses. After Ruffin died in 1992, Diane recalls, "his mother called me and said I'd stolen the dress from her son. The poor woman had lost her son, but I had to tell her, I did the dress *before* he became a designer."

IT TOOK A GREAT DEAL of trial and error to get the proportions of the wrap dress exactly right. In Italy, Bruna, Ferretti's pattern maker, spent hours cutting different patterns and pinning them

together. Diane and Feinberg tried on a series of prototypes, "testing and trying" to get it to work, says Diane. "It was like a puzzle, to make all the pieces fit."

The first wrap—in a wood grain print—was seen by buyers in September 1973. In April 1974 Diane launched the style, number T/72, in snakeskin and leopard prints. "It was nothing really—just a few yards of fabric with two sleeves and a wide wrap sash," Diane later wrote, describing its allure. At a time of schizophrenic skirt lengths—from microminis to midis to maxis—the wrap was an elegant, flattering knee length. It didn't have a zipper or buttons, so you could slip it on quickly and slink out of a bedroom "without waking a sleeping man," as Diane often says. It wrapped around the body like a kimono and molded to the individual woman's shape. The movement of the print enhanced a woman's curves. You could wash it.

"We shipped it out, and the retailers went crazy," says Conrad. The country was in the middle of a recession, and most other clothing lines were not selling well. "But salesgirls were literally fighting over who got to sell Diane's dresses," adds Conrad.

The wrap flew out of the stores, and the reorders poured in. Saks alone ordered fifteen hundred dresses. Conrad telexed Ferretti to stop the sewing machines, to take the print fabric slated for Diane's other styles and sew them all into the wrap. They would offer the wrap in sixteen prints. They were betting the collection on one dress, and amazingly, "it worked," Conrad says.

A typical wearer was writer Leslie Garis. "I had a black wrap dress that I always felt sexy in," she says. "I remember how it defined my waist and was easy on the bust and hips. It moved with me. It gave me the illusion that my body was perfect."

Leslie Bennetts, who traveled a great deal for her job as a reporter, recalls being "very grateful for the stretchy jersey fabric. You never had to iron a DVF dress, even when it had been crumpled up in your suitcase. But the most miraculous thing was that the dress was flattering to almost

everyone. I remember going with my ex-husband, who had remained a dear friend, to his high school reunion, where we spent the evening talking to a former classmate of his who had also brought her former spouse. Both she and I were wearing the same DVF wrap dress—I think it was a tan bamboo pattern—but we were polar opposites in physical type: She was a short, angular, pencil-thin brunette, and I was a tall, voluptuous blonde. Her ex-husband said, 'You each look like the dress was made for you!'"

Because of Diane's favorable terms with Ferretti, It cost only $16.57 to make the wrap dress, which Diane sold for $39.75 to the stores, which then marked it up to $75, about $350 in 2014 dollars. "We were making a sixty- to sixty-three-percent gross margin. If you were making forty percent, you were lucky," Conrad says. "We had a license to steal."

After being apprised of the sales numbers in October 1975, Diane sent Conrad a telegram from Paris:

> darling dick, i cannot believe the figures, and each
> of us are responsible for it . . . i love you so much.
> diane

The wrap hit America like a tsunami in matte jersey. Thousands of women of all ages, sizes, occupations, and ethnicities bought the dress. You couldn't enter a restaurant or walk down an avenue or go to a PTA meeting anywhere in America without seeing a flattering "Diane" dress in bold, printed jersey. Once, while having her hair styled with Fran Boyar at an East Fifty-Seventh Street salon, Diane and her house model gazed out the picture window, counting the number of women in a wrap who passed by. "I can't remember the exact number, but it was an outrageous amount," Boyar recalls.

The wrap was everywhere at the 1976 political conventions, worn by Republicans and Democrats alike. Celebrities from Dina Merrill and Gloria Steinem to Bella Abzug and Candice Bergen wore it. Cybill Shep-

herd, playing the role of a campaign worker, wore a wrap in the 1976 hit movie *Taxi Driver*. When several society swans showed up at Le Cirque one day that year wearing the same model in a green and white print, the city's gossip columnists treated it not as an embarrassing coincidence but as evidence of the women's membership in an exclusive club—the sisterhood of the little wrap dress.

Most journalists writing about the dress, however, didn't actually call it "the wrap," a moniker that took a while to catch on. *WWD* mostly referred to it as "the Diane dress," and Bernadine Morris, chief fashion critic at the *New York Times,* called it "the wrap-around dress."

The wrap fulfilled Diane's idea of the true purpose of fashion—to enhance a woman's natural allure. Too many male designers, she believed, exploited and distorted women with their ridiculous, misogynistic styles. "Women are too intelligent, to bright, to be told, 'You're going to wear a feather in your behind,'" Diane said. She designed with women's bodies in mind—she knew how she wanted to look and how her style would appeal to others. The nation's women repaid her by anointing her a celebrity, the most bankable female designer since Coco Chanel. By the mid-seventies, at the height of the wrap's popularity, Diane was selling twenty-five thousand dresses a week.

Her friends in the heady world of high fashion cheered her on and embraced her as an integral part of their social world. "I'd always see her with the best people," says André Leon Talley, the imposing fashion authority and *Vogue* contributing editor. "I'd met her at Le Jardin, *the* disco before Studio 54 opened, and she'd come in with Yves Saint Laurent and [his partner] Pierre Bergé. When Saint Laurent had his first big couture show in New York at the Hotel Pierre, Diane was in the front row with Bianca Jagger and Nan Kempner, et cetera, et cetera."

Mostly, the high-end design brigade was generous in commenting on Diane's work. "She knows her customer. She understands women and the power of femininity," says Oscar de la Renta. After all, Diane wasn't

competing against the Lagerfelds and de la Rentas of fashion, whose clothes were far more expensive than hers.

Privately, the fashion world's reaction to her success was more guarded, partly because they considered her more of a merchandiser than a designer, and partly, perhaps, because they were jealous of her success. French couturiers such as Yves Saint Laurent and Karl Lagerfeld "loved Diane as a person; she was such an amusing girl. But, no, I don't think they loved her as a designer," says François Catroux, an interior designer based in Paris and a close friend of Diane's.

Some Seventh Avenue observers called her a fake and a fad. She wasn't *really* a designer—she merely copied the colorful little dresses she saw in Europe. Her name wasn't even her own. Her princess title impressed ordinary people, but it was laughable to real aristocrats, her critics said. The insults got back to Diane and fed her insecurity. When interviewers asked her about her talent, her answers were as humble as a denim skirt. "I don't pretend to do original things," she told one interviewer. And to me, she said, "I didn't call myself a designer until recently."

Her reluctance to take credit for creating original fashion perhaps reflected her sense of inferiority compared with such friends as Yves Saint Laurent, Halston, and Oscar de la Renta. It also perhaps reflected her acknowledgment that others were at least in part responsible for some of the work marketed under her name. "She took credit for everything that was done by everyone else," says DeBare Saunders, her jewelry designer in the seventies.

The snarky comments and her own self-doubts pushed her to strive harder. She was tough on herself. She always worked best when she knew people didn't believe in her. Then she had something to prove.

Diane's journals and diaries, which are written in French, reflect her fears and insecurities. "She was scared. She describes her malaise," says Linda Bird Francke, who was privy to some of these entries while she worked with Diane on her memoirs.

Andy Warhol, who generally preferred transvestites to real women

and could be especially catty about strong women like Diane, rarely had anything good to say about her or her clothes. At a party one night in 1980 he complimented a friend, Sondra Gilman, on her "beautiful bright yellow dress" and asked her who designed it. "You'll fall over if I tell you," she said.

It was Diane von Furstenberg. "I did fall over," Warhol wrote in his diary, before grudgingly admitting that the dress "really was pretty."

When Bernadine Morris of the *New York Times* saw the wrap dress for the first time, she says, "it reminded me of the housedresses my mother wore when she worked around the house. It was a housedress, dressed up in nice fabric." The wrap dress wasn't revolutionary, she adds. "It was a minor big trend. There just aren't that many new ideas in fashion." Maybe two, she says. "Dior's New Look and [Yves Saint Laurent's] trouser suit."

It's rare for one particular dress to cause a sensation, though there are at least a couple of examples of the phenomenon in fashion history. In 1922 the French fashion house Premet put out a black satin slip dress with a white collar and cuffs. Called "La Garçonne," after the year's best-selling novel of the same title about a free-spirited tomboy who sleeps around, it sold more than a million copies, including knockoffs. Ten years later, Macy's reportedly sold a half million copies of the white evening gown with ruffled sleeves created by the Hollywood designer Adrian for Joan Crawford to wear in the movie *Letty Lynton*.

Diane did not invent the idea of a garment that wrapped. The Romans had togas, after all. Before Diane's wrap, a number of variations of the style had appeared over the years. In the 1930s Elsa Schiaparelli designed a beach cover-up that wrapped around the body and tied at the sides. During World War II, Claire McCardell did the first version of her famous "popover" dress, conceived for active women who worked in and outside the home. In unassuming fabrics like denim, the dress was meant to be "popped over" a pair of trousers, a bathing suit, or underwear. It could also be worn as a coat. Vicky Tiel designed a mint-green mini

wrap that was worn by the Swedish model Ewa Aulin in the 1968 movie *Candy*. Bonnie Cashin made a wool wrap coat in 1950, and Stephen Burrows did a long-sleeved wrap dress in red jersey in 1970. Halston, too, produced many wraps—tops, coats, and dresses in jersey and his signature ultra-suede.

What Diane did was mold the wrap in comfortable, alluring jersey in colorful bold prints and make it a staple of a woman's wardrobe. Now, after forty years, Diane no longer feels the need to downplay her achievement. "Who else has done a dress that's been popular for so long?" she says. "People think that the wrap dress was an accident or just plain luck. What they don't realize is how I took my frustrations and aspirations, transformed them into a positive force, and poured it all into that little dress."

Diane's wrap was "a climax to the American sportswear wrapping tradition," according to a description of it at New York's Metropolitan Museum of Art, which has a green and white dotted wrap from the seventies in its costume collection. Diane "translated the style into 1970s fabrics and colors, generally brighter, bolder and more synthetic (and stretchy) than the early examples of which the silhouette and design principle are indebted."

The American wrapping tradition grew largely from the work of women designers who were infused with a spirit of democracy and feminism. Wrapped garments relinquished control to the wearer. They were fluid, not fixed. They could be worn loose or pulled taut. They conformed to an individual's body and style and could accommodate a variety of shapes, sizes, and sensibilities.

Part of the early appeal of the wrap was that it was supposed to be washable and drip-dry. Not all wraps, though, turned out to be colorfast. Customers complained that the dye in some of the prints ran when water hit them. Though Conrad insisted the problem affected only "one tenth of one percent" of the dresses, Diane soon changed the labels to read "Dry Clean Only."

The necessity for dry cleaning did not slow the wrap's explosive growth. Though America was in a recession and many Seventh Avenue manufacturers were losing money or going out of business, within a year Diane had sold several millions of dollars' worth of wraps. "The stars were aligned" to make the dress a smash, says Feinberg. "If Diane hadn't met Ferretti, and he hadn't bought a factory that happened to have a mer-rowing machine, she never would have made as much money as she did."

Diane's success was illustrative of the new democratic forces shaping fashion, and she was not the only American designer getting noticed for making affordable and accessible clothes. Norma Kamali, for one, produced inventive dresses and separates in humble fabrics, including a puffer coat inspired by a sleeping bag she'd curled up in on a camping trip after her divorce. Avant-garde rockers, movie stars, and socialites flocked to Kamali's second-floor Madison Avenue shop, OMO (for "on my own"), to buy jumpsuits and ruffled evening gowns made from para-chute silk, and bloomers, tunics, and skirts cut from sweatshirt fabric.

Diane herself had a closetful of colorful, tiered Kamali skirts. She wore her own clothes during the day, but to go dancing at night, she wore Kamali.

ACROSS AMERICA, STORES SOLD OUT of the wrap as quickly as the dresses arrived. Many women already had one or two in their closets, but they clamored for more, and Diane felt pressured to constantly produce new variations: sleeveless wraps, short-sleeved wraps, wraps with halters and ruffled necklines, long wraps, short wraps, dressy wraps, casual wraps, wraps with pants. She also pushed to come up with new prints. Soon she added a chain print, art deco prints, and more flo-rals and geometrics.

Meanwhile, Diane's animal prints were smash hits that fed the wrap's monster success. *WWD* hailed them on the cover. *People* photographed the designer herself in a leopard-print wrap, and the top department stores ran huge ads promoting the "jungle" designs. "No matter how

many times you've seen these feline spots before your eyes, they never have seemed fresher than in Diane's hands," gushed a B. Altman ad.

By the end of 1975, Ferretti's factory was making so many wraps that Diane rented a warehouse at Fortieth Street and Tenth Avenue to store them. "It was exciting just to be in the office," says Jaine O'Neil, one of the sales staff. "You'd pick up the phone to make appointments with buyers, and everyone was happy to hear from you. The clothes were selling themselves."

Tasked as she was with recording the company's mounting profits, Marion Stein, the bookkeeper, had a special place in Diane's affections. "I am very drunk right now and that is probably why I write this letter and open myself, but I really feel well when I come to the office and a lot of it is because of you," Diane once wrote to Marion on Eastern Air Lines stationery while traveling. "We all love you a lot!!"

TO MARK HER SUCCESS, IN 1974 Diane commissioned four silkscreen portraits from Andy Warhol at a total cost of forty thousand dollars—twenty-five thousand for the first and five thousand for each additional picture. (Ten years later she would commission a second series of the artist's portraits.) Being featured in a Warhol silkscreen was an essential status symbol for a New York celebrity in the seventies, in the same way a John Singer Sargent portrait was de rigueur for a society star of the belle époque—it signaled a kind of moneyed cool. Diane had met the pop art king soon after arriving in New York with Egon and saw him frequently at events. "He was always around at her parties," says Linda Bird Francke.

The commission, though, did nothing to soften Warhol's attitude toward Diane, which was resentful to the point of hostile. Though Warhol was fascinated by fashion, "Diane's style wasn't Andy's style," recalls Bob Colacello. "Diane has mass taste. Andy liked Saint Laurent and Halston. Also, Andy could be a little anti-Semitic, to tell you the truth."

But perhaps the chief reason Warhol resented Diane was her failure

to be caught in his cruel traps. "Andy loved people who were desperate to be famous and who were exhibitionist but who weren't smart enough to realize what fools they were making of themselves. And Diane would never make a fool of herself," says Colacello. "Warhol always had his tape recorder going, and he'd say to a woman, 'Does your husband have a big cock? How many times do you have sex?' If a woman got into that with him, he'd love it. Then he'd have a good tape. Diane would never fall for that."

Not that Warhol didn't try to goad her into humiliating herself. For her first appearance in *Interview*, the magazine he founded in 1969 that featured mostly unedited conversations among celebrities, he paired Diane with the improbably named Victor Hugo, a crazy Venezuelan pseudo artist and Halston lover.

Hugo sometimes showed up at Studio 54 in nothing but a jockstrap. He arranged the sex acts between street hustlers and call boys that Warhol photographed for his series of "torso" paintings in 1979. Halston put Hugo in charge of his store windows on Madison Avenue, and one season Hugo had mannequins with machine guns act out the Patty Hearst bank robbery. Another season the windows featured a birthing scene in which faceless mannequins stood around a hospital bed where a pregnant figure was wrapped in a long cashmere blanket. "This is really sick," one passerby wrote in chalk across the windows.

For their *Interview* conversation, Victor Hugo asked the questions and Diane answered, as Warhol sat nearby recording it all. The session must have been a disappointment to Warhol, for the Master of Raunch did not push Diane to debase or embarrass herself. Instead, the result was a harmless coffee klatch chat between a princess (P) and a gay gigolo (VH):

VH: By the way, do you make love every day?

P: Yes (girlishly).

VH: Do you think it is a must? It is like a beauty treatment every day?

P: Well, it is like a bath, you know. If you have a good bath
 sometimes you can "jump" a day.

VH: Are you interested in ménage à trois?

P: No! I like ménage à deux.

In the aftermath of her breakup with Egon, Diane took many lovers. She recorded her conquests in her diary by writing "our bodies met." ("I was so subtle," she says now.) Among them were three famous actors, Ryan O'Neal, Warren Beatty, and Richard Gere. She slept with Warren Beatty and Ryan O'Neal in the same weekend when she was staying at the Beverly Wilshire Hotel in Los Angeles. "I was having a little thing with Ryan, and Warren was in the hotel," she says. She'd had "a fantasy" about sleeping with both stars, and so "it just happened."

Fran Boyar recalls that when Diane's affair with Warren Beatty was over, she herself "got him." She continues, "He used to call Diane's private line, and I was the only one allowed to answer it. So he calls one day, and I ended up meeting him at the Carlyle Hotel. I screwed him a couple of times, then I brought a girlfriend, and we had a three-way."

Before her movie star conquests, though, and in the immediate aftermath of her breakup with Egon, Diane's boyfriend was Jas Gawronski, an Italian TV newscaster stationed in New York who was ten years her senior. Gawronski was kind and serious and comfortably European, a member of the international set that often came to Diane's apartment for parties. She and Gawronski spoke Italian together, and as a young journalist in Italy, he had known Egon and the entire Agnelli clan.

He also understood that ambition did not negate her desire to be loved as a woman. "On the one hand, Diane is very tough. On the other, she's very sweet," says Gawronski, who is now retired after serving many years in the European parliament. "She has these two things blended together. Sometimes one side comes up stronger than the other. But I always felt that she had a feeling for helping other women."

Diane was in the middle of her affair with Gawronski when she

bought her country home in Connecticut. In November 1973 a real estate agent had sent her some pictures of available properties. One turned out to be a beautiful estate rambling over fifty acres of lyrical countryside in New Milford, two hours north of Manhattan. Diane drove up to see it with her mother and Kenny Lane. Called Cloudwalk, it held a main house and four outbuildings erected in the 1920s by Evangeline Johnson, a pharmaceutical heiress and onetime wife of conductor Leopold Stokowski, who'd been a DVF woman before Diane invented the type. Decorated by President Woodrow Wilson for her services in the Red Cross during World War I, Johnson fought a one-woman war in the 1920s against the city of Palm Beach, Florida, which had banned women from appearing in public in skimpy bathing suits. She had stacks of handbills protesting the ban printed up, then buzzed over the beach, tossing them from the cockpit of a propeller plane she'd just learned to fly.

Diane paid two hundred thousand dollars for Cloudwalk and took possession of it on December 31, 1973, her twenty-seventh birthday. For all her city glamour, she loved the peace and beauty of the country, and she worked hard to make Cloudwalk a model of natural delight. She planted a grove of magnolia trees and cleaned up the woods, apple orchards, and fields. She set up the farmhouse for family life, with a well-stocked kitchen, a living room, bedrooms, and bathrooms for her children and her guests. She herself slept in the nearby barn. Though drafty and ramshackle, it was a perfect spot to bring lovers, far from the prying eyes of Tatiana and Alex, with whom she could communicate by intercom—until Alex cut the wires when he was twelve.

The area around Cloudwalk was more New York than New England, with many of Diane's friends from fashion and society, including Alexander and Tatiana Liberman, Oscar and Françoise de la Renta, John Richardson, Bill Blass, and Henry and Nancy Kissinger (with whom she spent several Thanksgivings), rusticating nearby in their own country homes. Dressed in jeans and no makeup, Diane read and took long, restorative hikes through the fields and woods. On Saturday, the cook's

night off, she made what her family called "Saturday-night chicken," one of the few dishes her son says she knows how to prepare.

Though Diane owned her apartment in New York and would later own a Paris flat, she regarded Cloudwalk as her true home. This is where she always returned, after a marathon public appearance tour, after a humiliating business flop, after the end of an affair. It is where she felt and still feels most herself, and where someday she will be laid to rest.

Diane spent her first night at Cloudwalk with Gawronski, eating lamb chops she'd bought from a local supermarket and drinking champagne—it was her birthday *and* New Year's Eve. "The house was kind of empty, but Diane decorated it to her taste in no time," Gawronski recalls.

Though the couple didn't live together in Manhattan, they spent most weekends at Cloudwalk. Gawronski had little interest in clothes, and when Diane's friends from the fashion world arrived, as they often did to spend a few hours or the day, he'd escape outside with a ladder and a hand saw to trim trees. "I developed a strange passion for it," he says, and laughs. "I started with the trees closest to the house and worked my way out."

By the time Diane broke up with him at the end of 1976, Gawronski had trimmed most of Cloudwalk's trees. "I think she was grateful because they looked so much better," he says.

ALEX VON FURSTENBERG SAYS HE and Tatiana had "a typical Upper East Side childhood, except that my mom was super famous and super cool and smoked joints and we traveled the world and people like Mick Jagger came over." Because Diane was away so much, the children had a lot of freedom—and luxury—with servants and drivers at their disposal. "My driver was the school bus for my friends," says Alex.

Lily lived with the family for eight months of the year (the rest of the year she mostly lived in Switzerland with Hans Muller). She was like a second mother to her grandchildren. Much of their rearing fell to her. "She was very influential. She taught me finance, which is now

my career," says Alex. "We used to look at the stock tables together. She also taught me how to play backgammon with the [doubling] cube, so I understood at a very young age when to press my bets and cut my losses. She also was very loving and supportive, and she always taught us to live to the max. The only regrets she had were the things she hadn't done."

Lily lived for four o'clock when the children returned from their private schools—Alex from Allen-Stevenson on East Seventy-Eighth Street and Tatiana from Spence on East Ninety-First. Lily "called me her oxygen, and she was *my* salvation," Tatiana says.

Tatiana was artistic and suffered from Brody disease, a genetic disorder that affects the muscles and prevented her from participating in athletics or even climbing stairs. She felt like an outsider in "this family where everyone was moving so fast and had so much vitality," she says. Tatiana was fragile like Lily, with whom she shared long, deep, "even mystical" conversations about life—in French. "I felt pressure to make her happy, to entertain her, to connect with her, and I wanted to because I needed her so badly," says Tatiana.

Lily read to the children every day and pushed them to develop their minds and become trilingual like their parents. "I remember being really little and having a Richard Scarry reader, and it wasn't good enough to read it in English. Lily also had us learn every word in French and Italian," says Tatiana.

At the time, Egon was struggling with the menswear business he'd launched in the wake of Diane's success. Diane had asked her friend Olivier Gelbsman to become Egon's partner; in fact, Gelbsman recalls, "she wouldn't let me refuse." One of his first duties was to accompany Egon on a gay cruise to Guatemala. "It was a deluxe French boat that had been used for classical music cruises," recalls Gelbsman. "We didn't have classical music; we had disco. The only women on board were the maids. And we went crazy every night, dancing and getting stoned."

When the boat docked in Guatemala, Egon took Olivier to a bordello, "a *woman* bordello," says Gelbsman. Egon "always did the thing

you'd least expect him to do," even when seeking out sexual adventure, "though on balance, he preferred men."

Gelbsman believes Egon wanted him as a business partner because he was an "intelligent, good-looking Jew," like Diane, and Egon hoped Gelbsman would do for him what Diane had done for herself. "Diane had the recipe for success, and the idea was the recipe was good to follow," says Gelbsman. "Except that it wasn't exactly transmittable for menswear." Egon's shirts, which were sold at high-end stores such as Barneys, were manufactured in Brazil and mimicked Diane's colorful prints. But the fabric wasn't as good as Ferretti's, nor were the shirts made as well as Diane's dresses. "Egon's shirts didn't do too well," says Gelbsman.

Still, Diane did everything she could to support Egon's business. During the fall collection shows in April 1974, the couple held their second joint show, this one attended by their children. As the girl models paraded in Diane's shirtwaists and wraps and the boy models in Egon's shirts, sweaters, and casual pants, Alex, four, and Tatiana, three, sat "quietly in the audience," the *New York Times's* Bernadine Morris noted. "But soon, startled either by the music or the models dancing along the runway with their arms flailing like windmills, the children ran to join Mommy offstage."

With the preternatural insight children often display, Alex explained to Morris that his parents were like "Tatiana and me." They had "the same sort of" brother-sister relationship.

Diane was the big sister looking out for Egon, protecting him, indulging him. "Egon would come into the showroom with his girlfriends and take the samples off the racks and throw them on the floor like we should pick them up," says Conrad. "I would get very angry with him, and I had to threaten him a couple of times. He was brought up as a prince, and he felt he could do whatever he wanted, whenever he wanted."

Though Diane says Egon had plenty of money, his extravagant lifestyle sometimes left him with cash-flow problems. One day Diane asked

Conrad to loan Egon forty thousand dollars. "If I loan it to him, I'll never see it again," Diane said. "If you loan it to him, I'll make sure he pays you back." When Conrad demurred, Diane gave him two paintings as security, one by Jean Dubuffet and one by Max Ernst. Egon never repaid Conrad, who eventually sold the Dubuffet for a profit. The Ernst hangs to this day in Conrad's New York living room.

A DVF World

In the 1970s you could don a DVF fur over your DVF dress, toss a DVF scarf around your neck, and pack for a trip with a DVF suitcase. You could wear DVF jewelry and improve your vision or shield your eyes from the sun with DVF glasses. You could carry a DVF handbag, step out in DVF heels worn over your DVF panty hose, tell time on a DVF watch, and go to sleep in a DVF nightgown. (In later years, you could also have surgery in a DVF hospital gown, attended by a nurse in a DVF uniform.)

According *to WWD* by the end of 1975, Diane's name was on twelve products worth about forty million dollars in annual sales. Like many designers, she'd discovered licensing, which had become the hottest way to grow a fashion brand. But it was a risky business that could ruin a hard-won image if a designer slapped her name on too many cheap, tacky products. Walt Disney had started it all in the 1930s by hiring outside companies to produce and distribute Mickey Mouse toys, books, and other kitsch. The practice quickly spread to French fashion, with designers from Dior to Saint Laurent to Pierre Cardin putting their names on

almost everything, including stockings, sheets, chocolates, wigs, frying pans, golf clubs, sausage machines, stereos, and inflatable boats.

Licensing worked like this: Once a contract was signed, the designer was paid either a lump sum or a percentage of projected first-year royalties. Afterward, the designer's royalties amounted to anywhere from 5 to 10 percent of net wholesale sales. The designer often (but not always) retained control of the quality and style of the products, while the license holder took care of manufacturing and distribution.

Though American designers were slower to embrace licensing than the French, by the 1970s, John Weitz, Anne Klein, and Bill Blass all had lucrative licensing agreements. No one, though, was making more money from the practice than Halston, who had thirty-one licensing accounts, generating myriad products and four million dollars in annual royalties. Then, in 1973, Halston sold his company to the conglomerate Norton Simon for ten million dollars. The sale made him spectacularly rich, but it was the start of his steep downward slide. He lost the right to control the use of his own name and would never get it back.

Diane took the cautionary lesson to heart. She knew her trademark was her most valuable asset. She told herself she would never accept a deal, no matter how lucrative, that forced her to give it up. Diane von Furstenberg stood for something. It stood for *her*. She was the brand. "There's always an echo with an icon," says Stefani Greenfield, the creative brand director of DVF Studio. "People are attracted to an icon's essence," which they've picked up from advertising and the media. So when they buy a feminine, sexy dress by Diane von Furstenberg in bold color and fabulous print, "it's as if they're buying a piece of Diane's energy and confidence," Greenfield says.

Diane, however, did not maintain tight control over her licenses. She fell into the trap of signing on with too many mediocre companies whose products, including children's clothes and stationery, had nothing to do with her core collection of feminine, sassy clothes. "People were offering

me deals [right and left], everything was moving so fast, and I was so young," she says.

The success of the wrap dress gave Diane the luxury of exploring new directions. She decided what she wanted now was to start a cosmetics business. The idea first came to her during her tryst with Ryan O'Neal at the Beverly Wilshire Hotel in Beverly Hills. Seeing the pots of makeup in her hotel room bathroom, the *Love Story* star chided her, "Why do you need all that stuff?" Embarrassed, Diane blurted, because "I'm thinking of buying the company" that made the cosmetics.

The bluff soon turned into a fierce ambition. She dreamed of joining "the ranks of women like Helena Rubinstein, Elizabeth Arden, and Estée Lauder, who created their own empires," she wrote. "I loved the legends of these women and rather fancied myself as an up-and-coming one of them."

Diane formed a cosmetics division in her company and hired a staff to produce a line of makeup and treatment products. In 1974 she opened her own DVF beauty store, finding an ideal spot in a small, empty shop on Madison Avenue between Sixty-First and Sixty-Second Streets, a few blocks from Halston's boutique. (Soon, the cosmetics would also be sold in stores that carried Diane's clothes.) She supervised the renovations, modeling the décor on the house of Guerlain on the Champs-Elysées, everything understated and elegant, with clinical bars and stools where women could sit to test the cosmetics. Diane's products, packed in beige pots and stored in cabinets painted with images of women representing the four seasons, included lip gloss, lipstick, powder, eyeliner, body shampoo, bath oil, and talcum powder, all moderately priced.

To celebrate the opening on November 11, 1974, Diane took out a full-page ad in the *New York Times*, featuring professionally written ad copy and a photograph of her by Francesco Scavullo. She hired a sales staff and makeup artists, including Gigi Williams, a twenty-four-year-old downtown club girl and wife of Andy Warhol assistant Ronnie Cutrone. Wil-

liams had a decidedly punk style—she favored boots, chains, studs, and spiky hair. But Diane insisted that Williams wear DVF to work like the other shop assistants. "I thought, 'Oh, my God, you've got to be fucking kidding me," recalls Williams. On the day the beauty shop opened, Williams was behind the counter in a DVF shirtdress in a green and black zebra print when an elderly woman with a cloud of white hair walked in wearing the exact same dress. "I was mortified!" she says. Diane gave Williams and the other sales staff two new DVF dresses a month, and eventually Williams learned how to adapt them to her own style. Diane let her express herself by wearing "two dresses at a time, with one like a coat, and crazy belts and cowboy boots," Williams recalls.

Diane loved having a cosmetics business, but her dream of becoming the next Estée Lauder never came true. "We never should have gone into cosmetics," says Dick Conrad. "I should have warned Diane off it. But I was just as infatuated with our success as she was. When you're a very fast-moving vehicle, as we were, you don't want to step off. You figure, everything else has worked out so well, this will, too."

But Diane couldn't repeat her wrap-dress success with lip gloss and mascara. "We were going up against armies, and we didn't even have a squad," says Conrad. "We were undercapitalized and undermanaged, and we were competing with world-class companies. Because of the clout of our dress business, we got good positioning in the stores, but it was still tough. We started losing a couple million a year."

The only bright spot in Diane's cosmetics line was Tatiana, a fragrance named after her daughter. Since couturier Paul Poiret introduced a signature perfume, Rosine, in 1911, designers have been linking scent to their fashion lines, the most famous example being Coco Chanel's Chanel No. 5. Introduced in 1921, Chanel No. 5 remains the world's most popular scent—every thirty seconds a bottle of it is sold somewhere in the world.

There are many reasons for a designer to get into the fragrance business. Scent is relatively inexpensive to manufacture, and it's cheaper than designer clothes, so it's a great way to draw customers to a brand. To

formulate Tatiana, Diane turned to Roure Bertrand Dupont in Grasse, France. One of the world's major creators of fragrances and the supplier of several of Estée Lauder's perfumes, Roure Bertrand Dupont produced hundreds of scents before Diane approved a fresh floral one that she felt not only smelled sensational but also comported with the bright femininity of her clothes.

Halston had hired Elsa Peretti to create a bulbous teardrop for his blockbuster eponymous fragrance, but to keep costs down, Diane used an ordinary stock bottle for Tatiana. She also came up with an ingenious way to promote the scent—a packet of Tatiana was attached to the cleaning instructions of the thousands of dresses she sold each week. Women tried the fragrance, and many turned around and bought a bottle. "We did very well with it. It made money," says Conrad.

The sales of the perfume Tatiana enabled Diane to fool herself that her cosmetics business was a wild success. "Diane can't tolerate anything negative," says Linda Bird Francke. "Everything has to be up."

In 1976, according to *WWD*, Diane employed one hundred people and her business overall made $133 million—$40 million from her licenses and $93 million in retail sales from her dress, cosmetics, and fine-jewelry divisions. Conrad says the bulk of the millions came from the wrap dress. She paid herself a salary of $100,000, plus $150,000 in annual bonuses, the equivalent of about a million in today's dollars.

Though her cosmetics line lost money, Diane would not give up her ambition to transform the faces of American women. In 1976 she published a book, *Diane von Furstenberg's Book of Beauty: How to Become a More Attractive, Confident and Sensual Woman*. The advice inside amounted to little more than generic tips on skin care and exercise, but Diane sincerely wanted to help women.

Her idea of doing cosmetic makeovers sprang from the same desire. Diane wanted to save women from their cosmetic mistakes, show them how to make the most of their looks, ease their anxieties about aging, and, in the process, improve their confidence. "Women would book

makeovers on the phone and come into the shop," Williams explains. "Then Diane and I started doing makeovers by mail. I made a questionnaire. Women would fill out information about their beauty routines. I'd make a face chart, and I'd paint the cosmetics on the face chart with my finger and send it back to them; they'd send it back to me and order the cosmetics."

When Diane sent Williams to do makeovers at the DVF cosmetics counter at Bloomingdales, Williams had to admit that she'd been fired from a job there and banned from the store a couple of years earlier after she'd been caught shoplifting an Estée Lauder lipstick. "Diane was appalled," Williams recalls. "She took it like a betrayal, and I understood. I was managing her boutique; I was in charge of all the money! But mostly, she was just hurt and disappointed. There's a very moralistic side to Diane. She just thought I was too good a person to stoop so low as to shoplift."

In fact, at the time she worked for Diane, Williams faced another personal issue—a serious drug problem. She shot up heroin every Friday night—"I only did it once a week; that was my rule," she says—and she'd arrive at work on Saturday morning after no sleep. But she was young and never seemed to show any ill effects. If Diane knew, she didn't let on. She decided to trust Williams, and Williams never gave her a reason to doubt the trust. "I was worried about going into Bloomindale's because I'd been banned, but [one of Diane's cosmetics executives] told me not to worry. 'They're not going to say anything because you're working for Diane,' he said." And he was right.

During the next several years, Williams traveled across the country to do makeovers and train the sales staff in department stores that sold DVF cosmetics, sometimes with Diane herself. Occasionally, they'd conduct makeup seminars in hotels. "We would do sixty makeovers a day," Williams recalls. "We'd pick a face in the crowd, and we'd say, 'Come on, come over here, within seven minutes you'll look beautiful.'

But we weren't just selling cosmetics. We were selling feminism. We'd tell women, you shouldn't be spending more than seven minutes on your makeup, and this is what you need—some mascara, cheek color, and lipstick—because you have more important things to do. Because you can be whatever you want to be."

The Adventuress

*T*hough their marriage was over, Diane and Egon would not divorce until 1983. They remained extremely close, bonded by their children, their shared past, their European roots, and their general delight in each other. "Do I think I could have lived with Egon my whole life?" Diane asks, her voice trailing off. She looks out the tall windows of the downtown building where she lives and works today to the sky beyond, as if searching for the answer in the clouds. The question remains open, but her wistful expression suggests she still misses Egon.

She spent most holidays with him and their children and, often, her boyfriend of the moment. Egon still bought Diane expensive jewelry, and they sometimes went out together as a couple. One evening in 1974 they arrived together at the Dakota on Seventy-Second Street and Central Park West for a party at the home of real estate developer Gil Shiva and his wife, Susan, the daughter of MCA Entertainment founder Jules Stein. The guest of honor that evening was the new chairman of Paramount Pictures, a thirty-two-year-old wunderkind named Barry Diller.

Diane usually delighted in meeting powerhouse men, but when she was introduced to Diller, "she was fairly dismissive of me," he recalls. Egon wasn't any more encouraging. He "told me my pants were too short," Diller says. "Probably they were. I was not a great sophisticate then."

Still, several months later Diane invited Diller to a party in her apartment for Hollywood agent Sue Mengers, who represented such stars as Michael Caine, Cher, Barbra Streisand, and Faye Dunaway. "I didn't want to go," Diller recalls. "But Sue said, 'It's for me, you have to come.' I arrived very late. It was at eight, and I probably showed up at ten. I thought I'd say hello, be nice to Sue, and leave."

Instead, he got involved in a conversation with Diane that changed his life. He doesn't recall what they talked about, but he felt powerfully drawn to her intelligence and sensuality. When Diane walked him to the door, for "some inexplicable reason, without a plot or anything in my head, I said, 'I'm going to call you,'" Diller says.

Diane was fascinated by Hollywood, and she thought Diller would be someone to know. His history had the feel of a movie on fast-forward. Raised in Beverly Hills, the son of a Jewish real estate developer and his gentile wife, Diller had dropped out of UCLA at nineteen to work in the mailroom of the William Morris talent agency, in those days the fastest route to moguldom for a Hollywood-enchanted boy.

Since its beginnings handling vaudeville acts at the turn of the twentieth century, William Morris had represented some of America's biggest stars, from Marilyn Monroe and Elvis Presley to Katharine Hepburn, Frank Sinatra, and Steve McQueen. In the mailroom, newly minted law school graduates and MBAs sorted mail and delivered contracts and scripts for forty dollars a week in the hopes of being tapped as an agent's assistant, the first step to becoming an agent themselves. "It was very much like West Point or freshman year at Harvard Law School," agent John Hartman told author David Rensin. Only the best and the brightest survived.

Diller got around the college degree requirement for most mailroom

employees because he'd been recommended by William Morris client Danny Thomas, whose daughter Marlo had been Diller's classmate at Beverly Hills High School. During his year in the mailroom, Diller observed the power structure at William Morris and studied the interoffice memos that detailed the agency's deals.

Soon he was tapped by agent Phil Weltman to become his assistant. A quick study, Diller absorbed everything there was to know about structuring deals. No one had to teach him the art of negotiating. He owned a killer instinct as powerful as Diane's sense of style.

Weltman soon promoted Diller to junior agent, but the restless young man did not stay in the job for long. At twenty-four, he left to become assistant to the head of programming at ABC. Later, as the network's vice-president of prime-time programming, he transformed television with innovations such as the *Movie of the Week* and the miniseries, including Alex Haley's slave drama, *Roots*, which exploded all ratings records. Then he moved to Paramount to concentrate on movies.

After an initial misstep with *Black Sunday,* a film about an Arab terrorist attack on a Super Bowl game in Miami that was partially told from the point of view of the terrorists, Diller went on to set industry records for box office receipts with movies such as *Saturday Night Fever* and *Grease.*

Soon after Diane's party for Mengers, Diller called Diane and explained that he wasn't sure where to take her to dinner, as he knew nothing about Manhattan restaurants. Diane suggested that he come to her apartment and had her cook prepare a meal. By the end of the evening, Diller says today, he was in love. Already, at least in the gay community, there was talk that Diller was gay, and one of his closest friends says that Diller's affair with Diane was the first he'd had with a woman. Diane herself says as much, writing in her second memoir that "no one had known [Diller] with a woman before." Diller started calling Diane every day. When she went to Paris a week later, he continued to call her and one day suggested she cut her trip short to visit him in Los Angeles. Diane agreed.

When the plane stopped in Montreal, she called her boyfriend, Jas Gawronski, from a phone booth and told him that she was on her way to visit another man. He only later found out it was Diller. The news shocked him because he thought his romance with her was going well. Following a classic pattern for Diane, they remained friends and continued to see each other occasionally.

Before her plane landed at LAX, Diane locked herself in the teensy bathroom to wash, perfume herself, apply makeup, and, in defiance of the fashion philosophy she'd been preaching, to "feel like a woman, wear a dress," changed out of her comfortable frock into a blue pin-striped pantsuit, which made her feel "sassy."

DILLER PICKED DIANE UP AT the airport in his yellow Jaguar and zipped her off to his house in Coldwater Canyon. A limousine trailed behind with her luggage. The sprawling Mediterranean-style stucco house, which had once been owned by Doris Day and which Diller had admired since visiting it as a boy, had a comfortable, old Hollywood feel and, indeed, had been furnished with props from Paramount movies. Diller had prepared a guest room for Diane with fresh flowers, "but I didn't sleep there that night—or, indeed, ever," she recalled. She slept in Diller's bedroom, with him. The first night, however, both of them were so nervous that they each took a Valium and promptly fell asleep.

"We spent about a week together in the LA house. It was just a big romance," Diller says. He drove Diane to the airport and when he got home found that "she'd left little notes for me all over my house."

Diller went to sleep that night feeling confident that he'd finally found his soul mate. At two in the morning, the ringing phone snapped him awake. It was a call from his mother—his brother, Donald, had been shot dead.

Donald Diller, who was four years older, had struggled with heroin addiction since his teen years. He'd been arrested several times for drug dealing and once for burglary. At eighteen he'd spent six months

in prison for writing a bad check. At the time of his death, he'd recently been released from prison on a drug charge. Police found him in a motel room outside San Diego with a bullet in his forehead, an apparent homicide victim in a drug deal gone wrong.

The news was shattering. It marked "the end of something," Diller recalls, but also "the beginning of something." His brother's death, he says, "was like a sign, a symbol" that the family he'd grown up with would be replaced by the family he'd form with Diane.

During the Los Angeles trip, Diane said later, she had fallen "very much in love with Barry, and I was overwhelmed by the way he loved me. Barry totally gave in to me, trusted me blindly, and loved me unconditionally."

Diller and Diane began to be seen together at Hollywood premieres and Manhattan parties. They traveled to Japan, where Diane made personal appearances in stores that carried her clothes. In the Philippines, they had a private tour of the presidential palace then occupied by Ferdinand and Imelda Marcos and rode a helicopter to the mountains to visit director Francis Ford Coppola on the set of *Apocalypse Now*.

When Diller presented Diane with twenty-nine diamonds in a Band-Aid box for her twenty-ninth birthday in 1975, many friends assumed they were engaged. That didn't stop the rumors about Diller's sexuality, or the snarky comments. "I guess the reason [Diller] and Diane are a couple is because she gives him straightness and he gives her powerfulness," Andy Warhol wrote in his diary after a 1978 Christmas Eve party at Diane's apartment.

Diller has refused to discuss his private life. Though he's been "outed" as a gay man by the gossip press and in mainstream publications such as *New York* magazine, and in books, including *The Operator*, Tom King's biography of Diller's close friend David Geffen, the press has mostly respected his privacy.

Diane says she's baffled by the curiosity about the couple's private life. "I don't understand what there is to understand," she told the writer

Andrew Goldman in 2013, during the twelfth year of her marriage to Diller. "This man has been my lover, my friend, and now he's my husband. I've been with him for thirty-five years. At times we were separated, at times we were only friends, at times we were lovers, at times we were husband and wife, that's our life."

Within no time Diller gave up his apartment in New York and lived with Diane and her children whenever he was in town. Once, while a reporter for *Vogue* interviewed Diane, Tatiana appeared all dressed up for her birthday party. "Go show [Barry]," Diane said.

"Where is he?" asked Tatiana.

"In the bedroom," Diane whispered.

"In your bedroom," Tatiana said sternly. "He's always in your bedroom."

They were two moguls in love—rich, good-looking, successful beyond their dreams. Diller had a projection room installed at Cloudwalk and showered Diane's children with presents. "He was always very generous and sweet," recalls Alex. "We'd get pinball machines and every licensing product from Paramount that you could imagine, [entry] to every movie. I'd roll into theaters with my friends, VIP style."

Life was *too* good, Diane said. She thought she would just die because it was all so wonderful, it couldn't continue.

Diane adored Diller, but that didn't stop her from having "flirtations" with others. "I slept with other people," she admits. The couple were often apart due to the demands of their careers. Long-term faithfulness was an ideal that didn't fit their lives or temperaments.

Diane says that in her relationship with Diller, as in her romances with other men, she's never been deeply concerned about what the other person does when he's not with her. "I don't ask questions," she says.

She admits she's had moments of being jealous, but her need for independence far surpasses whatever distress she might feel about a lover's infidelity. "I hate convention," she says, adding, "I'd much rather be the mistress than the wife."

Having bisexual partners is perhaps an ideal way for a woman to

maintain her independence, since bisexual men are less likely to want to possess a woman fully and exclusively. The tension between love and independence, the yearning to give herself to a man and the fierce drive to be completely self-sufficient has never resolved itself in Diane. Her mother had raised her to rely first and foremost on herself, to be content with her own company, to be her own best friend, a lesson that she passed on to her own children. "It hasn't been valuable in my family to have [exclusive] partnerships," says Tatiana. "The emergence of self has been a far, far greater force."

DURING THESE YEARS, DIANE THOUGHT of herself as an *aventurière*. The word, *adventuress* in English, connotes a scheming gold digger. But it can also evoke the image of a female risk taker, a woman who takes chances in business and in love. By her mid-twenties, Diane had achieved one of her chief goals—financial independence. She did not need a man for anything but pleasure, companionship, and emotional support. She had a conventionally male attitude toward sex: she would take lovers whenever and wherever it suited her. Diane's seductiveness became legendary, to the point where observers assumed she was sleeping with every man she was seen talking to at parties.

In the spring of 1976, in the middle of her affair with Barry Diller, gossip about Diane's love life focused on California governor Jerry Brown. They made an odd match. Brown was ascetic, Jesuit-educated, and unemotional. Diane was social, Jewish, and flamboyant. She loved clothes, jewelry, cars, and real estate. Brown disdained worldly possessions. He refused to live in the governor's mansion in Sacramento, occupying instead a small apartment where he slept on a mattress on the floor. Yet he shared with Diane a distinct quirkiness that led Chicago columnist Mike Royko to dub him "Governor Moonbeam."

On a warm evening in May 1976, Diane arrived at Brown's Manhattan hotel to escort him to a fund-raiser for him that she and Barry cohosted. Brown refused to ride in her chauffeur-driven black Mercedes,

instead arriving at the event in a dirty, mud-colored Ford supplied by one of his supporters.

A crowd of 140 prominent New Yorkers filled the elegant East Side townhouse that Guy de Brantes, Diane's vice president of finance, shared with his wife, Marina. The evening got off to an awkward start. Brown, who never touched alcohol, refused to drink, then when the *New York Times* editorial page editor, John Oakes, asked him a question, Brown accused the editor of using bad grammar.

Dustin Hoffman chatted with Bob Evans, who told a joke to Keith Carradine, who flirted with Marlo Thomas. Through it all, Brown looked miserable. "I'm here because I want to be president," he told Nancy Collins, who covered the event for *WWD*.

For a while, Diane kept a picture of Brown near a picture of Barry Diller in her bedroom, and she admitted to *People* magazine that Jerry Brown "was the first governor who ever kissed me." He "was so irresistible," she says today. At a party once Andy Warhol overheard Diane telling Brown "he'd gotten too skinny, that he'd lost his 'love handles' and that she'd liked them." When Warhol asked "Is Jerry a fairy?" Diane looked at him with flashing eyes. "No," she said. "Jerry's no fairy!"

Did they have an affair? "Yeah, briefly," says Diane, adding in a typical malapropism that uses a French word in place of an English one, "it was never actually consumed."

She couldn't say the same about her couplings with the men she picked up at Studio 54. Diane had discovered this new nocturnal center of New York decadence a year after the fund-raiser for Jerry Brown. The club had opened on West Fifty-Fourth Street between Broadway and Eighth Avenue in a vast, onetime opera house and TV studio that held three thousand people. To the pounding beat of disco music, Studio 54 offered a drug-fueled mix of sex, fashion, and neon cool. You didn't have to be rich or famous to get past Steve Rubell, the club's nebbishy co-owner, who often patrolled the velvet ropes guarding the entrance. But you did have to be young and beautiful. And if you weren't, no manner

of begging or bribing would get you in, though humiliation sometimes did. A suburbanite in a polyester suit once got through the door when he allowed Rubell to extinguish a cigarette on his jacket lapel, burning a large hole.

Diane first visited Studio 54 in May 1977 for a private party Halston threw for Bianca Jagger's birthday, a much photographed fête (the paparazzi almost outnumbered the one hundred guests). Bianca rode bareback across the immense dance floor on a white pony as the deejay played a disco version of "Happy Birthday." Her husband, Mick Jagger, danced with Baryshnikov. Colorful balloons swirled down from the ceiling.

From that night on, Diane became a regular at the club. At midnight she'd drive her gleaming Mercedes through the silent caverns of Midtown, then park in a garage and walk toward Eighth Avenue. Lights from the club's huge art deco sign pierced the inky sky. Rotating beams from police cars parked across the street (in case the partying got out of hand) sprayed the crowd with hot red light.

As one of the Chosen, Diane went to the head of the line, where the velvet ropes opened for her. Then she was inside, dancing to Donna Summer, flirting with handsome strangers, greeting her friends—Calvin, Andy, Truman, Halston, Diana. "I loved the feeling of walking in alone, like a cowboy walking into a saloon, feeling that I was breaking a taboo," she wrote in her first autobiography.

Her feeling of being a cowboy was apt, as the club had a decidedly gay male vibe. "It was all for the boys; there was nothing going on for the girls," says a Frenchwoman who frequented Studio 54 when she lived in New York in the seventies. "It was so sad. It was boys' shit: boys with boys, boys dancing with boys—boys, boys, boys. The people who were having the most fun were the gay boys. Their attitude toward the heterosexuals and the women was, 'You can watch, if you're good.' The girls who liked it were fag hags. I just hated it. At the clubs in Paris, even the gay clubs like the Palace, men made a fuss over you, and you wanted to look pretty because people looked at you. But at Studio 54 it was all about

guys salivating over the waiters with their shorts and bare chests. The women were superfluous. There wasn't even a veneer of civilization that says, 'Let's have a nice time.' It was very New York, in that everything in New York is agenda-driven. The agenda at Studio 54 was gays getting laid and getting high."

Diane never ventured to the hidden passages and subterranean rooms, the rubber-lined balcony where couples copulated openly. She wasn't there to join an orgy or blow her mind on drugs. When the tray of quaaludes held by a bare-chested bartender floated past in the blue dimness, she turned away.

She was there for fun and romance. "The hours between midnight and 2 A.M. belonged to me," she wrote. The men she picked up at Studio 54 included a onetime teenage runaway from Buffalo who gave her a switchblade and a dog named Roxanne. The switchblade was confiscated at the airport soon afterward, but she had the dog for sixteen years. Another partner was a college boy who lived with his parents in New Jersey.

She brought her young lovers to her new home, a sixteen-room apartment at 1060 Fifth Avenue that had once been owned by Rodman Rockefeller, Nelson's son. Flush with new wrap-dress money, she purchased the old WASP-style apartment in December 1976 as a thirtieth birthday present to herself, and moved in in May. The apartment overlooked the Central Park Reservoir and wasn't far from the home she'd shared with Egon on Park Avenue. But it marked a crucial change from her life as a wife. It was a woman's apartment, with a mirrored hallway, pink satin upholstery, a lipstick-red phone with push buttons for five lines, floral-patterned carpeting in the public rooms, and leopard carpeting in the bedroom. An emasculated male torso in bronze greeted visitors in the foyer.

Instead of the hard-edged surrealist and pop art favored by Egon, Diane bought sensual French orientalist paintings. In the living room, a dreamy vision of Fortuna, the goddess of chance and good luck, stared out from above the mantel at Andy Warhol's sultry silkscreen of Diane

on the opposite wall. The master suite had a spa bathroom with a sink big enough for Diane to climb up and sit in, as she often did when she applied her makeup. "The whole apartment had a very opulent, decadent 'in the harem' kind of feel," says Bob Colacello. "It felt like a Parisienne's version of the Ottoman Empire."

One August in the 1970s when he was working in New York, André Leon Talley, then the Paris editor of *WWD*, lived in Diane's apartment in a guest room "way in the back, way beyond the kitchen," he recalls. Diane and Talley were alone with the servants—her children were either at Cloudwalk or in Europe—and every night they went together to Studio 54. Diane loved to dance, but when she was with Talley, they'd mostly "sit on a banquette and look at people and comment. We were there to be part of the scene," he says. Diane's boyfriend that summer was a "very young, very hot-looking [boy], who did something like surfing or swimming. He didn't stay in the apartment, though he came once or twice for dinner." Once Diane lent him her Mercedes to drive home, and he totaled the car, though he escaped unhurt.

Diane's nocturnal uniform at the time was a black bodysuit, Norma Kamali ruffled gypsy skirt, black fishnet stockings, and ankle-strapped silk pumps with a closed toe and skinny heel, by Charles Jourdan, the Manolo Blahnik of his day. "Her closet was full of Kamali and Charles Jourdan," says Talley. Often, she'd wear rock-crystal bracelets and carry one of the minaudières she'd bought for next to nothing from antique jewelry dealer Fred Leighton. Later, Leighton moved uptown and became famous, but at the time he was still selling out of the back room of a downtown vintage shop.

Diane was often photographed on her evenings out in her Kamali and Jourdan shoes with her legs wound around each other in a double cross known in yoga as eagle pose. "She was very proud of her legs," says Talley, and crossing them in this serpentine way became "one of her identity moments in her signature look."

Fashion people talk a lot about "moments"—their parlance for the

instant when an item of clothing or a component of style is elevated to special status in the minds of those who care about such things. Diane had many fabulous "moments"—when Cecil Beaton photographed her in a black taffeta Oscar de la Renta gown at one of the last balls Marie-Hélène de Rothschild hosted at her Paris château; when she posed against a stark white wall with her arm thrown over her head for a Polaroid that became the basis of one of Andy Warhol's iconic portraits of her; and when she conceived the wrap dress, which was resonating still in the fashion zeitgeist.

DIANE RELISHED BEING A FEMALE dude, supporting herself in style and sleeping with whomever she liked. "I was playing the games men play," she wrote. And reversing gender roles "turned out to be fun," She cultivated the look of elaborate boredom and enjoyed playing that perennial turn-on, the girl who was impossible to get.

Rumors of lesbian affairs swirled around her. They'd begun with the 1973 *New York* article about her unconventional marriage and were fueled by rumored spottings of Diane in male disguise at the Anvil, a raunchy gay dive on Fourteenth Street. For a feminist like Diane, who believed that women "are better than men at everything they do," as she says, and who saw her mission in life as helping other women, it would not be surprising for her to occasionally be attracted to women. Nor would it be surprising for those feelings to spill over from time to time into actual sex. At boarding school in England, Diane had fallen in love with a masculine girl, her friend Deanna, with whom she lived in Spain for a year. The idea of Diane as bisexual fit into her louche public persona and her private conviction that sexuality should be fluid. "My mother doesn't understand why anyone would define their sexual orientation, because you could fall in love with a person of either gender. If you're open to everything, if you're loose," says Tatiana.

"Have I slept with women? Yes," says Diane. But, she adds, "I'm definitely not a lesbian."

She rejoiced at the weddings of her friends, including Marisa Berenson's 1976 marriage to the American industrialist James Randall, a celebrity-studded extravaganza that was filmed by ABC-TV. Diane told herself she was better off being single. She saw too many of her friends submerge their identities to conform to their husbands' desires, only to be adrift when the marriages ended.

IN THE MID-SEVENTIES, DIANE SEARCHED for ways to build on the success of the wrap and grow her business. After a manufacturer who made bedspreads for Sears offered Diane what she called a "huge advance" to put her name on his product, she decided to approach Sears directly about designing an entire line for their home furnishings department, which accounted for more than $1 billion a year in sales. One morning she flew to Chicago to meet with a group of executives, including Charles Moran, the general manager of Sears's catalogue division.

Diane sashayed into the meeting in the Sears Tower in a clingy, flowered-print dress. "Well, what do you think you could do for us?" asked a dazzled Moran.

"I'm dressing so many women in America that I would welcome the challenge of designing American homes," Diane answered.

She saw Sears as a chance to make some big money and expand her brand. Today high-low fashion pairings are common—Jason Wu and Target, Karl Lagerfeld and Macy's, H&M and Lanvin, to name a few— but in the late seventies such match-ups were controversial. Putting one's name on "cheap stuff," as Andy Warhol put it, was seen as selling out, and for some designers it became the kiss of death.

In 1982 when Halston announced he would design clothes for JCPenney in a deal that would guarantee him an estimated sixteen million dollars over the course of six years, Bergdorf Goodman, which had helped him start his career and had sold his clothes for a decade, dropped him completely.

Diane's Sears deal, though, did not interfere with her relationship

with the upper-tier department stores like Bloomingdale's and Saks, largely because the Sears products did not compete with her fashion and cosmetics lines. Nor was she defensive about offering her designs to a lower-end retailer. "I am not a snob," she said.

Diane's Sears line started with sheets—in an uncharacteristically sweet floral pattern—then expanded to towels, curtains, rugs, tableware, and furniture. She hired a team of designers to work on her Sears products, but still met regularly with the Chicago executives, who sometimes traveled to New York to see her. "There she is . . . like Sheena dropped among the dull Midwesterners in their conservative suits," as Julie Baumgold wrote in *New York*. Diane "sits at the bathmat lecture taking notes on the marketing analysis of shags and saxonies, whispering asides in French to the head of her studio, Olivier Gelbsman."

Diane's days passed in a blur of meetings, travel, promotional appearances, and more meetings. She recounted her hectic schedule for Bob Colacello in her second sit-down with *Interview,* in March 1977: "This morning I had breakfast at Bonwit's for about a hundred women; then after that, I came back here. We're going to have a product meeting soon; after that . . . from four to six—Tatiana is six today, so she . . . has a birthday party . . . after that I'm working till about eight, and then at eight I'm flying down to Miami . . . yesterday I was in Washington all day; last week I was in Minneapolis and Chicago, the week before in California."

This time she graced the cover of *Interview* in a portrait taken by her friend Ara Gallant, a former hairdresser who'd made a name photographing supermodels such as Twiggy and Veruschka. The photo had been shot late one night with her hair wet.

For the article, Colacello sat in Diane's Seventh Avenue office and interviewed her for an hour. Occasionally the conversation would be interrupted by visitors, such as designer Michael Vollbracht and several of her employees. At one point Diane said she liked television, which led Colacello to ask if she found "it difficult at all to design for the masses." Diane's reply revealed the uncynical sense of connection to her customers

that underpinned her success. "It's wrong to think that the mass is dumb and stupid, because it isn't true," she said.

Though Diane had reached the top of American life with lavish homes, servants, travel to exotic places, and high-achieving, famous friends, a part of her still identified as an ordinary woman. "Diane understands the person outside the glass, looking in at the magic garden," Howard Rosenman told the writer Michael Gross.

A year earlier, on January 28, 1976, Diane had landed on the front page of the *Wall Street Journal* in a piece headlined ONCE UPON A TIME A PRINCESS MADE IT WITH THE HOI POLLOI. That morning she was on an early-morning flight to Cleveland and found herself sitting next to a man who leered at her long, slender legs and slinky shirtdress. "What's a pretty girl like you doing reading *The Wall Street Journal*?" he asked.

Diane smiled but said nothing. Even if strangers on airplanes thought her nothing but a flirt-worthy babe, *she* knew who she was. She was Diane von Furstenberg, head of what the *WSJ* called a "fashion empire."

The story was just a prelude to the wider publicity Diane received two months later when *Newsweek* magazine put her on the cover of its March 22, 1976, issue in a story titled "Rags & Riches." The magazine had considered devoting the cover to Gerald Ford, who would soon win the Republican presidential primary, but at the last minute decided to go with Diane. "That [wrap] dress was very popular, and she wasn't bad looking, so we had her photographed," recalls Edward Kosner, then *Newsweek* editor.

Her notoriety also didn't hurt. "Part of her reputation at the time was that she was an oddball," Kosner says. "She was thought of as a little flaky. All that stuff about whether her husband, Egon, was gay, and whether she was a lesbian. She was an outré figure."

Newsweek assigned the piece to Linda Bird Francke, who'd written the scandalous 1973 *New York* story that revealed the von Furstenbergs' marriage to be a sham. Though her friends had been chagrined by the piece, Diane liked and respected Francke and felt that in the long run

the journalist had done her a favor by forcing her to face the unpleasant truth of her marriage.

For the cover photo by Francesco Scavullo, Diane wore a luxuriant fall and a green and white twig-print shirtdress. It was surprising that she didn't wear a wrap for the most important magazine cover of her career, but, as she explains, "I was so busy, I just grabbed the first thing" at hand. In the photograph she looks directly and unsmilingly at the viewer with her hands on her hips, the very model of the sexy, liberated woman.

The seven-page article was lavishly illustrated with color photographs of Diane in her office, with her children, with Barry Diller, and on the phone in bed. Diane is quoted saying, "For someone who never learned how to sew, I didn't do too bad, did I?" Francke interviewed Egon, who noted that "Diane is a good friend, an excellent mother and a terrible wife." Diana Vreeland also weighed in: "Diane is a wildly clever merchandiser. It is a lesson to some of the great designers that you don't have to keep coming out with something new. Do one thing very, very well."

Newsweek's editors did not believe Diane was twenty-nine, as she claimed, so they insisted she produce her birth certificate from Brussels, which she did. With her hollow cheeks and world-weary eyes, she looked older. But mostly she seemed older because few women her age had become so rich and successful.

The *Newsweek* cover exploded Diane's fame with reverberations far beyond fashion. She became a household star, her name and face recognizable to millions of people. Sales of all things DVF accelerated, and she found herself in even higher demand than before for interviews and public appearances. For a while she conducted a daily five-minute radio show on CBS in which she gave advice to other female executives.

At the time, feminists were searching for role models, and Diane was eager to serve. "I gave up the princess title so I could use the Ms. title, " she says. Still, *Ms.* magazine, the first periodical to be created, run, and owned solely by women, ignored her. The brainchild of Gloria Steinem, who'd become famous in 1963 for her exposé in *Show* magazine about

working undercover as a Playboy Bunny, *Ms.* first appeared as an insert in *New York* in 1971, and then in January 1972 as a monthly stand-alone publication.

Though Gloria Steinem today says, "I haven't worn a dress in thirty years," in the early seventies she wore the wrap. Later she and Diane became friendly through their shared commitment to global issues involving women, including the Women in the World Summit, a three-day conference held annually since 2010 in New York. Over the years, each also dated real estate and media mogul Mort Zuckerman. But *Ms.* did not get around to writing about Diane until 1986, and then in a group profile of four women designers, including Donna Karan, Liz Claiborne, and Katharine Hamnett, an Englishwoman best known for her political T-shirts, notably one emblazoned with the slogan NO MORE FASHION VICTIMS.

The lack of interest by *Ms.* probably says as much about a lingering conflict within feminism as it does about the magazine. Many feminists considered a focus on fashion and beauty as retrograde and demeaning to women. Diane, of course, disagreed, and she insisted that her eroticized image and the femininity of her clothes was not antifeminist. Being a feminist, doesn't mean "you have to look like a truck driver," she said.

Yet in popular culture that idea persisted. Gloria Steinem recalls how the stereotype affected impressions of her. "Before feminism, in college, I was a quote-unquote attractive, pretty girl. Then, because people were convinced feminists were ugly, I became a great beauty. Like an overnight sensation. It was quite amazing."

As the feminist debate grew more heated, Fashion came under fire for holding out impossible standards of perfection and for manipulating women into becoming objects of male desire. It didn't help that *Vogue*, still under the editorship of Diana Vreeland, ran articles that sneered at such brilliant but plainly garbed women as Susan Sontag, calling her "a tomboy who suffers from a bad Electra complex, has mysteriously produced a son, and tends to look upon men as intellectual wrestling opponents."

Perhaps as an antidote to such silliness and to the fact that historically, women journalists had been relegated to writing about little else but clothes, food, and society, *Ms.* went to the opposite extreme. "We rarely covered anyone in the fashion industry," says *Ms.* cofounder Letty Pogrebin. "*Ms.* was a serious newsmagazine. It had a limited number of pages each month and hundreds of underpublicized women's issues to cover both nationally and internationally. You wouldn't expect *The New Republic* or the *National Review* to cover fashion, would you?"

Steinem says, "We regarded ourselves as a remedial magazine. So we were striving to cover that which was not covered. Diane already was quite well known in the fashion world and quite well known in the social world, so I don't think it would have occurred to us. We were diligently engaged in covering what wasn't covered."

On the rare occasions when *Ms.* did write about fashion, the tone was earnest and defensive. Joanne Edgar, a founding editor of the magazine, remembers one article "in the early days that focused on cost per wear—how it made sense to spend a lot of money on one outfit if you wore it enough. This did not please advertisers who wanted us to buy a lot of clothes."

In the 1970s, feminism was joined at the hip with egalitarianism. Diane's lifestyle represented the kind of extravagance that made many feminists uncomfortable. They thought it unseemly to live as luxuriously as Diane did when so many women were suffering. She resided in splendor in Manhattan and Connecticut. She employed servants. She entertained lavishly. She wore jewels and fur coats.

Diane's political convictions, however, were liberal. She followed politics in the news, enjoyed discussing national and world events, and perfected the skills of a political hostess at fund-raisers in her apartment for New York mayor Edward Koch, a Democrat. She relished being close to political power.

On March 17, 1976, Luis Estévez, the California designer who dressed First Lady Betty Ford, invited Diane to be his date at a White

House state dinner in honor of Irish prime minister Liam Cosgrave. While having cocktails in her hotel suite with Estévez before the dinner, Diller called. *He* wanted to be the one to take her to the White House for the first time. "Too bad, I got there first!" says Estévez.

Diane entered the East Room in a black satin strapless dress she'd borrowed from Halston that had ties under the bust holding it up. The ties kept slipping, and Diane struggled to hold the dress in place. The party was in full swing, jammed to a standstill with celebrities and dignitaries, the women in ball gowns, the men in black tie.

Though Diane was not an American citizen and couldn't vote, she would not be supporting President Gerald Ford in the upcoming election, backing instead his opponent, Jimmy Carter, who had won the Democratic presidential nomination. Still, at the White House dinner she earned a place at the head table, seated on the president's left. Estévez was seated on Betty Ford's left, at her table. Diane told Ford that she'd only beaten him out as the *Newsweek* cover at the last minute. "If I had to be beaten by anyone, I'm glad it was you," he told her.

Then he asked Diane to dance. "It was the fox-trot or some old-fashioned dance like that which I absolutely could not do at all," she recalled in her first autobiography. The president "was a very good dancer, but all I did was trip over his feet and pray the dance would end before my strapless dress fell off."

Requiem for a Dress

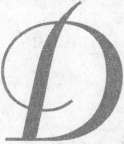iane's life had the breakneck quality of a sprint in stilettoes. She was living out a fantasy of money and fame, but she was moving too fast on a base that was nothing more than a teetering spike.

All art forms are subject to trends. But a good novel, painting, or symphony holds its artistic value, whereas fashion reflects the moment, the collective craving for what's hot now. Worship of the new means it's only a matter of time before yesterday's favorite is passé, before something else takes the top spot. Diane feared someday she'd fall, and when she did, her decline was swift and merciless.

One hot Sunday morning in June 1977, while reading the papers in bed, Diane saw a spate of ads that made her freeze with dread. Some of the top department stores in New York, including B. Altman, Saks, Macy's, and Lord & Taylor, had slashed the price of her dresses. Styles that had been selling for $80 were now going for $64, and those at the high end, at $186, were being offered at $93. The ads avoided spelling out her name but references to "that exciting designer who brought you that famous wrap" left

nothing to speculation. She read and reread the ads in the pink satin plushness of her bedroom, and each time the words and numbers shocked. This was disaster. Her business had grown too big too fast. She'd started with three little outfits and by 1977 was selling twenty-five thousand dresses a week, an explosion that fueled her lucrative licenses.

The papers the next day held more bad news. Bonwit Teller and Bloomingdale's had also slashed the price of her dresses. *WWD* followed with a front-page story. Under a huge headline, VON FURSTENBERG LINE MARKED DOWN BY SIX N.Y. STORES, the story began:

> Diane von Furstenberg dresses, not named as such but thinly disguised in advertising copy, went on sale Sunday. . . . Retailers were reluctant to discuss the genesis of the decision to break prices on the same day. . . . But one store official referred to it as "an eyebrow-raising coincidence" which could create a "sticky" situation.
>
> What is behind the slowdown in sales, some believe, is the thought that the classic von Furstenberg wrap dress may have run out of gas. . . . The lack of diversification may have finally come back to haunt the company. Criticism was voiced that von Furstenberg may have stayed on top of this dress too long; retailers had earlier indicated this lack of diversity was a major danger point for the firm, but it evidently may be coming to a head sooner than anticipated.
>
> It was also pointed out that the von Furstenberg lines have been knocked off, imitated (in some cases with the same basic fabric and print styling) but with enough difference to make the dresses a bit more interesting so women wouldn't see themselves coming and going. This has hurt von Furstenberg sales.

WWD covered the fashion business, so reporting on sales was no surprise, but what startled Seventh Avenue insiders was the prominent play

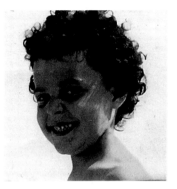

Curls and smiles—
Diane as a child.
(Courtesy of Diane von Furstenberg)

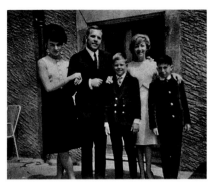

Diane, Hans, Martin, Lily and
Philippe in Geneva, summer 1963.
(Courtesy of Martin Muller)

Future femme fatale—
Diane in the 1960s.
(Courtesy of Martin Muller)

Climbing up—
Diane in the 1960s.
(Courtesy of Martin Muller)

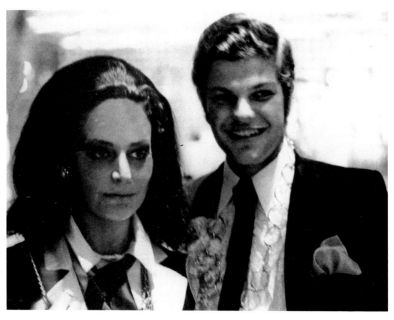

Diane and Egon at a party at the Venice Film Festival, 1967.
(Photograph by Countess Marina Cicogna, courtesy of Countess Marina Cicogna)

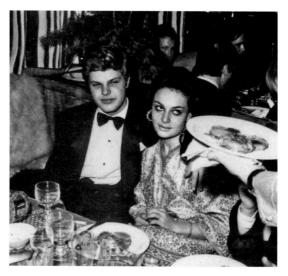

The prince and his future princess.
(Courtesy of Martin Muller)

Angelo Ferretti
in Monte Carlo.
*(Courtesy of
Diane von Furstenberg)*

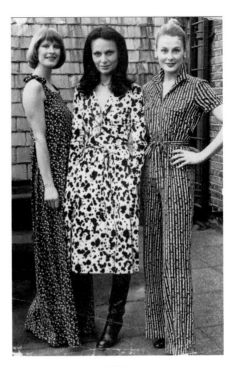

Posing in DVF for *Vogue*—
Diane and two models.
*(Photograph by Marcio Madeira/Clifford Ling/
Evening News/Rex USA)*

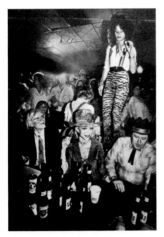

Andy Warhol in a rare
moment looking up to
Diane—at the *Urban
Cowboy* premier party in
Dallas, 1980.
*(John van Beekum/
The Houston Chronicle)*

Diane
kicking back
with friends
at Studio 54.
*(Ron Galella/
Getty Images)*

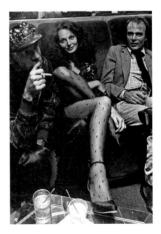

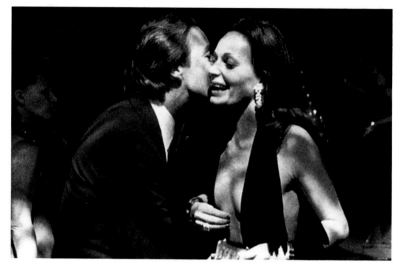

Halston and Diane at the Costume Institute show at the
Metropolitan Museum of Art in 1970.

(Larry Morris/The New York Times)

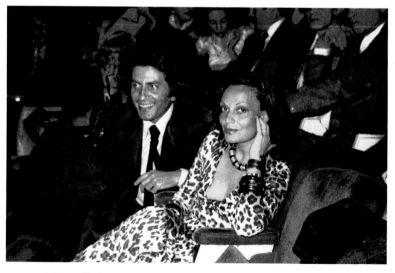

Olivier Gelbsman and Diane at a screening of *Andy Warhol's
Frankenstein* in New York, May 1974.

(Tim Boxer/Getty Images)

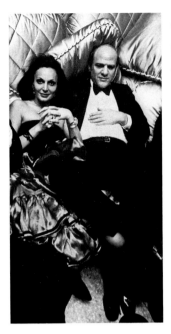

Two moguls in love—
Diane and Barry.

(Photograph courtesy Daily Mail)

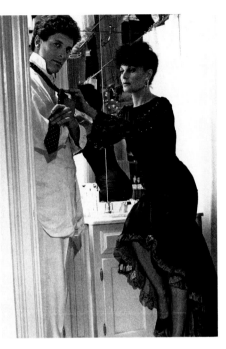

Getting ready for a night out with Alain.

(Courtesy of Diane von Furstenberg)

Tatiana and Alexandre attend
mom's fashion show at the Pierre
Hotel in New York, 1974.

*(Courtesy of Diane von Furstenberg,
photograph by Ann Phillips)*

Martin Muller, Diane, Alain and Lois
Lehrman, publisher of the *Nob Hill Gazette*,
at a signing for Alain's book *Piazza
Carignano* in San Francisco in 1986.

(Courtesy of Martin Muller)

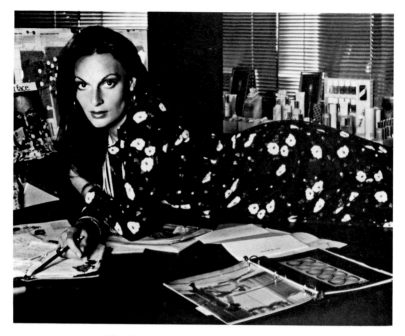

The feline designer in her office, 1976.

(Photograph by Ara Gallant, courtesy of Diane von Furstenberg)

Lily and Hans in Lisbon, Portugal, 1970.

(Courtesy of Martin Muller)

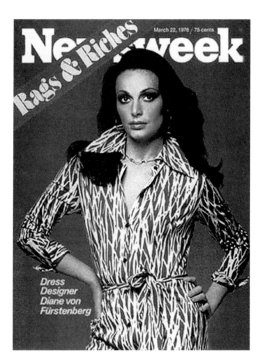

Beating out
President Gerald Ford
for the *Newsweek* cover
on March 22, 1976.

A wrap top and the first wrap
dress—from a buyer's catalog.

(Courtesy of Diane von Furstenberg)

In the beginning—an ad for a
wrap top and flare skirt.

(Courtesy of Diane von Furstenberg)

The wrap redux—
Alexandra von Furstenberg
and her then mother-in-law.
(Steffen Thalemann)

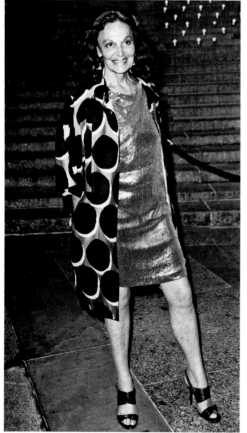

A woman for all seasons.
(epa/Peter Foley)

the newspaper had given the story. For all the pleasure publisher John Fairchild took in his power to make or break designers, no one could recall when he had singled out one designer for a piece about a season-end clearance, let alone in a banner headline on the front page.

At one time Fairchild had promoted Diane's career. *WWD* had written about Diane frequently in stories and columns and, aside from an occasional dis, had mostly favorably reviewed her collections. Now she was Fairchild's latest victim.

And yet Diane couldn't blame the publisher. The story was accurate. She and Dick Conrad knew that sales had slowed. "The handwriting was on the wall in January," says Conrad. "For the first time since we'd started the business in April 1972, our bookings were down."

"I was traveling around the country, and I could see that the stores were [saturated] with wrap dresses. I was worried," says Diane.

Still, she was unable or unwilling to respond to what was happening. "She was bringing in the bacon, but she wasn't keeping track of where it was going," says one observer. "She's not savvy about money and numbers. It was naïve to think wrap-dress sales would continue at that pace. For someone who supposedly understands women so well, didn't she realize women wouldn't need more than one or two wrap dresses? She was spending all her energy on keeping up with demand. She never stepped back and said, 'How long can this continue?' Well, the market answered the question for her."

WWD's story killed the wrap as effectively as if Fairchild himself had slashed the dresses with a knife. Within days Diane von Furstenberg dresses went on sale in every city in the nation. Orders for new dresses screeched to a halt. Overnight, Diane found herself stuck with four million dollars in dead inventory. (Conrad says he was not taken by surprise by the sudden markdowns, that he had offered the New York stores discounts, and that he suggested they reduce the price of the dresses 25 percent.) Diane's company was close to bankruptcy, and she feared she'd lose her apartment and Cloudwalk. She concluded that the men in her

professional life—her accountant, her lawyer, and her business partner—had given her bad advice. When the wrap became an instant sensation in 1974, and money was pouring in from practically every store in America "that had four walls and a ceiling," as Diane wrote, her advisors embraced the runaway growth. Her instincts had told her to build slowly, cautiously, but she'd been swayed by the men around her. Something in the male ego, she decided, impelled them to charge ahead. Men were such fools, such bumblers—*les pauvres*, her mother had called them.

The terrible paradox, Diane knew, was that women still loved her dresses, still wore them constantly. In desperation, the partners decided to produce some dresses in solid colors, and they turned to the domestic textile firm Burlington. (As brilliant as Ferretti was with printed jersey, "he could not make a clean piece of solid jersey fabric," says Conrad.) But the line of dresses in solid colors flopped.

Though Diane's printed wraps were languishing on department store racks, they remained hot sellers on the street. In recent months, Diane's warehouse had been broken into several times. One gang of thieves backed a truck up to the warehouse in the middle of the night, cut a hole in the wall, and made off with twenty thousand dresses.

After that, Dick Conrad hired a childhood friend who had a license to carry a gun to patrol the warehouse. "Diane hates guns, and when she found out about it, she said I had to fire him. But I wouldn't do it; he needed the job. So Diane fired him," Conrad recalls.

By this time, Conrad and Diane were barely speaking. They'd created something out of nothing and grown rich together. They'd become so successful, they started to feel they could do anything. Diane recalls that Conrad even "came in one morning toward the end and said he was going to run for president!" She suspected he'd been drinking and turned wildly grandiose. Still, it worried her, and she called her lawyer. "I think we have a problem," she told him. There wasn't much the lawyer could do.

The incident was only one symptom of the flakiness that had enveloped the studio. "It was a House of Eurotrash," recalls DeBare Saun-

ders, who oversaw Diane's licenses and designed her jewelry collection. "Diane employed a lot people who were friends and playmates of hers and Egon's. They'd come to work or not come to work. As nice as some of these people were, I kept firing them because they'd come in stoned or spend three hours having lunch."

The office was chaotic, plagued by disorganization and theft, says Saunders. Diane paid him well, but he found her difficult to work with, very combative and argumentative. "I was twenty-two years old. Only my EST training," the controversial self-awareness program founded by Werner Erhard, "gave me the strength to stand up to her," he says.

After several instances when Saunders claims Diane denied that she'd approved items that he had ordered, Saunders began keeping a logbook of all his projects and expenditures. He asked Diane to sign and date every authorized item.

"What happened to [Diane] is classic," says Barry Diller. "She built up a huge business without much talent on the business side, and so it was inevitable. . . . The channels got clogged, backed up; she didn't have enough capital, and she was squeezed. It's a common story of an under-capitalized company growing faster than its brains and experience and getting caught."

What Diane should have done, says Diller, is recognize the risk when her business exploded in the mid-seventies, and plan for it by shaving inventory down. Now it was too late. Diane knew that in order to secure her financial future she had to do the unthinkable—sell her dress business. Still, every time she walked into the showroom, the dazzle of color on the racks and shelves extending from floor to ceiling caused a catch in her throat. *Her dresses!* She couldn't imagine life without them.

"I was just glad there was a customer" to take them off her hands, says Diller.

His name was Carl Rosen. A short fireplug of a man with the temperament of a bulldog and the decadent tastes of a French king, Rosen owned Puritan Fashion, the world's largest low-priced clothing manufac-

turer. Seventh Avenue insiders liked to sneer that Puritan was famous for churning out "dresses for the masses with fat asses." Even the company's name was a joke: Rosen routinely supplied his best customers with hookers and treated them to debauched parties in Las Vegas. Puritan's salesmen were notoriously unfaithful to their wives; the company's divorce rate was stratospheric.

Rosen kept *his* mistress, the mother of one of his three daughters, in a lavish Park Avenue apartment, while he shared a duplex on Central Park South with his wife. He also owned homes in Miami Beach, Massachusetts, and Palm Springs, a stable of racehorses, and a gold Rolls-Royce with a royal crest that supposedly had once belonged to England's queen mother.

Rosen's office sat at Thirty-Eighth and Broadway, a short block from Diane's Seventh Avenue showroom but a world away in aesthetics. Seventh Avenue meant class: pricey, well-made, stylish. Broadway meant mass: cheap, flimsy, vulgar. In Rosen's office, racing trophies jammed the bookshelves and photographs of horses in the winner's circle hung on the walls in silver frames. Rosen had a craggy, tanned face and abundant aluminum-colored hair slicked back with brilliantine. He wore bespoke suits; diamonds winked from the French cuffs of his shirts. An entourage of sycophants trailed him wherever he went, which often was to the helipad atop the Pan Am Building. "We took helicopters everywhere—to the airport, the Hamptons, the track," recalls Lee Mellis, Puritan's chief financial officer. At the racetrack, Rosen bet so heavily that he had an employee trail him with a suitcase full of cash.

Puritan had been started by Rosen's father, Arthur, in 1912, but Carl made the company rich by exploiting trends. In the fifties, when Paris fashion was still the last word on style, Rosen paid a commission to a roster of couture houses, including Lanvin, Givenchy, Cardin, Patou, and Dior, for use of their names and knocked off their clothes for middle-class Americans. He also produced a line of clothing by silent film star Gloria Swanson, who'd had a smash comeback in *Sunset Boulevard*. At the height

of the British music invasion in the sixties, he sold Beatles merchandise. As the seventies dawned, Rosen became convinced that Puritan should move out of schlock and into upscale designer apparel, especially clothes attached to big names. He'd done well with a Chris Evert line of sports clothes, and he hit the jackpot with a license to manufacture and market Calvin Klein jeans. "Designers were becoming stars. My dad knew this was the future of the business," says Andrew Rosen, CEO of the apparel company Theory, who got his start working for his father. "He wouldn't have taken a long time deciding he wanted to buy Diane's business. He knew dresses better than anyone."

When Rosen heard that Diane was in trouble, "we approached her," says Mellis. "We were set on picking up designers. We'd already made an attempt to get Ralph Lauren and Betsey Johnson. We thought we could duplicate the success we'd had with Calvin Klein with Diane."

Diane's business collapsed during a period when she and Diller were romantically involved, and he took charge of the negotiations with Carl Rosen. "It was over Christmas, and we were in the country at Cloudwalk for a week, and almost every day we had to drive into New York and back for a meeting with him," says Diller. Rosen "was very tough, and I was tough." At one point, Diller recalls, "I pushed too far, and [Rosen] said, 'It's over!' Then we put [the deal] back together again. This happened twice. It was very difficult, but Diane had to do it. She had no choice."

In the end, Rosen sat in Diane's New York living room in one of her marshmallowy satin chairs, a cigarette between the broad manicured fingers of his right hand. A scrim of smoke mixed with the flowery scent of Fracas, a heavy French women's perfume that Rosen always wore, giving him the whiff of an expensive whore.

Mostly, though, he smelled like money. Flicking ash from his cigarette into an ashtray, he sized Diane up with two intent black eyes and smiled broadly. He was a sucker for a beautiful woman, even one who wanted to best him in a business deal.

In the end, Rosen bought Diane's entire inventory of dresses, which

he unloaded at a steep discount, mostly in South Korea. He also gave her a minimum guarantee of one million dollars a year for her consulting and design services, plus a percentage on royalties of dresses Rosen would produce under Diane's name.

Diane hadn't sold her soul, just her dresses. She still had her cosmetics line and her other licenses. Why, then, did she feel so empty? After signing the agreement, she walked out into the boisterous New York afternoon and thought of her mother, as she always did during times of distress. She "was never a victim, *never*," Diane says. Lily Nahmias was a survivor, and Diane would be one, too.

DIANE'S EMPLOYEES TOOK THE NEWS badly. "Suddenly, overnight, it was over," says Jaine O'Neil. "Carl Rosen came to tell us what was going on, and I remember knowing, 'This is it. Our days are numbered.' He was Broadway, the wrong side of the fashion tracks. One by one we were told that now it was Rosen's business, so he was going to use *his* people." O'Neil and the rest of the staff were out of jobs.

No one was more distressed than Angelo Ferretti. As Diane's business had grown, he'd canceled most of his other contracts. Diane had also insisted that he not sell the jersey fabric used for her dresses to other designers, and Ferretti had agreed. "But he couldn't help himself" from reneging on the promise when the opportunity arose, Conrad says. One day in the early seventies, Ferretti met Oscar de la Renta in Monte Carlo and offered to sell the designer the wrap-dress jersey. De la Renta declined the offer once Diller and Conrad apprised him of Diane's agreement with the Italian.

By 1977, Ferretti's employees at the Montevarchi factory worked almost exclusively for Diane. She pressed Rosen to continue with Ferretti, and Rosen made the journey to Europe to meet him. They hit the casinos in Monte Carlo together, two flamboyant operators who understood each other only in the lingua franca of gambling. "Diane owed us a lot of money, and we were very worried," says Mimmo Ferretti.

As it turned out, Rosen had his DVF line made in Asia. Ferretti's orders from DVF screeched to a halt. "We sat in front of the fax, like we always did, but the orders didn't come. It was shocking, really shocking," says Mimmo.

His father was desperate, at risk of losing everything. He started paying the workers with his own money, and he sent Mimmo to New York to find a solution, to perhaps work out an arrangement with Puritan. Mimmo moved into a suite at Olympic Tower, "where all the Eurotrash stayed," he says, and plotted his next move. "Now I'm in New York, and I'm able to look at the situation in a shark-like, New York business way, not a [laid-back] Italian way, and I know that I have to sue Diane," says Mimmo. "She owes my father a lot of money, and then there's the issue of breach of contract."

Mimmo interviewed several white-glove lawyers "who all had big offices with big paintings, like Picassos, on the walls," he says. Then he got the idea to contact Roy Cohn.

Cohn had become famous during the Red Scare of the 1950s as counsel to Senator Joseph McCarthy, mouthpiece of the nation's communist witch hunt. Afterward, in private practice, Cohn worked a favor bank of politics, gangster, and union-boss connections to get results that seemed magical. "I don't want to know what the law is," he'd often tell his assistants. "I want to know who the judge is."

A habitué of Manhattan's gay netherworld of bars and hook-up joints, Cohn—who would die of AIDS in 1986—didn't think of himself as homosexual; he was too manly, tough, and aggressive to be queer, no matter whom he liked to bed.

One sunny afternoon Mimmo showed up at Cohn's East Sixty-Eighth Street townhouse that doubled as his office. The place "was full of beautiful boys," Mimmo recalls. One of them escorted Mimmo to the rooftop terrace, where Cohn lay spread-eagled on a chaise lounge in a tiny Speedo, the sun glistening off his oiled body.

Blinking against the sun, Mimmo explained the Ferrettis' case, "that

Diane had breached her contract with us and that she owed us a lot of money. Then I mentioned Carl Rosen and Calvin Klein jeans."

That got Cohn's attention. He put on a robe and escorted Mimmo inside to his office. He asked for twenty thousand dollars up front, and 15 percent of any settlement that was reached with Diane. The two men shook hands, and Mimmo left, feeling confident that he'd done the right thing for this father.

Soon afterward Diane received legal papers from Cohn's office. Ferretti had filed a lawsuit in New York State Supreme Court against Diane and Puritan, seeking $104 million in damages for loss of business and breach of contract. "I will never forget the terror knowing that I had Roy Cohn against me," Diane recalled in her first memoir. Still, she summoned the courage to telephone Cohn and "threatened him with something so dire [about Ferretti] that the suit was retracted. Maybe I pretended I knew something I didn't know. I can't remember."

Mimmo says Diane knew that his father had substantial sums of money hidden in Swiss bank accounts. If this came out, he could have gone to jail in Italy for hiding assets and avoiding taxes. "My father got scared," says Mimmo.

Angelo Ferretti ended up bitter and unhappy, dropping dead of complications from diabetes as he exited a Monte Carlo casino in April 1994. Mimmo, though, doesn't blame Diane for his father's misery, and they remain friends. "Everyone has some responsibility here—Diane for not warning us that the American market was changing, and my father for being too complacent. He made a lot of money with Diane, and he gambled it all away."

BY THE END OF 1978 Diane was once again full of hope. She was only thirty-two; she had plenty of time to remake her life and her fortune. "I have a lot down my sleeve," she told a reporter, revealing her weak command of English idioms after almost a decade in New York. "Maybe I *could* be the next Estée Lauder."

Never mind that a DVF cosmetics business had already floundered once and that she'd been forced to shut her Madison Avenue shop. She told herself this time would be different.

Diane restructured her company from top to bottom, buying out Richard Conrad, who moved on to run the women's apparel company Kimberly Knitwear, and replacing her lawyer and accountant, the men she'd relied on but felt "had ill advised me." As her new president, she hired Sheppard Zinovoy, who'd been a senior vice president of marketing for Calvin Klein. To run her cosmetics division, she approached Gary Savage, a young man who'd worked on fragrances for some of the world's top fashion houses, including Pierre Cardin, Bill Blass, Lanvin, and Saint Laurent. Diane was impressed by Savage, but before she hired him she put him through her usual test for important executives. He had to have lunch with her mother. Lily "asked me about my background, about my parents and grandparents. She wanted to make sure I was a real mensch," says Savage.

Afterward, Diane told him, "My mother likes you. Now you have to meet Yolana," Diane's psychic. "So I go over to Diane's apartment, and there's Yolana," Savage recalls. "She had the longest nails I've ever seen, and she was dressed kind of bohemian. But she was a very nice person. She asked me questions about my career, about how I saw myself fitting in with Diane."

Savage believes Diane also discussed him with Barry Diller. "They all wanted to make sure that I could get along with Diane without overpowering her, but that also if I felt strongly enough about something, I would tell her."

In keeping with her ambition to become the world's next cosmetics queen, Diane moved her offices uptown to New York's hallowed corner of conspicuous consumption, Fifty-Seventh Street and Fifth Avenue. She leased an entire floor in the art deco Squibb building, across the street from the headquarters of Estée Lauder and within lipstick-throwing distance of those high temples of luxury—Bergdorf Goodman, Tiffany, and the Plaza Hotel.

She decorated the ten-thousand-square-foot space with purple carpets, photos of herself, and framed press clippings. A huge painting of an orchid looking distinctly like a vagina hung prominently in the reception area. Diane's pink command center featured a photograph of Marilyn Monroe holding a martini glass and looking tipsy, and a plant that Diane spritzed with Evian water, because "it's a very chic plant." In a nearby lab, an Italian chemist experimented with beauty formulas while a makeup artist played with colors for Diane's new cosmetics line, the Color Authority.

The new headquarters held a design studio, where Diane consulted with the licensees who made products under her name. But her heart wasn't in it. She told a reporter that she was down on fashion, because women had become more interested in their houses and jobs than in clothes. The truth was, in giving up her dress business to Rosen, *she'd* lost interest. She now focused her ambition on beauty and scent.

Savage immediately got to work repackaging Tatiana, which had been Diane's best-selling beauty product. French sculptor Serge Mansau designed an angled glass bottle for the fragrance, and Diane came up with a new tag line—"for a woman to love and a man to remember." Savage also reformulated Tatiana's fragrance components to make it more evocative of a Euro-disco idea of sexy, as Diane told *WWD*, "very velvety, purple and slightly perverse." Her ambition for Tatiana was the same as it had been for her dresses. "She wanted to be the low of the high," says Savage—that is, at the lowest price point and still be a luxury brand. They priced Tatiana about four dollars below Chanel No. 5., "and the strategy worked. Tatiana became the number five fragrance in US department stores, and internationally, it sold in forty-five countries. "We did especially well with it in the Middle East, and the Filipinos bought it like no tomorrow," says Savage.

Producing a hit cosmetics line turned out to be more problematic. Unlike fragrance, cosmetics had to be reinvented every season just like clothes, with new colors, themes, and promotions. Diane felt tremen-

dous pressure. Her licenses weren't doing well. After Rosen unloaded the dresses from Diane's warehouse, he began manufacturing new ones under her name, though in inferior fabric and, despite Diane's input, inferior style. "They didn't turn out to be as profitable as we anticipated," understates Lee Mellis. "They weren't selling. Part of it was that we didn't put enough into it. But it just didn't work." Still, Puritan held on to the DVF dress license for five years, finally ending it in 1982.

Nor were Diane's other fashion ventures faring well. In 1979, in the middle of the designer-jeans craze, she put her name to a jeans line. Across the country—in a ritual reminiscent of nineteenth-century fashion victims who corseted themselves to suffocation to get the tiniest waist possible—women were lying on the floor, sucking in their breath, and zippering themselves into glove-snug blue denim with a designer name stitched on the butt. Gloria Vanderbilt alone had sold six million of the tighter version of the old farmers' Levis. She was soon outdone by Calvin Klein. In 1980 he launched a provocative ad campaign in which fifteen-year-old Brooke Shields purred seductively as she wiggled in her jeans: "You wanna know what comes between me and my Calvins? Nothing." Soon Klein was selling two million pairs of jeans a month.

Diane's foray into jeans flopped spectacularly. Though she usually had a genius for striking the right note, a kitschy ad she ran to promote the line in Japan is emblematic of the venture's misguided nature. It carried a photograph of Diane, her hair frizzing wildly, stretched out catlike in light-blue DVF jeans and red boots, superimposed on a photograph of the Empire State Building.

WHEN THE FASHION GODS ARE against you, there isn't much to be done. Still, Diane soldiered on. She continued her manic traveling, much of it for business meetings and appearances at department stores around the nation, but also for high-profile social events. In June 1980 she was in Houston with Barry Diller for the city's premiere of *Urban Cowboy*. *WWD* photographed her wearing vintage diamond jewelry,

skin-tight zebra-print pants, leopard cowboy boots, and a vest pinned with a sheriff's badge reading DISCO SUCKS. By the end of the seventies, loathing disco, which was deplored by rock fans and musicians for its hollow escapism, had become a mark of cool.

At the Gaylynn Theater, named after Houston socialite Lynn Wyatt, Diane and Diller sat with Andy Warhol and his entourage. John Travolta, the film's star, chatted nearby with a pretty girl who turned out to be a "DVF groupie," Warhol noted in his diary, adding that Diane was so "desperate to be recognized that if one person says, 'You're Diane von Furstenberg, I love you,' she says, 'Come with me,' and she makes them follow her around for the rest of the night so she can have a following, and then she gives them presents—she carries lipsticks and compacts with her to give out, and she autographs them."

Warhol excelled at putting a mean spin on events, but he noticed something that others had also begun to sense—Diane's presence no longer caused the stir it once did. Her looks hadn't changed—she was still beautiful and sexy—but she'd stopped being the kind of celebrity who quickened pulses and awakened curiosity. Her moment had passed. The wrap dress was over. She was out of sync with what was hot and in, a bleak spot for any designer.

Egon, meanwhile, was still playing catch-up. He had followed Diane's career with a mixture of admiration and frustration. There was something poignant about his attempts to emulate her at every step. She launched a home furnishings line; he did, too. She created a fragrance; he produced Prince Egon cologne for men. She wrote a beauty book for women; he published a grooming manual for men, *The Power Look*, in 1978. He often told reporters that *he* had pushed Diane into fashion in the first place. Diane says, "He resented my big, huge success."

Egon had also launched a line of high-end women's wear, which he sold, in addition to fur and leather coats, at his eponymous boutique at 800 Madison Avenue. Egon "was really difficult," says Sally Randall, an art school graduate who worked as a secretary and makeup artist for

Diane in the early eighties. "He would call people up in Diane's office and ask them to do things for him. He called me. He wanted me to do drawings for an invitation. Egon was nice, but he expected you to say yes to these requests. I asked Diane, 'What should I do?' She'd sigh and roll her eyes and say, 'Don't worry about it.' Then she'd get on the phone and tell him no."

Though by now separated from Egon for almost eight years, Diane had no interest in getting a divorce. "I don't like to renege on things. I was born Belgian, so I'll stay Belgian. I was married, so I'll stay married," she told an interviewer in November 1981. But Egon had met someone he wanted to marry, a twenty-nine-year-old black-haired beauty from Mississippi named Lynn Marshall. He decided to get remarried around the time "he found out he was [HIV] positive," says Diane. Marrying Lynn was a way of denying the illness, then at the height of its stigma. He couldn't fool his children, though, who were in Mexico with Egon at the time of his second marriage. "I think Daddy's gay," Alex told Diane.

The divorce (the terms of which have remained private) and Egon's remarriage did little to change his relationship with Diane. "He loved me, and he was always much closer to me than he was to Lynn," she says.

From his office on West Fifty-Seventh Street, Egon could see into Diane's Fifth Avenue showroom. Sometimes during the day they would stick their heads out of their respective windows, wave, and send signals. Egon's apartment at Eighty-Second Street and Park Avenue was a short walk from Diane's. They continued to spend many evenings and holidays together with their children. Still, the end of the marriage made Diane feel very alone. Though she had no lack of male companions, she did not feel as deeply connected to her lovers as she had to Egon, the father of her children. They would still have each other, but it would be different; he would not belong to her in the same way.

Starting in the mid-eighties, Egon lived much of the time in Italy, where his dressy line of women's wear found a small but loyal clientele. Despite the physical distance between them, Diane wanted her children

to maintain a close relationship with Egon, though he sometimes proved a less than responsible father. Once, when Bob Colacello was in Colombia for a film festival, he visited Egon's aunt, Suni Agnelli, Contessa Rattazzi, who was entertaining Egon and his children in her home in the ancient walled city of Ciudad Amurallada. Egon happened to be out when Colacello arrived, but he found Tatiana and Alex, then about five and six, alone "upstairs huddled on the sofa reading *Hustler*," the pornography magazine. "Oh, Daddy left this," they explained.

Egon had dropped them off and gone out somewhere. "I thought it was pretty awful," says Colacello. When he told Diane about it later during a phone call, "she thought it was pretty awful, too. But she didn't react by saying, 'Oh, my God, my crazy, horrible ex-husband.'"

Diane knew that Egon adored the children and that he tried in his fashion to be a good father. He would never consciously do anything to harm them. But he was spoiled and immature and accustomed to being waited on by servants. It probably never occurred to him to put the magazine away.

Tatiana and Alex spent their summers in Europe with Egon. "We'd stay for a month with my grandmother in Capri. She'd rent half of one hotel with all her staff. My dad would park us with her, and he'd stay at another hotel with four or five of his boy toys and pop in to see us," recalls Alex.

Despite the nannies, cooks, and drivers at their disposal, the children were mostly unsupervised. "Me and Tats were totally independent. I was rolling around Saint-Tropez on a motorcycle at twelve years old," says Alex.

Diane protected Egon with the children. "I never once heard her criticize him," says Colacello. "And if the children said something [negative] that someone had said about their father, Diane would say, 'Your father is the greatest. He's wonderful.'"

Loyalty is one of the qualities Diane prizes most in herself and others. "She's unbelievably loyal to her friends, and also to the things she believes in," says Oscar de la Renta. When Studio 54 owners Steve Rubell and

Ian Schrager were convicted on tax-evasion charges in 1979, Diane was appalled that they testified against some of their associates to win reduced prison time. She told Warhol "she's not going to go to Studio 54 anymore because she thinks it was wrong of Steve to be naming names," the artist wrote in his diary.

In any case, by then she'd discovered a new nocturnal haunt, the Mudd Club on White Street in Tribeca. The Mudd Club's metal chain across the front door had supplanted the velvet rope outside Studio 54 as *the* barricade to breach. The shift signaled a darker ambiance in the club scene, presaging the horror that would soon befall the fashion world with the onslaught of AIDS.

Named after Samuel Mudd, the physician who treated John Wilkes Booth after he assassinated Abraham Lincoln, the Mudd Club had a feel of menace—dark and shadowy with one flickering strobe light, throbbing punk music, and rockers in leather jackets shooting up heroin. Fights sometimes broke out. One night a young, half-Chinese designer marched onto the dance floor and punched another young woman in the face just because, she later explained, she "didn't like the way [the girl] was dancing."

Destructive behavior was getting out of hand, and the teenage model Gia Carangi became a prominent victim. Brown-haired, brown-eyed, honey-skinned, and curvy slender, Gia had flawless, natural beauty. "Now people remake themselves," says Fran Lebowitz. "But there weren't five million plastic surgeons then. It was the era of unassisted beauty, so there were very few true beauties like Gia. Beauty was rare, and it was very prized."

Diane met Gia, as she was professionally known, at the Mudd Club one night and thought her the most gorgeous girl she'd ever seen. But what really made Gia irresistible to Diane was the model's lost-girl quality. If ever there was a young woman who needed to be saved, who needed the guidance of an older, wiser mother figure, it was Gia.

She had grown up in a working-class Philadelphia family. When Gia

was eleven, her mother moved out to live with the man who became her second husband, and Gia and her two brothers saw her infrequently. She was discovered as a teenager, while working at her father's luncheonette, Hoagie City. Within a year she'd become one of the world's top models, on the cover of *Cosmopolitan* and *Vogue* and making a hundred thousand dollars a year. But she was a deeply troubled young woman who suffered from severe depression, exacerbated by a heroin habit.

"She was very rough, from a rough background, which was not uncommon for these girls," recalls Lebowitz. Modeling "generally was not a profession that middle-class girls went into. Their parents wouldn't have wanted them to, and their parents were right. These girls were available [sexually]. That was one of the points of them. Now [modeling] is different because it's been professionalized."

Diane and Gia became friends, and in 1979 Diane hired the young model for an eight-page *Vogue* ad campaign featuring DVF clothes, cosmetics, and treatment products. "I definitely had a big attraction [to her]," Diane says.

Some people murmured that they were lovers. "I *would* have gone further [than friendship with her], but it just never happened," says Diane.

Gia wasn't interested. She "was a very cruisy gay woman, but she liked blondes," says Stephen Fried, author of her biography, *A Thing of Beauty*. "Diane would not have been her type. I can tell you from going through Gia's stuff that there's not a lot of references to Diane von Furstenberg. If Gia had a crush on Diane, there would have been."

Diane had better luck with other women who attracted her, though she won't name names. Gigi Williams, the makeup artist who traveled with Diane in the late seventies and early eighties to promote the designer's beauty book and cosmetics line, says, "Diane and I always talked about having an affair, but we thought it wouldn't be a good idea because we worked together." One weekend when Williams was away, however, her ex-husband cut up her clothes, including a hundred DVF dresses, because he thought Diane and Williams were sleeping together.

When John Fairchild sent a young reporter named Jane F. Lane to interview Diane for *W* in September 1978, he insisted she ask Diane about "her rumored sexual preference for women," Lane recalls. "Fairchild always wanted the dirt. When you got back to the office, he wanted to know, 'Did you bring back the bacon?'"

Lane reported that when she asked Diane, the designer lost "step for the briefest moment, the color rising delicately to her face. She looks shocked, not so much by the question, but that one would think such a thing of her. 'I cannot,' she answered with a certain ardor, 'live without men.'"

Gia's lack of sexual interest in her did not prevent Diane from trying to help the troubled model. "The impression I got from Diane was that she felt very motherly toward Gia," says Fried, who interviewed the designer for his book. "I think she realized Gia's fragility and what danger she was in, which not everyone did at the time."

After the March 1980 death from lung cancer of Wilhhelmina Cooper, head of the modeling agency that represented Gia, the young model's need for a mother figure intensified. That summer Calvin Klein had lent Diane his house at the Pines on Fire Island, and Diane invited Gia for a weekend. The model brought one of her girlfriends, Sandy Linter, a blond makeup artist. One afternoon Diane walked into Gia's bedroom and found her sitting on the floor of her closet in an agitated state. "Later I realized she had probably been shooting heroin," Diane wrote.

Diane continued to hire Gia as a model from time to time. But as Gia descended further into heroin addiction, they lost touch. The last time Diane saw Gia, she lent her a hundred dollars. She had not been in communication with the model for some time when Gia died of AIDS-related illness in 1986.

By then the disease had ravaged Fashion. The first cases of a mysterious immune-deficiency illness linked to homosexuals had been documented by doctors five years earlier, in 1981. No one knew what caused it. AIDS was veiled in denial, mystery, and fear. Though some victims were intravenous drug users like Gia, the disease in the United States

predominantly struck gay men, connecting homosexual sex to death, an association horrific in its suggestions of moral retribution for a group that had only recently thrown off the presumed guilt of their sexual preferences. "The AIDS epidemic was very painful to us as a family, between my mom's business and my father's friends," says Tatiana.

AIDS claimed the lives of famous designers from Halston to Perry Ellis to Willi Smith. Before they would sign a deal with a male designer, many investors began demanding "key man" insurance policies, a form of life insurance in which the beneficiaries are the investors in an enterprise. To get key man insurance, designers often had to submit to AIDS testing. Todd Oldham told the *New York Times* in 1990 that he'd taken the AIDS test four times to satisfy the worries of potential investors, who "don't want their money to drop dead in ten years."

The disease also devastated the rank and file—makeup artists, stylists, hairdressers, photographers, showroom assistants, journalists. Because AIDS struck so many in Fashion, a world where gays thrived, the disease also seemed a rebuke to the industry as a whole, exposing the cruel illusions at its core. Fashion lured with its possibility of perfection. With the right dress, the right shoes, the right handbag, you, too, could achieve the youth and beauty of the models on the runway and in *Vogue*. But it was a false promise based on a hollow ideal.

By the time the AIDS virus had struck, Diane had dialed back her sexual adventuring, entering into a couple of monogamous relationships in the eighties. But no matter who her boyfriend was at any given time, Egon and Barry remained important presences in her life—Egon, whom she would always honor as the father of her children, and Barry, her soul mate and advisor.

Diane's romantic relationship with Diller had ended around 1980, after they'd been together a few years. Neither of them can remember the precise date or reason. "The truth is, she left me," says Diller. "There wasn't a smoking gun," though his unwillingness to have a child might have had something to do with it. "We talked about having a child, and

I did not want to. I shook at the idea because to me it meant that all adventure would be over. I'd be living in the Valley in a house with a big station wagon and have a boring life. I was immature. I thought, 'How horrible!' Of course, I regret it, but it was ridiculously strong in me. And I think that signal somehow sent her away from me. It was a sign to her that I was unworthy, and some months after that, I moved out."

Diller says he "was a wreck for six months," but then he and Diane were friends again, "though we'd go for long periods without communicating."

For emotional support, Diane also had her mother, who continued to live with Diane and her children for several months every year. Whenever Diane's friends encountered Lily, they marveled anew at how unscathed she seemed by her concentration camp experiences. One evening in April 1978 after a cocktail party at the home of publicist Eleanor Lambert, who lived in Diane's building at 1060 Fifth Avenue, Diane invited Bob Colacello and Andy Warhol to her apartment for dinner and to watch the TV miniseries *Holocaust*, starring Meryl Streep. Lily joined the group. "When the concentration camps came on . . . [Lily] said that they made it so much more glamorous than it was when she was there, that all the women had crewcuts and it was a lot more crowded, that where the movie had twenty people there were really 300,000," Warhol wrote in his diary.

Also present was filmmaker Marina Cicogna, who was the grand-daughter of Giuseppe Volpi, Mussolini's minister of finance. "I remember Andy and I thinking it was odd to be watching it with a Holocaust survivor and someone [whose] family was part of Mussolini's regime," recalls Colacello. "It was an awkward situation. And Diane seemed to handle it by talking on the phone all the time. She didn't seem to be paying any attention to the TV. It was all a little surreal."

Lily remained determined to protect Diane and her brother, Philippe, from knowing the horrors she'd suffered. "I think my mother had night-mares, but she hid that from us," says Philippe Halfin. "She pretended always that things were all right. But the deprivation in the camps affected her much more than we thought."

Tatiana, however, with her artist's sensitivity to emotional nuance, recognized her grandmother's depression. "She was literally crippled by her trauma and [in New York] she was very isolated and disconnected from the Jewish community and by the fact that she [mostly] spoke French. She was very fearful," says Tatiana. She continued to sleep with the light on.

The inevitable crisis occurred in April 1980, thirty-five years after the war ended, when Lily, now fifty-seven, accompanied Hans Muller on a business trip to Berlin. At a restaurant where they had dinner with some of Muller's clients, the gaggle of German voices pushed Lily into the past. She thought of soldiers in black boots and dank cells and piles of bones and acrid smoke from burning flesh. She said nothing to Muller, but he woke up to find her missing. Soon afterward, he discovered her cowering under the concierge's desk in the hotel lobby, her shoulders scrunched and her knees clutched to her chest. She was trembling and babbling incoherently.

Muller drove Lily to Geneva, where he admitted her to a psychiatric hospital. Diane, Tatiana, and Alexandre arrived the next day and were soon joined by Philippe and Leon Halfin. Diane checked into a hotel with her children. Leaving them in the care of a babysitter, she spent every day with Lily. She'd been unable to sleep since Lily's breakdown, and listening to her mother's ravings mingled with the screams of the other patients, Diane felt she was going crazy herself.

Lily "had lost her mind. It was very frightening," says Philippe. She refused to eat or drink. Diane and Philippe watched her shrink inside her fur coat, which she insisted on wearing in her hospital bed. Then, one day, just as suddenly as she'd collapsed, she came back to life. Lily's doctors believed that her fierce love for her family had enabled her to pull out of the blackness, to reach inside herself to a core of inner strength. She managed to banish her torment and replace it with tough determination. She was herself again.

Diane and Philippe never found out exactly what had happened to

their mother in Berlin, and Lily never discussed it. She went back to telling stories about the inherent goodness of humanity, about "how a bad man, even a German, could not necessarily be all bad," says Philippe.

Diane tried to put the horror of it behind her, too, which was, of course, what Lily wanted. It was "too awful to contemplate. Even after my mother's breakdown, I continued to keep the truth at arm's length," Diane confessed.

She went back to being DVF, businesswoman, style queen, femme fatale. Jewishness was not a big part of her identity. Then, about a year later, she was given a Woman of Achievement award by the Anti-Defamation League of B'nai B'rith and found herself in the ballroom of a Manhattan hotel with five hundred chattering Jewish women, their voices whirling up in a deafening clatter. She hurried out to the hallway and phoned her secretary. "Why'd you get me into this?" Diane demanded.

"They're all customers," the secretary said.

During the lunch Diane listened to several impassioned speeches about injustice. Actress Blanche Baker, herself the daughter of a Holocaust survivor, who played a young woman raped by German soldiers in the *Holocaust* miniseries, spoke. Then it was Diane's turn. She hadn't planned to say anything deeply personal, but once she was at the podium, the words poured out. "Everyone knows about Diane von Furstenberg's drive and ambition. Maybe it's because two years before I was born my mother was in Auschwitz," she said. A collective gasp pierced the air.

Then Diane burst into tears. Looking out into the vast ballroom, she saw that many of the women in the audience also were crying.

Diane had never before spoken publicly about her mother being a Holocaust survivor. But when she heard herself actually say the words, "It was a major revelation because I realized that it was my heritage, and I hadn't realized how deeply connected I really felt," she said.

Lily's breakdown had shattered Diane and made her reassess her priorities. At thirty-four, she was rich and famous with two beautiful children, scores of interesting friends, and plenty of lovers, most of them

casual. These were her "flirtations," as opposed to her "relationships," which for her typically endured for three to five years. So far she'd had three of these: with Egon, Jas Gawronski, and Barry Diller.

Around the time of her mother's breakdown, Diane met Richard Gere at a party at the LA home of producer and talent manager Sandy Gallin. She found the actor "to be shy and tender in spite of the image he tried to project of being tough and a rebel," she wrote. They began an affair. Gere is possibly the actor Julie Baumgold refered to in her 1981 *New York* profile of Diane, who thought the designer "too big a package with the homes, the children, the crowded life, her name on everything around the house. Walking into the bathroom and washing his hands with Tatiana body shampoo," or walking into Bloomingdale's and seeing "her name and panther-eyed label dangling from rows of underpants" that were manufactured by one of her licensees. It was hard for Diane, as it was for many high-achieving women, to find a man who would not be threatened by her success. Her romance with Gere lasted less than a year. But Diane realized that what she wanted now more than anything was to fall in love again—and be loved in return.

Volcano of Love

hile Lily recuperated in a clinic in Geneva, Diane flew to Japan on a business trip, taking her children and Olivier Gelbsman. Reeling from her mother's breakdown, her failed romance with Gere, and severe overwork, she decided to stop on the way home for a rest in Bali. Decades before Elizabeth Gilbert turned her own search for "balance" on this tiny Hindu island into the best-seller *Eat Pray Love*, Diane found the answer to her spiritual malaise.

She checked herself, the children, and Gelbsman into the Oberoi Hotel, a luxury seaside resort with thatched villas and vivid gardens surrounded by lush jungle and volcanoes visible on the horizon. One morning, just as the sun was rising from the quiet blue sea, Diane set off for a stroll along the white ribbon of beach that stretched out from the hotel. Suddenly, a shadow crossed her path; she looked up to see a tall, handsome man with a brown beard, a green stone in one earlobe, and a sarong tied around his waist. He looked strong, sexy, and available.

The man was a South American artist who, at thirty years old, was three

years her junior. His name was Paulo. He made a living selling traditional Balinese clothing and lived in a bamboo house off the beach. Diane felt an instant connection to Paulo, as if they'd known each other forever, and a powerful physical attraction. At the end of the day, she brought him to meet Gelbsman, who was sunbathing on the beach. "Diane is wearing a big hat, and Paulo is wearing a sarong, and because I'm lying on my back, I can see right up to what's under it," recalls Gelbsman. "I said something really terrible but hysterical to Diane like, 'That's not for you.' She became so mad at me she didn't speak to me for the rest of the trip."

By then she was smitten. Paulo made her feel like a natural woman, in the words of the Aretha Franklin song, and she invited him to New York. Diane was a stressed-out businesswoman and single mother. She was lonely. At the end of the day, when the streets of New York bustled with commuters in taxis and buses on their way to high-rise apartments and brownstone walk-ups, Paulo would be someone to go home to, someone to eat dinner with, someone to talk to about something besides look books and Passion Pink lipstick.

At first Paulo stayed with Gelbsman in his apartment on Eighth Street and Fifth Avenue. Diane knew that her children had to get used to him before he moved permanently into their lives. To introduce him to her friends, she threw a party. "It was winter, and I remember he was wearing a sarong and a cashmere sweater," says Gelbsman. "We get to Diane's and everybody you could imagine is there, including Diana Ross and Diana Vreeland."

Diane's friends were mostly appalled that she actually was serious about "this guy she met on the beach," recalls Fran Lebowitz. "A less romantic person would have left him on the beach. But Diane imports him to New York, and now does this mean we all have to talk to him for two years or however long she keeps him around? He was very rough, and my impression was he was not that smart. I didn't find him interesting."

Paulo went back to Bali for a while, then returned to New York, preceded by crates of his possessions. He was coming to stay. Diane took her

Mercedes to the airport to pick him up at four thirty one morning. She'd fasted for two days before. "I'm purifying my body so I can *feel everything more*," she told Julie Baumgold. "I had become so DVF; I had to get out of DVF. I'm more creative now. I'm seeing everything bigger, freer."

Paulo had no job in New York other than to be Diane's companion. Still, he released in her a flood of ideas. She called her new cosmetics line Sunset Goddess and based it on the romantic hues of the sunset over Bali's Kuta Beach. Before they'd met, she'd been thinking of marketing a new perfume called Deadly Feminine. Now, inspired by her explosive meeting with Paulo in the shadow of a Bali volcano, she decided to call the new fragrance Volcan d'Amour. Vulcan, the god of fire, including volcanic conflagrations, was married to Venus, the goddess of love. A perfect match, like she and Paulo. They worked on the scent together.

The perfume's volcano-shaped glass bottle with the black top was designed by Dakota Jackson, who'd also designed the twelve-foot-wide "cloud" bed in Diane's New York apartment—it had a headboard covered in pink satin and was lit from behind to resemble the moon in shadow. The bottle was made in Normandy "in a factory that specialized in exotic bottles," says Gary Savage.

It was packaged in an oversized black box emblazoned with a deep-blue nighttime seascape that had been painted by a Brazilian artist Diane met in Bali. Included in the box was a poem Diane had written for Paulo:

> *Into my life you came*
> *Bringing peace to my heart*
> *Fire to my body*
> *Love to my soul*
> *In your eyes I see myself*
> *Feeling, reaching, looking*
> *For perfect harmony.*

She launched Volcan d'Amour at a breakfast for the press in her office, which had been decorated with thousands of frangipani flown in from

Hawaii and arranged in the shape of volcanoes. Reporters dined on apricot pancakes as a band played Indonesian music. Later, models in blue sarongs that had been hand-painted with gold volcanoes at the Denpasar market in Bali spritzed shoppers at Saks with Diane's new fragrance.

With Tatiana, Diane created a classic *bouquet des fleurs*. For Volcan d'Amour, she strove for something completely different—an exotic elixir.

The dominant note was a strong, purple violet, like the flowers grown on Mount Etna, where, according to mythology, Vulcan had lived. Unfortunately, the fragrance wasn't "particularly pleasant," says Savage. Fashion executive Rose Marie Bravo says, "Everything about it was wrong—the bottle, the scent. It was heavy. It just didn't work."

Customers didn't like it. Despite Diane's passion for the new scent, not to mention her frenzied promotion of it, Volcan d'Amour flopped.

Paulo's influence stretched everywhere into Diane's life. Suddenly tropical prints appeared in her sheets for Sears. She decorated her office with a gaggle of carved wooden Balinese geese. Along the river that ran through her property at Cloudwalk, she planted twenty-foot-high Balinese flags in bright crayon colors and covered her furniture in Indonesian batiks. Instead of clingy jersey dresses, fishnets, and stilettoes, Diane now wore sarongs and padded around barefoot, just like Paulo. "Why don't you wear real clothes?" Lily asked her. Lily never liked Paulo and was dismayed that Diane had submerged her style in his.

In light of her fierce determination to be independent, the way Diane changed her life around for Paulo shocked her friends. "Diane is the most romantic person I know, and the most willing to change everything around for romance," says Fran Lebowitz. "And it's exactly opposite of other aspects of Diane. So that, in this area of life, Diane will jump out of a window, and in every other area of life, she wouldn't."

Diane herself explained it by her deep yearning to lose herself in love and to find relief from the stress of business. She was ready to be submissive to a man, to lead a calmer, more satisfying domestic life.

For once she wanted to be taken care of. Never mind that it was Diane

who paid the bills. Paulo tended to her needs the way no man had before. He spent hours browsing with her in rare bookshops and fabric stores as she hunted for ideas for new prints. He accompanied her on business trips, ironing her clothes in hotel rooms while she showered.

"He was a nice guy and loyal to her, but he didn't have a true understanding of what she was doing," says Savage.

That didn't stop him from giving her advice. "He was always around the office," recalls Sally Randall. "We were happy that he was making her happy, but he was no match for Diane. He always looked like he was ready to hit the beach, even in winter."

At the time, "people were dying of AIDS in the fashion industry, in her social circle," says Tatiana. "I get that she'd want to go in the opposite direction, if just for her safety. Paulo was someone with whom she could start fresh. It was also reassuring because he was quite manly"—that is, his sexual preference was entirely for women.

Diane's relationship with Paulo also coincided with her children becoming teenagers and pulling away from her. Alex turned rebellious and started getting into trouble in New York. He was drinking and, he recalls, "taking my skateboard and going to Area [a popular Hudson Street nightclub] at two in the morning. My mom said, 'That's it. I'm moving you to Connecticut,' and my sister had to go along with it."

Diane moved the children to Cloudwalk full-time and enrolled them in Rumsey Hall, a local private school that emphasized athletics. Alex, who played every sport, loved it. "I was super successful at Rumsey. I had girlfriends, a motocross bike, and a track at Cloudwalk, and I used to race around with my friends," he recalls. But Tatiana, who'd been a star student at Spence, the private school in Manhattan, was miserable. She still suffered from the muscle disorder that prevented her from participating in sports, and, she says, "my currency at Rumsey Hall went way down from what it had been at Spence. I didn't understand the kids in Connecticut, so I just buried myself in my books and I skipped a grade."

With Diane's hectic schedule, her preoccupation with Paulo, and

her inclination to suppress unpleasant realities, she failed to see Tatiana's unhappiness. To make matters worse for the girl, Lily was living in Geneva with Hans and spending time in Brussels with Philippe and Greta, who'd just given birth to the couple's first child, a daughter, Sarah. "I missed Lily terribly, but I didn't know how to dial the numbers to call Europe. I was an angry, unfulfilled, really sad adolescent," Tatiana says.

Paulo mostly stayed out of the children's way. He built a cottage on Cloudwalk property—"my mom let him so he'd have something to do," says Alex—that he used as a retreat. Occasionally, he gave the children presents. Paulo bought Alex his first motocross bike. Still Alex and Tatiana resented him. "Me and Tats thought, 'The guy isn't doing anything, and he's living off Mom,' so we didn't have much respect for him," says Alex.

One evening when Alex, Tatiana, and Paulo were to drive into the city to meet Diane, Paulo and Alex got into a terrible argument. The children were eager to get to Manhattan, and Paulo seemed to be dawdling, which angered Alex. The row ended with Paulo striking Alex in the jaw. Diane says the blow was more of a slap than a punch, but Alex had recently broken his jaw in a car accident, and he collapsed to the floor in pain. Tatiana called the police. When they arrived, she was waiting for them at the door with her arms crossed over her chest. "I'm so glad you're here," she said.

Diane declined to press charges, much to Tatiana's disappointment. "You know, [I] could call People magazine," she told her mother.

Diane acknowledges the difficulty of Paulo's situation. "He was barely thirty; he'd been living alone on the beach in Bali. He was a hippie, really, and I was this huge success."

Paulo tried to get along with Alex and Tatiana, and he seemed genuinely fond of them. He kept an eye on them when Diane was working in the city. It was Paulo, in fact, who first noticed Tatiana's distress and "told me she was unhappy," says Diane.

She was just as oblivious to her business troubles. While Diane traveled

with Paulo, often to remote Indonesian islands to hunt for exotic textiles, her executives in New York borrowed increasing amounts of cash to keep her company afloat. Since selling her dress division to Carl Rosen, cosmetics and scent had comprised the bulk of Diane's business, and both required huge infusions of money for advertising and inventory—money Diane didn't have. Every week Savage and Zinovoy put the financial reports on Diane's desk, and every week she ignored them.

One day in 1982, when Diane was in Paris, she got a call from her office in New York: Chemical Bank had refused to loan her business more money unless she signed a personal note of guarantee. "Suddenly all I saw was the loss, the loss of Cloudwalk, the loss of my apartment," she wrote.

Back in New York, she met with a banker at Chemical who told her she owed a staggering ten million dollars. "What do you want me to do?" she asked him. "Sell the company?"

He looked at her with a condescending sneer. "If you can," he said.

Diane began negotiations with Beecham, the English pharmaceuticals company. It was a period when she was not close to Barry Diller. "I wasn't involved," he says. "I don't even know if we talked about it." Things might have gone quicker if she'd had his counsel. In the end, it took three agonizing months for the deal to go through. During this time, Chemical Bank continually pressed Diane for repayment of its loan, and Diane was nearly out of her mind with worry, as she had been when her dress business tanked in the late seventies. She feared she'd lose everything.

In the end, she sold her cosmetics business to Beecham for twenty-two million dollars in 1983, which left her with twelve million after paying off Chemical Bank. Puritan had stopped manufacturing her dresses the year before and had stopped paying her. With her real estate, jewelry, art, furniture, cars, and cash, she had assets of sixteen million dollars.

To celebrate the Beecham sale, she bought herself a matching set of eighteenth-century English aquamarine jewelry—necklace, earrings, and brooch—at La Vielle Russie, a pricey antique store in the Sherry-

Netherland Hotel on Fifth Avenue. On the way out, she noticed an empty store on the far side of the lobby and, on impulse, decided to rent it.

Her plan was to sell high-end items, including made-to-measure couture clothes of her own design. She hired Michael Graves, the renowned postmodern architect famous for his small circular windows and squat columns, to design the fourteen-hundred-square-foot duplex space. She invested two million dollars in the project and charged Graves with designing "a shrine to Venus, a glorification of women," she said. She gave Graves a favorite pre-Raphaelite painting to show him the mood she wanted—at once modern and ancient.

Diane began having second thoughts when she sat next to Andy Warhol at a dinner at the steakhouse Club A. He told her "not to count on a May opening," as Graves was notorious for dragging out projects. Warhol also warned her that Graves would "probably take her little store and divide it into fifteen rooms with forty columns in each, and then she got scared."

Warhol was right about the delay. The shop didn't open until late fall 1985. To mark the opening, Diane held a party at Regine's—a gaggle of VIPS from Ted Turner to Diana Ross showed up. Afterward, her guests got a tour. The maple Biedermeier-and-glass display cases on the first floor held cosmetics, jewelry, scarves, and the little 1940s hat with a red rose and veil that Diane had worn with a black pantsuit for a *Vogue* ad promoting her new venture. A stairway led past trompe l'oeil marble and faux copper latticework to the pink-carpeted custom collection and fitting rooms. The made-to-order clothes designed by Diane were divided into five categories according to "occasion"—Smart Lunch, Vernissage, Party, Hostess, and Gala. Having dressed the average American woman, Diane was now going for the "fairly thin and fairly rich" crowd. The ready-to-wear started at five hundred dollars for a blouse; the couture collection at eighteen hundred for a skirt. One three-thousand-five-hundred-dollar silk and satin evening gown sold to Aretha Franklin. The clothes on the first floor were

available in sizes 4 to 12, though Diane would make a size 14 for someone who requested it.

The clothes were sophisticated, well made, and in good fabrics but had no extraordinary features or special allure to spark much excitement. "You know what people are saying about the boutique? The *scarves* are wonderful," sniffed one guest at the opening party at Regine's.

WWD was more generous. "Standouts in the designer's so-chic repertoire are seductively cut wool jersey chemises, especially in signature pink with a shapely black hipband, and beaded-collar evening sweaters over easy wool and silk pants." The paper went on to note, however, that Diane "misses" with dresses that had draped fabric at the derriere and others with "waist-to-floor organza fishtail backs."

Like other expensive fare offered at Upper East Side boutiques, the clothes reflected the extravagant wealth of the Reagan eighties nouveau riche. But they were a radical departure for a designer who'd made her mark in the seventies selling moderately priced fashion. It was as if the DVF woman, that sexy working girl who slipped off her wrap dress at the end of the day to delight a lover, had morphed into a middle-aged divorcée intent on racking up credit card bills to torment her ex-husband.

DVF couture didn't mesh with the DVF brand, which stood for affordable glamour. A luxury brand like Chanel, say, has no trouble selling mid-priced items. But rarely is the reverse true. Fashion is aspirational, after all. If a brand's image is not set from the outset at the high end of the runway, it's almost impossible to get customers to pay premium prices for high-end goods.

DVF couture was a misguided venture at a time when Diane's brand could have used some polishing. Her licenses still brought in some income, but the quality of the DVF products had steadily declined, and they were taking her name down with them.

Such items as Queenie panty hose for plus-size women did nothing for the brand's cool factor. The low point came when comedian Sandra

Bernhard appeared on *Late Night with David Letterman* with a roll of DVF paper towels, which she used to poke fun at the designer who once epitomized New York glamour. "Andy Warhol calls Diane von Furstenberg and says, 'Let's go dancing,'" mocked Bernhard as she waved the paper towel roll. "But she says, 'No. I've got to clean up with my Diane von Furstenberg towel paper.'"

MEANWHILE, DIANE'S RELATIONSHIP WITH PAULO continued to fray. "My mom fell out of love with him," says Alex. "He wasn't *doing* anything." He put on weight. "He'd had a good physique, then he got fat."

It didn't help that he also shaved off his beard. "He had no chin. He looked terrible!" Diane says.

The end came on a cool day in October 1984. Diane's old friend Jerry Brown, who had run unsuccessfully for the United States Senate after having served two terms as governor of California, happened to be in New York and showed up at Diane's apartment for a casual meal in her kitchen. Paulo, who was present at the meal, felt way out of his league with the famous politician. After Brown left, Paulo did "what men do when they feel inadequate," Diane says. "He made love to me, and then he fell asleep."

While Paulo dozed, Diane went off to the thirteenth birthday party of Jade Jagger, daughter of the now divorced Bianca and Mick, and Diane's goddaughter. One of the guests she met at the party was Alain Elkann, a thirty-four-year-old Italian-French writer living in Paris. Diane was as attracted by Elkann's bookish air as by his slender elegance, chiseled features, and masses of curly dark hair. There was much to draw them together. Diane had always been an avid reader and loved getting to know writers. Elkann's ex-wife, Margherita, the only daughter of Fiat chairman Gianni Agnelli, was Egon's first cousin; Elkann's three children were second cousins to Alex and Tatiana. "I was just out of a marriage that was tormented and difficult, and it was not the best period in

Diane's life," recalls Elkann, who was four years younger than Diane. He had a Hamlet-like brooding intensity and gave off a wounded vibe that appealed to Diane's need to nurture. Her children had arranged to spend that night with friends, so Diane felt free to go home with Elkann, to the townhouse on Madison Avenue where he was staying.

When Diane returned to her apartment the next morning, "Paulo was very upset," recalls Diane. He left the apartment but later showed up at her office, where he stole a glance in her diary. Diane had written something about her night with Elkann that made Paulo "very sad, and so we split," she says.

"I got a call from him. He was on the street with his suitcases and needed a place to stay," recalls Olivier Gelbsman, who at the time was managing Diane's Sherry-Netherland boutique. Gelbsman took Paulo in for a few days. The South American was understandably distraught, and Gelbsman "made coffee for him and talked to him."

Paulo soon left, and eventually he moved back to South America. Diane does not keep in touch with him. "He's one of the few [lovers] she's erased," says Gelbsman.

Lily was so happy to see Paulo go that she lit scented candles throughout Diane's apartment to get rid of any trace of his "aura." Elkann was a big improvement, Diane's family and friends believed, though Andy Warhol ridiculed her for "going the Marilyn Monroe route of marrying one person for the name," then latching onto a writer "who'll write books about her." (In Monroe's case, the name was Joe DiMaggio and the writer was Arthur Miller.)

Elkann had a reputation for being what the French call an *homme à femmes,* a more elegant rendering of the Anglo "womanizer." Diane chose to ignore the stories about his many conquests. At last she was in love with someone of her own tribe—European, urban, sophisticated, Jewish. Elkann's father, a French industrialist, was chairman of Dior and head of the organization that appointed the chief rabbis of Paris. His mother was from a prominent Italian-Jewish banking family.

As her relationship with Elkann deepened, Diane grew exhausted flying back and forth between New York to tend to her couture business and Paris to be with Elkann. The stress took its toll. She lost weight and looked haggard. Her appearance was not helped by her chopping off her hair on impulse one day shortly before meeting Elkann. She so feared her staff's reaction that she insisted her hairdresser escort her back to her office after the deed was done. Diane's employees kept a close watch on the boss's changing hairstyles. Straight hair meant she felt insecure; curly hair meant she felt on top of the world.

Diane's new hairdo, though, seemed to mark a different state of mind. The little cap of profuse curls made her look older and also gave her an uncanny resemblance to photographs of Edith Piaf. They had the same large, liquid eyes, strong mouth, and sensitive expression. They both looked very French and very sad.

WITHIN A YEAR, DIANE REALIZED that her couture venture wasn't going to work. Her heart hadn't been in it from the start, and she had begun to crave a life of domestic calm in Paris with Elkann. Also, "designing very expensive products that only a few can afford was definitely not something I truly enjoyed," she said.

With her children away at boarding school—Tatiana would attend schools in London and Switzerland, and Alex would transfer from boarding at Rumsey in Connecticut to Brooks in Massachusetts—Diane sold her lease on the Sherry-Netherland shop to Geoffrey Beene. In her most radical move, she also sold her Fifth Avenue apartment. The buyer was Alain Wertheimer, the grandson of Coco Chanel's original partner and, with his brother Gerard, the current owner of the Chanel empire.

Her friends were stunned. Real estate "is something so central to New Yorkers. Once you have an apartment, you keep that apartment," says Fran Lebowitz. "People say, even when their friends get married— 'What? You gave up your apartment? What if you get divorced?'" That Diane would sell her New York apartment for love shows her deep

romanticism, how "she'd jump out a window" for a man, says Lebowitz. "She meets Alain, and five minutes later she's living with him in Paris."

In the seventies Diane had been one of the first women to reach national prominence in American fashion. A decade later, the role of superwoman that she'd pioneered—the woman with a briefcase in one hand and a baby on the hip—had become a hard-won ideal. Now Diane seemed to be betraying that ideal by exhibiting a "stand-by-your-man" submissiveness and deference.

Financial factors also played into the decision. "There'd been a fuckup in her company, and she meets Alain and thinks, 'I might as well go live in Paris,'" says a French journalist who saw Diane frequently during this period. "It was a good time to do that because in the eighties the dollar was so strong compared to the franc."

Still, Diane was madly in love—perhaps more than she'd ever been before. She doted on Elkann, who, her friends say, did not return her devotion. "She suffered," says Olivier Gelbsman. Elkann "treated her like a saleswoman. I don't think he understood what she did."

DIANE'S LOVE NEST WAS AN eighteenth-century apartment at 12 rue de Seine in the heart of Left Bank literary bohemia. James Joyce, Henry James, Ernest Hemingway, Baudelaire, Oscar Wilde, and Racine had all lived in the quarter. The classical rooms had high ceilings, spacious proportions, and parquet de Versailles floors that dated to the French Revolution. One side of the apartment faced a cobblestone courtyard; another faced a colorful garden. Inside, Diane installed a huge canopied bed and furniture, paintings, and antiques from her Manhattan home. Her beloved leopard carpets and bright colors, which Elkann loathed, were banished, as was everything Balinese and Paulo-related. Elkann "was very controlling," says Barry Diller, who didn't see Diane much during this period.

Diane adjusted her world to fit Elkann's. To please him, she dressed in flat shoes, pants, wool skirts, and sweaters. She planned her schedule

around his writing. She learned to be quiet when he was working and not make demands. When he was ready to share his writing, she spent hours listening to him read from his work.

Diane's teenage children were dismayed to see her once again submerge her identity to please a man. They complained that their mother was nothing but "a boring doormat." Alex moaned that she had no personality; "she always became whoever she was with." With Elkann, though, she'd gone further than she ever had in changing herself and her life for a man.

When they met, Elkann had just finished his third book, a novel called *Piazza Carignano*, which is based on one of his uncles, who, though Jewish, supported the Italian fascist movement. A prominent theme of the twenty-five well-received novels and nonfiction books Elkann would go on to write by 2014 would be the history of Jews in Italy. He also was the Paris representative for Mondadori, the Italian publishing house. Diane accompanied Elkann to book fairs in Frankfurt, Turin, and Jerusalem. They also spent a lot of time in Capri, where they rented an apartment. Diane took long walks and read the newspaper while Elkann worked.

She met many writers, befriended them, and often invited them to parties at rue de Seine, where the mix was a mélange of accomplished artists, writers, actors, designers, and journalists, though heavy now on the literary side, with a few celebrities such as Marcello Mastroianni and Anouk Aimée thrown in.

Nurturing writers activated Diane's maternal instincts at a time when her children were away in boarding school. She set aside one of the apartment's bedrooms as "the literary room" and invited writers to stay for extended periods. The Italian novelist Alberto Moravia lived there for two years while Elkann wrote Moravia's biography. The American writer Edmund White, who attended parties at the apartment, remembered Moravia as a very old man sitting in a corner like a ghost. *American Psycho* author Bret Easton Ellis spent a couple of months in the apartment, as did James Fox, the author of *White Mischief*.

While living in Diane's apartment, Fox spent his days writing. "I was there because of that deeply generous, connecting spirit of [Diane's]," says Fox. "She didn't know me very well, but decided to help me nonetheless. I knew she'd been a mentor to other writers—to Moravia, for example—so I was flattered. What is so attractive and endearing about Diane . . . is how it comes across that this is purely a gesture on her part which comes from the heart—there would have been no obligation on my part to even thank her."

Mark Peploe wrote much of his screenplay for *The Sheltering Sky*, based on the Paul Bowles book, at 12, rue de Seine. The poet Frederick Seidel, who finished his collection *My Tokyo* while living with Diane and Alain, described in a poem the sweet, airy atmosphere at the apartment, where he and his colleagues thrived like "hummingbirds on nectar and oxygen."

Seidel had known Diane since the seventies. "I remember asking her with incredulity [about her strenuous social life], and she said it was part of her job, of creating herself and her business and her brand, of forging the reality of herself," says Seidel.

Hosting gatherings for an eclectic mix of people was still part of that reality. Evenings at rue de Seine included Diane's friends from fashion, such as Valentino, new star Christian Lacroix, whose colorful, poufy party dresses were a sensation with American and European socialites, onetime Chanel model Ines de la Fressange, and the young beauties Claudia Schiffer and Elle Macpherson, who in the coming decade would become part of the first generation of supermodels.

Despite the presence of assorted Americans, the dinners had a decidedly European tone—lots of flirting and admiring of female beauty, and no vulgar talk about money and careers. One evening Edmund White violated this Gallic rule of etiquette by asking de la Fressange "what she did," and the other guests at the table "gasped," White recalled. De la Fressange, who in 1989 would become the model for the bust of Marianne, the official emblem of the French Republic (and enrage Karl Lagerfeld for daring to do something that got more attention than mod-

eling for *him*), treated White's faux pas as a joke. Laughing, she explained lightly that she'd just returned from a trip to India and was planning to open a boutique.

The new, domestic Diane often bumped up against her old celebrity self. On New Year's Eve 1986, Diane's fortieth birthday, she, Elkann, and their children were in Gstaad, where Diane had rented a house for the Christmas holiday. They skied during the day and that night trooped to Valentino's chalet for a party. Diane found herself sitting next to Frank Sinatra, who serenaded her with "Happy Birthday" when a cake with lighted candles was brought out at the end of the meal.

In October the previous year, she was welcomed as a fashion celebrity at an event at Rome's Renaissance Palazzo Venezia to launch the house of Fendi's first perfume. Standing on the same balcony where Mussolini had declared war, she sipped champagne with Elkann and felt wistful about her old life. At the dinner afterward—in the room that had been Il Duce's office—she chatted with a group of journalists who'd been invited to cover the fragrance launch, most of whom she knew from the days when they'd covered *her*.

That night in Rome, Diane "felt a little pang," she admitted. "It was so easy for me to talk to my journalist friends. . . . It was a weird feeling. I felt both superior and inferior, attached and detached. On the one hand, I felt quite smug that I'd been there, done that, and moved on. On the other hand, other designers were doing fashion, and I wasn't."

Mostly, she was missing an unenlightened moment in New York style, an era of Madonna-inspired bustiers and shredded fishnets and *Working Girl* shoulder pads, big hair, and poufy skirts.

Yet the eighties also saw the increasing importance of brands in America and Europe. The five Fendi sisters, for example, had expanded their family's venerable fur business into a full-scale fashion empire that produced everything from shoes to luggage to ready-to-wear designed by rising star Karl Lagerfeld, moonlighting from his day job designing couture and ready-to-wear for Chanel.

Diane spent hours on the phone discussing her licenses—which were partially paying for her life in Paris. Her most lucrative license was her home furnishings line for Sears. She also held licenses for inexpensive children's clothes, stationery, nurses' uniforms, luggage, eyewear, and a fashion line in Mexico. Twice a month she traveled to Manhattan, where she kept a two-bedroom apartment at the Carlyle Hotel and office space at the Squibb Building on Fifth Avenue. In Paris she made one brief foray into fashion. She designed a small collection of jersey dresses in solid colors with the French designer Hervé Peugnet, the founder of the French fashion house Herve Léger, who was known for his "bandage" dresses made from strips of fabric that molded to the body. Diane showed the collection in her living room. The clothes did well at the popular rue de Passy boutique Victoire and at the department store Printemps. But Diane lost interest after one season. "I didn't want to get back into a real business," she said.

For a time, she didn't feel the need for it. Her life was full of new opportunities. She designed costumes for a Moravia play that was being produced at the Spoleto performing arts festival in Umbria. And in 1986 she started a small publishing company with Gérard-Julien Salvy, who had been the first to publish the work of Bruce Chatwin, author of *In Patagonia*, and Paul Bowles. Salvy, as they would call their publishing house, concentrated on translating British writers, including Vita Sackville-West, Cyril Connolly, and Barbara Pym. Diane worked on some of the translations herself and also spent time writing in her diary. She thought now she might like to be a writer but soon realized that writing was not what she did best—the effort made her feel anxious and insecure. She tried to put these feelings aside, telling herself that love, not work, was her priority now. And for a while she was content with Elkann. "We were a family, and my relationship with Alain was like a marriage. I loved his children, and they became close to mine," she said.

The rue de Seine apartment was the scene of lively parties when the children arrived for vacation. Elkann's elementary school-aged

offspring—sons John and Lapo and daughter Ginevra—lived with their mother in Brazil but visited Paris frequently. Both families traveled together on trips to Capri, Egypt, Switzerland (for skiing), and the United States. John Elkann, who today is chairman of Fiat, the car company started by his great-great-grandfather Giovanni Agnelli, recalls Diane as a loving and indulgent stepmother figure. She let him make up his face like a clown from pots of cosmetics left over from her Color Authority line. She organized a birthday party for him and took him to see James Bond movies. Once on a trip to New York, as a treat to delight John and his siblings, she rented a stretch limo to transport them to Cloudwalk. "Fundamentally, what I remember of those years was the feeling of a very close family," says John.

At his tenth birthday party on rue de Seine, Diane presented John with a photograph that she'd taken of his father and had mounted in a silver frame. "It seems like a strange present for a child, but Diane said, 'You will be glad to have it someday,'" John recalls. "And I am. I've kept it all these years."

Diane visited Elkann's parents in Turin and invited them to Paris for holidays that also included Egon's parents and her own. Elkann's mother, a religious Jew, grew very fond of Diane "and thought she'd be a perfect life companion for my father," says John.

There were hints, though, that all was not well. To Alex, the rue de Seine apartment seemed like a stage set, and his mother appeared to be acting the role of writer's muse. "She had no business, and she had to occupy her time—so she became an intellectual," he says.

The role felt wrong, like a sleeve set too tightly in an armhole. Diane understands the world through a visual, not a cerebral sense. "That's her key, her essence," says Linda Bird Francke.

Though he remains close to Elkann's children, Alex doesn't remember this period fondly. "It was annoying because I had to go to Paris, which I hate. It's a woman's city. It wasn't plugged in; I didn't have my network. I'd say, 'Mom, I'm a teen. I don't want to go to Spoleto and Paris!'"

In her 1998 autobiography, Diane portrays Elkann as unwilling to allow her any life separate from his. He objected to her leaving his side to travel to the United States for meetings with her licensees. In 1986 when New York Mayor Edward Koch awarded her the Mayor's Liberty Award, which was given to foreigners who'd made significant contributions to American life, she sent her mother to accept it in her place. "The award was a big deal, but I knew Alain wouldn't want me to go to the ceremony," at which dancer Mikhail Baryshnikov and poet Joseph Brodsky were also honored, she recalled. "When I got the telegram from Mayor Koch, rather than being able to enjoy it and show it off . . . I played it down."

Elkann disputes the contention that he thwarted Diane's business and personal opportunities. Their relationship, he says, "was so much more poetical than she described it in the book. She learned a lot by being with me in Paris, and also, it was a love story, which she forgets."

As much as Diane tried to tamp herself down, to live Elkann's life and make him her priority, he always felt the imbalance of power between them. "I think at a certain moment she was too overwhelming for me—the public success, the big money, the [famous people]," he says. "It was not my world. I was discovering my voice as a writer; my children were very young. I'd been away from Italy; I wanted to go back to Italy. I wanted to be part of the Italian literary world. I wanted to be less pro-tected and more independent."

At the same time, Diane began to yearn for her old life. She found that a personality cannot be remade like last season's dresses and that by acting the role of submissive girlfriend, she'd betrayed something deep within her.

Then Diane discovered she was pregnant. She was not overjoyed. Elkann wanted her to have the baby, but Diane was ambivalent. "She's very family oriented. She liked to have the children and their friends around," says Elkann. Yet at forty-one, with Alex and Tatiana nearing the end of their teens, she wasn't sure she wanted to start again raising an infant.

At eight thirty one winter morning when Elkann was out of town,

Diane went to an abortion clinic. She sat in the waiting room, her mind churning, as she struggled to reach a decision. Outside the snow fell softly, dusting the city in ghostly white. For hours Diane stared out the window, watching the day's slow fade to black. At five thirty the nurse told her the clinic was about to close. Only then did Diane agree to the procedure.

Afterward, when Diane called Elkann to tell him that she'd ended the pregnancy, "he was not happy," Diane says.

"When a woman can have a man's child, and she doesn't, it does something to their love story," Elkann says.

The relationship might have continued, however, had Elkann soon afterward not embarked on an affair with Diane's friend Loulou de la Falaise. Elkann had had other flings during their relationship, but his dalliance with de la Falaise broke Diane's heart.

She'd first met the slender beauty in the seventies when de la Falaise had moved to New York at age twenty-one, following the end of her brief marriage to an Irish nobleman. De la Falaise was immediately taken up by Halston and Andy Warhol and their cliques and then became part of Diane's inner circle, one of those, like Marisa Berenson, whom Diane kept *"très proche,"* says François Catroux.

De la Falaise had the delicate, pre-Raphaelite looks of a Burne-Jones portrait, "with none of the passive tragic undertones," as journalist Alicia Drake wrote. She was known for her sparkling blue eyes, raucous laugh, and daring, original style. One day she'd be dressed in a chiffon tunic and harem pants, her short, reddish-blond hair buried under a turban and her frail wrists weighed down with bangles. Another day she'd be in purple bell-bottoms with a wreath of flowers in her hair, and the next in a couture gown of blue mousseline.

But de la Falaise wasn't just some wispy model girl who liked to dress up. She had brains, talent, charisma, and boundless vitality. Part of her allure was her exotic background, which was as glamorously bohemian as Diane's was solidly bourgeois. The daughter of a French count and a half-Irish, half-English Schiaparelli model, de la Falaise had been sent off to

boarding school at a young age. After her parents' divorce, she spent time in foster homes arranged by her father's family, who had custody of her and her brother.

In New York she modeled and designed fabrics for Halston, including one that depicted rabbits cavorting with erections. Next she turned up in Paris. She met Yves Saint Laurent and his partner, Pierre Bergé, while working as a fashion editor for the British society magazine *Queen*, and she went to work for Saint Laurent as a muse and jewelry designer. She also became the fashion house's unofficial director of morale, the only person who could cheer up the depressed, dour, drug-addled designer. She had what the French call *légèreté*, "a refusal to accept gravity or to take anything seriously," as journalist Joan Juliet Buck wrote.

Yet de la Falaise took her job seriously. She showed up for work every day and on time, no matter how late she'd been out the night before. Like Diane, she valued her independence and her ability to support herself. She did not want to be kept by a man. Though de la Falaise shared many of Diane's feminist beliefs, she did not share Diane's capacity for empathy. She was "this mad little bohemian creature, full of ideas, full of jokes, hopping around," according to her mother. But her insouciance verged on cruelty.

One weekend in 1977, de la Falaise went off to Venice with Thadée Klossowski, a son of the painter Balthus and the longtime, live-in boyfriend of her friend and colleague Clara Saint, Saint Laurent's press director. The couple returned from the weekend engaged. Saint was devastated and did not attend the lavish wedding that Saint Laurent threw for the couple on an island in the Bois de Bologne. But Saint and de la Falaise continued to work together until Saint retired in 1999. De la Falaise stayed on with Saint Laurent through his own retirement in 2002.

At the time de la Falaise took up with Elkann, she was the mother of a three-year-old girl and living with Klossowski, the child's father, in a grand, high-ceilinged apartment in Montparnasse, where the couple's massive bed sat in the middle of the living room under a chandelier hold-

ing hundreds of candles. "Loulou fell in love with Alain, but Alain wasn't in love with her, he was just having an affair," says François Catroux.

That was no consolation to Diane, who says she remained faithful to Elkann while they lived together (as she had with Paulo until the end). After she discovered a note de la Falaise had written to Elkann, confirming that they were lovers, she walked the streets of Paris mulling over what to do. Later she confronted Elkann and de la Falaise, and Elkann broke off the affair. De la Falaise continued to live with her husband—at her death in 2011 they were still together—and Diane stayed with Elkann. But their relationship was marred by disappointment and mistrust.

Elkann could not forgive her for the abortion. "She could have had a child and she didn't," he says. "I'm sure the abortion was difficult for her, but if a woman has an abortion, it weakens the [love] story she's having with the father of his child," he says.

Diane had had two abortions after becoming pregnant by Egon following Tatiana's birth. Yet she seems particularly wistful about this child of Elkann's who was never born and who "would be twenty-five now," she says.

After Elkann ended his affair with de la Falaise, "there were others," Diane says, and her unhappiness grew. "Alain and I have become foreign to each other," she wrote in her diary in the spring of 1989. At the end of May she was in New York. "Terrible morning with toothache. Feel sad and disappointed. Alain hasn't called," she noted in another diary entry.

She suffered a great deal of pain and a high fever and saw a dentist, who pulled the tooth. Afterward, Diane thought, "So goes Alain with the tooth."

She bought herself a ring, as she always did when she broke up with a man, to symbolize her commitment to herself. She returned to Paris, and as she packed her bags, she dreamed. In her dreams she saw women in dresses—*her dresses*—with a label bearing "DVF" against the soft spot at the nape of their necks. Her heart, scarred by pain and disappointment, swelled. She would go back to work, and she would heal.

Can We Shop?

iane's name had fallen downward through Fashion with the swift trajectory of a boot dropped from the sky. During her five years in Paris she'd lost many of her licenses, including the most lucrative one, with Sears. The Midwest retailer had canceled her contract in the late eighties after she failed to attend several key meetings in Chicago. Those licenses she had left—for cheap children's clothes, stationery, nurse's uniforms, luggage, eyewear, and a fashion line in Mexico—were mostly producing "junk," she recalled. "I tried to talk to them, but they wouldn't listen. I could tell, they thought, 'She's a has-been. What does she know?'" Her cosmetics line, The Color Authority, had disappeared when Beecham underwent a series of mergers and acquisitions. In the process, Revlon bought Diane's Tatiana fragrance, but then colored it purple and reformulated it into a tacky, sickly sweet scent. By 1989, Diane's annual income had dropped 75 percent, from four million dollars to one million.

What Diane dreaded most had happened—her brand had become passé in a world where brands ruled supreme. Fashion now was domi-

nated by big corporations focused on marketing, growth, brand aware-
ness, and profits, as opposed to innovation and artistry. Seventh Avenue
was almost unrecognizable from the seventies when Diane had entered
the business. Many design firms had closed, as manufacturing was out-
sourced to large factories in Asia.

New York fashion boomed with a roster of new stars: Donna Karan,
Calvin Klein, and Ralph Lauren. This outer-borough-born triumvi-
rate comprised the first American designers to win global recognition,
and each member carved out a particular territory in the fashion land-
scape— Karan, having-it-all chic; Klein, youthful sex; Lauren, preppy
elegance.

Karan's territory had once been Diane's. In the 1970s, while Diane
was the toast of New York, Karan had labored in back-room obscurity
as an assistant to Anne Klein. She'd worked on the Anne Klein col-
lection for the landmark Versailles fashion showdown, and after Klein's
death the following year, she became chief designer of the house. "Donna
designed Anne Klein longer than Anne Klein did," says Karan's long-
time marketing and communications director, Patti Cohen. "She wanted
to have a little Donna Karan label within Anne Klein, and they said no,
so after a long time of going back and forth, in 1984 they basically fired
her and gave her money to start her own company."

In 1985, Karan moved into the former showroom of deposed fashion
king Halston. In an act symbolizing how completely Halston's moment
had passed, one of his associates erased the videotapes of the designer's
fashion shows with the intent to sell the blank cassettes to Karan.

Her first collection of "Essentials," seven easy pieces that could be
mixed and matched, was an immediate hit. In the coming seasons, Karan
became known for her sophisticated jersey dresses, Lycra tights, and
feminine power suits. Her soft fabrics and fondness for wrapped skirts,
shirts, and dresses recalled Diane's aesthetic, though unlike Diane,
Karan favored a neutral palette and avoided prints. She also sold at a
higher price point than DVF, though in 1989, the year Diane returned

to New York, Karan debuted a less expensive, youthful clothing line, DKNY, that went after the type of independent, on-the-go working women who'd made Diane famous.

Big-boned and heavy-featured, Karan had none of Diane's feline allure. Yet, as a CEO and working mother of a young daughter, she embodied the superwoman idea of the eighties, an image reinforced by her 1992 ad campaign featuring a model posing as a woman president. In October 1989 the cover of *Manhattan, Inc.* magazine proclaimed Karan "The New Queen of New York."

Amy Spindler, then the *New York Times*' chief fashion critic, wrote that Karan had become "the heroic female personification of New York fashion," revered for her flattering panty hose—a staple in the American woman's wardrobe—"forgiving colors," and practical, timeless designs that were "full of solutions for imperfect bodies" and women who cannot afford to replace an entire wardrobe each season.

Still, Karan's sales paled next to those of Calvin Klein and Ralph Lauren. They were two smart, streetwise tycoons from the same bustling neighborhood in the Bronx—who'd risen to the top of American life with a couple of good ideas and audacious marketing.

Both depended for their print and TV ads on photographer Bruce Weber, the bearish, disheveled "auteur" of their sleek, polished images. Weber's stock-in-trade, as Michael Gross wrote in *Genuine Authentic: The Real Life of Ralph Lauren,* was to create "selling imagery from the raw material of high-end fantasy." Weber was a genius at articulating the "codes" of a brand in visual terms, so that what the brand stood for was immediately apparent. For Lauren that meant glossy, Gatsby-esque scenes of beautiful people cavorting on the manicured lawns of estates and in rooms laden with the rich trappings of wealth—lush upholstery, crystal chandeliers, extravagant carpets. For Klein's underwear and per-fume ads, Weber created a sophisticated world of elegant sex, incorpo-rating beautiful, semi-nude bodies that evoked classical statues against spare monotone backgrounds.

Handsome and bisexual, Klein was a struggling young designer working out of a small showroom at the York Hotel on Seventh Avenue when one day in 1968 his life was changed by the opening of an elevator door. A vice president of Bonwit Teller was on his way to an appointment on the floor above Klein when the elevator stopped unexpectedly. The executive saw Klein's minimalist, tailored dresses and coats in neutral colors and immediately recognized their commercial potential. He stepped out, introduced himself to Klein, and told the young designer to take his samples to Bonwit's. Soon Klein was one of the store's top sellers.

At the time, Klein was married to his childhood sweetheart, Jayne Centre, and the father of a daughter, Marci. As his business took off, he moved his family from three rent-controlled rooms in Forest Hills to a glamorous Upper East Side apartment. In 1974 he split with Jayne. Four years later, Marci was kidnapped but rescued after Klein paid the $100,000 ransom, dropping it off himself in a paper bag at the top of an escalator in the Pan Am Building. A former Klein babysitter and two accomplices were caught and convicted.

The trauma disrupted the decadent life of sex, drugs, and partying till dawn that Klein had embarked on since leaving Jayne. He was seen with beautiful women but also at gay discos, and he shared a house with his fellow designer Giorgio di Sant'Angelo in the mostly gay beach community of Fire Island Pines.

As a new gilded age dawned with the 1980s and AIDS decimated the gay community, Klein entered Hazelden, the drug rehabilitation hospital in Center City, Minnesota, joined AA, and married his pretty, tawny-haired assistant, Kelly Rector, who'd once worked for Ralph Lauren. When the profits from Klein's jeans began sliding in 1983 after Carl Rosen's death, Klein bought Puritan Fashion. As time went on, Klein's women's clothes grew more elegant and expensive and his status jeans more popular with both sexes. He became a style icon among gay men, in part for his sexy underwear ads starring rapper Marky Mark, soon to morph into the movie star Mark Wahlberg.

In the race to the top of American fashion, Klein's only rival was Ralph Lauren. Born Ralph Lifshitz, Lauren was the anti-Calvin, his style of WASP old-money prosperity the opposite of Klein's hip, androgynous aesthetic, and his family-man image the opposite of Klein's hard-partying decadence. Lauren lived quietly with his wife, Ricky, and three children in faux aristocratic splendor in homes in New York, Colorado, Jamaica, and the Hamptons.

Lauren's clothes seemed fogyish next to Klein's sleekly minimalist creations and Karan's sexy, draped jersey outfits. But that was exactly the point. Lauren's flagship Polo brand stood for a world of manor houses, tailored clothes, servants, old silver, horses, sports cars, and antiques, a world he had created in his own Disneyland of a store in a grand limestone mansion on the southwest corner of Madison Avenue and Seventy-Second Street.

With its polo-player-on-a-horse emblem, the Polo brand evoked an American version of a familiar though often mocked type—the dim aristocrat. But while the Polo aesthetic was a risible cliché to the Brits, and the London Polo shop failed, closing after two years, Americans loved all things Polo. Never before Ralph Lauren, *Time* magazine gushed, had a clothing designer "established a product range so wide, a retailing network so extensive, a marketing image so well defined." In 1986, Polo sales of a wide range of products (expensive women's clothes were the least of it), from shirts and chinos to sheets and shoes, hit $1.3 billion, a fourfold jump from 1981.

CalvinDonnaRalph. The names were repeated so often together that they could have been one word. In New York in the early eighties, their celebrity clout was unrivaled in fashion. Meanwhile, Paris had produced its own stars, including Claude Montana with his aggressive black leather clothes, Thierry Mugler with his padded shoulders and power-woman space suits, and Azzedine Alaïa, whose gorgeous, body-conscious clothes recalled the designer's designer of the pre–World War II era, Madeleine Vionnet.

FOR SOMEONE LIKE DIANE, "WHO has this great, great need to be at the center of attention," as one journalist who's observed her over the decades puts it, being out of the limelight felt crushing. It was not in Diane's nature, though, to feel sorry for herself or sit around brooding. Her style was to keep moving forward, to keep busy. Among the projects she undertook on her return to New York in 1989 was a series of coffee table books. The first one, *Beds,* featured color photographs of 170 beds around the world, some of them her own and those of her friends, including Marisa Berenson's girly cloud of a bed draped in golden fabric and Kenny Lane's masculine, dark-wood bed covered in cool, crisp linens.

To launch the book, Diane had five parties on two continents—two in New York, one in Los Angeles, hosted by Barry Diller, one in Paris, attended by ex-beau Alain Elkann, and one in Rome, hosted by ex-husband Egon von Furstenberg.

She also covered the couture collections in Paris in July for *Interview.* The magazine's contributor's note described her as the owner of "a licensing business, which includes fashion, beauty, and home products. She is also backing Salvy, a Paris based publishing house." Her article, illustrated with drawings by Konstantin Kakanias, featured the openings of Christian Lacroix, Dior—designed by Gianfranco Ferré—Ungaro, Valentino, Saint Laurent, and Chanel, recently revived by "the Kaiser (as they call Karl Lagerfeld in Paris)," Diane wrote.

FOR DIANE, KEEPING BUSY ALSO included dating. She was never long without male companionship, and the first person she began seeing after her breakup with Elkann was Mort Zuckerman, the billionaire real estate mogul, who was as famous for his liaisons with powerhouse women as he was for his media acquisitions, which included *The Atlantic Monthly, US News & World Report,* and, later (in 1993), the New York *Daily News.*

By the time Diane began dating him, Zuckerman had already had relationships with the newscaster Betty Rollin, who was best known for

writing one of the first breast cancer memoirs, *First, You Cry,* and Gloria
Steinem. "Mort Zuckerman is the only one [of my lovers] I'm embarrassed
about," says Diane. "Even while I was dating him, I was embarrassed."
He didn't comport with her sense of self as interesting and creative. In
the past, Diane had been attracted mostly to artists and writers and men
like Diller, who worked in entertainment. She told friends she couldn't
bear to date golf-playing bankers and lawyers. With his focus on business
and politics (through his publications), his love of tennis and softball,
Zuckerman was not her usual type. Nonetheless, he was a consoling lover
during a period of deep malaise. He also provided Diane reentry into the
world of New York power.

At Zuckerman's side, Diane was once again at the center of things. In
August 1989 she went as his date to Malcolm Forbes's seventieth birthday
party extravaganza in Morocco, a three-day blowout that embodied the
eighties spirit of extravagant excess. Some eight hundred of the world's
best-known people from business, politics, media, entertainment, soci-
ety, and fashion attended, including Rupert Murdoch, Henry Kissinger,
Barbara Walters, Nan Kempner, Calvin Klein, and Elizabeth Taylor,
who was Forbes's date.

Guests who hadn't sailed in on their own yachts were flown in by
Forbes and met at the airport by one hundred clapping, dancing, brightly
clad Moroccan women, as men in flowing djellabas blew trumpets. Lux-
ury accommodations were provided in Forbe's white Palais Mendoub
overlooking the Straits of Gibraltar, and the festivities included lavish,
champagne-soaked meals, fireworks, belly dancers, and a performance
by two hundred horsemen in Moroccan costume.

Diane wrote in her first memoir that the mob of celebrities and blow-
out entertainments made her wistful for her relatively quiet life with
Elkann. "I would have preferred to visit author Paul Bowles, who lived in
Tangier," she wrote. Perhaps her wistfulness had as much to do with the
fact that of all the designers at the event, including Oscar de la Renta and
Calvin Klein, she was the only one not designing.

More trips with Zuckerman followed. In November 1989 she traveled with him to Germany and witnessed the fall of the Berlin Wall. (Several years later, after she stopped sleeping with Zuckerman, she says, she traveled with him to Cuba, where they spent two days with Fidel Castro in Havana. Diane found the Cuban leader "charming" but "not quite as macho as I had expected.")

She also went on her own to Spain, China, Japan, Sri Lanka, and Turkey. But the manic traveling could not cure her unhappiness. In the summer of 1990 she was with Barry Diller, David Geffen, and Calvin Klein in the Hamptons when the discussion turned to work. Klein was recovering from injuries suffered in a horseback-riding accident and faced financial difficulties due to flagging jeans sales, but he still had a business. Listening to Klein and the others discuss their work, Diane burst into tears. "I had no business at all," she recalled.

She realized what she wanted more than anything was to get back into fashion.

She decided to reenter the way she started—by approaching several established Seventh Avenue firms about taking her on as a division. She would do the designing and leave the manufacturing and distribution to others. In 1990 she signed a deal to design a moderate sportswear line for Russ Togs.

The company had been founded, like so many American clothing businesses, by Jewish entrepreneurs who'd grown up on the Lower East Side. Eli and Irving Rousso left school as teenagers to work in the garment industry. After serving in the armed forces during World War II, they started Russ Togs with their father in 1946. At the time Diane signed on with the firm, Irving Rousso, a man of driving ambition and epic chutzpah, who built the firm into one of the nation's most successful manufacturers of moderately priced sportswear, still served on the company's board.

Irving had started out as a salesman *and* a designer, and he worked every day, all day, even on Yom Kippur. "My father was going to kill me.

But I didn't care," he recalled in *Schmatta*, the 2009 documentary about the New York garment business. In his quest for success, Irving stopped at nothing. His two uncles also had a business on Seventh Avenue, making ladies' suits. "They were very successful, and we weren't doing any business," Irving recalled. So he went to all the stores in New York that carried his uncles' line, bought every style, and knocked them off. "My uncle called my father screaming, so my father comes over to me and says, 'Son, did you do such a thing?' And I said, 'Pop, let me say something to you. If you were my competition, I'd knock the shit out of you, also.'"

By the early nineties the retail landscape had changed dramatically, and Russ Togs had hit hard times. Department stores were closing out their budget divisions and, in an era before Target and other big-box stores, moderately priced lines such as Russ Togs had no place to go. The company came up with the idea to reinvent itself by acquiring prestige labels. At the time they signed a deal with Diane, they'd already bought Diesel, a hip European jeans brand, which they would introduce in the United States.

Russ Togs seemed to be Diane's best option. "This third child of hers—her brand—was floundering," recalls Kathy Landau, a New Yorker who'd been living in Los Angeles when Russ Togs hired her to move home to oversee marketing for its new DVF division. The morning after she'd been hired, Landau opened the *Los Angeles Times* to see a huge ad for schlocky, ninety-nine-cent DVF cosmetics cases sold by the Thrifty Drug Store chain. Landau remembered Diane's glory days with the wrap dress and couldn't believe her brand had sunk so low. Diane herself had also faded from public consciousness. When Landau told her friends she was going to work for Diane von Furstenberg, they couldn't even place who that was. Diane had merged in their minds with other dark-haired beauties who'd been famous in the seventies. "They'd ask me, 'Oh, was she the one who was kidnapped?' And I'd say, 'No, she's not Gloria Vanderbilt. And she's not Paloma Picasso, either,'" Landau recalls.

Russ Togs set up a showroom for Diane in the company's Seventh

Avenue headquarters, and she went to work. She was unhappy designing inexpensive sportswear in cheap fabrics—leggings, catsuits, jackets, and skirts. "I ate a lot of humble pies," she said. But at least she was working. She'd also begun the process of divesting herself of her remaining licenses and reclaiming her name. "In some cases, I had to buy it back, in some cases, beg it back," she recalled. By 1992, the only products still produced under a DVF license were eyewear, luggage, children's wear, and the fragrance Tatiana.

Things improved a bit the next year, when Diane got to design dresses, her sweet spot. "I was marginally happier with the dresses I went on to design in 1991, clever woven wrap tops and stretch woven skirts," she wrote. "The fabric wasn't what I wished it could be, but finally there was a product I could somewhat identify with."

Diane decided to celebrate the new dress line by hosting a press breakfast similar to the ones she'd held in the seventies at her Fifth Avenue office. She had all the furniture cleared out and installed a display with the new clothes. At 7 A.M., a couple of hours before the breakfast was to start, Landau got a call at home with startling news: Russ Togs had declared bankruptcy. (In a short time, the company would go out of business.) She rushed to the office and told Diane. Without missing a beat, Diane said, "In that case, we'll do it ourselves."

The press breakfast went ahead as planned, and soon after, Diane moved Landau and the president of the Russ Togs Diane von Furstenberg Sportswear division, Kathy Van Ness, uptown and went back into business. "It was nothing but us and a desk," recalls Van Ness. "We did everything from finding the factories [in Hong Kong], to setting up the organization, to planning the buys, to figuring out the gross margins, to talking to retail stores, to managing salespeople—everything you do in any other business, but this was a start-up, from zero. It was a huge rush of energy to launch it. I couldn't have imagined what her brand would become considering where we started, which was with nothing. But Diane was very clear about where she wanted to take it."

The wrap dress, and the story of the wrap dress, permeated all her ideas about her business, even in planning a separates line. She wanted to make easy, comfortable, affordable clothes that enhanced a woman's femininity and confidence. "Her customer profile of a strong, confident, independent woman was the same as it had been in the seventies," says Van Ness.

As in the seventies, Diane's designs centered on prints. She "would sit in her office sketching ideas—checks, geometrics—very bold and brave designs," says Landau.

Adds Van Ness, "She was very much about clothes that anyone could wear—if you had a bust or didn't, if you had a waist or didn't."

Diane launched the dresses in March 1992 at Macy's flagship store in New York's Herald Square. The store had given her the windows, which Diane decorated to look like her office, with a desk, books, photos, posters, and sketches scattered across the floor.

As a crowd of sixty people gathered outside, Diane stood in the window with a microphone. "I feel like a fool," she began, her voice echoing outside through a loudspeaker. Then she held up each dress to the perplexed crowd, explaining that "they are designed for women who work."

Afterward, she met customers on the fourth floor, where fifteen hundred square feet had been devoted to displays and racks of Diane's dresses. The next day she hosted a reception for fifty of Macy's best customers in the store café, followed by a fashion show. She also made appearances at Macy's stores in Tysons Corner, Virginia, and in Cherry Hill and Paramus, both in New Jersey. The dresses sold well enough, though, as Diane later admitted, the fabric wasn't good, and they were not well made. She stayed with it for a while, but her heart wasn't in it, and after a few seasons she ended the line.

By then she was on to a new project. It had started in the summer of 1991, when, in the Concorde Lounge at JFK on her way to Paris, she ran into Joe Spellman, a marketing expert for Elizabeth Arden. Diane told Spellman about her frustration—she wanted to rebuild her business

but didn't know how. Spellman put her in touch with Marvin Traub, the former chairman of Bloomingdale's, and Lester Gribetz, the store's former vice co-chairman. She considered forming a partnership with the three men, and they began discussions on the best way to relaunch DVF. During one of their talks, Spellman suggested Diane start by selling her clothes on QVC, the home shopping channel.

QVC, for "Quality, Value and Convenience," had been founded four years earlier, in 1986, by a restless entrepreneur named Joseph M. Segel. After watching a videotape of the Florida-based Home Shopping Network, the broadcast cable TV network, Segel decided he could do a better job. Operating out of a huge, windowless brick hangar in a bland suburban corporate park in West Chester, Pennsylvania, about twenty miles west of Philadelphia, QVC first broadcast on November 24, 1986, from 7:30 PM to midnight, and reached an audience of 7.6 million.

In a few years, the network was broadcasting 24/7 and had established itself as the world's foremost purveyor of such products as fake jewels, macramé sweaters, frozen crab cakes, and inflatable mattresses. QVC was piped into cable networks that went to 45 million US homes, as well as hospital waiting rooms and auto repair shops, where it flashed nonstop on TV screens. In 1992, sales were $1 billion a year.

From its start, QVC was a landing pad for celebrities sliding down the trash chute of pop culture. This was where Annette Funicello hawked her mohair Teddy bears, Victoria Principal pitched her makeup line, and Marie Osmond sold her doll collectibles. But no one epitomized the huckster vibe of QVC more than comedian Joan Rivers, who at fifty-nine was already a plastic-surgery cautionary tale and whose eponymous costume jewelry line provided her a comfortable "annuity," as she put it. "God bless QVC," she told Novid Parsi of *Time Out Chicago*. "They came to me when nobody was doing it, when it was a dirty thing to do, and it's been my rock."

On the last Saturday in February 1992, Diane took the Metroliner to West Chester with her would-be partners—Gribetz, Traub, and

Spellman. The moment she walked into the QVC studio, she saw her future—it looked like money. As she followed the three men down the hall, she found herself thinking out loud, "I want to own this place."

At that moment the soap opera actress Susan Lucci was on the air pitching hair products. Operators sitting at tables keyed in phone orders on computer screens from customers watching on television, charged each order to a credit card, and then pressed the Send key, which transmitted the order to a warehouse. QVC was able to slash costs by cutting out the middlemen. The company bought all the merchandise sold on the channel directly from manufacturers and shipped it from the company's immense loading dock in West Chester. Delivery was promised in a week.

Diane watched in amazement as the phones lit up. At the end of her hourlong segment, Lucci had sold around a half million dollars' worth of shampoo and conditioner. Diane saw Lucci's pitch as an extension of what she herself had always done—talking directly to customers during her countless personal appearances at boutiques and department stores. But on QVC, Lucci reached more people at one time than Diane could have imagined.

As soon as she got back to New York, Diane called Diller. "Barry, you've got to go there," she said. At the time, he was just as much at sea as Diane. He'd recently resigned from Fox, the network he'd started six years earlier, after Rupert Murdoch refused to make him an equity partner. He had no idea what he would do next. He was restless, newly fifty, and eager for a fresh challenge. No one had been more sharply cognizant of the changing cultural zeitgeist than Diller. But media and entertainment had grown far more complex since the start of his career. He decided he should at least look at QVC, for Diane's sake, if nothing else.

Home shopping seemed a small thing for Diller's huge ambition. What's more, he was put off by the schlocky merchandise QVC offered. That could be changed, Diane told him. Indeed, Darlene Daggett, the brains behind QVC's fashion merchandising, was trying to attract a more

sophisticated audience with higher-caliber products pitched by higher-caliber celebrities. Recently, socialite C. Z. Guest had been hawking garden tools, and Diane's friend Kenny Lane had sold a lower-priced line of his upscale costume jewelry.

After his first trip to the QVC studios in West Chester, Diller came away impressed. "It was the first time I'd seen screens used for something besides telling stories," he says, "and I thought, 'Wow, that's really interesting.'"

Still, he wasn't convinced. At the time, Diane had signed a partnership agreement with Gribetz, Spellman, and Traub to produce a fashion line for QVC. Traub often met with Diane and Diller for Sunday dinner at the Carlyle Hotel—where they had separate apartments—and he recalled Diller complaining, "Why are we bothering with this? This is minor league stuff. Let's go buy NBC, and we'll put Diane's [clothes] on NBC."

"You may be right," Traub answered. "But [QVC] is like starting in the minor leagues in baseball" or opening a play outside New York to test the waters. "Let's see if we can make it work with QVC" first.

In the end Diller agreed, but he advised Diane to go forward on her own, so she could control her fashion line 100 percent. Diller bought out Traub, Spellman, and Gribetz for a nominal amount and negotiated Diane's deal with QVC himself. (Diane's first memoir relates a differing narrative. According to *A Signature Life*, Diane's partners had declined to take part in the apparel line at all.)

Diane would design a small collection of silk garments called Silk Assets. The collection would include three dresses priced from $105 to $120; a blazer at $105; a kimono-style jacket at $98, oversized shirts from $78 to $88, two pants styles at $48 and $58, a wrap skirt at $48, T-shirts from $38 to $49, and two scarves at $40 and $48. Depending on the success of Diane's first appearance, a new collection would be produced every two months or so and would include pieces that would coordinate with earlier collections so shoppers could build a complete wardrobe.

At 8 AM on November 7, 1992, Diane strode onto a triangular slice of stage that had swiveled into place on the revolving QVC set, wearing a purple Silk Assets wrap dress and black Manolo Blahnik pumps, as Katherine Betts wrote in *Vogue*. Squinting into a bank of hot lights, she regarded the set, which had been decorated like a living room, with a sofa, a fireplace, and a stark white backdrop, to which an assistant was tacking up one of her colorful scarves. "Please, let's not have scarves tacked up on the wall!" Diane said.

Her segment had been set up like a talk show, with a host, Jane Rudolph Treacy, a pretty, ebullient young woman, interviewing Diane at a desk. One of the network's most popular hosts, Treacy had logged close to ten thousand hours hawking Breezies underwear, budget shoes, and gemstones on a show called *Rock Stars*.

"I'm not familiar with this buying and selling on television," Diane admitted, as two models twirled in Silk Assets outfits. Her sophisticated, European face looked hard next to the über perky Treacy, a former local TV reporter. Also, Diane kept pursing her lips and running her fingers through her hair, fashiony mannerisms that looked unfriendly on TV. As the morning progressed, though, she grew more relaxed, telling the audience that "building a wardrobe is like building a circle of friends your whole life."

The screens of viewers watching at home were dominated by the QVC phone number in bold white next to the words "Diane von Furstenberg Fashions." A column on the left described the item being shown, for example, a "Silk Jewel Neck Floral Blouse, Retail Value $70.00; QVC PRICE $47.00"—though the retail price was just a hypothetical, reflecting the price at which a traditional retailer might have sold the item.

The first caller, a woman named Anne-Marie, confessed that she was an extra-large, who avoided bright colors. She bought Diane's palazzo pants in black. "Well, black is perfect then. You can never have enough black," Diane said. "Wear it in good health."

When Anne-Marie mentioned that she lived in Brewster, New York,

Diane, whose Cloudwalk was nearby, said they were neighbors. "You must know the Texas Taco where I buy my Mexican. Maybe I'll see you there in your new silk pants!"

At one point, Diane changed from her purple dress—which at $90 had sold out—into a print shirt and pants. A caller from Baltimore was interested in the shirt, which had a purple background, but wondered if it would go with her hair. "Are you blonde or brunette?" asked Diane. When the woman said she was a redhead, Diane exclaimed, "Even better!" She told the caller that the print was copied from a piece of sixteenth-century Florentine inlaid furniture in her Connecticut house. "Don't be afraid of bright colors. The basic silk thing you need is black, but bright colors and prints can give you a great lift."

Barry Diller watched the show from the greenroom backstage, his eyes glued to the computer screen monitoring call-ins. No sooner had Diane glided onto the set than 407 calls came in. Diller began to think this wasn't such a small thing after all.

By 9:30 AM the on-air calls had soared to 721—a considerably higher number than typical for a QVC show—and the computer cash register had rung up a quarter of a million dollars in sales. After a short break, Diane returned at ten thirty, dressed in a Silk Assets blouse and pants. She'd now sold one million dollars' worth of merchandise, and 1,166 callers waited on line. A woman from West Virginia gushed about how much she loved Diane's wrap dresses, the new Silk Assets style and the original.

Diane demonstrated how to wear the last item offered, a silk scarf emblazoned with her signature. "I'm giving it to all my friends for Christmas," she told viewers. The pitch failed, however; the scarf didn't sell well. Still, when the show ended at 11 AM, Diane had sold out twelve of the seventeen Silk Assets styles featured and run up $1.2 million in sales.

As she headed home, speeding north toward the tall, lighted city in her green Jaguar—a present from Diller—leaving behind the rolling

hills and drab corporate park, Diane's spirit soared. QVC made her feel confident again.

DILLER'S TALKS WITH NBC HAD continued through the summer of 1992, but as he studied the state of information technology, owning a network began to seem less attractive than it had when he'd first left Fox. What's more, seeing Diane's success on QVC hit home to Diller that cable, with its myriad viewer choices, would continue to leach customers from the networks. There was only one thing for him to do—buy into QVC himself. His new partners were Brian L. Roberts, the president of Comcast Corporation, the nation's fourth-largest cable company, and John Malone, the CEO of Tele-Communications, Inc., the largest. Diller became head of QVC, and because Diane had introduced him to the channel, Diller gave her 10 percent of his share in the company.

Taking over QVC, Diller says, "was my transition from pure entertainment to pure interactivity. That was a big leap! And I did it as I do all things, without an understanding of risk, without anything except being driven by curiosity and serendipity."

And foolishness, some people believed. "Diners passing Diller at his regular table in the Grill Room of the Four Seasons had almost embarrassed expressions as, uncharacteristically, [Diller] kept looking around, as if for applause," Ken Auletta wrote in his 1993 *New Yorker* profile of Diller. "Those who knew Diller waved a greeting, but they seemed to be thinking, Barry Diller's going to run *what*? A home-shopping network? You've got to be kidding!"

ON HIS FIRST DAY AS the head of QVC, Diller called Diane and moaned, "Could you please tell me what I'm doing here?"

Soon, though, he stopped whining and started doing what he did best—deal making. What he'd had in mind all along was to use QVC as

a platform to grow beyond the small world of channels into a limitless, interactive universe. He wanted to be as big as Murdoch and Turner. To this end, Diller began a battle to acquire Paramount, the studio he'd once run. Owning Paramount would allow him to start building new cable services and even perhaps create a fifth network. Eventually, though, he lost out to Viacom's Sumner Redstone. Undaunted, he next tried to buy CBS, but Comcast, which had a majority interest in QVC, killed the deal when Comcast president Brian Roberts realized the cable company would have no say in the network's programming.

Diller's frustrations mounted as his ambitions were thwarted. But Diane thrived. She appeared on QVC once a week and experienced some of the exhilaration she'd felt in the seventies from having an unstoppable success. "I'm having fun with this vulgar little thing," she told her friend Fred Seidel.

"She wasn't afraid to look like a fool," Seidel recalls.

On one QVC show broadcast at midnight, Diane sold $750,000 worth of Silk Assets clothes in fifteen minutes, including twelve thousand shirts. On another night, she sold twenty-two hundred pairs of trousers with elasticized waistbands in less than two minutes. They might have been, like Carl Rosen's dresses, trousers "for the masses with fat asses," but "sitting in the greenroom and watching all the numbers come up on the computer screen was like being at a horse race," she recalled.

Through it all, says Diller, he and Diane were "getting back together." They were photographed by Annie Leibovitz in Diller's suite at the Waldorf-Astoria Towers for *Vanity Fair*'s 1993 Hall of Fame. The magazine called them "a power couple that have doubled their power. Together, they stroll hand-in-hand down the information superhighway." Leibovitz snapped them lounging on a couch, Diller in a tuxedo and Diane in a black Valentino couture slip dress with spaghetti straps and jet embroidery. With the money she earned putting QVC viewers into Silk Assets pants with elasticized waists and oversized shirts, she had plenty to spend on French couture.

"Diller is *almost* a husband," Diane once told a reporter. Still, she was free to date other men. She never felt entirely comfortable as part of an exclusive couple. "I always fight that," she says. Even with Alain Elkann, as she was submerging her personality and style to please him, a part of her never surrendered completely. She never gave *all* of herself. "My deepest, closest relationship has always been with myself," she says.

One of her flirtations during this period was Roffredo Gaetani, an Italian sportsman six years her junior, who had the aristocratic charm and movie star looks of a professional playboy. Gaetani sold Ferraris—a car that cost $150,000 used in 1992—in Glen Cove, Long Island, though his avocation was collecting women. His liaisons with a series of jet set beauties had landed him frequently in the gossip columns, most famously when he challenged the actor Mickey Rourke to a boxing match after Rourke insulted model (and Rourke paramour) Carré Otis at a *Vogue* magazine party. The fight never happened, but Gaetani later said that forever afterward when Rourke "hears my name he quivers like a dog in a storm."

Earlier, in the mid-eighties, the writer Taki Theodoracopolus had boxed Roffredo for three rounds in an Upper East Side match organized for the spectacle of it and attended by the cream of international white trash, including Claus von Bülow, who'd recently been acquitted in his second trial on charges that he'd attempted to murder his wife, Sunny, by insulin injection.

Gaetani had grown up in a palace, the Palazzo Lovatelli, in Rome, and counted two popes among his ancestors. He carried as many names as Egon von Furstenberg—five to be exact: Rofreddo di Laurenzana dell'Aquila d'Aragona Lovatelli. Roffredo, though, had more titles. He was a count, a prince, and a duke. In New York he lived in a Broome Street loft that had a brass bull protruding from the dining room wall and a huge tree trunk that spanned the length of the living room suspended from the ceiling.

Gaetani and Diane spoke Italian together. They had many friends in

common and shared a love of fast cars. But the affair was never more than casual. In the language Diane typically employed when describing her lovers, their "bodies met," but the union never evolved beyond a "flirtation" into a "relationship." Gaetani "was around," recalls Kathy Landau. He would go on to famously squire Ivana Trump a few years later, and then die a playboy's flamboyant death, in 2005, when he drove off the road while traveling to Argiano, his ancestral castle in Tuscany.

DIANE'S QVC SUCCESS ENCOURAGED HER to branch out, to get back into cosmetics. She had an idea for a new line of aromatic bath products based on floral scents, and she approached Revlon about manufacturing and distributing the line, which she called Surroundings. When that didn't work out, she decided to produce the candles, air fresheners, soap, shampoo, and body lotion herself and sell them on QVC. At the same time, she was promoting her new book, *The Bath*, a celebration of the bathing ritual. (A third book, *The Table*, which focused on the art of dining, appeared in 1996.) A picture in the September 1993 issue of *Vanity Fair* showed Diane floating in bubbles in her own cast-iron tub. That same month she introduced Surroundings on QVC in a special broadcast from her country estate that was covered by the *New York Times*.

The old tobacco barn that served as Diane's bedroom and office had been converted into a temporary television studio with blazing lights, tangles of black cables, and an army of assistants.

"Welcome to my bathroom," Diane said into the camera while sitting barefoot on the edge of her tub. "Here is where I have my bath. Here is where I complain about life."

The blond and bright-eyed QVC host Judy Crowell enthused over Diane's Spring Hyacinth shampoo and Egyptian Kyphi candles. Outside, a herd of dogs—Diane's cocker spaniel, Tatiana's dalmatian, Alex's Rottweiler, a German shepherd that had once belonged to Paulo, and a couple of mutts—romped around a New England Satellite Systems truck

parked in the white-pebbled driveway. Alex, at twenty-three an employee of the New York financial-services firm Allen & Company, hosed down his black Acura sports car, blasting the Rolling Stones from a tape player, as servants bustled about setting the table for dinner under the pergola overlooking the pool. Nearby, the garage had been turned into a control room where a group of QVC executives watched a bank of TV monitors.

In the end, Surroundings sold only moderately, and Diane concluded that the line was priced too high. For whatever reason, it just didn't catch on—another example of Diane's failure with beauty products.

WITH DILLER, DIANE NEXT CONCEIVED the idea of Q2, a new televised shopping channel that would be devoted to fashion. Q2 would feature moderately priced clothes by celebrity designers and aim for an audience more upscale than QVC's Fashion Channel, which it would replace. Diller named Diane creative planning director of Q2 and headquartered the new channel closer to Manhattan, in the Silvercup Studios in Queens.

Diane described her position to reporters as "an ambassador," whose chief job was to convince her fellow designers to sell on TV. Working the Seventh Avenue circuit and Triangle d'Or luxury district in Paris like a politician, she tried to broker deals with fashion stars from Karl Lagerfeld, Gianni Versace, and Claude Montana to Calvin Klein, Christian Louboutin, and Ralph Lauren. Diane had once ignored a psychic who told her to go into television, because she thought television was boring. Now she found herself in the middle of a retail revolution on TV, proving the psychic right.

Karl Lagerfeld agreed to appear on Q2 after Diane flew to Paris to discuss it with him. He told *WWD* he planned to sell a version of the "skin dress," a body-hugging knit sheath that he'd shown in his previous two collections for Chanel. It stretched to fit a variety of body types and solved the sizing problem inherent in teleshopping of having to buy something without trying it on. In the end, however, the deal fell through.

Though Q2, which began broadcasting in May 1994, had less brazen puffery and fewer call-ins than QVC, it had the same boxed-in studio set, the same nonstop nattering about products, the same flashing toll-free number, the same tacky vibe as its parent channel. Designers also worried that selling on Q2 would upset their relationships with department stores. In the end, Diane was unable to convince any top designer to sign on.

The channel also had trouble attracting viewers. One problem was that it was mostly available in geographically middle-American cable systems, not in the upscale markets on the coasts, where most of its targeted audience of yuppies and aspiring yuppies lived. Another problem was that Amazon.com, founded in the same year as Q2, was about to compete for the home shopping audience. Diller's idea of "shopping for underwear in your underwear" had been inspired. But once modems were a reality, waiting around to buy, say, an outfit offered on a special program scheduled for Thursday made no sense if it was Sunday and you could get it online.

But Q2's demise was two years away, and in the spring of 1994 Diane still had great faith in the channel's future. Ralph Lauren was among the designers she tried to lure, and one day she invited him to lunch. She did not know him well; it was the first time they'd lunched together. After Diane made her Q2 pitch, to which Lauren listened politely but indifferently, the conversation turned to more personal matters.

Lauren told Diane that several years earlier his world had been shattered when he was diagnosed with a brain tumor. It had all started with an incessant ringing in his ear, accompanied by searing headaches that grew worse. The tumor turned out to be benign, but Lauren had to suffer through many months of worry and pain.

As Lauren spoke, Diane realized, *she* had a ringing in her ear, too, and the next day, she made an appointment with an ear specialist. During the exam the doctor noticed a swollen gland in Diane's neck. He put her on antibiotics, but when the swollen gland didn't go away, he grew

concerned. More tests followed. The initial results were optimistic, and though Diane's doctors believed there was no rush to remove the growth, she insisted it be excised immediately.

Diane underwent surgery in May at the Memorial Sloan Kettering Cancer Center overlooking Central Park. During the operation, Tatiana and Lily sat nervously in the hospital waiting area (Alex was in Hong Kong, according to Diane, but would soon fly to his mother's side.) When it was over Diane was wheeled into the recovery room. Twenty minutes passed. Then the doctor strode into the waiting room and spoke directly to Tatiana. "It's cancer," he said. A malignancy had been found at the base of Diane's tongue and in the soft palate of her mouth.

"I had to translate for Lily," says Tatiana. "Then my mom woke up, and I had to tell *her*. She sat up straight in her hospital bed and about crawled out of her skin. There was so much fear."

After a few days, when the initial shock of the diagnosis wore off, Diane "went into executive mode," says Tatiana. "She and Barry and my brother, the pragmatic people in our family, came up with a plan, and she made decisions about her treatment."

Among the options was radical surgery that would have removed part of Diane's jawbone and cheek, where any microscopic cancer cells might be lurking. "They wanted to cut half her face off, and she said, 'Never!'" recalls Tatiana.

Doctors stood at the side of her bed, read her chart, and chatted. They told Diane they thought they'd "gotten it all," but there's never any certainty of that. The fear that they didn't "get it all," that some of it, even just one tiny cell, was left behind to grow, tormented Diane.

Hospitals have a way of making you feel humbled, defeated, not yourself. Diane couldn't wait to go home, and as soon as she was released, she returned to work. She didn't talk about her illness to her staff. She didn't want their fear and pity reflected back to her. It wasn't that she tried to keep it a secret, but the disease seemed less real if she didn't talk about it. If she acted as if everything was normal, perhaps it would be.

Diane's oncologist prescribed eight weeks of radiation. She considered alternatives and consulted Deepak Chopra, the holistic health guru, who one Friday night at Cloudwalk taught her to meditate. Chopra also invited Diane to the Chopra Center in Carlsbad, California, where Diane prayed, meditated, and took long solitary walks on the beach. By then she'd decided to go ahead with the radiation, and she vowed to face the course with courage and discipline.

Also with help from Bianca Kermorvant, a Parisian healer to whom Diane was introduced by Marisa Berenson. Kermorvant insists she's not a psychic, though, she says, "I have these moments when I know things by instinct." She helps her clients "make the right choices," by turning her mind to their problems and the vibrations of energy surrounding them. Everyone's body is like a radio station that emits a frequency, says Kermorvant, and she maintains that a healer can pick up the vibrations and interpret them—even from a great distance. Kermorvant was located in Paris, while Diane was in New York.

Diane had moments of terror and depression, but ever Lily's daughter, she never succumbed to despair. Every morning she did her hair and makeup carefully and dressed in bright, cheerful colors. She would not let anyone accompany her to Sloan Kettering, walking from her home to the hospital alone. The route between her apartment at Eighty-Seventh Street, Sloan Kettering on Sixty-Eighth Street, and her office on Fifty-Seventh Street formed a *V*, which Diane interpreted as a *V* for Victory. "As I walked, I sang a little French victory song I had made up in which the bad cells were killed and never came back. Even now, when I walk fast, the song comes back to me," she wrote.

To pass time in the hospital, as she waited with other cancer patients for her treatment, she read *Wild Swans* by Jung Chang, a book chosen for its 500 plus-page length—she calculated it would take eight weeks, the duration of her treatment, to complete—and inspiring subject, three generations of women who survived the turbulence of twentieth-century China.

During the actual treatments, Diane forced herself to think positive

thoughts, to concentrate on "the victorious destruction of the bad cells and the strengthening of the good ones." On the way home she stopped at a health food store and drank a shot of wheat-grass juice. Every afternoon she had a shiatsu massage.

The radiation burns on her face and back—something that had worried her terribly—turned out to look like a suntan, albeit an uneven one. She temporarily lost her sense of taste, and though it eventually returned, the numbing of her taste buds permanently diminished her already minimal interest in food. "My mom was never a sensual eater. She could care less about this gourmet foodie culture going on now, especially since she's had cancer," says Tatiana.

The most painful side effect Diane experienced was a severe sore throat that made swallowing difficult. Instead of taking the medicine her doctor prescribed to treat it, however, she gargled with sesame oil, as Deepak Chopra had recommended. She healed her mouth blisters, another vexing result of radiation, with powdered Gashu, a rare type of ginger root given to her by her masseur, Eizo.

Her family and friends stayed close but respected her privacy. The filmmaker Mark Peploe, a longtime friend with whom she'd recently become romantically involved, called her daily from London. Fred Seidel called to bolster her spirits every night before she went to sleep, and he found that the conversation usually ended up with Diane bolstering *his*. Mort Zuckerman took her to a state dinner at the White House, Bill Clinton's first as president, in honor of the emperor of Japan. For the occasion, she turned to rising star John Galliano and borrowed the pink satin and chiffon dress that been the masterpiece of a dazzling collection he'd shown in Paris in March. Diane had been present that day, and as she watched the models parade across the leaf-strewn floor of an empty old mansion, she knew she was witnessing a new fashion *moment*. "Powerful," Suzy Menkes wrote of the show in the *New York Times*. "Perhaps the most celebrated fashion event since Dior introduced his New Look," wrote Michael Specter in *The New Yorker*.

Diane had Galliano expand the bodice, which had been worn in the show by the rail-thin model Christy Turlington, and she herself added some chiffon to the already frothy train. It turned out to be "the most uncomfortable dress I've ever worn," Diane wrote. By wearing it, however, she proved to herself and everyone else that despite her illness and though she had no business to speak of outside QVC, she still had the pulse of Fashion. "Diane got the dress and wore it to the White House, and I thought that was very smart," says André Leon Talley. "She realized that this was something she should embrace, that she'd look good in it; that it was something different, something dramatic. It's instinct. Intuitiveness. She's always been able to pick up on the temperature of fashion at a certain time."

THROUGHOUT THE SUMMER OF 1994, Diane's father was dying. Leon Halfin had been suffering from Alzheimer's for years, but he'd recently taken a turn for the worse. Barry Diller lent Diane the use of his plane for the Fourth of July weekend, when she had a brief reprieve from radiation, and she flew to Brussels to see her father for the last time. He would die three weeks later. "He intensely loved his children and grandchildren," says Tatiana. " He sent me care packages every week when I was in boarding school. He was a devoted family man," who would be deeply missed by his family.

At the time, Diller was in the throes of trying to take over CBS. He pined after the network as a "soul mate" for QVC that would bring him that much closer to having a media empire of his own. By the end of July, however, the deal had fallen through. Comcast, which already owned 15.6 percent of QVC, killed the merger by buying all of QVC for $2.1 billion.

Six months later Diller resigned as chairman of QVC with his visions for the home shopping channel unfulfilled. Grandiose predictions and frenzied media attention had marked his tenure as QVC chief, but his plan to attract high-quality designers and retailers never got off the

ground. Nor was he able to leverage the shopping network to finance bigger deals.

Diller still saw home shopping as a means to an end—the best way to move toward the cutting edge of multimedia technology, television, and film. No sooner had he resigned from QVC than he took over its rival, Home Shopping Network. Diane followed him. Her Silk Assets line would now be sold on HSN. Considered a B-level QVC associated with selling such low-rent fare as polyester leisure suits pitched by such fourth-rate celebrities as *Wheel of Fortune* hostess Vanna White, HSN had tapped out its customer base and was losing money—in 1995, $17.7 million in the third quarter alone.

Around this time Diller bought a controlling stake in Silver King Communications, the tiny TV network that broadcast HSN. Within a year, he'd merged HSN, Silver King, and a production company into a new corporation. As IAC in the new millennium, this corporation would own fifty brands that control online commercial transactions from travel to lending to dating.

Diller also became astoundingly rich. By 2004, *Fortune* estimated his wealth from stock options, gains from stock sales, salary, and bonuses at $1.6 billion. In March 2014, *Forbes* put his wealth at $2.4 billion. He would spend many millions of it to help Diane recharge her brand.

The Comeback

iane's bout with cancer gave her life a fierce intensity. Like many survivors, she saw this as a positive aspect of what otherwise was a horrific experience. Facing death led her to live at a deeper emotional level than before. As the years passed, she tried to hold on to her profound sense of gratitude and worked hard "to honor" life every day.

Having cancer also gave her a clear sense of priorities. If she was going to recharge her brand, she had to act *now*. In August 1995 she restructured her company, naming three new vice presidents and a board of advisors. This "reflects my desire to fully control the DVF brand and establish a full service design and marketing studio," she told *WWD*. Her mission was "to create chic, quality products at prices accessible to most." The focus of the new DVF Studio would be dresses, sold under the simple label "Diane."

Signaling her new beginning, she moved to West Twelfth Street in the Meatpacking District, a remote riverfront neighborhood between Washington Street and the gray waters of the Hudson. In the 1930s, the

"high line," the elevated freight tracks that ran along Manhattan's Lower West Side, had brought animal bodies here from midwestern slaughterhouses to be turned into steaks and chops. In the decades since, the area's dark, forgotten location made it a hub for gays, transvestites, and prostitutes of all persuasions. In 1997 you could still see men in wigs and stilettoes stepping over pieces of uncooked beef splayed on the cobblestones. But the drag queens and old meat-packing businesses, with their bloody carcasses hanging on hooks under tin sheds, were rapidly dwindling, replaced by hipsters and chic restaurants, galleries and boutiques. Still, the location was so far from the center of New York fashion, it "seemed like the end of the earth," says Alexandra von Furstenberg, who married Diane's son, Alexandre, in 1995. "We were all like, 'What is she thinking?'" It smelled bad. It was gloomy and dangerous.

"Everyone told her, 'You'll kill your business; no one will go there,'" says Kathy Landau. But Diane found a comforting beauty in the neighborhood's angled streets, low stoops, and dour old warehouses. They reminded her of Brussels and her childhood home.

She bought two nineteenth-century buildings, one of which had been used as a stable for New York Police Department horses, for four million dollars and spent many millions more renovating them into a dramatic design studio, office, and home. The conjoined buildings housed a great open space on the ground floor with a system of moving walls that could be closed or opened for parties and fashion shows. Upper floors held a design studio, administrative offices, and an apartment for Diane decorated with zebra-patterned chairs, sisal rugs, mounds of pillows, and Balinese carvings acquired during her Paulo period. The renovation kept the buildings' original brick walls, plank floors, and cast-iron columns while incorporating a huge skylight over a twenty-five-foot atrium, a small pool at the bottom of a spiral staircase, and a roof terrace with a greenhouse.

To help fund the renovation and the rebirth of her fashion business, Diane made a deal with Avon, the door-to-door cosmetics company,

which was trying to expand its customer base by offering fashion through its catalogs. Diane was still producing her Silk Assets line for HSN, which brought in some money. But now in addition Avon gave her a guarantee of one million dollars a year plus royalties on anticipated sales of more than forty million to design a moderately priced fashion line for them. She called it the Color Authority, resurrecting the name of her old cosmetics company.

In August 1995, Diane participated in the launch of the Avon catalog, spending an afternoon in the showroom at Avon headquarters in Washington, DC, where her collection was displayed on rolling racks. Sitting at a table with her shoes off, she signed autographs for a long line of sales managers who'd shown up to meet her.

It had been a little over a year since her last radiation treatment, and there was no hint of a cancer recurrence. (Many years later, Diane would give Ralph Lauren one of her father's gold coins from World War II because Lauren "had saved my life," she says.) Throughout Diane's ordeal, Lily never showed her fear. "I'd spy on her to see if she was worried," Diane recalls.

LILY SEEMED CONFIDENT OF HER daughter's recovery, and this greatly bolstered Diane. "I thought, 'If she's so cool about it, everything will be all right,'" Diane continues. Afterward, though, when Lily knew Diane would survive, all the terror and anguish she'd suppressed burst forth, and "she collapsed."

Diane felt energetic, ready to get back in the fashion game full steam. Before relaunching a line of clothes on her own, however, she decided to test the waters by becoming a private label for a large retailer. In early 1996, Diane met with executives of Federated Department Stores, the huge consortium that included Bloomingdale's and Macy's, to discuss Federated producing a fashion line under the label Diane. But at the last minute, in June 1996, as she was on her way to Cloudwalk for the weekend, she got a call on her cell telling her that the deal had fallen through.

Federated's executives, it turned out, were uncomfortable with Diane designing for Avon and HSN, which were both associated with unglamorous products for dowdy housewives. They also were wary because of grumbling from store buyers that Diane was a has-been, at fifty too old to design clothes for the youthful customers they wanted to attract.

Diane was devastated. But as Diller, who suffered through the weekend with her, told Ruth La Ferla of the *New York Times*, Diane's "resilience is bred in the genes; it's in her very bones."

"Most people would have given up. But Diane? Never," says Sue Feinberg. "Diane does things, they fail, and she goes on and does something else. And maybe that fails, too, but she keeps going."

By Monday morning, Diane had decided to produce the Diane fashion line herself.

Around this time, Diane's old wrap dresses from the seventies started showing up in Manhattan vintage shops. At the Soho store 1909 Company, a black wrap with red and blue flowers had pride of place inside the store's glass-paneled front door. Another disco-era wrap—in a swirly pink pattern—graced a mannequin prominently displayed in the window. Young women were grabbing the dresses up for two hundred dollars apiece. Celebrities such as actresses Gwyneth Paltrow and Kelly Lynch and MTV News host Serena Altschul were photographed wearing old wraps. Demand became so high that some shops had waiting lists for the dresses.

A nostalgia for the 1970s swept fashion. Tom Ford was reinventing Gucci with velvet hipsters and snug satin shirts inspired by *Saturday Night Fever*. Late seventies looks were reflected on the runways in slouchy shirts falling off the shoulder, fringed suede jackets, and leg warmers. The designer Todd Oldham invited Diane to a show that he'd planned as an homage to her. As she watched Oldham's models vamp down the runway in a series of his own wrap dresses, she thought, "I'm not dead yet."

In July 1996, while in Paris for the couture shows, Diane found herself on the escalator at the Louvre pyramid face-to-face with Rose

Marie Bravo, CEO of Saks. "I was going down, and Diane was going up," recalls Bravo. "I said, 'Diane, everyone is doing your wrap dress. You should bring it back.' And I could just see her face change. It was very dramatic."

Bravo said out loud what Diane had been mulling for weeks. She knew now it was what she should do, and when she got back to New York, she went to work. Diane wanted to keep the integrity of the original wrap while making it relevant for a new generation. To help her in the design process, Diane hired as her creative director (a position that morphed into "image director"), the person tasked with setting the overall tone of the collection, her daughter-in-law, Alexandra Miller von Furstenberg. At twenty-four, Alexandra was the youngest of the storied Miller sisters, the gorgeous blond offspring of duty-free tycoon Robert Miller and his style-icon wife, Chantal. The girls, who had become fixtures of the society pages, had been raised mostly in Hong Kong, where their father's business was based, but lived part-time in New York, where their parents kept an apartment at the Carlyle Hotel, two floors above Diane's.

Alexandra had met Alex von Furstenberg in the Carlyle elevator one day when they were teenagers, and they'd dated on and off since then. In October 1995 they married in a three-day extravaganza of a wedding, starting with a million-dollar black-tie ball for nine hundred in immense tents that had been set up in Battery Park overlooking New York Harbor.

Alexandra, who aspired for a while to design costumes for film, had studied art and costume history at Brown University and design at Parsons. She had a strong sense of style, yet her main qualifications for her job were that, in addition to being married to Diane's son, she was beautiful, hip, and connected to a crowd of cool, moneyed young women, the glamour girls of New York.

These daughters of the rich had gone to private schools and Ivy League colleges, but unlike their socialite, style-obsessed mothers, they wanted to work. They held jobs in art galleries, auction houses, fashion houses, and the media. They were cultured, well traveled, sophisticated, and multilin-

gual, and their knowledge and polish reflected well on their employers, many of whom dealt regularly with European clients. "You have to know when you see a reference to *crayon* that it's French for 'pencil' and not a reference to kindergarten," as one glamour-girl employer noted.

Alexandra brought a youthful sensibility to discussions about what the new wrap should look like. Incredibly, Diane had not saved any of her wraps from the seventies, though "I found some in my mother's closet," she says. She bought as many as she could from vintage stores and collectors she found online. Diane told a reporter who interviewed her for the *New York Times* that she would mail fifty dollars and a bottle of Tatiana to anyone who sent her an original wrap.

Diane had saved swatches of fabric, however, and she had an extensive archive of her beloved prints. But where to manufacture the new wraps? Ferretti had died; his factories were closed. "A certain Mr. Lam in Hong Kong," Diane wrote, had produced the dresses Carl Rosen and Puritan sold under Diane's name. So now she traveled to Hong Kong to visit Mr. Lam's factories.

Diane convinced Mr. Lam to upgrade his operation for printing fabric. In return, she agreed to transfer production of her Silk Assets line to Lam. She also spent hours with the Chinese workers, instructing them through an interpreter on the fine points of hand-printing fabric, an art she'd absorbed from her long association with Ferretti. "Together we developed the perfect jersey fabric, as tight as the original Italian one but this time one hundred percent silk," Diane wrote in her second memoir.

Actually, the fabric was not as snug as Ferretti's cotton jersey, though like the Italian cloth, it felt lush, draped well, and didn't wrinkle.

Back in New York, Alexandra acted as a kind of house model, trying on myriad prototypes to see what worked best. In the end, Diane modernized the wrap dress by making the collar small and round, rather than large and pointed, and shortening it so it hit at the knee. She also added variations on the classic wrap, including one with no collar or cuffs and one with a more generously cut A-line skirt for older women with spread-

ing hips. Some of the original prints from the seventies were revived, but many new prints were added, including one made up of repetitions of Diane's signature. "She got the idea while talking on the phone one day and absentmindedly doodling her signature," says Kathy Landau. She gave it to one of the two painters she employed who did nothing but paint prints for her design studio.

Diane relied heavily on Alexandra to be the ambassador for the new wrap. (Her own daughter, Tatiana, had no interest in fashion.) "Diane was a little nervous, putting herself out there again, starting her brand anew and not knowing if it was going to work or if she would get buyers to believe in her," Alexandra says. She and her friends played a key promotional role by wearing the wrap to prominent social events where they were photographed by the press.

To get fashion insiders intrigued by her new wrap, Diane wore one to John Galliano's Christian Dior couture show in Paris that July. Hollywood wives Rita Wilson (Tom Hanks) and Kate Capshaw (Steven Spielberg), sitting nearby, raved about it, and for the next day's show at Chanel, Diane had another wrap overnighted to her by Frenchway, the Manhattan travel agency that specialized in such fashion emergencies.

She also advertised in the September issues of *Interview*, *Vanity Fair*, and *W* and in the fall fashion supplement to the *New York Times*. Her ad campaign, the first she'd done in nearly a decade, featured black-and-white portraits of model Danielle Zinaich, a dark-haired, sultry DVF look-alike, shot by the renowned French photographer Bettina Rheims and captioned "He stared at me all night. Then he said . . . Something about you reminds me of my mother."

Not wishing to repeat her mistakes of the seventies, when she'd expanded too quickly, she decided to introduce the new wrap in only ten "doors"—the Manhattan boutique Scoop and in nine Saks Fifth Avenue stores in nine cities. Saks CEO Rose Marie Bravo, who'd sparked Diane's decision to bring back the dress in the first place, "wanted to roll out the wrap dress big, in far more stores than we were comfortable with," says

Kathy Landau. Diane believed it was crucial for her to visit every branch of Saks involved in the relaunch, "and if we were in forty stores, she couldn't do that, and then we wouldn't learn enough" about what was resonating "with the customers and what was not," Landau says.

In the end, Diane and her team decided that the wrap would debut in New York, Portland, Oregon, San Francisco, Cleveland, Saint Louis, Houston, Boston, Chicago, and Atlanta. The official launch was in Manhattan at Saks's flagship store on Fifth Avenue. As the day of reckoning approached, Diane grew increasingly nervous. Though the wrap had been tweaked for the nineties, basically it was the same dress from the seventies. Bringing it back would no doubt recall fond memories among fashion insiders and women who'd worn the dress in its earlier form. But it would also give Diane's critics a chance to weigh in. When the wrap showed up in an "American Ingenuity" exhibit at the Metropolitan Museum of Art's Costume Institute soon after its relaunch, design critic Herbert Muschamp decried it as "the winding cloth of the counter culture" and lamented its reappearance as "the rebirth of . . . label snob appeal and other connotations that people hoped the sixties had killed off for good." The return of the once famous didn't always signal inherent value. As Muschamp grumped, "Godzilla, too, is making a comeback."

THE OFFICIAL WRAP RELAUNCH CAME on the afternoon of September 9, 1997. Beyond the Saks elevators on the seventh floor, hundreds of dresses hung in neat formation on chrome racks, colorful regiments of style, ready to do battle with the dark forces of frumpiness.

Television cameras from CBS and ABC whirred, and reporters from the *New York Times*, *Women's Wear Daily*, and *Vogue* scribbled notes as swarms of women flipped through the hangers with violent snaps of their wrists. Long lines formed at the cash register. Many of the women holding two and three wraps were young, too young to remember Diane's first triumph in 1974.

"It's great to be back," Diane repeated into the microphones shoved

into her face. She'd worried and worked herself to death. But now her moment had arrived. Why didn't she feel elated? She was exhausted and not looking her best. Catching glimpses of herself in the mirrors that seemed to be everywhere, she felt unattractive and old, unsure if she had the energy and stamina for the grueling job ahead.

Her new wrap was only the beginning, the means to the end of building a global fashion brand. Yet she did not have a business plan or even a company president. She and Barry Diller were pouring millions of dollars into the DVF Studio. He estimates that they "were probably approaching twenty million as an investment" to fuel Diane's start-up and "build it up." Diller says he doesn't know how much of it was Diane's money and how much of it was his because "it was *our* money by then."

They considered themselves a couple and, with Diane's children—and eventually grandchildren—a family. Diane often said that Diller's presence in her life made it difficult for her boyfriends. "They feel small next to him," she told *WWD* in 1998. And to me she said, "No one could compete with the way he loved me unconditionally. They were all jealous of Barry."

Part of Diane's malaise at the time of her relaunch was that Mark Peploe, the handsome filmmaker she'd recently been involved with—quietly and not very publicly because he was living in London with the mother of his child—had broken up with her. "He's the only man who ever left me," says Diane.

He'd left her for another woman (though not the one with whom he was living). "With Mark it was all about stolen moments. I love stolen moments, secret affairs. I would have loved to have been a courtesan. That's a very European attitude. No American woman would ever say that," Diane says.

There would be no more exotic trips with Mark to Sri Lanka and the deserts of Cappadocia in Turkey. The poignant symmetry in this was not lost on Diane. She'd launched the wrap in 1974 in the wake of her breakup with Egon; now she was relaunching it during another period of heartbreak.

She coped, as she always had, by throwing herself into work. Over the next months, Diane traveled around the nation with Alexandra, often on Diller's plane, in a whirlwind of appearances at Saks stores. There were visits to morning TV shows, followed by press interviews, breakfast meetings, and talks to the Saks sales staff before the stores opened, then meet-and-greets with customers, more interviews, cocktail receptions, and dinners. "We were on the road together for six months," recalls Alexandra. "People always asked me, 'What's it like working for your mother-in-law?' But our relationship was more like a friendship than anything else. We got along very well."

The dresses were selling well at Saks and at hip boutiques—in Paris at Colette, in London at Brown's, and in New York at Scoop. "The wrap dress had such buzz," says Stefani Greenfield, the brand consultant who started her career as a retail entrepreneur. Greenfield opened her first Scoop store at 475 Broadway in Soho in 1996 and a second store at Seventy-Third and Third Avenue the next year. "We always had wrap dresses in the window, and people would stand outside looking at them and talking about them, and then they'd go inside and buy them," she says. "We were changing the windows every five minutes because women wanted the dress in the size on display. We were selling them hand over fist."

Uptown girls wore their wraps with heels and pearls, and downtown girls wore theirs with tights and boots. Greenfield's customers were reading in the press "that every cool girl is wearing the wrap," she continues. "So, wearing the wrap became a way to register, 'I'm cool, too.'"

Among the coolest girls in New York who wore the wrap was Gywneth Paltrow, the star of *Emma* and the upcoming *Shakespeare in Love*. As Greenfield notes, a powerful subliminal message pulsed from photos of Paltrow and other celebrities wearing the dress: "Maybe you can't be in my movie, but you can wear what I'm wearing. You're part of my club."

The verdict from the fashion critics, though, would not come for two more months. On November 3, the day of Diane's formal opening, a shiny

black ribbon of town cars clogged West Twelfth Street and unloaded a perfumed cavalcade of well-dressed women. At the entrance to the DVF Studio, a tense, tight crowd had gathered. When the doors finally opened, the crowd rushed toward the seats, hundreds of heels spiking the Diane von Furstenberg signature that was endlessly repeated in the black and white carpet.

Moments before the show started, Ellen DeGeneres appeared at the door. Stocking your fashion show with celebrities is a great branding opportunity, and who better to announce your independence, your relevance and commitment to women, than a TV star who just came out publicly—on the Oprah Winfrey show—as a lesbian. The photographers stampeded DeGeneres, the star of the sitcom *Ellen*, as if she were the last Famous Person on earth. A fireworks of flashbulbs followed, and DeGeneres glowed so much it seemed one of the flashbulbs had been planted inside her.

But she did not take her place in the front row among the leggy "it" girls and poker-faced editors. Actually, DeGeneres had shown up at the DVF Studio by mistake. She'd been on her way to Industria SuperStudio across the street, where her girlfriend, actress Anne Heche, was in a photo shoot. She'd gotten confused and ended up at the wrong address. Diane's staffers urged her to stay, but DeGeneres hurried out, explaining that Heche was waiting.

Then the lights dimmed and the models made their way down the steep spiral staircase over the rippling pool. Diane stayed invisible behind the scenes, emerging only at the end to loud applause. The critics did not repeat the acclaim.

The show "was boringly repetitious with seemingly endless variations of the wrap dress and the wrap jump suit in floral prints, leaf prints, wood-grain prints and reptile prints, but not enough to make a formal show worthwhile," concluded Anne-Marie Schiro in the *New York Times*.

"This should be Diane von Furstenberg's moment," wrote Suzy Menkes in the *International Herald Tribune*, "for her 1970s jersey wrap-dresses

are now flea-market chic . . . but as identical designs in different prints from batik and wood-grain to reptile prints wound down the spiral staircase, the show was short on variety."

More abuse came from *WWD*: "Everyone was primed for the seventies icon to deliver, in this comeback show, her new signature for the nineties. But Diane played it safe, sending out enough wraps and jumpsuits to outfit Farrah and her sister Angels through years of runs in 'Nick at Nite.'"

The reviews were hurtful, but Diane and her staff took them in stride. "You can't go from a disaster, which is what her brand had become when she lost control of it, to exceptional without traveling a fairly bumpy road," says Kathy Landau.

There was a lot of soul searching in the company and within Diane's family. In the three months after the relaunch, she sold about three thousand wraps at the nine Saks stores where the dress had debuted, and it was a best-seller at Scoop in Manhattan. But this was nothing compared with the fifteen to twenty-five thousand dresses a week she'd sold in the mid-seventies.

Diane, though, refused to dwell on negative thoughts. With her obsession for turning negatives into positives and little memory for pain, she threw herself into her work. The trouble was, she seemed to be spinning her wheels.

Diane brought in a series of consultants and sales people who had various ideas on how to turn things around. "They weren't good, and they didn't get the business," says Landau.

She also tried to "make a major marriage" with a big manufacturer. To this end, she met with executives at Liz Claiborne, the $2.5 billion career clothes company, and John Pomerantz, the CEO of Leslie Fay, the moderately priced dress company. With Pomerantz Diane had come full circle. In 1971 he had first suggested to Diane that she go into business for herself rather than become a division of an established firm like his, and he'd introduced her to Richard Conrad, the fashion executive who became her first partner.

Nothing came of the talks, however.

All Diane wanted to do was her own fashion, but she still had to devote time to Avon and HSN because she needed the income from those lines to fuel her own collections. These distractions left her exhausted and drained her creativity. It didn't help that Diane was restarting her business during a period—they pop up occasionally like peplums, shoulder pads, and, well, wrap dresses—in which fashion was declared to be dead. No less an authority than the *New York Times* sounded the death knell in a front-page article, citing as evidence that sales of women's apparel had fallen 12 percent, from a record $84 billion in 1989 to $73 billion in 1995. Women had roundly rejected expensive designer wear, according to the *Times*, noting that stores that once seemed invulnerable, from trendy boutiques such as Manhattan's Charivari to the conservative career-clothes chain Casual Corner, were "deeply troubled. . . . Women's apparel stores had their worst Christmas in nearly a decade last year."

Designers, meanwhile, faced global economic turmoil, sinking stock prices, and an overcrowded marketplace. In this unforgiving business climate, several designers had gone out of business, including onetime media darling Isaac Mizrahi. Others, such as Todd Oldham, had dropped their high-end "collection" lines. Designers were hopelessly out of touch with what women really wanted, the *Times* concluded, as evidenced by the sharp-angled, miniskirted power suit shown by Anne Klein—a style that made women look like pin-striped hookers—which had bombed. The story cited a long list of designers, including Carolyne Roehm and Stephen Sprouse, who'd excited press coverage for their flashy clothes but had been forced out of business because of flat sales. American women, the *Times* claimed, now wanted to spend their money on things other than fashion, "from vacations to home furnishings to plastic surgery."

ONE MORNING IN AUGUST 1998, Diane was speeding along Route 46 at the wheel of Barry Diller's BMW, talking distractedly on the phone to her office. She was on her way to Teterboro Airport, where

Diller's plane waited to fly her to Alaska for a weekend cruise for two hundred friends of the host, Microsoft billionaire Paul Allen. Careening off the exit ramp, she skidded into an eighteen-wheel truck. She woke up in the hospital with eighteen stitches in her head, five broken ribs, and a collapsed lung. (Diller's car was totaled.) Doctors put her on oxygen—an indication of the gravity of her condition. Diane was lucky to survive the crash and remained hospitalized for a couple of weeks. Still, she made light of her injuries to her friends and went out of her way to call a *WWD* reporter from her hospital bed to get the word out that she had a strong constitution and would soon be back at work. "Tell everyone I'm fine. I just have a few broken bones." Thanks to the hydrating effects of the oxygen, she said, her skin was beautiful.

Since she was already laid up, she thought this might be the time to have a face-lift. Diane had always looked older than she was. At twenty-five she looked thirty-five. Now, at fifty-one, she looked, well, fifty-one, which was old for fashion and old for New York society, filled as it was with so many astonishingly young-looking women, thanks to the wonders of modern dermatology and plastic surgery. Diane had been unhappy with recent pictures of herself, especially those that appeared in the press in connection with her relaunch. "When your identity is very much associated with your physical image, as hers was, time is not your friend," says Kathy Landau. Aging is difficult for most people, but it's especially hard, perhaps, for "someone like Diane, who is always photographed and at the same time looking at pictures of themselves in their younger years."

When Diane got out of the hospital, she consulted several plastic surgeons in New York and Los Angeles. Ultimately, she decided against a face-lift, worried that it would take too long to heal. "I mean, you swell for about a year. Who has a year?" she said.

She had a business to run, and it wasn't going well. "Just as a few years before I thought my tongue cancer symbolized my inability to express myself [while living with Elkann], I saw the accident as a symptom of my lack of a road map for my business," Diane wrote.

Soon she also had a book to promote. With enough distance from her childhood and early success to understand the forces that had shaped her, she had decided to write a memoir. She was old enough to look back. Also, a memoir was de rigueur for a celebrity with a new venture to promote.

As her ghost, Diane hired Linda Bird Francke, the veteran journalist who had written both the *New York* magazine and *Newsweek* cover stories about her in the 1970s. *Diane: A Signature Life* was published in 1998 by Simon & Schuster. Diane dedicated the book "to Egon, who gave me the children and the name." The book hit all the major notes of Diane's life— her childhood as the daughter of a Holocaust survivor, her marriage to a prince and the birth of her children, the start of her business, the collapse of that business, and her recent comeback. But it did not delve deeply into Diane's life or her personal struggles. Diane had been too distracted and overwhelmed by worry to concentrate on the book. "I didn't have a game plan, and I was really worried about [the business]," she says. "I was in a fog when I delivered the book."

On the eve of the book's publication, Diane suggested to the *New York Times* that she be interviewed about *Life Is Beautiful*, the new Italian World War II movie. In an Oscar-winning performance, actor Roberto Benigni portrays a father who protects his little son from the horrors of Auschwitz by convincing the child that the Nazis are only playing games.

The *Times* took the bait, though the editors suspected what Diane, a "consummate image maker," really had in mind in suggesting the interview: a desire to downplay the popular perception of her as a jet-setting glamazon and "highlight 'Diane,' the woman of substance and soul." For her interview with *Times* reporter Ruth La Ferla in Diane's West Twelfth Street loft, the designer wore a somber black dress and understated makeup.

Diane might have been eager to remind potential book buyers of her connection to the Holocaust and thus her bona fides as a soulful sufferer. But La Ferla's piece did not even mention Diane's mother, Lily. It did,

however, describe Diane "smiling through a glaze of tears" as she discussed the movie's theme of "the triumph not just of love, but of will" in the face of Nazi cruelty.

Earlier an excerpt of *Diane* had appeared in *Vogue*. "Diane is wonderfully gifted and resilient," wrote Anna Wintour in her "Letter from the Editor" column at the front of the magazine. "She has had great success and great disappointments, but she always recovers."

Diane and Wintour had known and liked each other since the seventies, when Diane was the toast of fashion and Wintour was a young fashion journalist. *Vogue* has frequently featured Diane and her clothes. Wintour regularly sits in the front row of Diane's shows, and in recent years the two have collaborated on projects to benefit the fashion industry and to promote Democratic political candidates.

Diane has a talent for forging relationships with prominent, powerful people, and in the fashion world, that included two editors of *Vogue*— Diana Vreeland, who had fashion's top job from 1963 to 1971, and Anna Wintour, who's held the post since 1988. (She was not close to Grace Mirabella, the editor from 1971 to 1988.)

The magazine's prestige and influence exploded under Wintour. The editor herself became a celebrity, her chilliness, discipline, and inscrutability as legendary as her oversized sunglasses and Buster Brown bob. Wintour didn't flinch when an antifur protester threw a dead raccoon on her plate one day in the nineties during lunch at the Four Seasons in New York. Nor did she betray her true feelings about *The Devil Wears Prada*, the 2003 roman à clef by her former assistant Lauren Weisberger, who portrayed the boss as a conniving monster. As if to announce that she was above anything so ordinary as hurt feelings, Wintour showed up in 2006 at the Manhattan premiere of the movie based on the book. She sat through it poker-faced and said nothing as she left the theater.

Wintour's power derives in large part from her ability to make or break designers' careers. Over the years she's avidly supported a long roster of talent, including Karl Lagerfeld, Azzedine Alaia, Miuccia Prada,

Marc Jacobs, Zac Posen, Tom Ford, and in the new millennium, Jason Wu and Thakoon. Meanwhile, she's famously shunned others, including Ralph Rucci.

Rucci is known for his exquisite, astronomically priced creations produced under his label, Chado Ralph Rucci. But for reasons that remain mysterious, he is not among the favored at *Vogue*. Wintour has never gone to a show of Rucci's, nor has she featured any of his clothes in her magazine. (Rucci left his label in November 2014.)

"Either Anna Wintour likes you or she doesn't, and if she doesn't, you're nowhere," says one longtime fashion observer.

AS IT TURNED OUT, DIANE'S friendship with Wintour and the *Vogue* excerpt did little to boost the reception of her book, which sold modestly and garnered mediocre reviews. The *New York Times* critic deplored the book's "bouts of superficiality," while conceding that it "persuasively illustrates how her hugely successful clothing and cosmetics businesses were nurtured by endless hours of hard work and hundreds of personal appearances."

Suzy Menkes, writing in the *International Herald Tribune*, criticized the book's "bathetic" tone. Menkes cited as examples Diane's complaint that while attending a White House dinner celebrating the 1979 Egypt-Israeli peace accord, she ruined her new Manolo Blahniks on the wet presidential lawn, and the mention of how Diane shared with Jacqueline Kennedy Onassis not only a recent battle against cancer but also the same hairdresser, Edgar Montalvo.

Menkes found the book's descriptions of famous social events "frustratingly feeble," including an account of the Proust ball held by Marie-Hélène de Rothschild, where all Diane had to say was that the "people had made a big effort to dress up." Menkes speculated that Diane was perhaps "just too nice (at least in print) to be a pertinent diarist or even a colorful gossip. . . . Anxious not to hurt anyone, there is barely a breath of criticism of friends and colleagues."

Diane wasted no time bemoaning her book's reviews and got busy on what really mattered—fashion. For a dose of fresh blood, in May 1998 she hired Catherine Malandrino, a Frenchwoman seventeen years her junior. Malandrino had graduated from the French fashion school ESMOD and trained at a series of Parisian couture houses, including Emanuel Ungaro, before becoming the head designer at Et Vous, a French company that made chic, affordable clothes for young working women. Recently, she'd left that job and moved to New York to be with her boyfriend, business-man Bernard Aidan. Diane first interviewed Malandrino at the Car-lyle Hotel, where Diane continued living during the renovation of her West Twelfth Street property. "Diane was so sensual, the way she sat on the sofa and moved her legs and arms," recalls Malandrino. "I thought, Diane *is* the wrap dress."

They had long talks about the DVF woman and what she represented and about the state of fashion in general. The era of the masculine power suit—with its oversized jackets and big shoulders—had finally waned, only to be replaced by hard-edged looks that were difficult to wear. At the extreme were British designer Alexander McQueen's "bumster" pants, which were cut so low on the hips that they revealed the buttocks. "Diane and I talked a lot about how to reinvent femininity in fashion," Malandrino says.

When it came to style, they found that they shared many of the same ideas, flowing from their common European heritage, including a rever-ence for the work of Yves Saint Laurent, whose clothes they both wore.

Diane and Malandrino studied the designer's old dresses together, until the Frenchwoman began to understand the "codes" of DVF. "I dove into her life and her archive," says Malandrino, who pored over Diane's files of old prints and ad campaigns. By the time she actually sat down to design Diane's dresses, Malandrino understood Diane and her aesthetic so completely, she says, "it was easy for me to design the dress, and soon I was in the studio draping and cutting."

By spring 1998, Diane had expanded her retail distribution to 118

stores, representing 30 accounts, including Neiman Marcus, Nordstrom, and Bloomingdale's. But the dresses arrived in a dizzying array of prints, including snakeskin, bamboo, chain-link, diamonds, and Diane's signature. On the racks, the swirl of prints "looked very schizophrenic," Diane conceded. Women were overwhelmed with choices, and the stores were left with racks of unsold dresses.

For Diane it was scarily reminiscent of the seventies, when she'd saturated the market with wraps and had nothing with which to replace them when the style ran its course.

Through it all, she still had a knack for grabbing attention. In a nod to the Y2K scare that global computer systems around the world would cease to function on January 1, 2000, she wore a "Diane life vest" at her February 1999 fashion opening. Described by the designer as a command center "for the wired woman," and created by Diane in conjunction with Sony, the silver silk vest had pockets and pouches to hold a cell phone and other high-tech gear.

Diane was the only live model in the show. To save money, she dispensed with hiring models and instead presented her collection on an installation of mannequins in her West Twelfth Street studio. "If there's no woman, there's no dress," Coco Chanel famously said. It's difficult to take the full measure of clothes without seeing them move on live bodies, and that's why designers have been showing their collections on real women since the belle époque. The first couturier, Charles Frederick Worth, employed house models to parade through his salon for customers, a practice that continued for decades and evolved into more elaborate "fashion parades" at Paris couture houses and Seventh Avenue showrooms.

By the nineties, when the Council of Fashion Designers of America consolidated the New York shows in big white tents in the east and west plazas of Bryant Park, runway presentations had grown so lavish that they could cost from $250,000 to $400,000, including models' fees, tent rental, and production costs. "It's an enormous amount of energy for fifteen or twenty minutes," Diane told *WWD*.

Diane was spending millions on her business, including salaries for a staff of 120, promotional events, and ad campaigns, while the relaunch of her wrap at $180 to $190 a dress brought in less than $1 million wholesale. At one point, she tried to raise $10 million by selling a piece of her business to Gucci, but Tom Ford, Gucci's creative director, and the company's CEO, Domenico De Sole, invested in Beatle daughter Stella McCartney's fashion house instead.

Barry Diller and her children were equal partners with her in the business, and they "wanted to pull the plug," as Diller puts it. They'd come to the conclusion that it wasn't smart to continue financing a comeback that might never make money. They'd recently established the Diller-von Furstenberg Family Foundation to support human rights, health, environment, arts, and education projects, and the funds being poured into Diane's fashion might have been better used for the foundation. "I don't know by [then] what the investment was, but it could have been between five and ten million, or it was going to be ten million in a few months," Diller says. "It's not like you're a bank or you've got partners. We were putting [our] money out." Some of it was Diller's and some of it was Diane's.

"She had savings," says Alex. "She'd sold [her apartment] at 1060 Fifth Avenue. She had money. And I said, 'DVF, you gotta stop investing all your money in this business.' It's like actors who invest their money in movies for themselves."

Diller decided there was only one solution. "We had a family intervention," he says. "Alex, Tats, me, and Diane. It was in my office, and we said to Diane, 'Look, it's not going well. It's losing money. It's not working.'"

Anger flashed in Diane's eyes. She glared at her family seated around the table in Diller's office and slammed her fist down on the table. "Give me six months," she demanded. "I'll turn it around. You'll see."

"We tried to talk her out of it," says Diller. Beyond the money, he was concerned that Diane was unhappy. In fact, he says, the intervention was

not really about the money. "It was because it was making her miserable, and who needs it?"

But Diane was determined to persevere, to prove that her success had not been a fluke the first time around. So Diller and Diane's children gave in. Diller recalls, "We said, 'Okay. You can have six months.'"

IN SEPTEMBER 1999, SEVERAL MONTHS after her family's ultimatum, Diane showed her spring 2000 collection. *WWD* pronounced it "a hit." The collection "sprang to life" with "fresh, whimsical and feminine" fashion. The paper praised her new prints inspired by nature, including "a bold giraffe motif, playful flamingoes, climbing ivy and—the most mischievous idea—a cannabis print."

Cathy Horyn, the new chief fashion critic for the *New York Times*, applauded the "sexy variations on wrap dresses and fluted, ruffled skirts." After the show, Diane introduced Horyn to a healer named Romeo, who handed out beads "which he said would ward off aggravating people."

Perhaps Romeo also brought good luck, because soon after the opening something extraordinary happened. In November Diane showed up at number six on *WWD*'s list of one hundred favorite brands, a "dramatic new entry," according to the newspaper. The biennial rankings typically changed little from year to year. Career-clothes workhorse Liz Claiborne held the top spot for the second year. Vera Wang, who'd received a lot of publicity for dressing celebrities for the most recent Academy Awards show, also broke into the Fairchild 100 brand chart.

Buyers and shoppers loved Diane's clothes—including a new batch of dresses in solid colors with soft draping—as much as the critics did. Diane's roster of accounts exploded, reaching more than three hundred by the end of the year. In many stores her brand was a best-seller. In 1997 she'd sold less than one million dollars' worth of clothes; in 1999 she sold more than twenty times that amount. Though her business had yet to break even, she was on the right track.

She'd asked Diller and her children for six months to turn the busi-

ness around, and she succeeded, as if by magic. "I knew I had a great product; I just had to get some traction," Diane says.

She credits much of this traction to the savvy management of the company's new president, Paula Sutter. A young woman and new mother who had been vice president of sales at DKNY's domestic women's division, Sutter worked for Diane as a consultant before being appointed president in 1999. Sutter came up with a business plan, including the establishment of monthly deliveries to create a fresh flow of DVF fashion to retailers and better placement of Diane's clothes in the nation's stores.

Diane also hired graphic designer Craig Braun, a former "flirtation" who had designed the cover of the Rolling Stones' album *Sticky Fingers,* to redesign her label. Braun used Diane's signature in a san serif typeface, with a lowercase *v* in *von.* To polish her image and dissociate herself from all things uncool, Diane stopped appearing on HSN to hawk her Silk Assets line (she was still relying on the income from Silk Assets to partially fuel her comeback), sending a young employee in her place.

Diane prided herself on the cabal of women she'd assembled to help her run her business, including Sutter and Kathy Landau, the company's senior vice president, who'd been with her since 1990. Diane had even allowed Landau to bring her baby and its nanny to work every day. And when Landau had a second child, Diane paid for a baby nurse who accompanied Landau and her infant to the office each morning. "She made it easy for me to come back to work," says Landau.

Diane trusted women, believed in them, and wanted to be surrounded by them. Male designers such as Yves Saint Laurent, Karl Lagerfeld, Halston, and Bill Blass might be geniuses of technique, but they would never know what it felt like to actually wear their clothes. Only women understood what other women wanted. Diane loved men, but she believed that women were stronger beings, more evolved. "I never met a woman who wasn't strong," she says. In the seventies, she admitted, she'd had "a tendency to hide behind a man in a suit, for the business part" of DVF fashion, "and every time I did that it was a mistake." The suits had given

her disastrous advice, and she'd almost lost everything. Of course, she also had herself to blame for the misguided handling of the business, a fact she acknowledges today.

A number of her employees and ex-employees say she does take responsibility for her decisions. But—always fighting to keep her confidence up—she has been known to blame others. Once, during a discussion about the demise of one of her company's most lucrative licensing deals, Diane said to a (female) DVF executive, "*You* blew that deal."

"*You* wanted out," the executive shot back. "You're rewriting history."

"If I didn't, I'd only have myself to blame," said Diane.

Seventh Avenue itself was becoming a place for women, and Diane benefited from this sea change in fashion. The millennium saw the rise of young women as the new generation of sales leaders, replacing the old cigar-chomping male garmentos. Dubbed *garmentas* by *WWD,* these new women were part of fashion's exploding focus on brand coherence, the principle that every component of a fashion business—stores, advertising, showrooms, and sales staff—should reflect a singular image. Diane's chief salesperson was a beautiful, cosmopolitan thirty-two-year-old named Astrid Martheleur. She had studied at the Lycée Français and spoke four languages. At night, dressed in DVF, she went out to stylish clubs and restaurants, such as Halo and Indochine, where she was a living advertisement for her boss.

As a group, women designers had come into their own. The AIDS epidemic had made investors wary of backing male designers, and in general, women had gained ground across the professions and in business. In the late nineties, these forces helped to usher in the era of the female designer. Recent years had seen the rise of Donna Karan, Jil Sander, Miuccia Prada, Donatella Versace, and, at a lower price point, Anna Sui, Cynthia Rowley, Nicole Miller, and Cynthia Steffe.

With more women in leadership roles on Seventh Avenue and in department stores, the business side of fashion was becoming more female-driven. The focus now was on relationships, not fast deal making.

Martheleur found herself doing business with young women like herself. The middle-aged men who'd been in control in department stores when Diane had started out in the seventies were gone, replaced increasingly by young women.

In those pre-9/11 days, there was once again a general exuberance in New York fashion, just half a decade after the *New York Times* had predicted its death. The economy boomed, which meant more opportunities for more designers and more money being spent on clothes. Mayor Rudolph Giuliani's cleanup of Times Square spread to Seventh Avenue, which was looking spiffier than it had in ages. Soon the Garment District would even get its own Hollywood-style Walk of Fame, with designers' names immortalized in the sidewalk between Thirty-Fourth Street and Times Square in decorative plaques.

The buoyant mood infused the DVF Studio. Diane's spring 2001 show had a "hotel life" theme and showcased clothes for "the woman on the go who is ready for anything at a moment's notice," according to the program notes. That meant easy, body-conscious dresses and clingy tops with side ruching in packable fabrics such as silk jersey and supple leather. The models paraded down the runway in Diane's studio with loose hair, their bright pink toenails peeping out from tall, strappy sandals. The show "caught the spirit of girl power in a refined way," wrote Suzy Menkes in the *International Herald Tribune*.

It all looked fresh and youthful, even to the hypercritical eye of the *New York Times* chief fashion writer. "Ms. von Furstenberg is not a great designer," wrote Cathy Horyn. "But she is good at doing what great designers do, which is to exploit a look, so that year by year, it becomes her own."

Diane was not an innovator in the art of dressmaking. Her clothes weren't marvels of technique and decoration. Still, her Hotel Life collection expressed a coherent and clearly defined aesthetic, one that had informed her fashion from the start and reached its apotheosis with the wrap. Diane had created a sensation with that dress, and when the sensa-

tion ended, when she couldn't repeat its success, she got busy extracting its essence. The DNA of the wrap—its ease, sexiness, brightness, and sass—was now revealed in an array of new models. Diane had left the arena of trendiness and entered the kingdom of style.

DIANE BECAME A GRANDMOTHER FOR the second time on June 1, 2000, when Tatiana gave birth in California to a daughter, Antonia, by her boyfriend, actor Russell Steinberg. (Alexandra and Alexandre von Furstenberg's daughter, Talita, had been born in May 1999.) Through her health was failing, Lily, accompanied by her nurse, made the trip to Los Angeles from New York, where she'd been staying in Diller's apartment at the Carlyle while being treated for a respiratory ailment.

In recent years, Lily had lived mostly in a house on Harbor Island in the Bahamas, tended to by caregivers arranged by Diane. Lily and Hans Muller had broken up, and Muller had married someone else, though Martin Muller says his father "was still in love with [Lily]. She was absolutely the love of his life." Lily's health was failing, and she was more comfortable living in a warm climate.

Before making the trip to California, Lily "had rested deeply—as in almost a coma," recalls Tatiana. Lily stayed at Diller's house in Malibu, and she and Tatiana "spent a lot of time together," says Tatiana. Lily promised Tatiana that she would live to meet the baby, and she kept her word. "She stood up and walked into my hospital room in Santa Monica. Her body was failing her, but her will and her mind were still powerful. She felt so accomplished and full of pride that we could all be together"—mother, child, the baby's maternal great-grandmother, grandmother, and grandfather. Diane and Egon had also both arrived, staying at Diller's house to be on hand to welcome their grandchild. Egon had brought a ridiculously grand present for the baby—a pair of diamond earrings and matching necklace that had been in his family for generations.

When Tatiana brought Antonia home to Silver Lake, Lily spent a few hours with them, then flew back to New York. She would soon fly

with her nurse to Brussels to be with Philippe and his wife, Greta. "You cannot imagine my grief watching Lily leave, knowing I would never see her again," says Tatiana.

Lily died a few weeks later at Philippe's and Greta's home. She was seventy-eight. Before the body was removed to the mortuary, her nurse, Lorna MacDonald, wrapped Lily's head in a green and blue DVF scarf with Diane's signature in bold black at the edge. Lily was buried in the scarf in Brussels, next to her husband, Leon. "They fought a lot, and now they are together at peace," says Philippe.

BACK IN NEW YORK, DIANE buried her grief in work. In the first year of the new millennium she had myriad new projects. She launched an Internet site, dvf.com, that allowed web surfers to email her directly, continuing the conversation she'd been having with her customers since the start of her career. She would still travel the department store circuit making public appearances, but now she could also communicate with women electronically and in this way reach many more of them. Each week fans sent dozens of emails, and every month Diane posted an online diary in which she regularly shared details about her travels and work. She also embarked on constructing her first freestanding boutique in a large space adjacent to her West Twelfth Street studio.

The Manhattan Meatpacking District had changed dramatically since Diane first moved there in 1997. The old marketplace was still home to about thirty meat-packing companies, but an influx of designer showrooms, hip restaurants, and boutiques was rapidly taking over the twelve-block neighborhood as the meat packers moved to the Bronx.

One day, as her mother lay dying, Diane told her she would probably marry Barry Diller "sooner or later." From time to time over the years, Diller and Diane had discussed marriage, "but not really a lot," says Diller. It wasn't something they were burning to do, yet their deep involvement in each other's lives and emotions made marriage a logical possibility. They were already living together "in the way we live

together," says Diller—that is, in separate residences, though within a short limo ride of each other.

Then, in late January 2001, a week before Diller's fifty-ninth birthday, it "just seemed like the right time," says Diller. Friends say that Diane's cancer and her mother's death led her to think deeply about her legacy, about what she would leave behind for her children and grandchildren. Diller was like a father and grandfather to them. Alex and Tatiana would be his heirs; he'd already deeded his Malibu house to Alex.

Diane told Oprah Winfrey in 2014 that *she* proposed to Diller. "I called him and said, 'You know, if you want, for your birthday I'll marry you. And he said, 'Let me see if I can arrange it.'"

In any case, no sooner had Diane decided to marry Diller than she began to have doubts and called her children and close friends for reassurance. "Am I betraying myself?" she asked Tatiana. "Am I going from being a free woman to a kept woman, a trophy wife?" Tatiana told her she was doing the right thing. André Leon Talley also reassured Diane. "I told her, 'You need to marry this man who's proved he loves you,'" says Talley. Diane called Egon, whose advice was "Make sure you are always happy. In any case, you will always be Diane von Furstenberg."

Still, Diane wavered until the last moment. When *WWD* heard about the possible marriage, a reporter from the paper called Diane for a comment. She was evasive. "Maybe one of us will still change our mind," she said. "And neither would take it badly if the other said, 'Let's not do it.' Neither of us would be offended. That's how large the thing we have is— it's hard to explain."

Nonetheless, she had a dress sewn up—a champagne-colored, dolman-sleeved model that she would be showing at her fall opening the following week. She also planned a party, though not as a wedding reception but as a birthday celebration for "the three Aquarians" in her life—Diller and her children, Alex and Tatiana, who all celebrated birthdays around this time.

On February 2, a glitteringly cold, blue day, Diane and Diller took his

limo to City Hall in Manhattan. Diane wore a sable vest over her dress and alligator boots, and she carried a bouquet of sweet peas and lily of the valley in honor of her mother. They were married at one thirty in a civil ceremony attended by her children; her daughter-in-law, Alexandra; Tatiana's boyfriend, Russell Steinberg; Tatiana's best friend, Francesca Gregorini; her baby granddaughters; and her brother, Philippe, and his wife, Greta, who'd flown in from Brussels. Annie Leibovitz took the official wedding photo. Diller's wedding present to Diane was a collection of twenty-six diamond studded bands for the twenty-six years they hadn't been married. Her present to him was "myself," she said.

Later, they celebrated with 350 of their friends. The guest list included Diane's fellow fashion powerhouses Calvin Klein and Carolina Herrera; celebrities such as Diane Sawyer and disco-era pal Ian Schrager, the former owner of Studio 54 who'd reinvented himself as a successful hotelier; and Egon. Guests dined on a buffet of chicken curry, pasta, eggplant parmigiana, and assorted salads. Afterward, they danced to a Cuban band. There were three birthday cakes (in honor of Tatiana, Alex, and Barry) and many toasts. Diane gave one "that was all about me," said Egon. "I was embarrassed for Barry."

And yet Barry had won. "My pattern" for thirty-five years had been serial lovers, with "one man kicking the other one out," says Diane. Jas ousted Egon; Barry ousted Jas; Paulo ousted Barry; Alain ousted Paulo; Mort ousted Alain, Roffredo ousted Mort; Mark ousted Roffredo. Now Diane's long string of flirtations and relationships, of seductions and secret trysts, was over.

IN A HEADLINE THE NEXT day, the *New York Times* called the wedding "a merger." "The marriage came after years of speculation about a relationship widely assumed to be platonic," the paper wrote. "Ms. Von Furstenberg characterized the romance as 'very intimate' and would offer nothing more."

WWD also weighed in, calling the von Furstenberg-Diller nuptials "a bit too Cole Porter for the unsophisticated."

What seemed to the outside world like something that shouldn't work, to their friends and family worked very well. "I'm so happy about it," Tatiana says of the marriage. "They love each other so much, like *soooo* much. They've shared this lifetime. It's a real partnership; it's really deep, it's crazy."

Diller is "madly in love with her," adds a close friend. "He thinks he's married to Grace Kelly, and she's beginning to think it, too."

"I don't think it would have worked if they were thirty. But when you're sixty, you've had everything in your life you could possibly have wished for on both sides, why not?" says Diane's friend François Catroux. "But it's not an 'arrangement.' It's something very sincere. It's real. It's done with the greatest respect for each other. I don't mean it's a passionate love, but it's really love, it's platonic love."

Catroux adds that getting married was "such a clever idea. It ensures the financial health of the family, and they do good works with the money. Barry has great confidence in Diane. She's not going to divorce him or sue him. Diane's children become the beneficiaries of this great fortune, and she and Barry are bigger together than they are separately. They understood how really powerful they could become if they were really together. In this they are so very different from the rest of the world, and they know that."

"It boggles the mind how socially prominent they became in New York after the marriage," says André Leon Talley. "Real true high socialites look up to Barry Diller like he's the king of the world. They love the yacht, and he's so successful. When Mercedes Bass was chairwoman of the [Metropolitan] Opera ball, there was Barry Diller on her right and Henry Kissinger on her left. At the Literary Lions dinner at the New York Library, there was Barry Diller next to Annette de la Renta. They seem to be so in awe of him."

Considering Diane's trajectory of "always inventing herself around the man she's with," says Kathy Landau, "it makes sense that "at this moment when she's crested over the success hurdle and is on the other side," she'd marry Barry. "A lot of things have come together for her now, later in life, in a way they hadn't in the other phases of her journey—her sense of self, her comfort with her age, her business."

Marriage is a way of drawing a line around herself, her children, her grandchildren, and Barry, defining them in the eyes of the world as a family.

Diller says he thought being married "wouldn't change a thing, because what was there to change? But a year, two years in, I thought, 'Oh, my God!' It's only emotional, but it's a complete change. It's commitment. It's a greater sense of family. It's absolute security."

AFTER A HONEYMOON WEEKEND AT Cloudwalk, Diane went back to work. Her boutique opened in April in a space carved from her vast West Twelfth Street studio. On the first day, a line ten women deep formed outside the dressing room. The most popular items were sheaths in ice cream colors and printed wraps. One customer bought $10,000 worth of dresses at $250 each. Around the nation, the dresses were selling as fast as they arrived in stores, and Diane's business was up about 40 percent. The dress orders for spring 2001 had been "insane," Martheleur, the vice president for sales, told *WWD*. "What we had done in one quarter is what I projected for three."

In June, to celebrate and fuel her success, Diane rented a billboard on Ninth Avenue near her studio and installed a blow-up of the 1972 black-and-white photograph of herself that she'd used in an early ad. Above the dark, cobblestoned streets and the fashionistas clicking along them in their Manolo spikes loomed a giant, twenty-five-year-old Diane. Wearing a shirtdress in her iconic chain-link print with her legs crossed provocatively, she leaned against a huge white cube, across which was scrawled in handwriting four yards high, "Feel like a woman, wear a dress."

Though she'd written those words long ago, they still evoked the essential feature animating her career. Diane had found her fashion DNA in the femininity of European clothes, in clingy fabrics, defined curves, hot colors, and flirtatious prints. But in translating Old World allure into American dresses, she had also drawn on her own struggle for independence. The result was a style as suitable for the boardroom and the office, the car pool and the classroom, as for the candlelit boudoir.

For the second time Diane had imposed her vision on American women, and a new generation was wearing her clothes. All she had done was respect the narrative of her brand; she'd shown how a woman could live a man's life while remaining a feminine woman. It had been a hard road back, but she'd stayed the course. Giving up would not have occurred to Lily's daughter.

Epilogue

2014

isco-era sex symbol Raquel Welch vamped for the cameras, and Bee Gees tunes wafted from a replica of Studio 54, but the party at the former May Company Building in Los Angeles really didn't capture seventies Manhattan. No (visible) drugs. No interesting mix of bohemia and high society. No Andy Warhol to write about it snarkily in his diary the next day.

Instead, the opening-night party on January 10 for "Journey of a Dress," an exhibit celebrating the fortieth anniversary of Diane's wrap, had the feel of the new millennium. Waiters carrying silver trays offered water as well as champagne. Hard-charging figures from business and entertainment with images to promote worked the room (Jeff Bezos, Marisa Tomei, Ed Norton, Paris Hilton, Demi Moore, and Gwyneth Paltrow among them). Meanwhile, milling about were a publicist-controlled roster of reporters and bloggers who'd write glowingly about the event.

The exhibit filled several cavernous spaces of the old Wilshire Boulevard building, which sits next to the Los Angeles County Museum of Art. The evening began with a live-streamed red-carpet event cohosted by Diane, model Coco Rocha, and television personality Andy Cohen. Guests entered through a wide, pink-walled corridor of photos of famous women wearing wraps: Michelle Obama, Amy Winehouse, Madonna, and Amy Adams, as the character Sydney in *American Hustle*, the hit movie of the moment and a love letter to seventies style. A gallery off the entrance was dedicated to portraits of Diane by artists and photographers, including Warhol, Chuck Close, Annie Leibovitz, and Helmut Newton.

Walking across floors covered in Diane's iconic animal and geometric prints, guests came upon the central exhibition space and the highlight of the show—hundreds of mannequins, their sculpted cheekbones resembling Diane's, in wraps dating from the birth of the dress to today. They lined up like the Chinese "terra cotta armies," Diane remarked, in reference to the collection of tomb sculptures in Shaanxi Province depicting the armies of the first emperor of China.

Diane herself wore a dramatic black wrap gown with a chartreuse sash and kimono sleeves lined in chartreuse that trailed to the floor. She'd created and paid for the exhibit herself, part of a yearlong celebration of the wrap's fortieth year.

Today Diane's clothes can be bought on four continents and—before the wrap dress celebration in Los Angeles—exhibits had honored her work in Beijing, Moscow, and São Paolo. Like many high-end brands, in recent years Diane has expanded into China, the world's fastest-growing market for luxury goods. She has fifteen shops in China with plans to more than double that number in the next four years, and 2.5 million followers on Weibo, the Chinese version of Twitter. "What I like about women is always strength, but Chinese women are like strong women on steroids," Diane told Deborah Kan of the *Wall Street Journal Digital*. She's recog-

nized on the street now in China. It's a measure of the global success she's achieved in the thirteen years since her marriage to Barry Diller.

Diane likes to tell reporters about the three stages of her business life: the first was reaching financial independence, the second was to prove that her early success wasn't an accident, and then the third is to develop a company that will last long after she's gone.

"I don't think about legacy, but she does," says Diller.

On a personal level, Diane says, "I want to be remembered as a nice woman who inspired other women."

She has bigger plans for the legacy of her brand. As Diane grows older, she's focused increasingly on strengthening DVF so it will start being less about one particular woman and more about the abstract things she represents—independence, confidence, having-it-all glamour. It also means that clothes have to become less important to her business than accessories. The wealthiest fashion companies, after all, make most of their money on such items as perfume, handbags, and sunglasses.

Diane's son, Alex, says her clothes sell well because they offer quality, fit, and design at a good price. But DVF—a $500 million company at retail, according to Diane—is not an "it" brand in the mold of, say, Michael Kors, a $3 billion dollar company that in 2013 was the most sought-after brand by American teenagers, though its stock has been underperforming in the past year. Mostly, the young covet Kors's signature "MK" handbags.

It's impossible for a fashion company to reach such mega-popularity and wealth without a must-have accessory, one that becomes an instantly recognizable status item—such as a Kors handbag with the MK logo, or sunglasses emblazoned with Chanel's double C's. (Scent is another means to this end. Chanel makes most of its billions through the company's Chanel No. 5 fragrance.)

Though there's no formula to achieving such success, becoming a public company can provide huge sums of money for the kind of relentless

marketing needed to take a brand to the top—and to get large numbers of people to pay a premium price for accessories featuring the brand's logo.

With this in mind, Diane has shaken things up in the executive ranks at DVF. In 2012 she hired as her cochairman Joel Horowitz, one of the architects of Tommy Hilfiger's success. *WWD* speculated that Horowitz was hired to take DVF public, as he had orchestrated Hilfiger's IPO in 1992. Fashion IPOs have suddenly become fashionable. Michael Kors's extraordinarily successful 2011 IPO sparked interest on Wall Street in other designers, and investors began nosing around Diane because of her celebrity and international clout—*Forbes* in 2012 named her the thirty-third most powerful woman in the world.

Joel Horowitz's arrival preceded by a year the departure of Paula Sutter, president of DVF since 1999, who'd played a key role in Diane's comeback. Now, after years of unfocused management, Diane says she finally has "clarity," and she's brought in a new team to take DVF to the next level. In April 2015 she hired Paolo Riva, a former executive at Tory Burch, as CEO. "For years I only wanted women executives," Diane says, "and now I only want Jewish [and Italian] men."

In September 2012, two days after taking a victory lap on the runway following her show at Lincoln Center with Yvan Mispelaere, the talented Frenchman who'd been her creative director for two years, Diane announced his departure. Mispelaere, who'd followed Nathan Jenden in the job, received mostly stellar reviews for his DVF collections. Cathy Horyn wrote that he was "one of the best right hands in the business," someone "who built on [Diane's] style without losing its cool, funky essence." But Diane says she started to feel that the clothes under Mispelaere's direction "had gone off brand," that they did not have enough of her signature easiness. Even more surprising, Diane announced that Mispelaere would not be replaced. Henceforth, she would rely on a team of designers, with only *her* creative vision leading the pack.

In February 2014, however, Diane hired Michael Herz, formerly creative director of the British brand Bally, as artistic director of DVF. As

curator of the L.A. wrap-dress exhibition, Herz had designed 40 new styles to join the 160 historic wraps. Reviews of his first DVF collection, shown in September 2014, were enthusiastic, with Vanessa Friedman of the *New York Times* crediting him with harnessing the "accessibility and straightforward spirit" at the heart of DVF.

More changes were under way. Diane and many of her fellow designers had begun to feel a nagging weariness over Fashion Week. In 1994 this festival of American style had moved to one centralized location in Bryant Park. Sixteen years later, in 2010, a dispute with park management over the timing of the shows forced a move to Lincoln Center. The fashion community, though, never warmed to the new location, grumbling that it had a trade-show vibe that grew more noticeable with time. In February 2014, Diane joined a cavalcade of design powerhouses, including Michael Kors, Oscar de la Renta, and Tracy Reese, who opted to show their collections off-site. The atmosphere at Lincoln Center, they complained, had become like an airport terminal, with noisy, long lines and designers rushing in and out, "haul[ed] away like the wedding caterer," as Vera Wang told Eric Wilson of the *New York Times*.

Losing Diane, who held her February and September 2014 openings at Tribeca's Spring Studios, came as a big blow to Fashion Week's producer, IMG Worldwide, the global sports and media conglomerate, and to the event's chief sponsor, Mercedes-Benz. As president of the Council of Fashion Designers of America since 2006, Diane takes the lead in all official matters relating to New York fashion. She was elected to the unpaid post in 2006, succeeding Stan Herman, who is perhaps best remembered for designing uniforms for such firms as McDonald's, FedEx and Avis. Diane takes the job seriously and has made the CFDA a real force. She vigorously promotes American designers and the causes important to them. Soon after taking over the leadership of CFDA, she lobbied Congress in support of copyright laws that would protect American fashion from knockoffs, noting in an op-ed piece she wrote in the *Los Angeles Times* that "the United States is the only

world fashion leader that does not protect the intellectual property of its fashion designers."

Even before her election to the CFDA post, Diane was regarded as the industry's queen mother; young and old designers alike turned to her for guidance and advice. Over the years, Diane's shows have been among the biggest and most buzzworthy. When models at her spring 2013 show sashayed down the runway wearing Google glasses—a few days later Diane released a short film compiled from the video recorded by the glasses—tweets about DVF exploded. She sparked another social media outburst the following year when she sent nineties supermodel Naomi Campbell down the runway in the finale of her spring 2014 show. Wearing a black and gold shift and a lot of attitude, Campbell strutted the catwalk as Marvin Gaye's "Got to Give It Up" blared. Featuring a forty-three-year-old bad-girl model who was famous for her phone-throwing tantrums amounted to another fashion "moment," held up and glorified by the style brigade. A flurry of tweets, Instagrams, and Pinterest pins streamed out on the web.

Ironically, Fashion Week's move to Bryant Park in 1993 had been sparked by a series of accidents at shows in lofts and artists' studios, including caved-in ceilings and blown generators that left audiences and models in total darkness. Diane herself only started showing in Bryant Park in 2006, the year after a track of ceiling lights in her studio crashed down during the finale of her September show, injuring several editors. Now she's considering dispensing with live shows altogether. She shocked fashion council members at a meeting in 2013 when she suggested that someday designers might show their collections only digitally. In an era of immediate online accessibility of clothes modeled on the runway, live fashion shows are starting to seem irrelevant.

If and when that all-digital day comes, Diane's job as CFDA president will be easier. Recently Fashion Week has come under attack from all sides. Last year Diane had to mediate when American designers grew furious that the organizers of Milan Fashion Week would not change

their schedule, forcing New York and London fashion weeks to overlap with the Jewish holidays. She sent a conciliatory letter to the international fashion community, urging everyone to cooperate, but the Italians wouldn't budge. Diane also had to field complaints from residents near Lincoln Center who were disturbed by the noise created by Fashion Week crowds. Neighbors resented, too, the immense generators that spewed pollution through the nearby streets, including a park where children played. (In December 2014, it was announced that New York Fashion Week would be evicted from Lincoln Center after the spring 2015 shows.)

The raised profile conferred on Diane by her CFDA presidency has given more authority to her political endorsements. In 2008 she supported Hillary Clinton for president but switched her support to Barack Obama when he won the nomination. Diane is proud that Michelle Obama wears her clothes—in 2009 the First Lady posed in a black and white wrap dress in Diane's classic chain-link print for the official White House Christmas card. Because of her strong Democratic leanings, Diane was less pleased during the 2012 campaign when Ann Romney, wife of the Republican candidate for president, donned a magenta, geometric-print wrap dress for a Republican rally. In September 2012, during New York's Fashion Night Out, a *Vogue*-sponsored festival of after-dark shopping that has since been discontinued, Diane told the crowd gathered at her boutique, "Everyone here better be a Democrat, no Republicans."

A lover of causes devoted to helping women, Diane sits on the board of Vital Voices Global Partnership, a nonprofit foundation that promotes women's economic progress. In 2010 she created the DVF Awards for women leaders and activists around the world who've worked for change in their communities. Every year several women "who have survived, learned from their survival, and are leading from their survival," as Diane puts it, are each given fifty-thousand-dollar grants underwritten by the Diller-von Furstenberg Foundation (winners also receive a statuette designed by Anh Duong). The ceremony is held annually in the United

Nations cafeteria, which is transformed for the occasion with soft lighting and cushy banquettes. Over the years the event has drawn an A-list crowd of women guests, presenters, and honorees, including Christiane Amanpour, Hillary Clinton, Julie Taymor, Nancy Pelosi, and Oprah Winfrey.

The spirit of the DVF Awards is perhaps best represented by one of its first recipients, Ingrid Betancourt. A former candidate for president of Colombia, Betancourt had been kidnapped by guerrillas while campaigning in 2002 and rescued in a daring military mission six and half years later. She received the DVF accolade from Meryl Streep at a ceremony on March 13, 2010. Five months later she showed up in the front row of Diane's spring show, chatting up her seatmate, Mr. DVF himself, Barry Diller.

It was perhaps the last place you'd expect to find a woman who'd spent most of the previous eight years imprisoned in a terrorist camp in the jungles of Colombia. But Betancourt's presence signaled Diane's steadfastness in the midst of fashion's frivolity—her commitment to her feminist and political beliefs. Any top designer can attract a Madonna or a Rihanna. It takes a special sort of fashion star to get a Betancourt.

The photographers, though, were ignoring the heroic redeemed captive as they scurried around in search of a *real* celebrity. When one presented herself in the form of Sarah Jessica Parker, their flashbulbs exploded. Many of the more than one thousand fashionistas who'd gathered under the big white tent—as much to pay homage to Diane as to eyeball her new collection—joined the flash mob, their cell phones held aloft in a collective electronic salute.

In the next moments, scores of photographs of Parker streamed out over the Internet, all glittering eyes and tumbling blond curls in a pink flowered froth of a dress. In some pictures, a swath of the front row could be glimpsed with Betancourt at the edge, a quiet presence as irrelevant to the fashion circus as last year's hot handbag.

Later, at a party in her studio, Diane sat at a banquette deep in conversation—in French—with her Columbian BFF. That Betancourt was

alive at all seemed a miracle. That Diane endures is also a marvel. Against all odds, she's survived Fashion.

WHAT MORE COULD DIANE WANT? At sixty-eight, it would seem she has everything—fame, fortune, houses, jewelry, cars, an airplane, a yacht, children, grandchildren, an adoring husband, a thriving business. And yet. "She wants to be as big as Chanel," says her son, Alex. That is, as big as a billion-and-a-half-dollar-a-year company that's lasted decades after the death of its founder. Chanel is what's known in business parlance as a "brand with soul," a phrase coined by ad consultant Laurence Knight to refer to brands that transcend their products and stand for shared values with a community of consumers. DVF has a way to go. "My mom's brand as an icon is great. She's like a little mini-god," says Alex. "But the company's brand is poor to fair."

Alex believes his mother has been involved in too many projects that are "off brand." In recent years she's designed clothes for Gap Kids and housewares and linens for Bloomingdale's, projects that did nothing to further all-important "brand awareness" because they had nothing to do with what DVF stands for, which is "the hot, independent, on-the-go woman," says Alex.

He blames the misguided ventures on a lack of focus at DVF, which Diane also has acknowledged. "She's had a bunch of women in this crazy office running around with no real strategy or any real structure or any real game plan," says Alex.

He also doubts that his mother is well served by the squishy, New Age sensibility of some of her advertising. The qualities that have made Diane beloved by her friends and family and in the fashion industry—her generosity, integrity, and warmth—are reflected in her working motto, "Love is life is love is life." She's used the slogan in ad campaigns, and it's emblazoned on some of her accessories, including an iPhone case. "What the fuck does that even mean?" asks Alex. "Is that glamorous?"

But Diane stands by the slogan. "I believe in the circle of love. All the

generosity and love you put out into the world over the decades comes back to you. I'm benefiting now from being nice my whole life," she says.

Alex and Tatiana have no interest in taking over DVF after their mother is gone. Tatiana, forty-three, works as a filmmaker. She says she "hates fashion" and could never function in its "volatile hierarchy. Oh, my God, how stressful. I'd die because you're either in or you're yesterday's news." *Tanner Hall*, Tatiana's 2009 feature film debut, is the story of four girls coming of age in a New England boarding school and stars Rooney Mara of *Girl with the Dragon Tattoo* fame. Tatiana cowrote and codirected the film with her girlhood friend Francesca Gregorini, daughter of Barbara Bach, once a Bond Girl and the wife of Ringo Starr. More than twenty years ago Gregorini, who is a lesbian, and Tatiana were romantically involved. That ended, and they remain friends. "I've been in love with both genders," says Tatiana. "I think my tribe is the LGBT tribe, not necessarily because of my sexual orientation but because of the way I was raised."

Currently single, Tatiana lives with her teenage daughter in a hillside house in the Los Feliz section of Los Angeles that's decorated in a bohemian mix of art and comfortable furniture.

At forty-four Alex lives in LA with his fiancée, twenty-nine-year-old Ali Kay, the mother of his baby son, Leon. The couple have been together for more than a decade, since meeting at Mynt Lounge, a nightclub in Miami, when Ali was still in high school and Alex was married to Alexandra. Breaking up with his wife, he says, "was super hard. We were soul mates. We'd been together since we were fourteen. We had a perfect life, but I fell in love with someone else." The perfect life included a townhouse on the Upper East Side and two children, Talita and Tassilo, born in 2001. (Alexandra left DVF when she and Alex broke up, but she and Diane remain close.) "I've had flings all my life. I'm my parents' child," Alex says. Most of his affairs were casual and fleeting, but the one with Ali became an obsession that ignited in Alex violent storms of jealousy.

One night in 2003, as he returned home to the Trump International on Central Park West, where he'd moved after separating from Alexandra, he saw Ali getting into the car of another man. "I really lost it," admits Alex. "I proceeded to hit my car into his, dragged him out, and beat him up. I broke my knuckle on his head." Meanwhile, his victim's car rolled down Central Park West and crashed into a police sedan. The officer inside arrested Alex, who was charged with felony assault. Alex says he gave the victim enough money to buy a nightclub and the assault charge was dropped.

Afterward, Alex performed a court-ordered stint of community service and attended anger-management classes, which did not prevent him six years later from engaging in another scandalous (though less violent) confrontation with one of Ali's admirers.

In the summer of 2009, after Alex and Ali had moved to Malibu, Ali met one of their neighbors, the former professional basketball player Reggie Miller. She embarked on a text-messaging flirtation with the onetime Indiana Pacers star. Her messages included pictures of herself in a bikini and lounging in bed. Alex found out and, as the *New York Post* reported, lobbed a flurry of threats at Miller, who had Alex slapped with a restraining order. Not to be deterred, Alex hired a plane that buzzed the Malibu beach trailing a banner reading REGGIE MILLER STOP PURSUING MARRIED WOMEN. Though Ali denied that she'd slept with Miller, Alex insisted she take a polygraph test. "She passed," he says, grinning.

The incident did not stop Diane from using Ali as the face of the DVF brand in her fall/winter 2010 ad campaign. If she was appalled by Alex's behavior, she never admitted it publicly. "My son was jealous. [Ali] was naïve. The truth is that, at the end, they're madly in love with each other. It made them realize how much they care for each other," Diane told *Page Six Magazine*.

Diane is unfailingly loyal to family—and those she considers family.

"I remember a holiday at Cloudwalk where all her ex-husbands and boy-friends were there: Egon, Jas Gawronski, Barry, Alain Elkann, and even Paulo," says Bob Colacello.

Of all Diane's exes, Egon had a special place in her affections as the father of her children "and the first one to believe in me," Diane says. She and her children were with Egon in Rome when he died at fifty-seven on June 11, 2004. Tatiana says her father had been suffering from cirrhosis of the liver brought on by an infection of the virus hepatitis C. (She denied rumors that he died of complications of AIDS.)

Egon had stayed married to his second wife, Lynn Marshall, though they lived separate lives. Diane arranged Egon's funeral service in Rome. "He'd had a lot of shame and denial. He didn't want to accept being gay," says Tatiana. "But by the end of his life he'd come out as a gay man. He very much claimed it. He was an advocate (for gay rights) in Rome," where he'd lived since the mid-eighties, and where he headed an eponymous fashion house that produced women's clothes reflecting a sexy, European sensibility—jewel colors, fitted silhouettes, plunging necklines. He sometimes presented his collections at outdoor shows, using Rome's Spanish Steps as a runway. Once, during a finale, he sent out a transgender bride.

Even Egon's mother, Clara, had come to accept his lifestyle, says Tatiana. She didn't judge her son or her bisexual granddaughter. "When I was with Francesca and I told my grandmother I'd been shopping, she'd say, 'Did you buy pants or a skirt?'" recalls Tatiana.

Toward the end of his life, Egon took his Brazilian boyfriend on a cruise with his friends Cedric Lopez-Huici and Marc Landeau. "We all knew Egon was dying. Sometimes he didn't come to dinner," says Landeau, who'd been in Asia with Egon in 1969 when the telegram arrived from Diane saying she was pregnant with their child. Illness, though, did not rob Egon of his signature charm. Everyone he met on the ship "was absolutely enamored of him," says Lopez-Huici. "He

always had a nice word for everyone, from the lady who made the bed in the morning to the person who carried the suitcase to the taxi."

During the years Egon lived in Europe, Diane became deeply rooted in New York. In a way, Diane *is* New York, so closely identified is she with the city's glamour and grit, its striving and sophistication. Still, she says she didn't think seriously about becoming an American citizen until meeting Bill Clinton at the Democratic National Convention in 1992 and attending his inaugural the following year. For the first time she felt a kinship with an American president. "I liked the fact that he had been a Rhodes Scholar, that Gabriel García Márquez is his favorite novelist, that he always appears on the good side of things, and that we are the same age," she wrote in her first memoir. She collected all the necessary documents for citizenship but was so intimidated by the requirement to list every trip she'd taken out of the United States in the previous twenty years that she gave up. It took her nearly a decade—and the incentive of tax benefits that came with citizenship after her marriage to Diller—to get around to tackling the task again. In July 2002 she finally became a US citizen.

THOUGH DIANE COMPLAINS FROM TIME to time that she's tired and feels old, she shows few signs of slowing down. She travels so much, it's hard to keep track of her movements—in Australia one month, Istanbul the next, then India and China. "I don't like to stay away from China for more than six months at a time," she says.

No sooner had she returned from trips to Greece and Sun Valley in the summer of 2014 than she was off to a Google camp in Sicily where she sat on a panel about fashion with Tory Burch, whose brand generated more than one billion dollars in sales last year. "She'll talk about how to do it, and I'll talk about how *not* to do it," Diane said with a rueful smile on the eve of her departure.

Diane stopped skiing after she broke her shoulder on the slopes of Aspen in 2013. Two years earlier she'd suffered facial injuries when a

skier rammed into her with his camera. She still enjoys vigorous hikes on her property at Cloudwalk—and sometimes takes an employee along to discuss serious business. She says she's proud of her lines and wrinkles— they're evidence of the rich life she's lived, and though tempted at times, she has not erased them with a face-lift.

In 2010 the Connecticut Department of Health approved Diane's application to create a cemetery at Cloudwalk for up to twenty plots. The space she's set aside to spend eternity sits on a secluded hill at the end of the woods behind her house. She built a stone wall that encloses the space but leaves open the downward-sloping side, so in death, as in life, Diane and her loved ones can enjoy the view of the lyrical fields and watch the sun set behind the trees. "I don't want to be cremated. I want my body to disintegrate into the earth. It's the natural thing," she says.

In 2006, the year she took over as president of the CFDA, Diane moved her New York home and business to a new location in the Meatpacking District, in three Victorian buildings on West Fourteenth Street that she merged into a six-story, thirty-five-thousand-square-foot home, office, studio, and boutique. Architects from the Manhattan firm of Work Architecture Company closed the gap between the two main structures with an airy, eighty-foot staircase. During the day, heliostat mirrors flood sunlight down from the glass-faceted structure on the roof—viewed from above, it looks like a giant diamond. The mirrors catch the light and blaze it up through waterfalls of Swarovski crystals, flooding the staircase and adjacent spaces in a sparkly glow.

The penthouse, or "treehouse," as Diane likes to call it, is her private space. She works and entertains friends and associates on the floor below among her beloved leopard-print carpets, books, photographs, and paintings, including portraits of herself by Andy Warhol, Francesco Clemente, and the Chinese artist Zhang Huan. A pink, lip-shaped sofa by Salvador Dalí has pride of place against a pink wall.

From her terrace, Diane looks out on the High Line, a lush green ribbon that unfurls high above the gritty pavement of Manhattan for

twenty-two blocks from Gansevoort Street to Thirty-Fourth Street. Her vision helped create it. She was an early supporter of turning the derelict elevated railway into a public park, and she and Diller, through their family foundation, have funded $35 million of the $170 million cost of the project.

In November 2014 the couple announced that their foundation would also fund a substantial portion of a proposed $150 million-plus open-air performing arts center on the ramshackle wharf at the end of Fourteenth Street, near Diane's headquarters.

Like her fashion, those headquarters reflect Diane's personality, her boldness, openness, and strength. "What defines me is the relationship I have with myself. I'm completely self-reliant," she says.

Diane is sitting behind her immensely long desk dressed in a black leather jacket and black denim pants printed in her classic chain-link pattern. She's spent the afternoon visiting the ateliers of young designers. Nurturing the next generation of talent is a key part of her job as CDFA president. She enjoys this enormously, but it's been a jam-packed week preparing for the debuts of her E! reality show and a new memoir, *The Woman I Wanted to Be*, and she's exhausted. An assistant brings her a small bottle of Kors energy drink. She downs it in two gulps and regards my outfit—a black and white shirtdress and a black wrap sweater. She nods approvingly, impressed that I'd had the style chops to pair that particular dress with that particular sweater. A moment later, though, she tempers the compliment. "Actually, that's the way we showed it on the runway."

My sweater was reminiscent of the wrap top Diane had done in the seventies, the one that had led directly to the wrap dress. "You know, [my design team] didn't want to do that sweater. I had to insist," she said.

It turned out to be a big hit, just like the "Amelia," a wrap dress with a jersey bodice and flared skirt that Diane also had to insist be done her way. The design team wanted to give it a blouson top. "A blouson on a wrap!" she exclaims in disbelief.

Such incidents suggest it might be unwise for her to relinquish design responsibility to a successor, as she's hinted to the press she might do. (The most likely candidate is Michael Herz, her artistic director.) No one has the pulse of DVF like, well, DVF.

While we talk, the sky beyond the tall windows in Diane's office turns from pink to deep blue. It's time to go. "Don't let her look at her phone while she's driving," says Ellen Gross, Diane's assistant, as we step into the elevator.

Soon we are floating through the streets of Chelsea in Diane's beautiful car—a rich, leaf-green Bentley. A few weeks earlier Diane got into a fender bender while on her phone, and now she sets it on the console between us and tries not to look at it. We pass the new Whitney Museum of American Art and the Diller-von Furstenberg Building, which serves as High Line headquarters, then the offices of IAC, Diller's company, a ten-story, one hundred-million-dollar structure that resembles a clipper ship with undulating sails of curved glass.

The Kors energy booster kicks in, and Diane grows hungry. Violating Ellen's dictate, she picks up the phone and calls her cook to order dinner. "Some soup would be nice," she says as she turns onto the highway.

Now Diane is speeding north toward Cloudwalk, passing telephone poles and suburban lights, then silent country trees black against the navy sky, leaving behind her the fittings and the sample rooms, the mood boards and the photo shoots, the loud, urgent call of New York Fashion.

Acknowledgments

I'd like to thank Diane von Furstenberg for not slamming the door in my face—metaphorically, that is—when I suggested to her I write this book. At first, Diane was understandably ambivalent about my project. Given her fame and her importance to fashion and the social history of New York, however, she knew a DVF biography was inevitable. Whatever qualms she might have had about what I would write seemed outweighed by her sense that I was the right person for the job. I've tried to honor that trust, and the New York fashion we both love, by writing a fair and balanced, yet also vivid and lively, portrait.

Diane has been extraordinarily generous with her time, spending hours talking to me on the phone and at her homes in New York and Connecticut. She also shared with me pictures, letters, and excerpts from her diaries, and introduced me to scores of her family and friends.

I'd like to thank everyone quoted in the book who graciously welcomed me into their homes and offices and shared their stories with me; those who talked to me over the phone, in many cases in multiple, lengthy conversations; and those who patiently answered questions in emails. I could not have written this book without you.

During my research in Paris, Isabelle Taudière provided a beautiful apartment, delicious meals and bright conversation, and mapped out Métro routes to my closely scheduled interviews. At the Musée Juif de Belgique in Brussels, Philippe Blondin and his staff spoke to me at length about the Nazi Occupation of Belgium and introduced me to documents in their archives about Diane's family. For research and translation help, I'm also indebted to Régine Cavallaro, a journalist and author in her own right.

Thanks to Denise Oswald, who edited this book with perception and thoughtfulness, and to everyone at HarperCollins who helped bring it to publication. Thanks also to Jennifer Joel—who rocks a wrap dress better than any other literary agent in New York—for her loyalty, intelligence, and unfailingly astute judgment; to Susan Vermazon Anderson, the shrewdest of photo editors, for her invaluable help in selecting and securing photos for the book; Clare Fentress for her precise and careful fact-checking; and Devi Vallabhaneni for being my rabbi on all things related to the business side of fashion.

I was lucky to write part of *Diane von Furstenberg: A Life Unwrapped* at a guest house overlooking a sunny, bricked garden in Savannah, Georgia, where I was a visiting writer at the Savannah College of Art and Design. I'm grateful to Paula Wallace, the founder and president of this wonderful school, for making it possible.

I could not get through the long process of writing a book without my irreplaceable posse of friends. (You know who you are.) My husband, Richard Babcock, has been at my side through every stage of this project, as he has been for thirty-five years. I'm eternally grateful for his wisdom, his wit, his patience, and, mostly, his all-enabling love. I couldn't bear life without him or our son, Joe.

Notes

This is a heavily reported book, based on scores of interviews. Other sources include newspapers, magazines, books, and documents in archives.

From the moment she started her business in 1970, Diane von Furstenberg has been regularly written about in *Women's Wear Daily*, which has covered the fashion industry since the early twentieth century. Myriad other newspapers and publications from *The New York Times* to *Vogue* and *People* have covered her fashion openings and other activities and written profiles of her. I've drawn on these sources, as well as accounts in books and in the archives at the Fashion Institute of Technology in New York. For the chapter set during World War II, I've drawn on documents in archives at the Musée Juif de Belgique and the Services des Victimes de la Guerre in Brussels.

Short phrases and quotes that Diane has repeated often have not been included. Abbreviations for frequently cited sources are as follows:

Diane von Furstenberg: DVF

Alexandre von Furstenberg: AVF

Egon von Furstenberg: EVF

Tatiana von Furstenberg: TVF

Prologue

3 *"You've got it all wrong":* Diane von Furstenberg to the author, August 1, 2014.

4 *"I have clarity again:* Ibid., March 18, 2012.

4 *"What is your sign?"* Julie Baumgold, "Diane von Furstenberg and Her Jungle Romance," *New York,* May 4, 1981.

5 *"She's a terrible":* Alexandre von Furstenberg to the author, June 17, 2013.

5 *"I never get":* Diane Von Furstenberg, *Diane: A Signature Life* (New York: Simon & Schuster, 2009), p. 160.

5 *"The vibrations":* Olivier Gelbsman to the author, September 9, 2011.

7 *"Let's wait until":* DVF to the author, November 5, 2009.

8 *"I have no secrets"* Ibid.

10 *"Like Tolstoy":* Ibid., October 3, 2014.

Lily

11 *"turned life into gold":* Philippe Halfin to the author, August 30, 2011.

13 *"My father was not":* Ibid.

14 *"I think a lot ":* Lily Nahmias to her parents, May 19, 1944, DVF private collection.

15 *"Do you smell ":* Diane von Furstenberg, *Diane: A Signature Life* (New York: Simon & Schuster, 2009), p. 36.

16 *"the worst of the worst":* Rochelle G. Saidel, *The Jewish Women of Ravensbruck Concentration Camp* (Madison: University of Wisconsin Press, 2006) p. 153.

16 *"a huge mountain":* Ibid., p. 157.

17 *"wasn't a fashion person":* Diane von Furstenberg to the author, July 31, 2014.

17 *"Lily was extremely":* Mireille de Hanover to the author, September 2, 2011.

17 *"My mother always":* Halfin to the author, August 30, 2011.

18 *"Wouldn't it be more interesting":* Diane von Furstenberg, *Diane von Furstenberg's Book of Beauty: How to Become a More Attractive, Confident and Sensual Woman* (New York: Simon & Schuster, 1977) pp. 54–55.

18 *"Lily had post-traumatic":* Tatiana von Furstenberg to the author, June, 15, 2013.

18 *"She had a lot of pain":* Ibid.

18 *"It must have been":* Ibid.

18 *"If I hadn't been born"*: Diane von Furstenberg, *The Woman I Wanted to Be* (New York: Simon & Schuster, 2014), p. 22.

18 *"He never stopped working"*: Halfin to the author, August 30, 2011.

19 *"never saw limits"*: Ibid.

19 *"There was very little"*: DVF to the author, October 2, 2104.

19 *"He didn't want"*: Von Furstenberg, *Woman I Wanted to Be,* p. 24.

19 *"He loved Diane intensely"*: Halfin to the author, August 30, 2011.

20 *"I really thought"*: DVF to the author, October 2, 2014.

20 *"We met at school"*: Didier Van Bruyssel to the author, September 2011.

20 *"I always wanted to be"*: David Colman, *Interview*, September 13, 2012.

21 *"But you're Jewish"*: Halfin to the author, August 30, 2011.

21 *"She never talked"*: Ibid.

21 *"about little things"*: Von Furstenberg, *Diane,* p. 36.

21 *"He said it was part"*: Lorna MacDonald to the author, December 5, 2011.

21 *"Lilly didn't seem"*: Fran Lebowitz to the author, April 1, 2011.

22 *"no numbers"*: Halfin to the author, August 30, 2011.

22 *"She was so depleted"*: TVF to the author, June 15, 2013.

22 *"She was a tiger mom"*: DVF to the author, October 2, 2014.

23 *"When I was eight"*: Von Furstenberg, *Diane,* p. 40.

23 *"I still feel sorry"*: DVF in conversation with Fern Mallis at the 92nd Street Y, September 12, 2012.

23 *"pretending we were princesses"*: Hanover to the author, September 2, 2011.

23 *"It would be something"*: Miriam Wittamer to the author, September 3, 2011.

24 *"totally sure"*: von Furstenberg, *Woman I Wanted to Be,* p. 94.

24 *"were two devils,"* Hanover to the author, September 2, 2011.

24 *"Beware, your parents"*: Ibid.

24 *"I'm sure it was"*: TVF to the author, June 15, 2013.

25 *"during the years"*: Martin Muller to the author, September 27, 2013.

25 *"I never saw"*: Ibid.

25 *"By his early thirties"*: Ibid.

26 *"become a woman soon"* and following: Marlo Thomas, *The Right Words at the Right Time* (New York, Atria, reprint, 2002), p. 107.

26 *"I didn't recognize Diane"*: Halfin to the author, August 30, 2011.

26 *"My mother wanted me"*: DVF to the author, October 2, 2014.

26 *"my grandparents were trying"*: TVF to the author, June 15, 2013.

27 *"The divorce was war"*: Halfin to the author, August 30, 2011.

27 *"Growing up I was:"* Alexander Fury, "An Audience with a Living Legend: Diane von Furstenberg Has Fashion All Wrapped Up," *Independent*, November 2, 2013.

28 *"at fifteen I was"*: DVF to the author, October 2, 2014.

28 *"She was very shy"*: DVF to the author, September 12, 2014.

30 *"had no social life"* and following: Von Furstenberg, *Diane*, pp. 46–47.

30 *"a gaudy dream"*: Taki, *Nothing to Declare: A Memoir* (New York: Atlantic Monthly Press, 1991), p. xi.

31 *"one thing I don't "*: DVF to the author, August 31, 2013.

Egon

33 *"I looked tan"*: Diane von Furstenberg: *Diane: A Signature Life* (New York: Simon & Schuster, 2009), p. 48.

34 *"Every pretty girl"*: Michael Gross, "The Education of Diane von Furstenberg," *Manhattan, Inc.*, February 1985.

34 *"chubbier than she is"*: Nona Gordon to the author, December 2010.

35 *"Egon was beautiful"*: Marina Cicogna to the author, November 28, 2012.

35 *"to go to Paris"*: Ibid.

36 *"were very spoiled"* and following: Ibid.

36 *"My grandfather"*: Alexandre von Furstenberg to the author, June 17, 2013.

36 *"oyster-in-an-r-month,"* Stanley Elkin, *Searches & Seizures,* ebook, location 2620.

36 *"He was adorable"*: Gordon to the author, December 4, 2010.

36 *"Egon wasn't studying"*: Marc Landeau to the author.

37 *"childish,"* DVF to the author, July 3, 2014.

37 *"like a rich girl,"* Barbara Rowes, "Women Buy, but Men Dominate the Fashion World: Then Along Came Diane von Furstenberg," *People,* May 21, 1979.

37 *"At the time":* DVF to the author, August 1, 2014.

37 *"I wanted to see whether":* Julie L. Belcove, "Diane's Wild Ride," *WWD*, September 17, 1998.

37 *"He was twenty-seven"* Mireille de Hanover to the author, September 2, 2011.

38 *"We were all waiting" and following:* Mimmo Ferretti to the author, September 12, 2011.

38 *"At the time":* Albert Koski to the author, September 8, 2011.

39 *"My mother was very":* Philippe Halfin to the author, August 30, 2011.

39 *"I was like an assistant":* DVF to the author, August 1, 2014.

39 *"Diane was very good":* Albert Koski to the author, September 8, 2011.

39 *"I had to put together":* Ibid.

39 *"There was a lid":* Thompson to the author, September 8, 2011.

40 *"when you had a girlfriend":* Cedric Lopez-Huici to the author, May 13, 2011.

40 *"Diane was wild":* Gordon to the author, December 2010.

40 *"He was the worst lay":* DVF to the author, August 1, 2014.

40 *"in the most superficial way,"* Von Furstenberg, *Diane*, p. 50.

41 *"Diane was a plump"* Taki to the author, December 2010.

42 *" didn't know [Diane]" and following:* Florence Grinda to the author, September 8, 2011.

42 *"My whole life":* Marisa Berenson to the author, October 9, 2012.

43 *"We became" and following:* Ibid.

44 *"who was a tyrant":* DVF to Fern Mallis, conversation at the 92nd Street Y, September 13, 2012

45 *"I knew everyone":* Berenson to the author, October 9, 2012.

45 *"We were all Eurotrash" and following:* Ferretti to the author, September 12, 2011.

45 *"hedonistic pleasure,"* Von Furstenberg, *Diane*, p. 51.

46 *"I didn't wait":* Ibid., p. 53.

46 *"I guess she knew":* Koski to the author, September 8, 2011.

46 *"I was looking for":* DVF to the author, August 1, 2014.

47 *"He was like a king":* Sue Feinberg to the author, November 1, 2010.

47 *"Today he'd be in jail" and following:* DVF to the author, August 1, 2014.

48 *"It was article 6030":* Mimmo Ferretti to the author, September 12, 2011.

48 *"horrible stuff":* Sue Feinberg to the author, November 1, 2010.

48 *"Ferretti had thousands" and following:* DVF to the author, October 2, 2014.

49 *"borrowed a dress":* Ibid.

49 *"that I'd lost the love":* Von Furstenberg, *Diane,* p. 52.

49 *"I was making a lot" and following,* Berenson to the author, October 9, 2012.

49 *"He used Marisa" and following:* DVF to the author, October 3, 2014.

50 *"We didn't think":* Marisa Berenson to the author, October 9, 2012.

50 *"When they were with you":* Gigi Williams to the author, May 14, 2011.

50 *"She was not terribly":* Marina Cicogna to the author, November 28, 2012.

51 *"and this way":* DVF to the author, October 4, 2014.

New York

54 *"Diane tried desperately":* Bob Colacello to the author, December 6, 2011.

54 *"Egon introduced me to all":* DVF to the author, October 3, 2014.

54 *"He was in perpetual":* Colacello to the author, December 6, 2011.

54 *"He never really made any money":* AVF to the author, June 17, 2013.

55 *"boy-about-town"* DVF to the author, October 3, 2014.

55 *"What I did know":* Diane von Furstenberg, *The Woman I Wanted to Be* (New York: Simon & Schuster, 2014), p. 14.

56 I'M SORRY TO DISTURB: DVF to EVF, telegram in DVF's possession.

56 *"We were in this little":* Marc Landeau to the author, July 19, 2011.

56 MARRIAGE WILL OCCUR: EVF to DVF, telegram in DVF's possession.

56 *"Egon wasn't the most" and following:* Landeau to the author, July 19, 2011.

57 *"They felt that Diane":* John Richardson to the author, February 21, 2014.

58 *"Tassilo was the younger":* AVF to the author, June 17, 2013.

58 *"Egon is a prince":* Anonymous to the author.

58 *"Jews are clever" and following:* Linda Bird Francke, "The Couple That Has Everything. Is Everything Enough?" *New York,* February 5, 1973.

59 *"enthusiasm was genuine"* Diane von Furstenberg: *Diane: A Signature Life* (New York: Simon & Schuster, 2009), p. 57.

59 *"I got ambitious":* DVF to the author, October 2, 2014.

59 *" felt it wasn't":* DVF to Fern Mallis, conversation at the 92nd Street Y, September 12, 2012.

59 *"Romany romantic" and following: Vogue,* October 15, 1969.

59 *"a charming provincial inn":* von Furstenberg, *Diane,* pp. 55–56.

60 *"Eddie": New York,* February 5, 1973.

60 *"like a woman," Town & Country,* August 1970.

60 *"I have a vision" and following:* Nona Gordon to the author, December 2010.

60 *"was like Pan":* Bob Colacello to the author, December 6, 2011.

61 *"Go to Paris":* EVF, Ginia Bellafante, "Front Row; Just Plain Egon," *New York Times,* July 10, 2001.

61 *"That's the kind of thing" and following:* DVF to the author, August 1, 2014.

62 *"My strengths have":* Susan Alai, "Fashion's Shy Di," *WWD,* September 10, 1985.

62 *"I'm involved with":* Eloise Salholz, "The Little Wrap Returns," *Newsweek,* February 11, 1985.

62 *"classic dress bodies":* Richard Conrad to the author, February 9, 2013.

63 *"was dancing madly":* Kenneth Jay Lane to the author, June 9, 2011.

63 *"I was racked":* Diane von Furstenberg, *Diane von Furstenberg's Book of Beauty: How to Be a More Attractive, Confident, and Sensual Woman* (New York: Simon & Schuster, 1977), p. 16.

64 *"We had the model":* Grace Mirabella to the author, May 2, 2011.

64 *"Terrific, terrific, terrific,"* von Furstenberg, *The Woman I Wanted to Be,* p. 151.

64 *"body-celebrating fashion":* Amanda Mackenzie Stuart: *Empress of Fashion: A Life of Diana Vreeland* (New York: Harper, 2012), p. 245.

65 *"the sharks":* Kathleen Brady, "Diane Means Business," *WWD,* June 14, 1973.

65 *"This is princess":* Bernadine Morris, "For the Princess, A Stylish Business," *New York Times,* April 21, 1970.

66 *"who was really crazy":* Gloria Schiff to the author, January 28, 2013.

66 *"I think your clothes,"* Diana Vreeland to DVF, private collection.

66 *"Don't put me in* Vogue*":* Grace Mirabella to the author, May 2, 2011.

68 *"We were sort of stuck" and following:* John Fairchild to the author, June 9, 2010.

69 *"Longuette is the length":* undated *WWD* clip from Diane's scrapbooks.

69 *"We object strongly":* quoted on the blog "A Vintage Ramble," June 1, 2009.

69 *"Diane just showed up":* Ron Ruskin to the author, August 25, 2010.

69 *"Diane totally charmed":* Mimmo Ferretti to the author, September 12, 2011.

69 *"because I'd hardly":* Von Furstenberg, *Diane*, p. 73.

70 *"I just liked the names":* DVF to the author, October 3, 2014.

71 *"being kind of" and following:* Bob Colacello to the author, December 6, 2011.

71 *"I got the feeling":* Jann Wenner to the author, March 16, 2011.

71 *"They invited whoever":* Howard Rosenman to the author, November 30, 2012.

72 *"We were smoking" and following:* Bob Colacello to the author, December 6, 2011.

72 *"It was an amazing":* Helen Harvey Mills to the author, September 2008.

72 *"Egon was never":* DVF to the author, July 31, 2014.

72 *"Only maids are in love" and following:* Susanna Agnelli, *We Always Wore Sailor Suits* (New York: Bantam, 1976), p. 108.

73 *"looked at each other":* Rosenman, "True Blue: Triumph or Turmoil, Diane Von Furstenberg is a Friend to the End," *Los Angeles Times Magazine*, September 2009.

73 *"This is the guy":* H. Rosenman to the author, November 30, 2012.

73 *"Egon had an aristocratic" and following:* John Richardson to the author, February 21, 2014.

76 *"an important part":* Allan Tannenbaum, *New York in the 70s* (New York: Overlook, 2009), p. 5.

77 *"I didn't have to":* Mimmo Ferretti to the author, September 12, 2011.

77 *"All right to be stylish":* Bob Colacello, *Holy Terror: Andy Warhol Close Up* (New York: HarperPerennial, 1992), p. 6.

78 *"brilliant invention":* John Richardson to the author, February 21, 2014.

78 *"style, charm, charisma,"* Stephanie Rosenbloom, "Tightening Belts? She's the Expert," *New York Times*, July 18, 2009.

78 *"I did make it all up":* DVF to the author, July 31, 2014.

78 *"I remember when":* Fran Boyar to the author, June 10, 2011.

78 *"It's all about":* Stefani Greenfield to the author, January 21, 2014.

79 *"perhaps disappointed":* "Crop Top," *WWD*, February 10, 1972.

79 *"I think she was going to":* "Today's Young Couple," *Newsweek*, January 1973.

79 *"Nothing makes a woman":* Von Furstenberg, *Book of Beauty*, p. 14.

80 *"They thought I was":* Judy Klemesrud, "Those Simple Little Dresses Seen Up and Down the Avenue, " *New York Times*, November 7, 1974.

80 *"I liked Diane's clothes":* John Pomerantz to the author, August 25, 2010.

81 *"The buyer for" and following:* Ibid.

82 *"seemed so old":* DVF to the author, October 28, 2010.

82 *"Henry would say":* Richard Conrad to the author, May 22, 2010.

83 *"I wore them":* Ibid., February 9, 2013.

83 *"He took me":* Ibid.

83 *"I'm making beautiful":* DVF to Richard Conrad, undated, private collection.

83 *"We put together" and following:* Richard Conrad to the author, May 22, 2010.

84 *"a place of Dreiserian" and following:* Bill Blass, *Bare Blass* (New York: , HarperCollins, 2002), pp. 19–20.

85 *"grateful,"* Ibid., p. 20.

87 *"had been completely" and following:* Stephen Burrows to the author, March 17, 2011.

No Zip, No Buttons

90 *"all you need":* Lillian Ross, "The Millionaire," *New Yorker*, January 7, 1950.

90 *"beehives" and following:* Guy Trebay, "Needle and Thread Still Have a Home," *New York Times*, April 29, 2010.

91 *"create some buzz":* Richard Conrad to the author, June 9, 2010.

91 *"That woman stayed":* Kathy van Ness to the author, August 27, 2013.

92 *"but we didn't have":* Conrad to author, May 22, 2010.

92 *"Oh, that's good":* Sue Feinberg to the author, November 1, 2010.

92 *"she'd have a famous":* DVF to the author, August 1, 2014.

93 *"When you're young":* DVF to the author, August 1, 2014.

93 *"I had a lot of things":* Feinberg to the author.

94 *"Diane's greatest talent":* DeBare Saunders to the author, August 27, 2014.

94 *"Diane would arrive":* Conrad to author, February 9, 2013.

94 *"that took the color":* Feinberg to author, October 2, 2014.

94 *"It felt like cashmere":* Conrad to the author, June 9, 2010.

95 *"I'm very worried":* DVF to Richard Conrad, July 1972, private collection.

95 *"It had dolman sleeves":* DVF to the author, September 12, 2014.

95 *"with no zip, no buttons":* EVF quoted in DVF to Richard Conrad, July 1972., private collection.

95 *"because they itched" and following:* Conrad to the author, February 9, 2013.

97 *"but when I saw the photo":* DVF in an email to the author, January 19, 2014.

97 *"since men's bodies":* Gloria Steinem, *Revolution from Within: A Book of Self-Esteem* (New York: Little Brown, 1992), p. 218.

98 *"excitement" and following:* "The Globetrotters," *WWD,* November 2, 1972.

99 *"a silk jersey":* Conrad to author, May 22, 2010.

99 *"not for Liz Claiborne":* Feinberg to author, November 1, 2010.

99 *"could have done without":* "Globe Trotters," *WWD,* November 2, 1972.

99 *"I told Ferretti":* Conrad to the author, June 9, 2010.

99 *"Egon encouraged me":* DVF to the author, July 31, 2014.

100 *"You always push others":* Lee Wohlfert-Wihlborg, "The Original von Furstenberg, Egon,Wakes Up to His Own Potential," *People,* December 21, 1981.

100 *"She was so much smarter":* Francke, *Newsweek,* March 22, 1976.

100 *"made a strong" and following:* "Now: Fall in New York," *WWD,* May 23, 1973.

101 *"I was just trying":* DVF to the author, July 31, 2014.

101 *"Egon had a lot":* Ibid., March 18, 2012.

101 *"Diane came to me" and following:* Fran Boyar to the author, May 24, 2011.

101 *" wasn't special":* DVF to the author, February 3, 2012.

102 *"You just live once" and following:* Linda Bird Francke, "The Couple That Has Everything. Is Everything Enough?" *New York,* February 5, 1973.

102 *"Our sex life":* DVF to the author, July 31, 2014.

102 *"You destroyed my marriage" and following:* Linda Bird Francke to the author, September 17, 2014.

103 *"Egon was more upset":* DVF to the author, July 31, 2014.

103 *"She said, 'Egon's leaving'" and following:* Conrad to the author, February 9, 2013.

104 *"Either you give me" and following:* Diane von Furstenberg, *Diane: A Signature Life* (New York: Simon & Schuster), p. 195.

104 *"We shared a lawyer":* DVF to the author, October 2, 2014.

104 *"He still came over":* Ibid., July 31, 2014.

104 *"Do you love me?"* Wolfert-Wihlborg, "Original von Furstenberg."

The Wrap

106 *"I knew we could":* Richard Conrad to the author, May 22, 2010.

106 *"Let's make it":* Sue Feinberg to the author, October 2, 2014.

106 *"his mother called":* DVF to the author, October 2, 2014.

107 *"testing and trying" and following:* Ibid., September 12, 2014.

107 *"It was nothing really":* Diane von Furstenberg, *Diane: A Signature Life* (New York: Simon & Schuster, 2009), 80.

107 *"We shipped it out" and following:* Conrad to the author, February 9, 2013.

107 *"I had a black":* Leslie Garis in an email to the author, September 26, 2014.

107 *"very grateful":* Leslie Bennetts in an email to the author, September 27, 2014.

108 *"We were making":* Conrad to author, February 9, 2013.

108 *DARLING DICK:* DVF to Richard Conrad, October 3, 1975, private collection.

108 *"I can't remember":* Boyar to author, June 10, 2011.

109 *"Women are too intelligent":* Judy Klemesrud, "Common Dresses Are Designed by a Princess," *New York Times,* November 7, 1974.

109 *"I'd always see her":* André Leon Talley to the author, December 4, 2013.

110 *"She knows her":* Oscar de la Renta to the author, July 20, 2011.

110 *"loved Diane":* Francois Catroux to the author, September 8, 2011.

110 *"I don't pretend":* Kathleen Brady, "Diane Means Business," *WWD,* June 14, 1973.

110 *"I didn't call myself":* DVF to the author, July 31, 2014.

110 *"She took credit":* DeBare Saunders to the author, August 27, 2014.

110 *"She was scared":* Linda Bird Francke to the author, September 17, 2014.

111 *"beautiful bright yellow" and following:* Andy Warhol, *The Andy Warhol Diaries,* edited by Pat Hackett (New York: Grand Central Publishing, 1991), p. 326.

111 *"it reminded me":* Bernadine Morris to the author, August 2, 2010.

112 *"Who else has done":* DVF to the author.

112 *"a climax to"*: Diane von Furstenberg, "Wrap dress," 1975–76 , Gift of
Richard Martin, 1997, in *Heilbrunn Timeline of Art History*, New York: The
Metropolitan Museum of Art, 2000–, http://www.metmuseum.org/toah/
works-of-art/1997.487.

113 *"one-tenth of one percent,"* Frances Cerra, "Who's to Blame For the Ruined
Clothes?", *New York Times*, August 30, 1976.

113 *"The stars were aligned"*: Sue Feinberg to the author, November 1, 2010.

114 *"It was exciting"*: Jaine O'Neil to the author, April 17, 2011.

114 *"I am very drunk"*: DVF to Marion Stein, May 12, no year, private collection.

114 *"He was always around"*: Linda Bird Francke to the author, September 17, 2014.

115 *"Diane's style wasn't"* and *following*: Bob Colacello to the author, December 6,
2011.

115 *"This is really sick"*: Steven Gaines, *Simply Halston* (New York: Jove, 1993),
p. 112.

116 *"By the way"* and *following*: Diane von Furstenberg interview by Victor Hugo,
Interview, January 1975.

116 *"our bodies"*: DVF to the author, August 31, 2013.

116 *"I was having"*: Ibid., 2014.

116 *"I got him"*: Fran Boyar to the author, June 10, 2011.

117 *"On the one hand"and following:* Jas Gawronski to the author, June 11, 2013.

118 *"a typical Upper East Side"and following:* AVF to the author, June 17, 2012.

119 *"called me her oxygen": and following:* TVF to the author, June 15, 2013.

119 *"she wouldn't let me"* and following: Olivier Gelbsman to the author, February
11, 2013.

120 *"quietly in the audience" and following:* Bernadine Morris, "On Seventh
Avenue, the Shows Gather Momentum," *New York Times*, April 29, 1974.

120 *"Egon would come"*: Richard Conrad to the author, February 9, 2013.

121 *"If I loan it"*: Ibid., June 9, 2010.

A DVF World

124 *"There's always an echo"*: Stefani Greenfield to the author, January 21, 2014.

124 *"People were offering"*: DVF to the author, October 3, 2014.

125 *"Why do you need"*: Diane von Furstenberg, *Diane: A Signature Life* (New
York: Simon & Schuster, 2009), p. 103.

125 *"the ranks of women"*: Ibid., p. 108.

126 *"I thought" and following*: Gigi Williams to the author, May 14, 2011.

126 *"We never should" and following*: Richard Conrad to the author, February 9, 2013.

127 *"We did very well"*: Ibid., June 9, 2010.

127 *"Diane can't tolerate"*: Linda Bird Francke to the author, September 17, 2014.

127 *"Women would book"*: Williams to author, May 14, 2011.

The Adventuress

131 *"Do I think"*: DVF to the author, October 3, 2014.

132 *"she was fairly" and following*: Barry Diller to the author, July 15, 2013

132 *"It was very much like"*: David Rensin, *The Mailroom: Hollywood History from the Bottom Up* (New York: Ballantine Books, 2007), ebook location 1811.

133 *"no one had known"*: Diane von Furstenberg, *The Woman I Wanted to Be* (New York, Simon & Schuster, 2014), p. 72.

134 *"but I didn't sleep"*: Diane von Furstenberg, *Diane: A Signature Life* (New York: Simon & Schuster, 2009), p. 115.

134 *"We spent about a week" and following*: Barry Diller to the author, July 15, 2013.

135 *"very much in love"*: Von Furstenberg, *Diane*, p. 115.

135 *"I guess the reason"*: Andy Warhol, *The Andy Warhol Diaries*, edited by Pat Hackett (New York: Grand Central, 1991), p. 192.

135 *"I don't understand"*: DVF to Andrew Goldman, "How Diane von Furstenberg Is Like a Cowboy," *New York Times*, June 28, 2013.

136 *"Go show" and following*: Jerry Bowles, "Diane von Furstenberg—At the Top," *Vogue*, July 1976, p. 141–42.

136 *"He was always"*: AVF to the author, June 17, 2013.

136 *"I slept with other people,"* DVF to the author, July 31, 2014.

136 *"I don't ask" and following*: DVF to the author, August 1, 2014.

137 *"It hasn't been valuable"*: TVF to the author, June 15, 2013.

138 *"I'm here because"*: Nancy Collins, "Brown Comes to Town," *WWD*, May 11, 1976.

138 *"was the first governor"*: Barbara Rowes, "Women Buy, but Men Dominate the Fashion World: Then Along Came Diane von Furstenberg," *People*, May 21, 1979.

138 *"was so irresistible":* DVF to the author, August 31, 2013.

138 *"he'd gotten":* Warhol, *Warhol Diaries,* p. 244.

138 *"Yeah, briefly":* DVF to the author, August 31, 2013.

139 *"I loved the feeling":* Von Furstenberg, *Diane,* p. 157.

139 *"It was all for the boys":* anonymous to the author, July 11, 2011.

140 *"The hours between":* Von Furstenberg, *Diane,* p. 155.

141 *"The whole apartment":* Bob Colacello to the author, December 6, 2011.

141 *"way in the back" and following:* André Leon Talley to the author. December

142 *"I was playing the games":* Von Furstenberg, *Diane,* p. 159.

142 *"are better than men":* "Verbatim," *Time,* February 16, 2004.

142 *"Have I slept with women":* DVF to the author, September 12, 2014.

143 *"huge advance":* Von Furstenberg, *Diane,* p. 120.

143 *"Well, what do you" and following:* von Furstenberg, *Diane,* p. 122.

144 *"I am not a snob":* HFT, June 1980, p. 49.

144 *"like Sheena":* Julie Baumgold, "Under the Volcano with Diane von Furstenberg," *New York,* May 1981.

144 *"Sits at the bathmat":* Baumgold, "Under the Volcano."

144 *"This morning" and following:* Diane von Furstenberg interview by Bob Colacello, *Interview,* March 1977.

145 *"Diane understands":* Michael Gross, "The Education of Diane von Furstenberg," *Manhattan, Inc.,* February 1985.

145 *"What's a pretty girl"* Von Furstenberg, *Diane,* p. 109.

145 *"That [wrap] dress" and following:* Edward Kosner to the author, July 2011.

146 *"I was so busy":* DVF to the author, October 2, 2014

146 *"For someone who" and following:* *Newsweek,* March 22, 1976.

146 *"I gave up the princess":* DVF to the author, August 1, 2014.

147 *"I haven't worn":* Gloria Steinem to the author, September 27, 2013.

147 *"you have to look":* transcript of DVF interview by Chrystia Freeland and Vanessa Friedman, published in the *Financial Times,* February 7, 2007.

147 *"Before feminism":* Gloria Steinem to the author, September 27, 2013.

147 *"a tomboy who suffers"*: Sally Beauman, "So Who's Liberated?" *Vogue*, September 1, 1970.

148 *"We rarely covered"*: Letty Pogrebin in emails to the author, February 18 and 19, 2013.

148 *"We regarded ourselves"*: Gloria Steinem to the author, September 27, 2013.

148 *"in the early days"*: Joanne Edgar in an email to the author, February 19, 2013.

149 *"Too bad, I got there"*: Luis Estevez to the author, May 17, 2011.

149 *"If I had to be beaten" and following*: Von Furstenberg, *Diane*, p. 112.

Requiem for a Dress

152 *VON FURSTENBERG LINE and following*: "Von Furstenberg Line Marked Down by Six N.Y. Stores," *WWD*, June 21, 1977.

153 *"The handwriting"*: Richard Conrad to the author, October 8, 2014.

153 *"I was traveling around"*: DVF to the author, August 2, 2014.

153 *"She was bringing in"*: anonymous to the author.

154 *"that had four walls"*: Diane von Furstenberg, *Diane: A Signature Life* (New York: Simon & Schuster, 2009), p. 131.

154 *"he could not make"*: Richard Conrad to the author, May 22, 2010.

154 *Diane hates guns"*: Ibid., June 9, 2010.

154 *"came in one morning"*: DVF to the author, August 1, 2014.

154 *"It was a House of Eurotrash," and following*: DeBare Saunders to the author, August 27, 2014.

155 *"What happened" and following*: Barry Diller to the author, July 15, 2013.

156 *"We took helicopters"*: Lee Mellis to the author, February 16, 2011.

157 *"Designers were becoming"*: Andrew Rosen to the author, December 10, 2010.

157 *"we approached her"*: Lee Mellis to the author.

157 *"It was over Christmas"*: Barry Diller to the author, July 15, 2013.

158 *"Suddenly, overnight"*: Jaine O'Neil to the author, April 17, 2011.

158 *"But he couldn't help"*: Richard Conrad to the author, May 22, 2010.

158 *"Diane owed us" and following*: Mimmo Ferretti to the author, September 12, 2011.

159 *"I don't want to know"*: quoted in *BusinessWeek*, February 19, 1995.

159 *"was full of beautiful" and following:* Ferretti to the author, September 12, 2011.

160 *"I will never forget":* Von Furstenberg, *Diane,* p. 134.

160 *"My father got scared":* Ferretti to author, September 12, 2011.

160 *"I have a lot down my sleeve":* "It's What You Don't Say," *WWD,* April 14, 1978.

161 *"asked me about my" and following:* Gary Savage to the author, June 8, 2011.

162 *"it's a very chic plant":* Michael Gross, "The Education of Diane von Furstenberg," *Manhattan , Inc.,* February 1985.

162 *"very velvety, purple":* Steve Ginsberg, "Beauty and the Bureaucracy," *WWD,* February 24, 1978.

162 *"She wanted to be" and following:* Savage to the author.

163 *"They didn't turn out to be":* Mellis to the author.

164 *"DVF groupie" and following:* Andy Warhol, *The Andy Warhol Diaries,* edited by Pat Hackett (New York: Grand Central Publishing, 1991), p. 292.

164 *"He resented my big":* DVF to the author, July 31, 2014.

164 *"was really difficult" and following:* Sally Randall to the author, July 28, 2011.

165 *"I don't like to renege":* DVF to Iris Love, *Interview,* November 1981.

165 *"he found out he was":* DVF to the author, August 1, 2014.

165 *"I think Daddy's gay":* Ibid.

165 *"He loved me":* Ibid.

166 *"upstairs huddled on" and following:* Bob Colacello to the author, December 6, 2011.

166 *"We'd stay for a month" and following:* AVF to the author, June 17, 2013.

166 *"I never once heard her ":* Colacello to author, December 6, 2011.

166 *"She's unbelievably loyal":* Oscar de la Renta to the author, July 20, 2011.

167 *"she's not going":* Warhol, *Warhol Diaries,* p. 237.

167 *"didn't like the way":* Anthony Haden-Guest, *The Last Party: Studio 54, Disco, and the Culture of the Night* (New York: It Books, 2009), p. 108.

167 *"Now people remake "and following:* Fran Lebowitz to the author, April 1, 2011.

168 *"I definitely had" and following:* DVF to the author, September 12, 2014.

168 *"was a very cruisy":* Stephen Fried to the author, May 17, 2013.

168 *"Diane and I always"*: Gigi Williams to the author, May 14, 2011.

169 *"her rumored sexual"*: Jane F. Lane to the author.

169 *"step for the briefest"*: Jane F. Lane, "Diane von Furstenberg: I Have a Man's Life," *W,* September 15–22, 1978

169 *"The impression I got"*: Fried to the author.

169 *"Later, I realized"*: Von Fursteberg, *Diane,* p. 149.

170 *"The AIDS epidemic"*: TVF to the author, June 15, 2013.

170 *"don't want their money"*: Woody Hochswender, "AIDS and the Fashion World: Industry Fears for Its Health," *New York Times,* February 11, 1990.

170 *"The truth is"*: Barry Diller to the author, July 15, 2013.

171 *"When the concentration camps"*: Warhol, *Andy Warhol Diaries,* p. 128.

171 *"I remember Andy and I"*: Bob Colacello to the author, December 6, 2011.

171 *"I think my mother"*: *and following:* Philippe Halfin to the author, August 30, 2011.

172 *"She was literally crippled"*: TVF to the author, June 15, 2013.

172 *"had lost her mind"*: Halfin to the author, August 30, 2011.

173 *"too awful to contemplate"*: Von Furstenberg, *Diane,* p. 163.

173 *"Why'd you get me" and following:* Julie Baumgold, "Diane Von Furstenberg and Her Jungle Romance, *New York,* May 4, 1981.

173 *"It was a major revelation"*: JTA, Global Jewish News Source, March 3, 2013.

174 *"to be shy and tender"*: Von Furstenberg, *Diane,* p. 155.

174 *"too big a package"*: Baumgold, "Diane von Furstenberg."

Volcano of Love

176 *"Diane is wearing" and following:* Olivier Gelbsman to the author, February 11, 2013.

176 *"this guy she met"*: Fran Lebowitz to the author, April 1, 2011.

177 *"I'm purifying"*: Julie Baumgold, "Diane von Furstenberg and Her Jungle Romance, *New York,* May 4, 1981.

177 *"in a factory"*: Gary Savage to the author, June 8, 2011.

178 *"particularly pleasant"*: Savage to the author.

178 *"Everything about it"*: Rose Marie Bravo to the author, November 1, 2010.

178 *"Why don't you wear":* Diane von Furstenberg, *Diane: A Signature Life* (New York, Simon & Schuster, 2009), p. 168.

178 *"Diane is the most romantic":* Fran Lebowitz to the author, April 1, 2011.

179 *"He was a nice guy":* Savage to the author.

179 *"He was always":* Sally Randall to the author, July 28, 2011.

179 *"people were dying" and following:* TVF to the author, June 15, 2013.

179 *"taking my skateboard" and following:* AVF to the author, June 17, 2013.

179 *"my currency" and following:* TVF to the author, June 15, 2013.

180 *"my mom let him" and following:* AVF to the author, June 17, 2013.

180 *"I'm so glad you're here" and following:* DVF to the author, October 3, 2014.

180 *"He was barely thirty":* DVF to the author, October 3, 2014.

180 *"told me she was":* Ibid.

181 *"Suddenly, all I saw" and following:* Von Furstenberg, *Diane: A Signature Life,* p. 171.

181 *"I wasn't involved":* Barry Diller to the author, July 15, 2013.

182 *"a shrine to Venus":* Bobby Queen, "The Newest Boutiques," *WWD*, November 30, 1984.

182 *"not to count on a May":* Warhol, *Warhol Diaries,* p. 567.

182 *"fairly thin and fairly rich,"* Bernadine Morris, "Diane von Furstenberg: Couture in a New Shop," *New York Times,* December 7, 1984.

183 *"You know what people"* Manhattan, Inc. February, 1985.

183 *"Standouts in the designer's":* "Emperor Collection," *WWD*, October 29, 1984.

184 *"Andy Warhol":* Warhol, *Warhol Diaries,* p. 714.

184 *"My mom fell":* AVF to the author, June 17, 2013.

184 *"He had no chin" and following:* DVF to the author, October 3, 2014.

184 *"I was just out":* Alain Elkann to the author, February 11, 2013.

185 *"Paulo was very upset" and following:* DVF to the author, October 3, 2014.

185 *"I got a call" and following:* Olivier Gelbsman to the author, September 9, 2011.

185 *"going the Marilyn Monroe":* Warhol, *Warhol Diaries,* p. 769.

186 *"designing very expensive products":* Von Furstenberg, *Diane,* p. 184.

186 *"is something so central":* Fran Lebowitz to the author.

187 *"There'd been a fuckup":* anonymous to the author, July 11, 2011.

187 *"she suffered":* Olivier Gelbsman to the author, September 9, 2011.

187 *"Elkann was very controlling":* Barry Diller to the author, July 15, 2013.

188 *"a boring doormat,"* Von Furstenberg, *Diane,* p. 185.

188 *"she always became":* AVF to the author, June 17, 2013.

189 *"I was there because of":* James Fox in an email to the author, June 19, 2013.

189 *"hummingbirds on nectar,"* Frederick Seidel, "Nectar," *Poems, 1959–2009* (ebook). p. 54.

189 *"I remember asking her":* Frederick Seidel to the author, June 18, 2013.

189 *"what she did":* Edmund White, *Inside a Pearl: My Years in Paris* (London: Bloomsbury, 2014) p. 20.

190 *"felt a little pang":* Von Furstenberg, *Diane,* p. 192.

191 *"I didn't want to get back":* Ibid.

191 *"We were a family":* Ibid., p. 193.

192 *"Fundamentally, what I" and following:* John Elkann to the author, July 29, 2013.

192 *"She had no business":* AVF to the author, June 17, 2013.

192 *"That's her key":* Linda Bird Francke to the author, September 17, 2014.

192 *"It was annoying":* AVF to the author, June 17, 2013.

193 *"The award was":* Von Furstenberg, *Diane,* p. 190

193 *"was so much more" and following:* Alain Elkann to the author, February 11, 2013.

194 *"he was not happy":* DVF to the author, July 31, 2014.

194 *"When a woman":* Alain Elkann to the author, February 11, 2013.

194 *"très proche":* Francois Catroux to the author, September 8, 2011.

194 *"with none of the":* Alicia Drake, *The Beautiful Fall: Fashion, Genius, and Glorious Excess in 1970s Paris* (New York: Little Brown, 2006), p. 97.

195 *"a refusal to accept ":* Joan Juliet Buck, "Blythe Spirit," *W,* February 2012.

195 *"She was this mad":* Drake, *Beautiful Fall,* p. 101.

196 *"Loulou fell in love":* Catroux to the author.

196 *"She could have had":* Alain Elkann to the author, February 11, 2013.

196 *"would be twenty-five now,"* DVF to the author, August 1, 2014.

196 *"there were others,"* Von Furstenberg, *Diane,* p. 196.

196 *"Alain and I have become":* DVF diary entry, April 1989.

196 *"terrible morning":* Ibid., May 30, 1989.

196 "So goes *Alain with the tooth,"* DVF to the author, August 1, 2014.

Can We Shop?

197 *"junk" and following:* Georgia Dullea, "On the Way Home With: Diane von Furstenberg; Always Room for Old Beaus," *New York Times,* December 23, 1993.

198 *"Donna designed":* Patti Cohen to the author, December 1, 2011.

199 *"the heroic female":* Amy M. Spindler, "For Karan and Lauren, Tent-Free Triumphs" (Reviews/Fashion) *New York Times,* April 4, 1996.

199 *"selling imagery":* Michael Gross, *Genuine Authentic: The Real Life of Ralph Lauren* (New York: HarperPerennial, 2004), p. 205.

201 *"established a product":* Stephen Koepp, "Selling a Dream of Elegance and the Good Life," *Time,* September 1, 1986.

202 *"who has this great, great":* anonymous to the author, July 2011.

202 *"a licensing business" and following, Interview,* July 1989.

203 *"Mort Zuckerman is":* DVF to the author, August 1, 2014.

203 "I would have preferred": Diane von Furstenberg, *Diane: A Signature Life* (New York: Simon & Schuster, 2009), p. 204.

204 *"charming":* Ibid., p. 205.

204 *"I had no business":* Ibid., p. 209.

204 *"My father was going":* Irving Rousso, in *Schmatta: Rags to Riches to Rags,* directed by Marc Levin (Home Box Office, Blowback Productions, 2009).

205 *"This third child" and following:* Kathy Landau to the author, August 7, 2013.

206 *"I ate a lot of . . .":* Georgia Dullea, "On the Way Home With: Diane von Furstenberg; Always Room for Old Beaus" *New York Times,* December 23, 1993.

206 *"I was marginally happier":* Von Furstenberg, *Diane,* p. 210.

206 *"In that case":* Kathy Landau to the author, August 7, 2013.

206 *"It was nothing" and following:* Kathy Van Ness to the author, August 27, 2013.

207 *"I feel like a fool,"* Dianne M. Pogoda, "Von Furstenberg's Window Dressing," *WWD,* March 31, 1992.

208 *"God Bless QVC"*: Interview, Joan Rivers, *Time Out Chicago,* July 27, 2009.

209 *"Barry, you've got to"*: Ken Auletta, "Barry Diller's Search for the Future," *The New Yorker,* February 22, 1993.

210 *"It was the first time"*: Barry Diller to the author, July 15, 2013.

210 *"Why are we bothering" and following:* Marvin Traub with Lisa Marsh, *Like No Other Career* (New York: Assouline, 2008), p. 50.

211 *"Please, let's not" and following:* Katherine Betts, "Show and Sell," *Vogue,* February 1993, pp. 82–86.

213 *"was my transition"*: Diller to the author. July 15, 2013

213 *"Diners passing Diller"*: Ken Auletta, "Barry Diller's Search for the Future," *New Yorker,* February 22, 1993.

213 *"Could you please"*: Von Furstenberg, *Diane,* p. 217.

214 *"I'm having fun"*: Frederick Seidel to the author, June 18, 2013.

214 *"sitting in the greenroom"*: Georgia Dullea, "On the Way Home with Diane von Furstenberg: Always Room for Old Beaus," *The New York Times,* December 23, 1993.

214 *"getting back together"*: Barry Diller to the author. July 15, 2013.

214 *"a power couple"*: *Vanity Fair*'s 1993 Hall of Fame, *Vanity Fair,* December 1993.

215 *"Diller is almost a husband"*: James Barron (with Geraldine Fabrikant and Linda Lee), "Public Lives," *New York Times,* January 30, 2001.

215 *"I always fight that:* DVF to the author, August 1, 2014.

215 *"hears my name"*: Frank DiGiacomo, "Irresistible and Slightly Lethal," *The New York Observer,* October 13, 1997.

216 *"was around"*: Kathy Landau to the author, August 7, 2013.

216 *"Welcome to my bathroom"*: Dan Shaw, "The Night; Not Home Alone," *New York Times,* September 5, 1993.

219 *"It's cancer" and following:* TVF to the author, June 15, 2013.

220 *"I have these moments"*: Bianca Kermorvant to the author, September, 2011.

220 *"As I walked"*: Von Furstenberg, *Diane,* p. 222.

221 *"My mom was never"*: TVF to the author, June 15, 2013.

221 *"Powerful,"* Suzy Menkes, "Lacroix Explores Limits of Ready-to-Wear," *International Herald Tribune,* March 7, 1994.

221 *"Perhaps the most celebrated"*: Michael Specter, "The Fantasist: How John Galliano Reimagined Fashion" *New Yorker,* September 22, 2003.

222 *"the most uncomfortable":* Von Furstenberg, *Diane,* p. 223.

222 *"Diane got the dress":* André Leon Talley to the author, December 4, 2013.

222 *"He intensely":* TVF to the author, June 15, 2013.

222 *" soul mate,"* Bernard Weinraub, "What's Driving Diller to Play for Paramount," *New York Times,* September 22, 1993.

The Comeback

225 *"to honor,"* Diane, p. 237

225 *"reflects my desire":* "Diane von Furstenberg Names Three VPs, Board of Advisors," *WWD,* August 22, 1995.

226 *"seemed like":* AVF to the author, June 14, 2013.

226 *"Everyone told her":* Kathy Landau to the author, August 7, 2013.

227 *"had saved my life" and following:* DVF to the author, October 2, 2014.

227 *"I'd spy on her"and following,* DVF to the author, October 2, 2014

228 *"resilience is bred":* Ruth La Ferla, "The Designer Tries on Another Image," *New York Times,* November 1, 1998.

228 *"Most people would":* Sue Feinberg to the author, October 2, 2014.

228 *"I'm not dead yet,"* Diane von Furstenberg, *Diane: A Signature Life* (New York: Simon & Schuster, 2009), p. 22.

229 *"I was going down":* Rose Marie Bravo to the author, November 1, 2010.

230 *"You have to know":* Charles Scribner III, quoted in "The Glamour Girls Guide to Life" by Monique Yazigi, *New York Times,* April 5, 1998.

230 *"I found some":* DVF to the author, August 1, 2014.

230 *"A certain Mr. Lam" and following:* Diane von Furstenberg with Linda Bird Francke, *The Woman I Wanted to Be* (New York: Simon & Schuster, 2014), pp. 184–85.

231 *"She got the idea":* Kathy Landau to the author, August 7, 2013.

231 *"Diane was a little nervous":* Alexandra von Furstenberg to the author, June 14, 2013.

231 *"He stared at me":* WWD, August 22, 1997.

231 *"wanted to roll out" and following:* Kathy Landau to the author. August 7, 2013.

232 *"the winding cloth" and following:* Herbert Muschamp, "Liberty, Equality, Sorority," *New York Times,* April 3, 1998.

232 *"It's great to be back", Diane,* p. 20.

233 *"were probably":* Barry Diller to the author, July 15, 2013.

233 *"They feel small":* Julie L. Belcove, "Diane's Wild Ride," *WWD,* September 17, 1998.

233 *"No one could compete" and following:* DVF to the author, July 31–August 1, 2014.

234 "We were on the road": Alexandra von Furstenberg to the author, June 14, 2013.

234 *"The wrap dress" and following:* Stefani Greenfield to the author, January 21, 2014.

235 *"was boringly repetitious":* Anne-Marie Schiro, "The Rewards of Keeping Faith," Review/Fashion, *New York Times,* November 5, 1997.

235 *"This should be":* Suzy Menkes, "A Wave of Femininity Sweeps In," *International Herald Tribune,* November 5, 1997.

236 *"Everyone was primed":* "New York Get Moving," *WWD,* November 4, 1997.

236 *"You can't go from":* Landau to the author, August 7, 2013

236 *"make a major marriage":* Eric Wilson, "Von Furstenberg Seeking a Buyer for Dress Line," *WWD,* October 20, 1998.

237 *"deeply troubled" and following:* Constance C. R. White and Jennifer Steinhauer, "Fashion Relearns Its Darwin: Be Adaptable or Be Extinct," *New York Times*, August 6, 1996.

238 *"Tell everyone" and following:* Julie L. Belcove, "Diane's Wild Ride," *WWD,* September 17, 1998.

238 *"When your identity":* Kathy Landau to the author, August 7, 2013.

238 *"I mean you swell":* Julie L. Belcove, "Diane's Wild Ride," *WWD,* September 17, 1998.

239 *"I didn't have":* DVF to the author, March 18, 2012.

239 *"consummate image maker" and following:* Ruth La Ferla, "The Designer Tries On Another Image," *New York Times,* November 1, 1998.

240 *"Diane is wonderfully gifted":* "Letter from the Editor," Anna Wintour, *Vogue,* November 1998.

241 *"Either Anna Wintour":* anonymous to the author.

241 *"bouts of superficiality":* Michele Orecklin, review of *Diane: A Signature Life,* etc. *New York Times,* November 22, 1998.

241 *"bathetic" and following:* Suzy Menkes, "The Charmed Lives and Free Spirit of Diane von Furstenberg: It's a Wrap: The Image of an Era," *International Herald Tribune,* December 1, 1998.

242 *"Diane was so sensual" and following:* Catherine Malandrino to the author, February 17, 2011.

243 *"looked very schizophrenic":* Eric Wilson, "Falk's DVF: Not Just a Wrap Star," *WWD*, March 24, 1998.

243 *"for the wired woman":* Suzy Menkes, "American Designers Shoot for the Year 2000: A Comfort in Modernity," *International Herald Tribune*, February 16, 1999.

243 *"It's an enormous,":* Eric Wilson, "Fashion Shows: Industry Lifeblood or Dance of Death?," *WWD*, September 10, 2001.

244 *"wanted to pull" and following:* Barry Diller to the author, July 15, 2013.

244 *"She had savings":* AVF to the author, June 17, 2013.

244 *"Give me six months":* Von Furstenberg with Francke, *Woman I Wanted to Be*, p. 196.

244 *"We tried to talk" and following:* Barry Diller to the author, July 15, 2013.

245 *"a hit" and following:* "Anything Goes," WWD, September 14, 1999.

245 *"sexy variations":* Cathy Horyn, "Boatloads of Stars, But Ideas Are Elsewhere," *New York Times*, September 14, 1999.

245 *"dramatic,"* Eric Wilson, "Old Names with New Games,"*WWD*, November 22, 1999.

246 *"I knew I had":* DVF to the author, October 2, 2014.

246 *"She made it easy":* Kathy Landau to the author, August 7, 2013.

246 *"a tendency to hide":* Stephanie Rosenbloom, "Tightening Belts? She's the Expert," *New York Times*, July 18, 2009.

247 *"You blew that deal" and following:* anonymous to the author.

248 *"caught the spirit":* Suzy Menkes, "New York Fashion: A Fresh Look at Female Empowerment," *International Herald Tribune*, September 19, 2000.

248 *"Ms. von Furstenberg is not":* Cathy Horyn, "Choosing a Destiny: Here-to-Stay or Here-to-Play," *New York Times*, September 19, 2000.

249 *"was still in love":* Martin Muller to the author, September 27, 2013.

249 *"had rested deeply" and following:* TVF in an email to the author, November 25, 2013.

250 *"They fought a lot":* Philippe Halfin to the author, August 30, 2001.

250 *"sooner or later":* Bridget Foley, "The Wedding Planners," *WWD*, February 2, 2001.

250 *"but not really a lot" and following:* Barry Diller to the author, July 15, 2013.

251 *"I called him and said"*: Kamala Kirk, *O*, November 12, 2014.

251 *"Am I betraying"*: Bridget Foley, "The Wedding Planners," *WWD*, February 2, 2001.

251 *"I told her"*: André Leon Talley to the author, December 4, 2013.

251 "Make sure you": Bridget Foley, "The Wedding Planners," *WWD*, February 2, 2001.

251 *Maybe one of us"*: Ibid.

251 *"the three Aquarians"*: Ibid.

252 *"Diane gave one"*: Ginia Bellafante, "Front Row: Just Plain Egon," *New York Times*, July 10, 2001.

252 *"My pattern"*: DVF to the author, August 1, 2014.

252 *"a merger" and following*: *New York Times*, February 3, 2001.

253 *"a bit too Cole Porter"*: Bridget Foley, "The Wedding Planners," *WWD*, February 2, 2001.

253 *"I'm so happy"*: TVF to the author, June 15, 2013.

253 *"madly in love"*: anonymous to the author.

253 *"I don't think it would"*: Francois Catroux to the author, September 8, 2011.

253 *"It boggles the mind"*: André Leon Talley to the author, December 4, 2013.

254 *"always inventing herself"*: Kathy Landau to the author, August 7, 2013.

254 *"wouldn't change a thing"*: Barry Diller to the author, July 15, 2013.

254 *"insane"*: Leonard McCants, "Spring Is Turning Up Dresses," *WWD*, October 31, 2000.

Epilogue

258 *"What I like about women"*: Deborah Kan, "Diane von Furstenberg on China," *Digital Wall Street Journal*, June 20, 2012.

259 *"I don't think about legacy"*: Barry Diller to the author, July 15, 2013.

259 *"I want to be remembered"*: DVF to Martha Stewart, Martha Stewart videos.

260 *"clarity," and following*. DVF to the author, August 31, 2013.

260 *"one of the best right hands"*: Cathy Horyn, Things Turn in the Right Direction," *New York Times*, February 13, 2012.

260 *"had gone off brand,"* DVF to the author, May 21, 2013.

261 *"accessibility"*: Vanessa Friedman, "Some Get the Point: Tommy Hilfiger, Diane von Furstenberg, Carolina Herrera, The Row," *New York Times*, September 8, 2014.

261 *"haul[ed] away"*: Eric Wilson, "Is New York Fashion Week Near the End of the Runway?" *New York Times*, September 4, 2013.

261 *"the United States is"*: Diane von Furstenberg, "Fashion Deserves Copyright Protection," *Los Angeles Times*, August 24, 2007.

263 *"Everyone here better be"*: Charlotte Cowles, *The Cut*, nymag.com, September 8, 2012.

263 *"who have survived"*: "DVF Honors Women Leaders," *Daily Beast*, February 10, 2010.

265 *"She wants to be" and following:* AVF to the author, June 17, 2013.

266 *"I believe in the circle"*: DVF to the author, October 28, 2010 and July 16, 2011.

266 *"hates fashion" and following:* TVF to the author, June 15, 2013.

266 *"was super hard" and following:* AVF to the author, June 17, 2013.

267 *"My son was jealous"*: New York Post, *Page Six Magazine*, February 11, 2010.

267 *"I remember a holiday"*: Bob Colacello to the author, December 6, 2011.

268 *"and the first one to believe:"* DVF to the author, July 16, 2011.

268 *"He'd had a lot of shame" and following:* TVF to the author, June 15, 2013.

268 *"We all knew" and following:* Marc Landeau to the author, July 19, 2011.

269 *"I liked the fact"*: Diane von Furstenberg, *Diane: A Signature Life* (New York: Simon & Schuster, 2009), p. 206.

269 *"I don't like to stay,"* Boston Common, Fall 2012.

269 *"She'll talk about"*: DVF to the author, August 1, 2013.

270 *"I don't want to be"*: DVF to the author, October 3, 2013.

271 *"What defines me"*: DVF to the author, July 31, 2014.

272 *"Don't let her look"*: Ellen Gross to the author, October 2, 2013.

Index

W